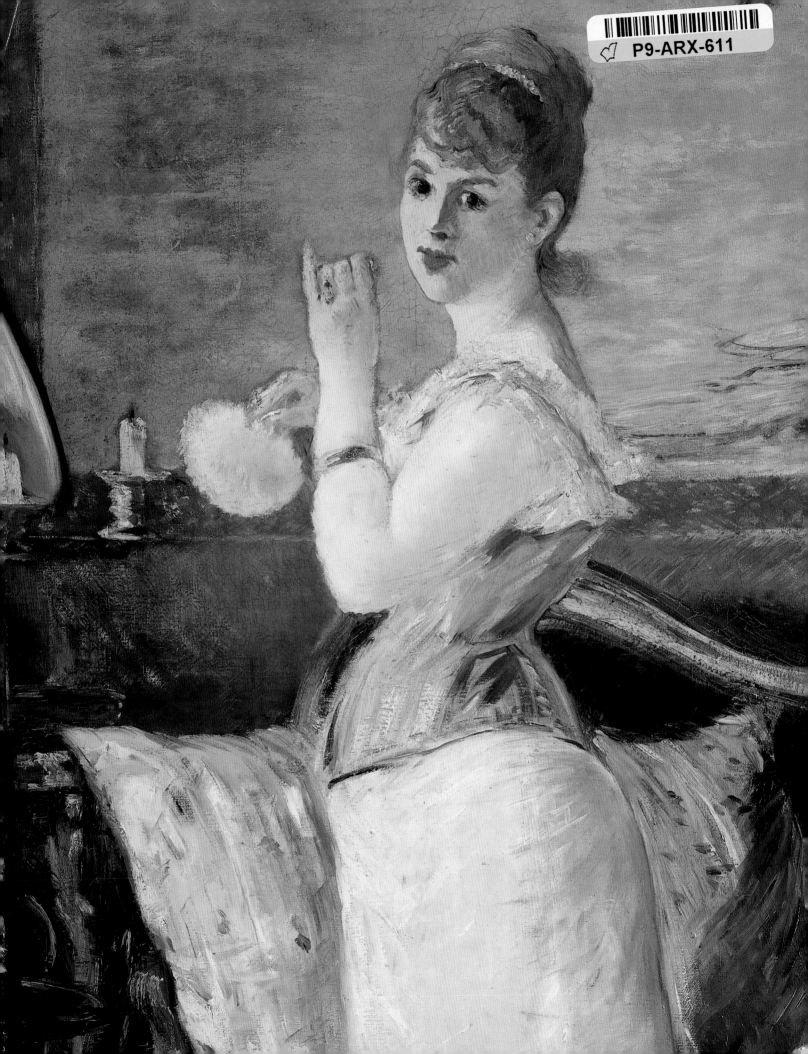

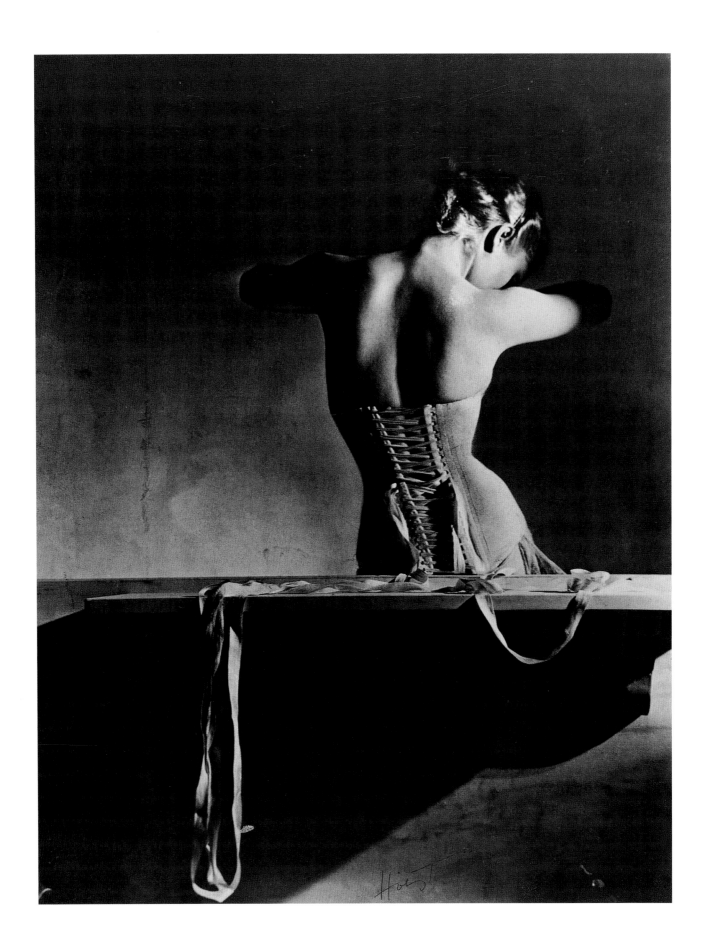

Valerie Steele

The Corset

A Cultural History

Yale University Press

New Haven & London

Designed by Gillian Malpass

Printed in Singapore

Library of Congress Cataloging-in-Publication Data

Steele, Valerie.
 The corset : a cultural history / by Valerie Steele.
 p. cm.
 Includes bibliographical references and index.
 ISBN 978-0-300-09071-0 cloth
 ISBN 978-0-300-09953-9 paper
 1. Corsets – History. 2. Corsets – Social aspects. 3. Costume – Erotic aspects. I. Title.
 GT2075 .S74 2001
 391.4′2 – dc21

 2001033330

A catalogue record for this book is available from
The British Library

PAGE i Edouard Manet, *Nana* (detail), 1877.
The Hamburger Kunsthalle, Hamburg.
Photograph © Elke Walford, Hamburg.

FRONTISPIECE Horst, photograph of the back view of a model wearing a corset
by Detolle for Mainbocher, from *Vogue*, September 15, 1939, p. 76.
© *Vogue*, Condé Nast Publications Inc.

Contents

Acknowledgments vi

1 Steel and Whalebone: Fashioning the Aristocratic Body 1

2 Art and Nature: Corset Controversies of the
 Nineteenth Century 35

3 Dressed to Kill: The Medical Consequences of Corsetry 67

4 Fashion and Fetishism: The Votaries of Tight-Lacing 87

5 The Satin Corset: An Erotic Iconography 113

6 The Hard Body: A Muscular Corset 143

Notes 177

Selected Bibliography 186

Index 195

Acknowledgments

IT HAS BEEN MORE THAN TWENTY YEARS since I first began studying the history of the corset. Earlier versions of parts of this book were delivered as lectures, conference papers, and articles in publications as diverse as *The Yale Journal of Criticism* and Japanese *Vogue*. Two of my previous books, *Fashion and Eroticism* (1985) and *Fetish: Fashion, Sex, and Power* (1996), contain lengthy chapters on the corset. A version of Chapter 5 appeared in *Fashion Theory: The Journal of Dress, Body & Culture* (1999). My thanks to those who invited me to speak about the corset at the American Historical Association, the Association for Asian Studies, Auburn University, Bowling Green University, the Center for Interdisciplinary Studies in Art and Design at Ohio State University, the Costume Society, the City University of New York, the Hood Museum at Dartmouth College, the Inter-University Center in Dubrovnik, the Kinsey Institute, the National Museum of American History, the New York Historical Society, New York University, the Parsons School of Design, the Rhode Island Historical Society, the Royal Ontario Museum, the School of the Art Institute of Chicago, the Society for the Scientific Study of Sexuality, Stephens College, the Underfashion Club of New York, the University of California at Davis, the Università IULM in Milan, the University of Rio, the University of Toronto, and the Yale Center for British Art. Thanks also to my students at Columbia University, the Fashion Institute of Technology, and New York University.

I am grateful to the staff of many museums and libraries, including the American Museum of Natural History, the Bibliothèque des Arts Decoratifs, the Bibliothèque Forney, the Bibliothèque Nationale, the Bodleian Library at Oxford University, the British Library, the Brooklyn Museum of Art, the Cambridge University Library, the Costume Institute of the Metropolitan Museum of Art, the Museum of Costume in Bath, the Gallery of English Costume at Platt Hall, the Kinsey Institute, the Kyoto Costume Institute, the Leicestershire Museums, Arts and Records Service, the Liverpool Polytechnic Art Library, the Museum of the City of New York, the Musée de la Mode et du Costume, the Musée de la Mode et du Textile, the New York Academy of Medicine, the New York Public Library, the Union Française des Arts du Costume, the University Club Library, the Victoria and Albert Museum, the Yale University Library, and my home base, the Fashion Institute of

Technology. My publisher and I would also like to thank the institutions and individuals who permitted their images to be reproduced. Every effort has been made to obtain permission for use of illustrations. If insufficient credit has been given, the publisher will be pleased to make amendments in future editions. If no source is given for an illustration, it belongs to my collection.

I have received assistance, encouragement, and inspiration from many colleagues and friends, including Djurja Milanovik Bartlett, Andreas Bergbauer, Christopher Breward, Patrizia Calefato, Aaron Cobbett, Judy Coffin, Jean Druesedow, Kathryn Earle, Joanne Entwhistle, Fabienne Falluel, Peter Farrer, Colleen Ruby Gau, Peter Gay, Pamela Golbin, Robert Herbert, Anne Hollander, Robert and Catherine Jung, Susan Kaiser, Martin Kamer, Jun Kanai, Claudia Brush Kidwell, Dorothy Ko, Harold Koda, Katell Le Bourhis, Sarah Levitt, Roxanne Lowit, Karmen MacKendrick, Phyllis Magidson, Michael Maione, the late Richard Martin, Patricia Mears, Joy Meier, Verna Metz, Dr. Robert van Mierop, Alden O'Brien, Stephanie Ovide, Alexandra Palmer, Pandora, Mr. Pearl, Jules Prown, Aileen Ribeiro, Helene Roberts, Dennita Sewell, Jody Shields, Irving Solero, Dean Sonnenberg, Margaret Spicer, Lou Taylor, Stephen Todd, Carol Tulloch, Barbara Vinken, Mark Walsh, and Elizabeth Wilson, among many others. I am especially grateful to Dr. Lynn Kutsche, who generously shared her research on the medical consequences of corsetry. Special thanks also to Fred Dennis and Bret Fowler, as well as everyone else who helped with the exhibition, "The Corset: Fashioning the Body," held in 2000 at the Museum at the Fashion Institute of Technology. This book is not, however, a catalogue of the exhibition. My editor, Gillian Malpass, can not be praised highly enough. Yale University Press's anonymous reader provided helpful suggestions. I am deeply grateful to Caroline Evans for reading the entire manuscript; her critique improved it greatly. Any errors that remain are my own. For advice and encouragement, thanks also to my son, Steve Major. Most of all, I want to thank my husband, John Major, without whose skills as an editor, photographer, and computer expert I never would have finished this book.

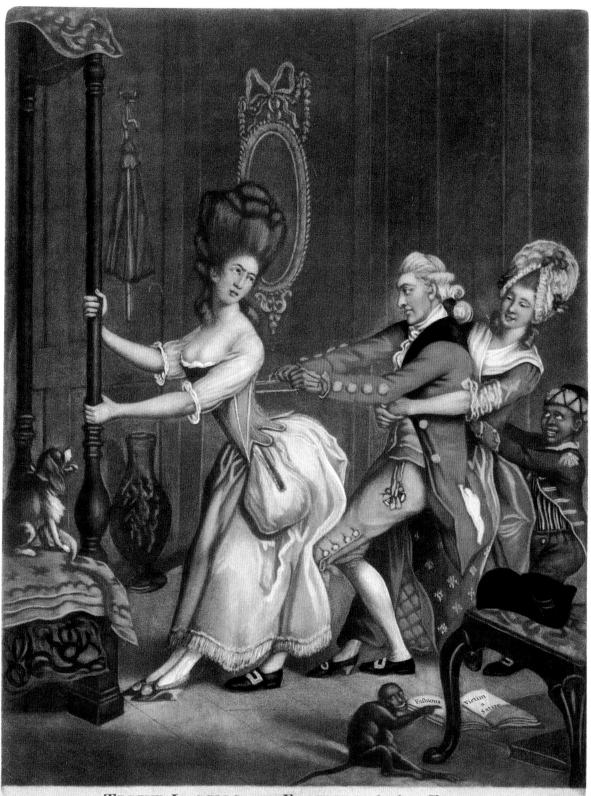

TIGHT LACING, or FASHION before EASE.

From the Original Picture by John Collet, in the possession of the Proprietors.

362 Printed for & Sold by Bowles & Carver, at their Map & Print Warehouse, Nº 69 in St Pauls Church Yard London. Published as the Act directs

1 Steel and Whalebone
Fashioning the Aristocratic Body

THE CORSET IS PROBABLY THE MOST CONTROVERSIAL GARMENT in the entire history of fashion. Worn by women throughout the western world from the late Renaissance into the twentieth century, the corset was an essential element of fashionable dress for about 400 years. Yet throughout its history, the corset was widely perceived as an "instrument of torture" and a major cause of ill health and even death.[1] Today the corset is almost universally condemned as having been an instrument of women's oppression. Historians argue that especially during the Victorian era, corsetry functioned as a coercive apparatus through which patriarchal society controlled women and exploited their sexuality. Many women supposedly "tight-laced," achieving waist measurements of less than eighteen inches, thereby crushing their ribs and internal organs. Fortunately, progress in women's emancipation resulted in the demise of corsetry at the beginning of the twentieth century.[2]

In this book, I shall challenge the reductiveness of this picture, which frames the history of the corset in terms of oppression versus liberation, and fashion versus comfort and health. Corsetry was not one monolithic, unchanging experience that all unfortunate women experienced before being liberated by feminism. It was a situated practice that meant different things to different people at different times. Some women did experience the corset as an assault on the body. But the corset also had many positive connotations – of social status, self-discipline, artistry, respectability, beauty, youth, and erotic allure. Far from being just a bourgeois Victorian fashion, the corset originated centuries earlier within aristocratic court culture and gradually spread throughout society – to working-class women, as well as women of the ruling class. Moreover, women wore different kinds of corsets; they laced their corsets more or less tightly and to different ends. In short, their embodied experience of corsetry varied considerably.

Research across a range of textual, visual, and material sources complicates our understanding of corsetry in fruitful ways. Everyone knows the famous scene in *Gone with the Wind* when Scarlett O'Hara is laced into her corset. "Twenty inches! She groaned aloud. That was what having babies did to your figure! . . . 'See if you can't make it eighteen-and-a-half inches or I can't get

John Collet, *Tight Lacing, or Fashion Before Ease*, 1770–75. Courtesy of the Colonial Williamsburg Foundation.

1

into any of my dresses.'"[3] The scene confirms a powerful stereotype that goes back to the eighteenth century, when caricatures portrayed female vanity in precisely this form. John Collet's print, *Tight Lacing, or Fashion Before Ease* (1770–75), is one of the first and most influential examples of this image. But how tightly were stays or corsets really laced? When Collet's print was displayed at Colonial Williamsburg, the curators noted that the image was misleading, since the smallest of the eighteenth-century stays in the Williamsburg collection measured 24 inches (61 cm) around the waist, while the largest measured over 30 inches.[4] In other words, they are not especially small. In the nineteenth century, technological developments made it possible to lace corsets more tightly, as we shall see.

Nevertheless, the idea that most women in the past had "wasp waists" needs to be radically revised. Many women did reduce their waists by several inches, but accounts of tight-lacing to extreme tenuity usually represent fantasies. I shall also demonstrate that the corset did not – could not – have caused all the diseases for which it has been blamed. This is not to say that corsetry had no negative health consequences, but it is important to be realistic about what those consequences were. Stories of Victorian women having their ribs surgically removed, for example, seem to be entirely mythical.

It is not accidental that so much of what we think we know about corsets is false or exaggerated. The discourse on fashion has tended to stress its negative connotations. In particular, women have been positioned as the "slaves" or "victims" of fashion. Traditionally, the subtext has been that women were "vain" or "foolish." More recently, it has been argued that women were oppressed by the fashion system, which is usually perceived as an instrument of patriarchy and capitalism.[5] Such an interpretation, however, ignores the fact that adornment and self-fashioning long preceded the rise of capitalism, and applied to men as well as women. By patronizing the women of the past as the passive "victims" of fashion, historians have ignored the reasons why so many women were willing to wear corsets for so long. Explanations that demonize patriarchy also ignore the complex gender politics surrounding the corset controversies of the past, since opponents of the corset included not only feminist women but also many men. Conversely, many women defended corsetry, and women were intimately involved in the production and sale of corsets. Some men also wore corsets.

To understand the changing and multifaceted significance of the corset, it is necessary to explore its history. Yet popular costume histories usually provide a misleading genealogy of the corset. The "origin myth" of the corset almost always incorporates several key themes. It is often argued that corsetry began in the ancient world – such as Greece or Minoan Crete. Alternatively, the first corset, "a tortuous device of steel," is attributed to a particular European aristocrat, usually Catherine de Medici. Sometimes examples of corsetry in nonwestern cultures are also cited. Thus, we are informed that

"The Corset and the Form Divine," *Chicago Sunday Tribune*, December 18, 1932.

2

The CORSET and the FORM DIVINE

By Constance Ray

How Milady's Modern Foundation Garment Was Evolved from a Torturous Device of Leather and Steel

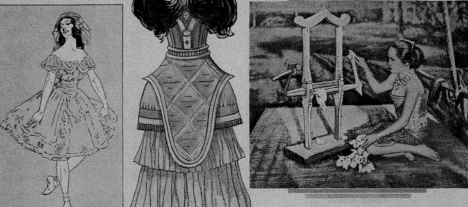

IN THE "whoopee" days following the World war it appeared as though the corset were doomed. Slender maids and matrons, and some not so slender, discarded that age-old garment to lead a freer and an unhampered existence. Stout women, it is true, still clung to its compressing embrace as a matter of necessity, but corset manufacturers were alarmed and complained bitterly that their trade was being ruined by the whim of fashion. But those days are gone. The corset is back in favor among women, young and old, and corset factories are busy as of yore.

The modern woman, however, likes to speak of her corset not as a corset, but as a foundation garment. It is a subtle, supple thing of silk and elastic, resembling very little that instrument of torture worn by our grandmothers, and entirely unlike that frightful garment of the time of Catherine de Medici, which had to be strong enough to reduce even the stoutest matron's waist to a circle of barely 13 inches; the circumference fixed by the French queen as a standard of fashion.

Just who invented the corset, back in the long ago, nobody knows. Men, of course, attribute the invention to a nameless woman, who made the first corset out of a piece of stiff leather; but men would do that. On the other hand, women contend that men were the inventors of the corset, and their reasoning is logical. In ancient times men were much more in authority in the world than they are today. They did all of the fighting and all of the talking. Women simply worked and reared families, and were allowed no time for anything else. They were not expected even to dress up in fancy clothes to attract attention. The male of the species was the gaudy creature, who strutted and bellowed and bedecked himself like a peacock. If anyone in those days wanted a fine figure, it surely must have been the man. A good, stout corset might have

The type of corset worn by the women of ancient Greece.

Corset of the type worn by men during the time of Catherine de Medici, and (below at left) a steel corset cover of the same period.

At left: Anna Held, a favorite French actress of two decades ago, as she appeared wearing a gown of the period over the "armor-clad" type of corset.

At left: The favorite type of corset of the women of France during the fifteenth century, a garment extending from the neck to the waist.

A tightly corseted toe dancer, personification of daintiness and grace, whose costume today is very much the same as that of the danseuse of a generation ago.

A distinctly modern creature was the corseted belle of Crete; but, contrary to recent modes, she preferred a decolletage.

Above: The corset of the women of the Iban tribe of Borneo is a series of brass or copper rings. In this picture the Borneo native woman, encased in her metal rings, is shown at work at a mangle, which extracts seeds from balls of cotton while she pulls the fibers out and twists them into the form of thread.

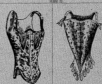

Two early types of corsets. At left: The type worn during the reign of St. Louis. At right: Leather corset of the time of the Georges.

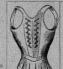

Two eighteenth century corsets. At left: The brocade corset. At right: "V" shaped corset in vogue during the reign of Louis XVI.

Three corsets which show various stages in the development of that garment. At left: A practical corset made in three pieces. Center: A cane device. Right: A woven corset.

mode of the times, and held on in various adaptations till after 1810. After the first decade of the nineteenth century the corset came back with a vengeance, a garment finished with steel, with a hoop more than an inch in width encircling around its upper line.

In 1820 a practical corset for tight lacing was invented. It was made in three pieces, and it laced at the sides as well as the back. This was truly the golden age of the corset, for every well appointed dressmaker's shop had an expert corsetier in attendance, and every lady of any importance ordered her corsets made over her form to an exact fit.

Later a Frenchman, Robert Verley, went into the business of manufacturing corsets by wholesale. The success of his looms at Bar-le-Duc prompted imitators to go into the corset making business, and it was not long before the business became firmly established in America. At first American women expressed a preference for corsets made in Europe, and particularly for German made corsets; but by 1870 the American product had been improved to such a degree that the foreign made article no longer could compete with it. Corsets made by the

stopped a spear thrust, and no one took the trouble then to appear a mere woman.

When the world first emerged from barbarism the men began thinking more of having their womenfolk appear beautiful. The women undoubtedly fell in whole-heartedly with the idea, so we have evidence today that the costume of an ancient Grecian lady never was complete without a girdle of linen stiffened with reeds or flat pieces of wood. That type of corset speedily was adopted wherever the name and fame of Greece made any impression.

It is said that the Hindu women of ancient times underwent a rigid system of fasting and training to attain the long, slender waist, a practice in vogue to this very day, and in ancient Ceylon it is said that perfection never was attained until the waist could be encircled by the fingers of the two hands. Jewish women of Biblical times wore stays.

The antecedent of the modern corset, is believed to have appeared in Europe during medieval times. A monk as early

as the eleventh century wrote an essay on the follies of fashion, laying particular stress on the practice of women of lacing their waists, and deploring the use of the corset. The essay still is preserved in the British museum. Princess Blanche, daughter of King Edward III. of England, who reigned in the fourteenth century, possessed a beautiful corset of beaten gold, which she wore as an outer garment so that it could be seen by all.

From the time of Saint Louis (Louis IX. of France), who reigned from 1226 until 1270, down to the beginning of the fifteenth century, members of both sexes in France wore corsets. These corsets varied considerably in length and shape, and often had fur-lined sleeves attached. It was Catherine de Medici, the wife of Henri II. of France, who, in the sixteenth century, brought the corset to its highest perfection as a device of torture, rivaling even the straitjacket and the rack. Catherine was a stylish queen, and she wanted all of her ladies-in-waiting and the aristocratic women of France

also to be stylish. Therefore she invented a kind of corset, called a "corps," which was absolutely inflexible. Into this corset the body was squeezed, and over the corset was placed a corset cover made of thin plates of steel which opened on hinges and which could be drawn up tight with laces. It was Catherine who laid down the dictum that no waist was stylish unless it could be drawn down to a bare 13 inches in circumference. Ladies of that day, it must be borne in mind, often were quite hefty from overeating, so Catherine's 13-inch corset was just as much an atrocity in its way as was the massacre of St. Bartholomew's day, which was the materialization of another of Catherine's ideas.

In the early part of the eighteenth century there came into fashion corsets made of leather, which were stiffened with whalebone. These flourished for a rather short period and were discarded when fashion decreed against them and for the return of the girdle similar to that worn by the women of ancient Greece. Even the classic robes of Greece were the

Verley factory in France were of the woven type, but these gradually were supplanted by corsets of the stitched type, in which the stiffness was effected by thin steel stays sewed between the inner and outer fabric of the garment. This type was in vogue in the beginning of the World war and was the inspiration of many a humorous writer and caricaturist, who pictured in word and sketch the plight of the poor henpecked husband who always was called upon at the last minute to draw tight the laces of his good wife's corset. The situation was anything but laugh-provoking for the poor husband.

The corset of today does not depend upon tight lacing and cruel constriction to produce a stylish figure. In fact, the very young misses nowadays do not think of corsets until the time comes to put on their party dresses, and the slender and the stout women obtain very graceful effects through the use of the modern foundation garment. Comfort and freedom of movement are the first consideration in the purchase of the present-day foundation garment.

"The corset of the woman of the Iban tribe of Borneo is a series of brass or copper rings."[6]

This constellation of myths obscures the degree to which corsetry was a historically situated phenomenon. An emphasis on the antiquity of the corset implies that some such garment has often or always been a component of "civilized" dress or, indeed, human culture. When the corsetier Ernest Léoty wrote *Le Corset à travers les âges* (1893), he argued that the modern corset combined the best features of the Greek *zona*, which shaped the waist, and the *strophium* and *mamillare* of Rome, which supported the breasts.[7] Like many advocates of the corset, Léoty liked to think corsetry was necessary, either to support women's breasts or because the slender waist was an essential, yet vulnerable, component of female physical beauty.

After the excavation of the palace at Knossos, Minoan Crete was increasingly cited as the origin of the corset.[8] It is true that in the third millennium BCE, wall paintings and statues depicted female figures wearing tight bodices that expose their breasts. Mosaics and wall paintings also show that the women of ancient Rome and Pompeii wrapped cloth around their breasts. A number of cultures have developed different types of waist-cinchers and bust-bodices, which have been interpreted as forerunners of the corset. Yet there seems to be no significant cultural continuity between these archaic garments and the European corset as it actually developed in Renaissance Spain and Italy. Admittedly, we know little about the history of underwear in the premodern period, but it seems to have been quite basic, consisting of garments such as breast cloths and loin cloths. Clothing in the ancient Mediterranean world was based on the draping of rectangular pieces of cloth. Neither stiffening nor lacing was typical of ancient garments. It is possible that some women bound their torsos with tight bandages of cloth but, until the sixteenth century, "There is no sign of any corsets or restriction other than fit."[9]

The second component of the origin myth emphasizes the role of an individual woman, a queen, who is associated with a cruel, tortuous fashion. Thus, the author of the fetishistic book *The Corset and the Crinoline* (1868) claimed that metal corsets were customarily worn "in the time of Catherine de Medici," when "extraordinary tenuity was insisted on, thirteen inches waist measure being the standard of fashionable elegance."[10] This statement is inaccurate in all particulars, as we shall see. However, elements of the story certainly caught the popular imagination. For example, a corset advertisement from the 1920s stated that "Because a queen named Anne was endowed with a thirteen inch waist, a generation of women wore perforce a thirteen inch corset."[11] This myth not only focuses attention on the royal origins and high status of corsetry, it also serves to emphasize how modern corsetry has improved in comparison with the "cruel constriction" of the past.[12]

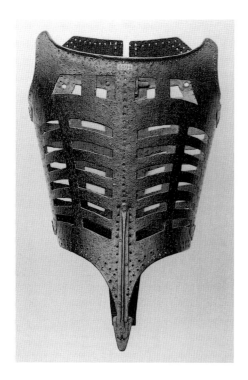

Iron corset, c. 1590. Musée National du Moyen Age, Paris.

FACING PAGE TOP "Corset cover of steel worn in the time of Catherine de Medici," from *The Corset and the Crinoline*, 1868.

FACING PAGE BOTTOM Metal corset, said to date from about 1600. Photograph by Irving Solero. The Museum at the Fashion Institute of Technology, New York. Gift of Janet and David Desmon.

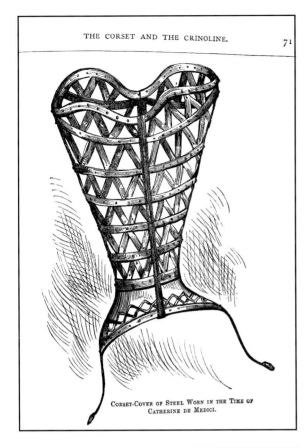

CORSET-COVER OF STEEL WORN IN THE TIME OF
CATHERINE DE MEDICI.

There do exist in museum collections certain notorious iron corsets, which are usually dated to about 1580 to 1600. But were they really the first fashionable corsets? Modern scholars who have examined them tend to believe that these metal corsets were probably orthopedic devices designed to correct spinal deformities – "when they are not, as is commonly the case, fanciful 'reproductions'. There is no evidence that they were worn by women as stays."[13] Instead, it seems that two types of corsets appeared in the sixteenth century: fashionable corsets created by tailors, which sometimes incorporated metal as well as whalebone stays, and orthopedic corsets constructed from plates of perforated metal, hinged at the sides, which were used by surgeons.

Ambroise Paré (c. 1510–90), a French army surgeon who became famous for reforming and modernizing the practice of surgery, described these metal corsets in his work, stating that they were used "to amend the crookednesse of the Bodie."[14] "In order to correct and to hide such a defect, they will be made to wear iron corsets, which shall be full of holes so that they will not be so heavy, and they will be well fitted and padded so as not to hurt at all, and will be changed often if the patient . . . [is] still growing."[15] Paré also suggested metal boots to straighten a crooked leg. According to him, some deformities were congenital, others the result of accidents. In addition, he believed that some girls became "hunched and deformed from having had their bodies too tightly bound," and he complained that mothers put their girls in tight clothes "with the aim of making their waists smaller."[16] Although Paré was a critic of fashionable corsetry, which he thought carried the risk of deformity by incorrect or excessive binding, he was an advocate of orthopedic corsets. Metal corsets were still sometimes recommended in the eighteenth century to correct crooked spines, although canvas stays were more commonly used (for example, by Alexander Pope); and, indeed, orthopedic corsetry continues to be used by doctors today as part of the treatment for scoliosis.

Accounts and illustrations of iron corsets seem to have resulted in the production of modern replicas or forgeries, just as we see with accounts of medieval chastity belts. The Museum at the Fashion Institute of Technology, for example, owns a metal corset that looks suspiciously similar to the one illustrated in *The Corset and the Crinoline*. Madame Kayne, a fetish corsetiere of the 1930s, apparently owned a metal corset, and Cathy Jung, a modern tight-lacer, has a silver corset or, more correctly, an over-corset, since, like all such metal devices, it cannot be tightened and must be worn over a laced corset. Such oddities notwithstanding, the factual

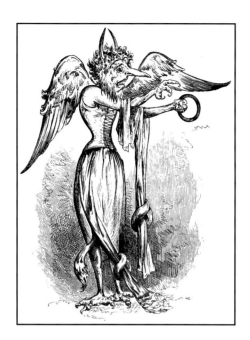

"The fiend of fashion," redrawn after "an ancient manuscript," from *The Corset and the Crinoline*, 1868.

history of corsetry is interesting enough without recourse to fantasies about women imprisoned in metal corsets.

Popular histories of the corset often reproduce a picture of the so-called "fiend of fashion," a demon in "an ancient manuscript" who is dressed as a woman in a laced bodice resembling a corset.[17] This image from an illuminated manuscript of the twelfth century in the British Museum is indeed striking, but it does not prove that corsets as such date from this era, only that fashion increasingly focused on displaying the body. In contrast with ancient dress, modern fashion as it emerged in medieval Europe was essentially tailored clothing, designed to follow the shape of the body. Shaping was accomplished through the gradual development of seams, gores, buttons, and lacing. In 1244, Leonor, Queen of Castille, was buried in a closely fitting gown that laced at the side.[18] As loose robes gave way to fitted garments, men's and women's clothing became increasingly differentiated, but the techniques used to create a fashionably close fit were applicable to both sexes. Men wore tight doublets and leg-revealing hose, while women wore gowns with fitted bodices. In medieval French, the word "corset" seems to have referred to both doublets and gowns, as well as body armor.[19]

By the fifteenth century, fashionable European ladies often wore dresses that laced closed, so as to make them fit more tightly and to emphasize the bosom. Jean Fouquet's painting of Agnes Sorel as the Virgin Mary depicts her wearing just such a form-fitting dress that laced up the front. This type of fitted and laced dress might be considered an immediate precursor of the corset. The other precursor of the corset was the basquine or vasquine, a laced bodice to which was attached a hooped skirt or farthingale. The vasquine apparently originated in Spain in the early sixteenth century, and quickly spread to Italy and France. Rabelais, for example, described women wearing "a corset [*vasquine*] of pure silk camblet, and over this a farthingale [*verdugale*] . . . on top of which was a silver taffeta skirt. . . ."[20]

This "corset," however, was merely a cloth bodice, albeit a tight-fitting one. As luxury fabrics, such as heavy silk brocade and velvet, came to supplant woolen cloth among the fashionable elite, dressmakers began to focus on constructing a separate bodice and skirt, rather than a one-piece gown. A higher priority was placed on how well clothing fit the body, and it is easier to fit clothes over a firm foundation.[21] When Eleanora de Medici, by birth a Spanish princess, was disinterred and her clothing removed from the grave, it was revealed that she was wearing a velvet bodice fastened at the center front with eighteen pairs of hooks and eyes. This bodice (c. 1560) measured about 24 inches (61 cm) around the waist. Over it, she wore a satin bodice that laced up the back.[22]

The first true corsets date from some time in the first half of the sixteenth century, when aristocratic women began wearing "whalebone bodies." In other words, their cloth bodices gradually began to incorporate more rigid

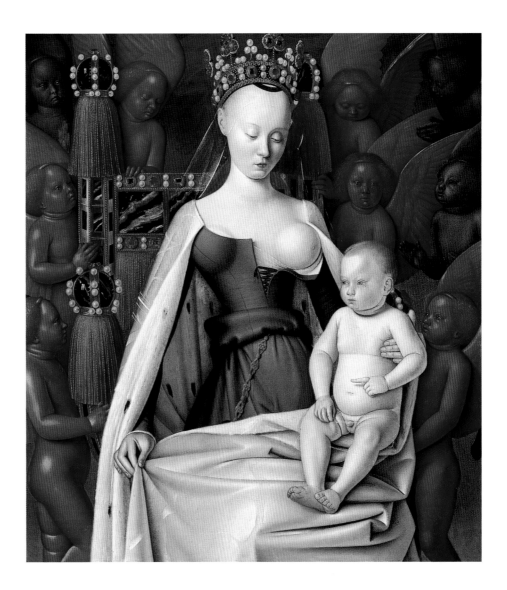

Jean Fouquet, *Madonna and Child*, second half of the fifteenth century. Koninklijk Museum voor Schone Kunsten, Antwerp.

materials, such as whalebone, horn, and buckram. The style seems to have originated in Spain and/or Italy, and spread rapidly to other European countries. Catherine de Medici (1519–89) may well have helped introduce the whalebone corset from Italy into France. In 1579, Henry Estienne described the new style: "The ladies call a whalebone (or something else, in the absence of the latter) their stay, which they put under their breast, right in the middle, in order to keep straighter."[23] This center front "stay" was generally referred to as the "busk." At some point, additional bones or stays were also added around the sides of the corset. The fact that early corsets were known as whalebone bodies – *corps à la baleine* – is extremely important, because of the way it blurs the distinction between fleshly bodies and the garments that cover and fashion them. The role of the body, and especially the female body, as a site of signification is implicitly emphasized.

Unknown artist, *Bal donné le 24 septembre 1581 à la cour de Henri III pour le mariage d'Anne, duc de Joyeuse, avec Marguerite de Lorraine-Vaudemont*, c. 1581–2. Musée de Versailles. © Photo RMN – Daniel Arnaudet.

In the sixteenth century and for some time thereafter, corsets or "bodies" were primarily worn by aristocratic women and girls. Queen Elizabeth I of England, for example, purchased "a peire of bodies of sweete lether" from the craftsman William Whittel. Several years later, in 1583, another artisan, William James, made her "a payer of bodyes of blake vellat lyned with canvas, styffenid with buckram." Stays could be closed or open, decorative or plain, underwear or outerwear. Closed stays laced up the center back. Open stays laced up the front, and the lacing was concealed by a decorative stomacher. Sleeves could also be attached with laces at the armholes. The Queen's dwarf Tomasen received two new pairs of bodies in 1597, one, apparently an outer bodice or visible corset, made of velvet, trimmed with silver lace, with a stomacher of white satin and attached sleeves; the other was "a payer of French bodies of damask lined with sackecloth, with whales bone."[24]

Most portraits, of course, show only the stiffened outer bodice, and not the stays underneath. However, around 1595–1600 an unknown artist painted a rare depiction of a woman who is only partly dressed. Elizabeth Vernon, Countess of Southampton, is shown in intimate dishabille, combing her hair in her dressing room, her jacket open to reveal a pair of pink silk stays. The lower

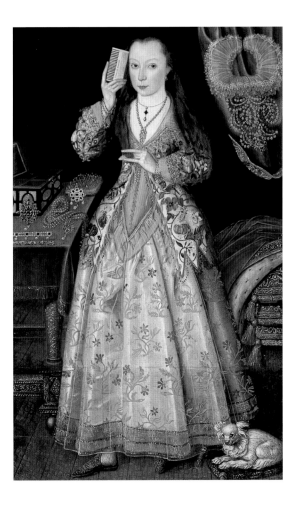

edge of her stays is tabbed and the front is laced. The bones are set vertically. According to the dress historian Naomi Tarrant, "The Countess has left her beautiful embroidered jacket undone whilst she does her hair, probably because she would not have been able to lift her arms with it fastened."[25] In other words, the jacket was physically more restrictive than the stays.

One of the most extraordinary textual accounts of corsetry comes from a manuscript of 1597, which describes how a 14-year-old English girl, the daughter of a gentleman named Mr. Starkie, was allegedly possessed by a devil, which caused her to shout out various sartorial demands, including a prestigious and luxurious pair of bodies:

> I will have a fine smock of silk . . . [and] a French bodie, not of whale-bone, for that is not stiff enough but of horne for that will hold it out, it shall come, to keep in my belly . . . My lad I will have a Busk of whale-bone, it shall be tyed with two silk points, and I will have a drawn wrought stomacher imbroidered with gold . . .[26]

This statement demonstrates the prestige associated with fashionable corsetry, although one longs to know why such a young girl would want a hard, stiff

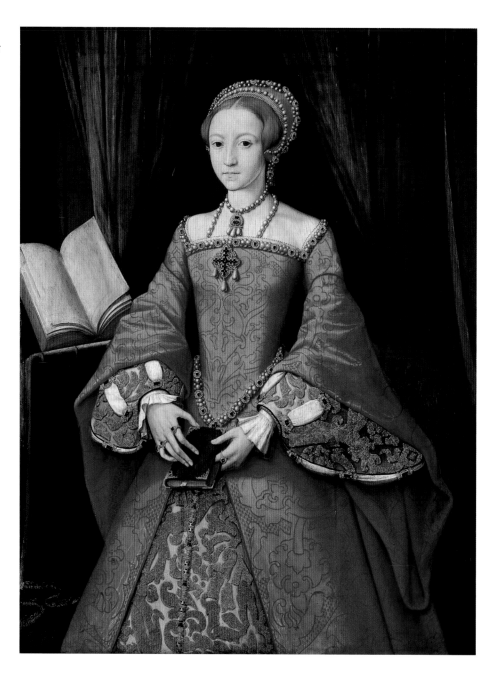

horn body to keep her belly in. Perhaps she was pregnant, for it was sometimes suggested that a hard busk and tight stays might causes miscarriages. As Stephen Gosson wrote in 1595: "The baudie buske . . . keeps down flat/The bed wherein the babe should breed."[27]

The busk that Miss Starkie coveted was an important component of the corset. To ensure that the wearer maintained an erect posture, a piece of wood, metal, or some other hard material was inserted in a slot down the center front of the corset, where it was tied in place with ribbons. The stay busk was sometimes decorated with amorous images or phrases. One metal

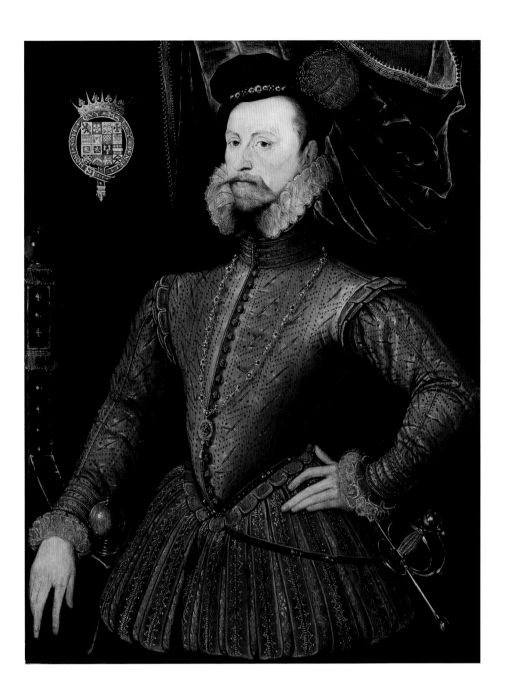

busk from the seventeenth century, made for Anne-Marie-Louise d'Orléans, Duchesse de Montpensier (today in the Metropolitan Museum of Art), is decorated with a crown and fleur-de-lis, as well as the text: "How I envy you the happiness that is yours, resting softly on her ivory white breast. Let us divide between us, if you please, this glory. You will be here the day and I shall be there the night." Other seventeenth-century busks, variously made of metal, horn, or ivory, are decorated with images of Cupid, a heart pierced with arrows, and a flaming heart, together with inscriptions such as "love

joins them" and "the arrow unites us." An eighteenth-century busk depicts a man holding a heart, which a woman pierces with a sword.[28]

Men of the ruling class did not wear corsets as such, but with their stiffened doublets and padded codpieces, they also adhered to a model of physical restraint and sartorial display. Moreover, sixteenth-century soldiers did wear what was known in French as a *corselet*, armor that covered the torso. The similarities between the male and female cuirass were noted by contemporaries. As Philip Gosson put it, in his poem of 1591 entitled "Pleasant Quippes for Upstart New-fangled Gentlewomen":

> These privie coats by art made strong,
> With bones and steels and suchlike ware
> Whereby their back and sides grow long,
> And now they harvest gallants are;
> Were they for use against the foe
> Our dames for amazons might go.[29]

A goddess wearing stylized body armor, frontispiece of an unknown book, seventeenth century.

Allegorical images of women in Roman-style body armor existed at the time, but Gosson's references to "bones and steels" make it clear that he is describing fashionable corsets, not those made entirely of metal.

Contrary to popular belief, no one person is responsible for "inventing" the corset. Clothing styles develop out of earlier styles, in accordance with other social, technological, and aesthetic phenomena. During the sixteenth century, "sartorial culture" increasingly "grant[ed] privilege to rigidity and rectitude, as well as geometric shape." In his analysis, "The Upward Training of the Body from the Age of Chivalry to Courtly Civility," Georges Vigarello argues that developments in fashion "complement[ed] other indicators which show a new awareness of the straight body. The court nobility . . . brought attention to the straightening of posture." Deportment, he adds, became "more rigorous."[30]

Training began in infancy. As a sixteenth-century text on women's childbirth put it: "A young tree, if it is kept straight and bent, keeps the same shape as it grows. The same happens with children, who, if they are well and properly bound in their little bonds and swaddling clothes, will grow up with straight body and limbs. On the other hand, if they are bound sideways and crookedly, they will remain the same way as they grow."[31] By the seventeenth century, girls as young as two years wore miniature corsets to support the body and "prevent deformities of the skeleton," as well as to "procure an agreeable waist and a well-positioned bust."[32] Mme de Sévigné wrote (May 6, 1676): "One must put them in small stays which are a little stiff if you want to keep the waist under control" ("Il faut lui mettre un petit corps un peu dur qui lui tienne la taille").[33] Little boys were also put into stays, at least until they were breeched at about age six.

A polished and disciplined mode of self-presentation was important for members of the elite, and control over the body was established through a range of social practices, from dancing to dress. One learned how to stand correctly, how to move, how to handle a fan or a sword. Castiglione's *Courtier* (1528) argued that aristocratic grace and civility were innate, but the book came to be read as a manual of civility. Although liberty was a major theme of Renaissance discourse, it did not impinge on this training in physical discipline, because the codification of refined, proper social behavior implied that appearances mirrored and supported aristocratic privilege. Indeed, it has been argued that European aristocrats were inclined to regard the body as a work of art.[34]

The discipline of aristocratic stays was, thus, inseparably linked to court display and physical self-control. "We see here . . . the diffusion of a cultural model," writes the French historian Daniel Roche, "that of the uprightness copied from the Spanish and Italian courts, which reshaped aristocratic silhouettes and conferred on posture a 'proud, imposing, theatrical form, manifesting the qualities of a soul and the virtues of a state'. Court society imposed its aesthetic of erectness, which was also a way of mastering the passions and emphasising the defenses indispensable to a female nature seen as fragile." For the nobility, stays were supposed to be constricting, because their culture "valorized the norms of stiffness and self-control, defining a social position." By contrast, the bodies of lower-class people "were bent by hardship and toil, or enjoyed a freedom unrestricted by etiquette."[35]

From the beginning, however, many observers believed that corsetry could be painful and dangerously unhealthy. Because this subject is central to our understanding of the experience of the corseted body, a chapter of this book will be entirely devoted to an analysis of the medical implications of corsetry. The subject is introduced here because as early as 1588 the French essayist Michel de Montaigne described how the famous surgeon "Ambroise Paré had seen on the dissection table these pretty women with slender waists, lifted the skin and the flesh, and showed us their ribs which overlapped each other."[36]

Paré's *Case Reports and Autopsy Records* include perhaps the first medical account of a supposed death by tight-lacing.:

> Too tight binding of the abdomen and parts used for breathing can cause suffocation and sudden death. One of recent memory happened in 1581 in the Church of St. Nicolas-des-Champs, when the young wife of Jean de la Forest, Master Barber-Surgeon of Paris, daughter of the late Jacques Ochede, lace merchant and of Claude Boufault, being too bound and compressed in her wedding dress, came from the altar after having taken bread and wine in the accustomed manner, thinking to return to her place, fell rigidly dead from suffocation. She was buried the same day in the same Church.

And some days later, the said de Forest married the said Boufault, mother of the dead girl at St. Germain-en-Laye, because his Curé had refused to marry them, saying that one could not espouse the daughter and the mother.[37]

Yet even case reports and autopsy records may be subject to more than one interpretation. It is entirely possible that the unfortunate bride was poisoned by her conveniently widowed spouse or her mother, since the two of them hastened to another town to marry each other.[38]

Why did women wear corsets? A number of sources suggest that they did so in order to attain a slender waist, which was perceived as a great beauty. According to Montaigne,

> To get a slim body, Spanish style [*un corps bien espagnolé*], what torture do women not endure, so tightly tied and bound, until they suffer gashes in their sides, right to the living flesh. Yes, sometimes they even die from it.[39]

Women will show "contempt for pain . . . if only they may hope for some increase in their beauty." For example, they may have healthy teeth extracted, in order "to arrange their other teeth in better order." Montaigne compared women's behavior to the physical courage of Roman gladiators and Christian saints, and he explicitly argued that "the taste of good and evil depends in large part on the opinion we have of them."[40]

Many of his contemporaries, however, implied that women's adherence to fashion was evidence of feminine vanity and duplicity. Critics of fashion frequently observed that women used clothing to alter the apparent shape of their bodies, padding their hips and breasts and squeezing their waists, or making themselves look taller than men by wearing high shoes. Such deceptions were routinely denounced as mortal sin. A misogynistic subtext lies close to the surface in John Bulwer's *The Artificial Changeling* (1653), which gloats over the sickness and death of vain, fashionable women:

> Another foolish affection there is in young Virgins, though grown big enough to be wiser, but that they are led blindfold by Custome to a fashion pernicious beyond imagination; who thinking a Slender-Waist a great beauty, strive all that they possibly can by streight-lacing themselves, to attain unto a wand-like smalnesse of Waste, never thinking themselves fine enough untill they can span their Waste. By which deadly artifice they reduce their Breasts into such streights, that they soon purchase a stinking breath; and while they ignorantly affect an August or narrow Breast, and to that end by strong compulsion shut up their Wasts in a Whale-bone prison, or little-ease, they open a door to Consumptions, and a withering rottennesse.[41]

Bulwer then quotes in Latin from Terence, adding that "it seems this foolish fashion was in request in the times that Terrence [sic] lived." He also quotes

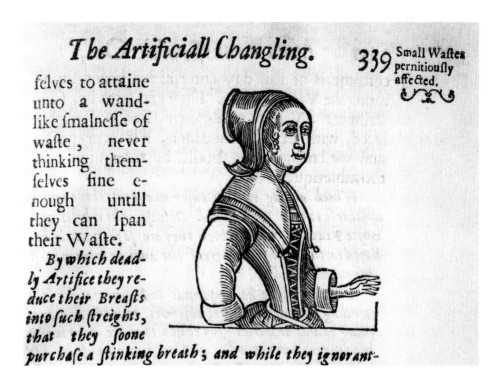

The Artificiall Changling. 339 Small Wastes pernitiously affected.

felves to attaine unto a wand-like fmalneffe of wafte, never thinking them-felves fine e-nough untill they can fpan their Wafte.

By which dead-ly Artifice they re-duce their Breafts into fuch ftreights, that they foone purchafe a ftinking breath; and while they ignorant-

a treatise of Paré (whom he refers to as Paraeus) to the effect that "the Bodies of young Maids or Girles (by reason they are more moist and tender than the bodies of Boyes,) are made crooked . . . [by] the straitnesse and narrow-nesse of the garments that are worne by them; which is occasioned by the folly of Mothers, who while they covet to have their young Daughters bodies so small in the middle as may be possible, pluck and draw their bones awry, and make them crooked." The girls also become "Astmatick, the Lungs and Muscles . . . being pressed together," and since "the Veines, Arteries, and Nerves are not in their places, the spirits do neither freely, nor the alimentary juyces plenteously flow . . . whence leannesse must needs ensue." In addition, Bulwer warns (still paraphrasing Paré), pregnant women who wear "straight-laced Garments, Busks, Rollers, or Breeches, bring forth Children awry." Surveying the customs of the world, Bulwer prefers "the *Venetian* Dames, who never lace themselves, accounting it an excellency to be round and full bodied."[42]

One of many criticisms of corsetry that blamed the practice for causing consumption and death, Bulwer's book as a whole constitutes a more general attack on artifice, which associates various European fashions, especially women's adornment, with alien forms of body modification, such as tattooing and scarification. Despite such criticism, corsets were still worn, in Puritan England as in fashionable France. Meanwhile, the terminology of corsetry continued to evolve. The word used in French remained *corps* (body), but by the seventeenth century the preferred term in English was "stays" – which

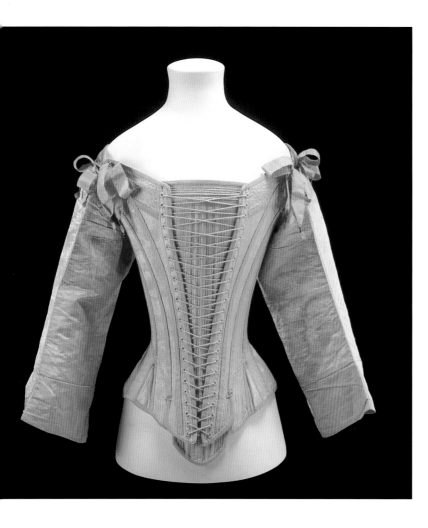

A sleeved pair of stays in pink silk, English, 1660–70. The Victoria and Albert Museum, London. Photo: V&A Picture Library.

originally meant "support," probably implying that the female body was naturally weak.[43]

Another discourse concerned the production of stays. Since the Middle Ages, the production and sale of clothing in much of western Europe had been organized into guilds, such as the tailors' guild, which were dominated by men. By about 1660 certain tailors in France had begun to specialize in making stays for women and children. The staymaker (*tailleur de corps baleiné*) was a specialist with considerable technical skill. Theoretically, most professional staymakers were men. In reality, however, the production of clothing (including stays) was divided – and sometimes hotly contested – between male and female workers, both guild members and clandestine workers. De Garsault's engraving of a French staymaker's workshop shows men cutting and fitting stays, while women sew them. Tailors' wives and daughters assisted them, widows were often permitted to practice their husbands' trade, and other women were also employed more or less legally as seamstresses.

Yet French men staymakers refused to permit women to join their guild; and they vigorously opposed women's clandestine production of clothing, which competed with their monopoly. They claimed that women lacked the skill and strength for the craft. Stays were constructed from six pieces of heavy linen or canvas, including two pieces for the shoulder straps. Whalebone was the usual stiffening material, and the staymaker did require strength and skill to cut numerous strips of whalebone into thin slices of uniform thickness, which were then inserted and stitched into place. The number and position of the bones varied according to whether the corset was fully boned or half-boned. The direction of the bones helped to shape the figure, narrowing the waist. Stays were cone-shaped, with tabs at the base that flared out over the hips. Curved pieces of heavier whalebone were laid across the top front, pushing the breasts up into a wide oval neckline. Eighteenth-century staymakers often claimed to understand anatomy and to produce "healthy stays." D'Offremont of Paris, for example, claimed to have invented stays that supported the body without constricting any part of it, "not even under the arms" – a design that supposedly won the approbation of the Faculty of Medicine and the Royal Academy of Sciences.[44]

In 1675 a couturières or dressmakers' guild was formed in Paris, which was legally entitled to make a variety of kinds of clothing for women, girls,

A staymaker's atelier, from Léoty, *Le Corset à travers les âges*, 1893.

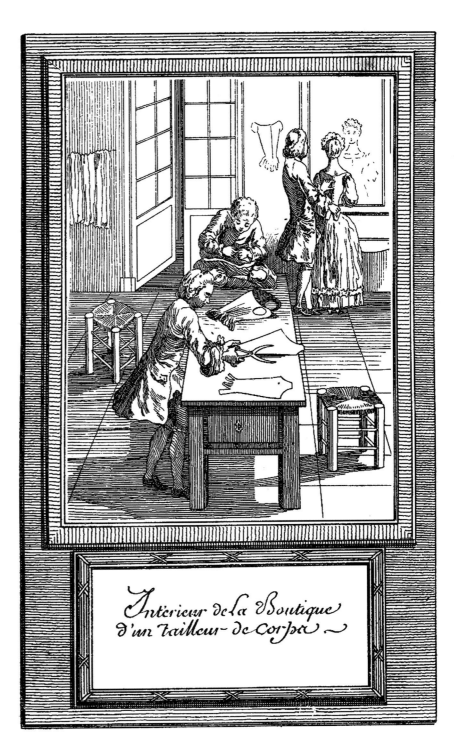

Intérieur de La Boutique d'un tailleur de corps

and boys under the age of eight. The establishment of the couturières' guild was supposed to support female modesty (since women who wished to could now have their clothing made by women), provide financial support for working women, and end quarrels between tailors and dressmakers. However, dressmakers were specifically forbidden from making boned stays, and the tailors and couturières continued to battle over this and other issues.

Resenting the dressmakers' competition, tailors often invaded the dressmakers' workshops, seizing garments and even physically assaulting female workers. Dressmakers and members of other female guilds, such as the linen drapers, fought back, petitioning the government for support, and arguing that for too long "the vulgar hands of men have held the delicate waist of a woman in order to measure it."[45] Notice the shift in emphasis. Whereas seventeenth-century dressmakers had wanted only to be allowed to work alongside tailors, a century later women workers had begun to argue that they alone should make clothes for other women. The feminization of the French clothing trades was under way. Later in the eighteenth century, the guild structure itself increasingly came under attack, and reforms instituted in France in 1776 permitted women over the age of eighteen to join hitherto male guilds, including the tailors' and staymakers' guilds.[46]

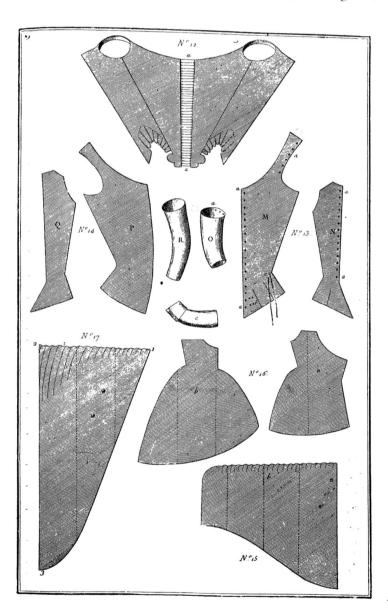

Eighteenth-century stays, after De Garsault.

The situation in England was similar. According to eighteenth-century publications on London trades, stays were "principally made by Men, though both Women and Men work on them." The staymaker "takes the Lady's Shape as nicely as he can." Where it is not naturally correct, he "supplies the Deficiency," since he is "obliged by Art to mend a crooked Shape, to bolster up a fallen Hip or a distorted Shoulder." Then he "cuts out the Tabby and Canvas by the Shape in Quarters, which are given out to Women to be stitched." It was said that most women lacked the physical strength necessary to "raise Walls of Defense about a Lady's Shape," although it was admitted that "Girls of Strength" might be able to make hooped petticoats. One observer, however, professed to be "surprised the Ladies have not found out a way to employ Women Stay-Makers rather than trust our sex with what should be kept as inviolable as Freemasonry."[47] By the late eighteenth century, as stays became less heavily boned, the craft gradually fell into female hands, in England as in France.

There were differences between the two countries, however, both with regard to the representation of stays and their actual use. In France, depictions of ladies dressing were extremely popular with both aristocratic and bourgeois art lovers. Within this genre, called *la toilette galante*, the theme of putting on the corset, the *essai du corset*, formed a popular and important subcategory. Jean-François Detroy's *A Lady Showing a Bracelet*

Jean-François Detroy, *A Lady Showing a Bracelet Miniature to Her Suitor*, c. 1734. The Nelson-Atkins Museum of Art, Kansas City, Missouri (Purchase: Nelson Trust). Photograph by Mel McLean.

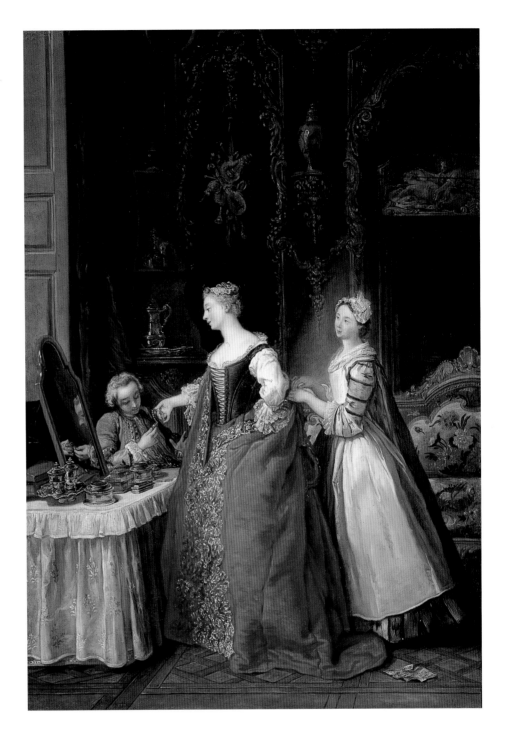

Miniature to Her Suitor (c. 1734) depicts a woman standing half-undressed in her boudoir. As her maid helps her dress, she leans over to show a miniature to a gentleman sitting nearby. He is quite unfazed by the sight of her blue silk stays.

It was apparently not uncommon for women to dress in front of male friends, who sometimes even assisted them. Nevertheless, some people still regarded this as inappropriate behavior, one writer commenting: "Often they even allow themselves to be laced by men, without attaching any more

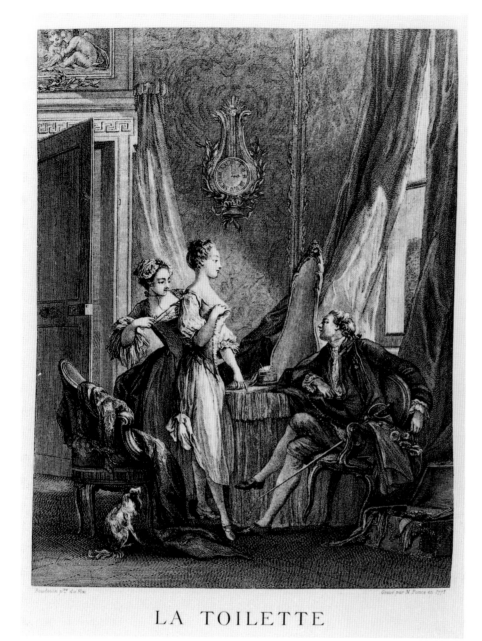

LA TOILETTE

Pierre-Antoine Baudouin, *La Toilette*, 1771.

importance to this than if it were a game."[48] François Boucher's son-in-law, Pierre-Antoine Baudouin, painted a number of such works, including *La Toilette* (1771), which depicts a young woman in her boudoir being laced into stays by her maid. A gentleman visitor sits casually in front of her, his sword pointing at her outstretched leg. More risqué were prints such as *An Abbé Lacing a Lady's Stays* and *Trying on the Corset*, the latter showing a lascivious staymaker molesting a woman under the pretence of fitting her.

Both visual and textual evidence indicates that the erotic appeal of stays was multi-faceted, including the exposure of underwear, the symbolism of lacing as surrogate intercourse, and the way stays displayed the bosom. Another print by Baudouin depicts a young woman adjusting the flimsy kerchief above her corset; the caption reads: "Her figure is ravishing/And one can already see/ The budding breasts/Pushing back the kerchief." Or as John Dunton wrote in the *Ladies Dictionary* (1694):

[Women] . . . commit their Body to a close Imprisonment, and pinch it in so narrow a compass, that the best part of its plumpness is forced to rise toward the Neck, to emancipate itself from such hard Captivity; and being proud of her liberty, appear with a kind of pleasant briskness, which becomes her infinitely. As for her fair Breasts, they are half imprisoned, and half free; and do their utmost endeavour to procure their absolute liberty.[49]

Anyone who has seen more or less authentically costumed films set in the eighteenth century, such as *Dangerous Liaisons*, knows that the stays of that period not only push the breasts upward and together, but create an illusion of amplitude not to be matched until the advent of the Wonderbra. More-

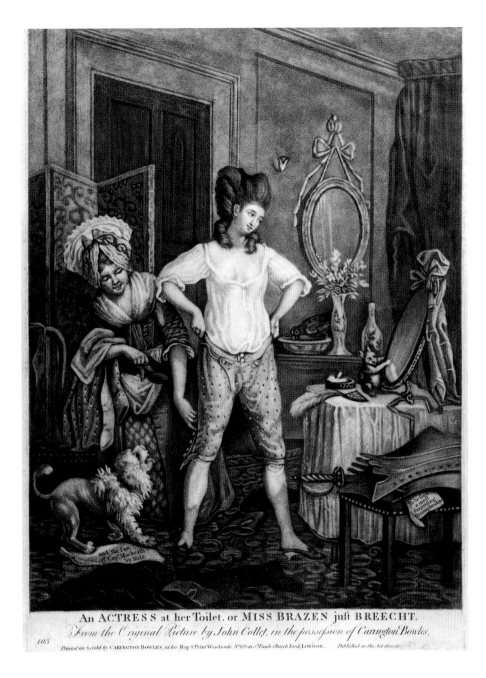

An ACTRESS at her Toilet. or MISS BRAZEN just BREECHT.
From the Original Picture by John Collet, in the possession of Carington Bowles.
Printed for & Sold by CARINGTON BOWLES, at his Map & Print Warehouse N°69 in S.t Pauls Church Yard, LONDON. Published as the Act directs

John Collet, *An Actress at her Toilet, or Miss Brazen just Breecht*, c. 1775.

over, even a moderately tight corset restricts the respiration, causing a reliance on upper-diaphramatic breathing, which contributes to palpitation of the breasts.

Meanwhile, in London, Hogarth used the serpentine curve of stays to illustrate his "Line of Beauty." He also prominently depicted stays in a number of his works, including *Harlot's Progress*, which shows Moll Hackabout arriving in London as a country girl in rustic working-class stays and being transformed into an urban prostitute in fashionable stays. In *Marriage à la Mode*, the married woman's dishonor is symbolized by her abandonment of stays. A riotous party depicted in *The Rake's Progress* also prominently featured a pair of stays, lying on a pile of clothing that a harlot has just taken off. On the other hand, Hogarth's portraits, like that of the Graham children, simply depicted the ubiquity of stay-wearing.

Hogarth's follower John Collet also produced various corset images, including *An Actress at her Toilet, or Miss Brazen just Breecht*, which depicts a woman cross-dressing to play the part of Captain Macheath in *The Beggar's Opera*. On a table nearby lies a pair of stays on top of a scrap of paper with the words "to be seen a most surprising Hermaphrodite." If her breeches signify masculinity, clearly the stays symbolize her female half. A satirical drawing from *The Human Passions* implicitly associated the insertion of the stay-lace into the holes with the act of penetration; the male figure simultaneously reaches into the woman's skirt pocket to touch her genitals. As these examples indicate, during England's golden age of caricature, artists variously used stays to represent a woman's honor, as well as her sexuality, gender, class, beauty, and vanity.

Many English caricatures also addressed the issue of tight-lacing. We have already seen John Collet's famous print, *Tight Lacing, or Fashion Before Ease*.

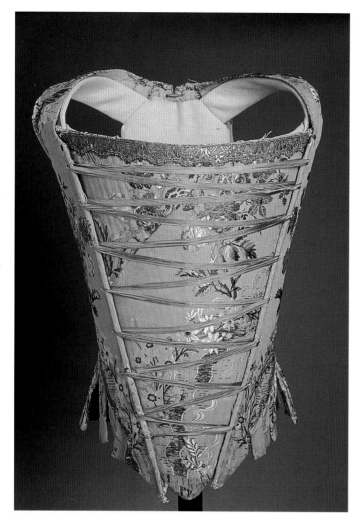

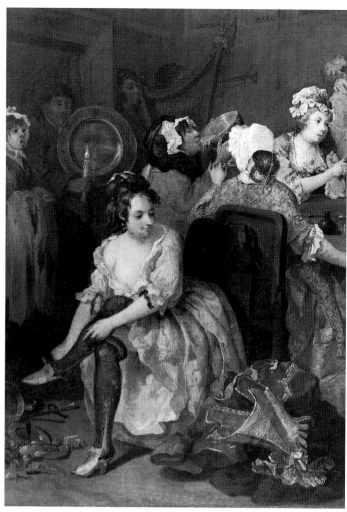

An etching entitled *Tight Lacing 1777* also depicted a woman clutching a bedpost, while her maid strains to lace her corset. This tight-lacer is an ugly, skinny old woman with a ridiculously high coiffure. Was it necessary for a woman to hold onto something while being laced up? In the eighteenth century, yes, it would have been helpful: the corset lace "was put in starting at the bottom, and was zigzagged through the staggered holes to the top where it was tied off," explain Peter and Ann Mactaggart, who are authorities on the subject. "When such stays were tightened the wearer was liable to be pulled off balance if she did not hold on to something. This arose partly because she was at one end of a 'tug of war' and partly because when one short section was pulled up after another, the pull was likely to have been first from one side and then from the other." By the nineteenth century, corsets were constructed differently: there were more holes, "the holes were placed opposite to one another, [and] the lace was put in so as to form a series of crossings," with the result that the corset could be "tightened

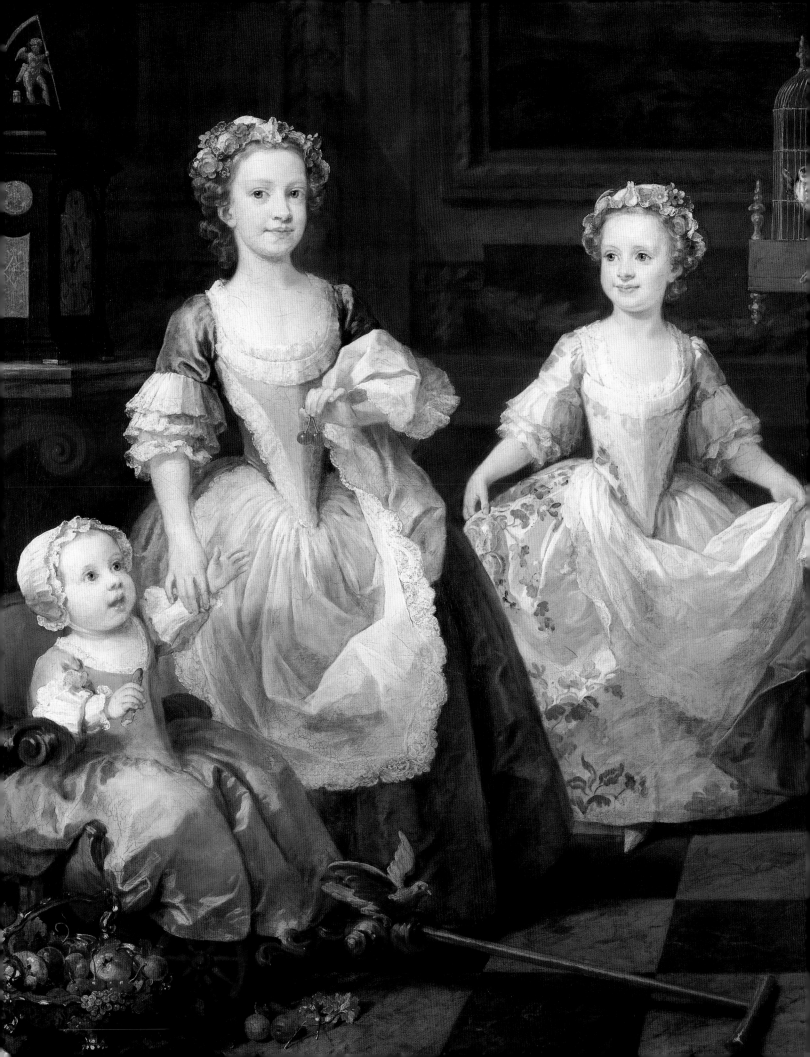

The Human Passions, c. 1780.

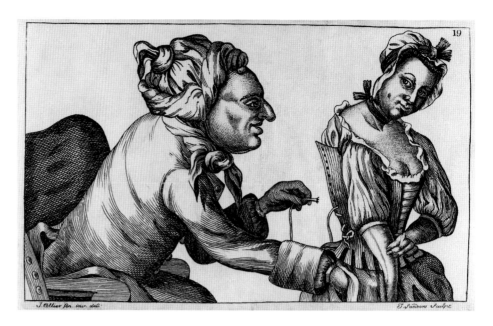

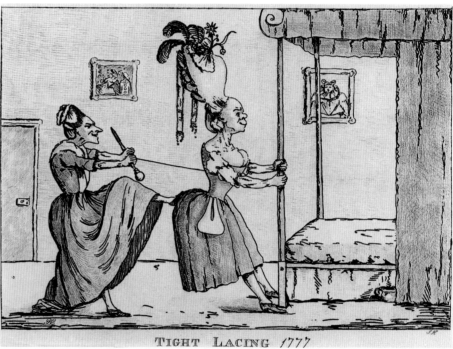

TIGHT LACING *1777*

Tight-Lacing, 1777.

without any oscilation in the pull . . . because the pull could be applied to both sides of the opening at the same time." By the nineteenth century, there was "no reason, except perhaps tradition, for her to hold onto anything."[50]

Were stays uncomfortable? Comfort is a relative concept, and for many centuries it was not regarded as particularly important. After all, many things were inevitably uncomfortable, from one's teeth to one's clothes. Some eighteenth-century women did complain that stays were uncomfortable, even "very nearly purgatory."[51] Others implied that any discomfort was less

important than the results that might be obtained. The idea that one must suffer for beauty was common. Thus, for example, Georgiana Cavendish, Duchess of Devonshire, wrote in her novel *The Sylph* (1778):

> My dear Louisa, you will laugh when I tell you that poor Winifred, who was reduced to be my gentlewoman's gentlewoman, broke two laces in endeavouring to draw my new French stays close. You know that I am naturally small at bottom but now you might literally span me. You never saw such a doll. Then, they are so intolerably wide across the breast, that my arms are absolutely sore with them; and my sides so pinched! – But it is the "ton"; and pride feels no pain.[52]

Tight-lacing was not only a practice but also a concept, which potentially conveyed a range of cultural meanings. In 1775, the Englishwoman Mrs. Delany wrote to a friend, "I hope Miss Sparrow will not fall into the absurd fashion of ye wasp-waisted ladies. Dr. Pringle declares he has had four of his patients martyrs to that folly (indeed wickedness), and when they were open'd it was evident that their deaths were occasioned by strait lacing."[53] It is probably safe to assume that both Mrs. Delany and her correspondent wore stays, but they obviously believed that they did not "tight-lace." Only foolish and wicked women like Miss Sparrow did that. Moreover, although Dr. Pringle may have performed autopsies on four of his women patients, we do not know what led him to conclude that their deaths had been caused by tight-lacing. Perhaps the ribs appeared to be deformed – as in the famous illustration comparing corseted and uncorseted female ribcages from the German medical text, *Über die Wirkungen der Schurbruste* by Samuel Thomas von Soemmerring.[54]

The caricaturist Gillray adapted the tight-lacing image as a political satire in *Fashion before Ease; or – a good constitution sacrificed for a fantastick form* (1793). In this image, the female figure, clutching a tree-trunk not a bed, is a handsome but aggrieved Britannia, tight-laced against her will by the radical Tom Paine, author of *The Rights of Man*. Paine had once worked professionally as a staymaker, a fact which allows Gillray to associate stays and fashionable dress with political fashions imported from Paris. British patriots often explicitly associated French fashions with the French political system, a tight French court suit, for example, representing tyranny, in contrast to the liberty of an English frock coat. Gillray's caption links Britain's political constitution with a healthy physical constitution, the former endangered by an irrational form of politics, just as fashionable stays deformed a natural body. A sign proclaims "THOMAS PAIN, STAY-MAKER . . . Paris Modes by express." In his pocket is a pair of scissors and a measuring tape with the words "Rights of Man." On his head he wears a hat with a French revolutionary cockade.

Perhaps the most famous English caricature of tight-lacing is Thomas Rowlandson's etching, *A Little Tighter* (1791), which depicts a small but

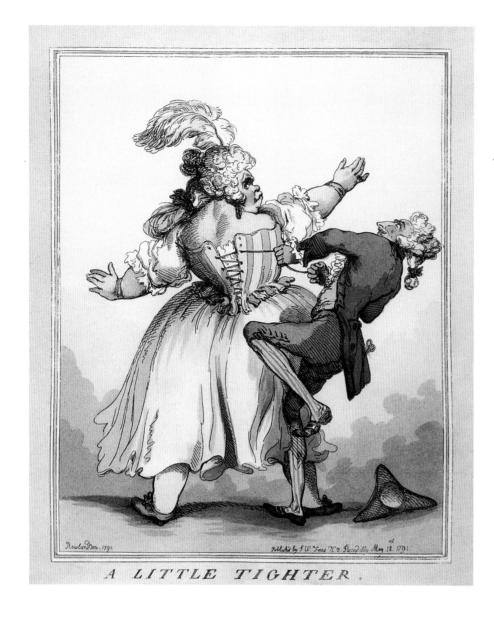

A LITTLE TIGHTER.

Thomas Rowlandson, *A Little Tighter*, 1791.

energetic man struggling to lace a large, fat, and ugly woman. On one level, Rowlandson has reversed Collet's stereotype: instead of a pretty young woman whose excessive pride in her appearance is at least partially justified, we see a woman who is manifestly deluded. This satire on "female vanity" focuses on the illusions of "ugly" women, since it would have been obvious to contemporaries that the woman depicted was not lacing to be fashionable, but rather in a failed attempt to conceal her obesity.

Travelers always observed that Englishwomen laced more than the French. For example, when C. L. von Pöllnitz visited England in 1733, he noted: "They are always laced, and 'tis as rare to see a Woman here without her Stays on, as it is to see one at Paris in full Dress."[55] The Swedish botonist Peter Kalm visited England in 1745 and described how even in the country "All go laced."[56] When Madame du Bocage visited England in 1750, she observed that "The women use no paint and are always laced."[57] The English apparently believed that loose dress signified loose morals. Stays were the visible sign of strict morality, whereas cosmetics were an artifice that signified immorality. When the heroine of Richardson's *Clarissa Harlowe* (1748) visits a brothel, she sees the whores "all in shocking dishabille and without stays."[58]

By contrast, French ladies were loosening their stays by the very beginning of the eighteenth century, as we learn from the letters of Elizabeth Charlotte, Princess Palatine, who was sister-in-law to Louis XIV of France. A stout and blunt-spoken German with much less interest in fashion than her bisexual husband, Monsieur, the Duke of Orleans, Madame was not the sort of person to suffer for the sake of beauty. Yet she always prefered tight formal dress to looser styles and was very much in favor of stays, which she seems to have associated both with decorum and beauty. In one of her many letters, dated December 14, 1704, she complained that "The ladies . . . have

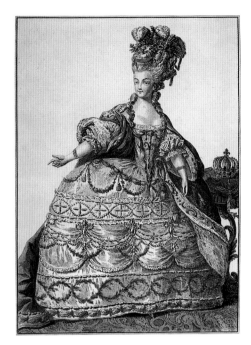

Marie Antoinette in court dress, c. 1778.

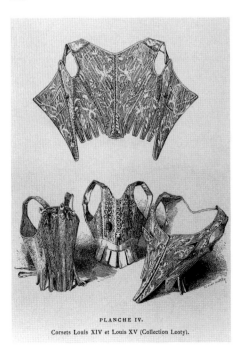

Stays from the eras of Louis XIV and Louis XV.

PLANCHE IV.
Corsets Louis XIV et Louis XV (Collection Leoty).

become lazy, and walk about without stays all day long. This makes their bodies grow thick; waistlines have disappeared."[59] This was an exaggeration. Aristocratic and bourgeois French women usually wore some kind of stays even under their fashionable loose dresses, but they did vary the degree of tightness to the occasion. Some working-class women also wore stays, especially in Paris, where servants were trendsetters in this respect, not only because they had access to cast-off clothing, but also because "they copied, at their own level, the manners of their superiors."[60]

In England, however, stays were part of the basic wardrobe of working women. Indeed, for a poor woman, the irreducible minimum consisted of stays and petticoat. Some acquired their stays secondhand, others made their own, often out of leather. Reeds or wood could be used in place of expensive whalebone. The English dress historian Anne Buck has provided ample visual and textual evidence that even rural laborers, such as sheep shearers and gleaners, wore short tabbed stays over their shifts and petticoats while working. As she puts it, "Women wearing their stays in this way [that is, visibly] felt no more undressed than a man who had removed his coat to work."[61] Such stays were, of course, nothing like the elegant ones worn by ladies. Frances Place recalled how "the wives of journeymen tradesmen and shopkeepers . . . either wore leather stays or what were called full-boned stays . . . These were never washed although worn every day for years . . . half-laced and black as a post."[62]

One type of stays were known as "jumps," the term apparently deriving from the French *jupe*, which in the eighteenth century referred to a short jacket. Designed to fit more loosely than fashionable stays, jumps were either boneless or only lightly boned. Because they laced up the front, jumps were more convenient for women who did not have a maid to dress them. Bourgeois and aristocratic Englishwomen also wore jumps as casual dress or during pregnancy, since they were much more flexible than fashionable back-lacing, busk-fronted stays. A merchant's diary from 1716 reported, "Bought my wife a new pair jumps instead of stays. She paid 36/6 for them."[63] In Samuel Foote's play *Taste* (1752), the character Lady Pentweasel says to the artist working on her portrait, "Don't mind my Shape this bout, for I'm only in Jumps." Hence also the line from the poem "Beauty and Fashion" (1762): "Now a shape in neat stays, now a slattern in jumps."[64] One unfortunate girl, apparently prohibited by her mother from wearing stiffened stays, committed suicide by leaping from a window – inspiring a contemporary journalist to make a rather cruel pun:

> Women, they tell us, have strange ways,
> So Harriet pin'd for stiffen'd stays;
> Till hopeless grown, and in the dumps,
> For want of *Stays*, she took to *Jumps*.[65]

French women had access to comparable styles.

Working-class woman in stays.

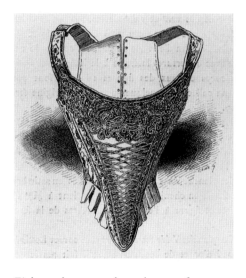

Eighteenth-century brocade stays, from Léoty, *Le Corset à travers les ages*, 1893.

As these examples indicate, stays functioned as a status symbol, because of their association with aristocracy. Once regarded as "genteel," however, stays retained much of their prestige even after working-class women adopted cheap facsimiles. Meanwhile, bourgeois observers like John Byng disapproved of working-class women wearing fashionable dress, and thought sufficient "a neat short gown . . . and easy stays (if stays be necessary at all?)"[66] Stays were also strongly associated with feminine erotic beauty, because they exaggerated the sexually dimorphic curves of the female body. Not only were the breasts pushed up, but the tabs at the lower edge of the corset flared out over the hips, which were themselves further extended by *paniers* or hoop skirts. Yet, paradoxically, stays also functioned as a sign of respectability, because they controlled the body and, by extension, the physical passions.

As we have seen, the word *corps* refered both to the body itself and the stays that shaped it. Similarly, to be aristocratic or genteel was not only a question of "blood." It also entailed behaving in an aristocratic manner. Scholars have argued that in *ancien régime* France, "the artful body" was not yet gendered as feminine but was still perceived as aristocratic. Louis XIV himself was "performing aristocracy" when he danced in court ballets. By the eighteenth century, the idea of aristocracy had become fashionable within a wider public, which increasingly consumed images of the aristocratic body through fashion plates, masquerade balls, and public performances of the *danse noble*.[67] However, it is argued, by the later part of the eighteenth century, as artifice was increasingly viewed with suspicion, grace was increasingly identified as a "natural" attribute of women, while the republican male body was read as strong and straightforward.[68] This leads me to believe that the aristocratic female body must always have been read in terms of feminine sexual beauty as well as status.

Yet, as Amanda Vickery points out, historians have been "unnecessarily reliant" on Thorstein Veblen, "assuming that beyond their material function goods only convey information about competitive status and sexuality," and that they "carry the same social and personal meanings for all consumers." It is true that the Industrial Revolution and the birth of a consumer society were two of the most significant developments of the eighteenth century, and fashion increasingly spread from the elite to the masses. But we should be wary of assuming that maids were simply imitating mistresses, and the bourgeoisie imitating the aristocracy. Even if "gentility" was one of the most important meanings accruing to stays, the concept may have meant something very different to a working-class country woman from what it did to, say, the daughter of an apothecary at the Chelsea Hospital. Members of subordinate groups may "appropriate" elite styles for their own purposes and creatively utilize goods in the construction of identity. It could be argued that "the primary information goods convey is not status but character."[69]

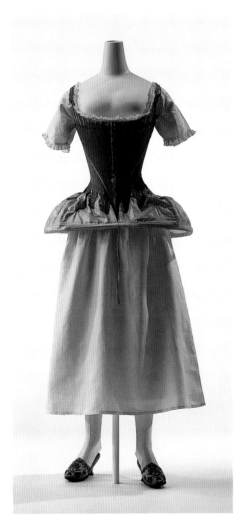

Stays, panier, and chemise, 1760–80.
Collection of the Kyoto Costume Institute.
Photograph by Takashi Hatakeyama.

The meanings of corsetry continued to evolve in the late eighteenth century, as new ideas about reason and the relativity of codes of behavior became more common. These factors seem to have contributed to a growing social critique of "artificial" fashions, including the practice of wearing stays. Under the banners of science and reason, doctors and *philosophes* extolled the "natural" and criticized fashions such as stays on the grounds that they deformed the bodies of women – and children. Along with Rousseau, many physicians also campaigned in favor of breastfeeding and against swaddling infants. Indeed, there was an outpouring of anti-corset propaganda in the second half of the eighteenth century. This "debate about the shackles of corsets . . . was an aspect of the great contemporary polemic about nature and culture, social control and permissiveness."[70]

It was not primarily a feminist debate. Indeed, one of the most famous anti-corset texts was Jacques Bonnaud's *Dégradation de l'espèce humaine par l'usage des corps à baleine* (1770), the full title of which may be translated as *The Degradation of the Human Race Through the Use of the Whalebone Corset: A Work in Which One Demonstrates That It Is to Go Against the Laws of Nature, to Increase Depopulation and Bastardize Man, So to Speak, When One Submits Him to Torture from the First Moments of His Existence Under the Pretext of Forming Him*. Submitting a woman to torture was apparently less of an issue for those who criticized stays on the grounds that they interfered with women's maternal functions. Advocates of "natural" beauty also argued that stays made the (female) body ugly. As early as 1731, an anonymous writer for the *Weekly Register* declared that "The Stay is a part of modern dress that I have an invincible aversion to, as giving a stiffness to the whole frame, which is void of all grace and an enemy of beauty." It was, he believed, "the ladies" who were "fond" of stays.[71]

Fashion, however, was moving toward a simpler and looser style of dress. By the 1770s, fashionable French women had begun to wear a "corset," which was defined as "a little pair of stays usually made of quilted linen and without bones that [ladies] fasten in front with strings or ribbons and that they wear in deshabille."[72] By 1785 *The Ladies Magazine* informed English women that "The French ladies . . . never wear anything more than a quilted waistcoat, which is called *un corset*, without any kind of stiffening."[73] "Never" was an exaggeration, but women were increasingly rejecting "the alleged grace of a stiff and pinched waist." For formal occasions and at court, women usually still wore traditional stays, but "light and flexible corsets that taste and reason substitute for old-fashioned stays take their place along side these." (Even when presented at the French court, it was permissible to wear a boneless corset if the individual lady could "not endure stays.")[74] "The barbarous custom of imprisoning children in heavily boned stays" was also disappearing.[75]

Bust-bodice from the Diréctoire period.

The French Revolution did not "cause" the demise of stays, which had already begun to fall out of favor before 1789. Revolutionary politics did, of course, play a role in the decline of stays within France itself, where "aristocratic" styles were frowned upon. In her history of fashion during the French Revolution, Aileen Ribeiro quotes from Hébert's radical journal, *Père Duchesne*: "If we are all equal . . . we must put an end to aristocracy of dress." She also cites one Césarine Boissard, "amie de nature," who publicly demanded the abolition of stays.[76] Some women consciously responded to the medical and philosophical campaign against stays. Certainly, related Enlightenment campaigns against swaddling infants and in favor of maternal breastfeeding were successful. The general sentiment in favor of "liberty" and "equality" undoubtedly also played a role in the loosening of whalebone stays, although it is unlikely that political ideology was the primary factor in this sartorial revolution.[77] Even Madame Royale, the 19-year-old daughter of Louis XVI, wore light corsets, not aristocratic boned stays, in her prison cell.[78]

By the 1790s there had developed a fashion for high-waisted, neoclassical gowns. Although such dresses could be worn with long stays and often were, the fashionable silhouette seemed better suited to short stays. The high-waisted style of dress spread widely, but it aroused considerable ridicule. In 1794, for example, there circulated in England a satirical poem entitled "The Rage or Shepherds I have lost my waist."

Shepherds I have lost my waist! Have you seen my body?
Sacrificed to modern taste, I'm quite a Hoddy Doddy.
For fashion I that part forsook where sages place the belly,
Tis gone and I have not a nook for cheesecake, tart or jelly.
Never shall I see it more till common sense returning
My body to my legs restore, then shall I cease from mourning.
Folly and Fashion do prevail to such extremes among the fair,
A woman's only top and tail, the body's banished God knows where![79]

Obviously, women still had waists, but fashion no longer emphasized that part of the body, focusing instead on the bosom. Women who followed the most extreme fashions were said to "Sport, in full view the meretricious breast;/ Loose the chaste cincture . . ."[80]

"The women no longer wear stays" ("*Les femmes ne portent plus de corps*"), declared one French-language phrase book dating from about 1800.[81] This was not entirely accurate. Long, heavily boned stays continued to be worn by many women, especially in England, where they were strongly associated with respectable sexual morality. Nevertheless, boneless or lightly boned corsets, bust-bodices and other such garments became increasingly popular, especially in France and to a lesser degree in America. When neoclassicism was in fashion, some fashionable women even adopted a kind of proto-brassiere based on the bust-bodices of ancient Rome. Mercier reported,

Corset à la Ninon, 1810.

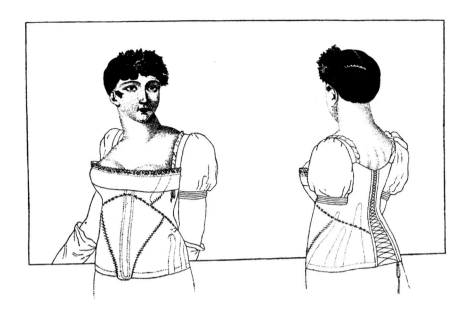

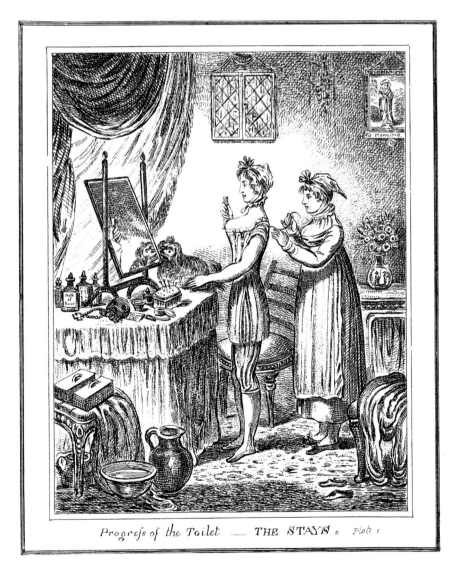

James Gillray, *The Stays*, c. 1810.

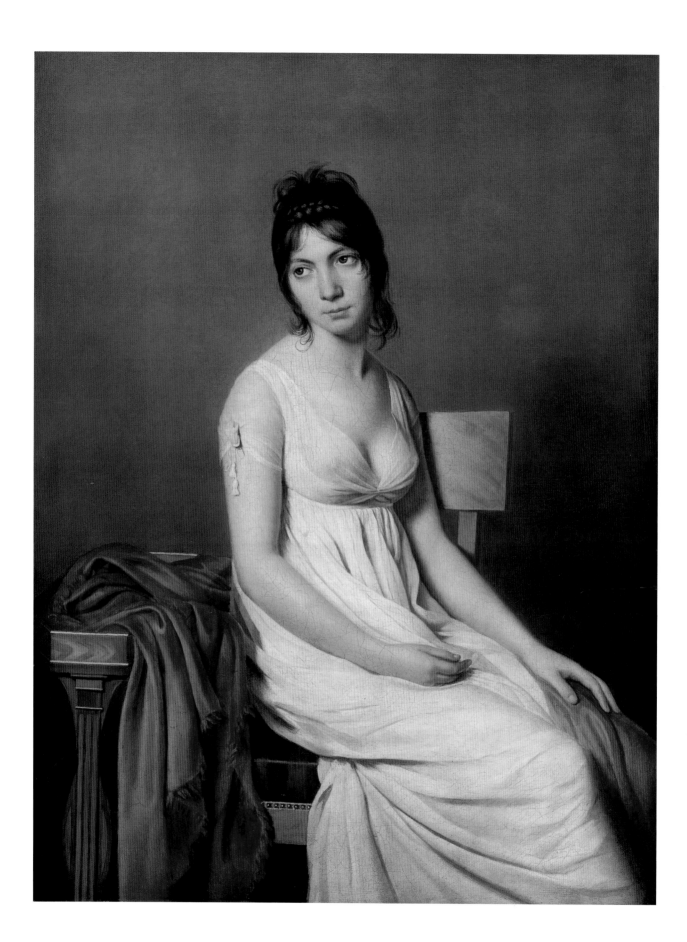

for example, that some ultra-fashionable Parisiennes wore "flesh-colored knit-work silk stays, which stuck close to the body [and] did not leave the beholder to divine, but to perceive, every secret charm."[82] Visiting Paris in 1802, Fanny Burney reported on the current fashions: "THREE petticoats? No one wears more than one! STAYS? Every body has left off even corsets!"[83]

Yet after a brief interregnum around 1800, the boned corset not only reappeared but spread throughout society. We might have expected that having once loosened their stays, women would never again wear corsets. Yet they did, in greater numbers than ever before. At the end of the Napoleonic Wars, in 1814 and 1815, the fashion for high-waisted "empire" gowns was waning. As the waistline on fashionable dresses began to drop to its normal position, skirts became fuller and boned corsets increasingly reappeared. Already by 1811, a writer for *The Mirror of the Graces* was predicting a return to tight-lacing, "Deformity once more drawing the steeled boddice upon the bruised ribs."[84] The fashion for neoclassical dress and no stays was regarded, in retrospect, as having been part and parcel of the disorder and promiscuity of the Revolutionary era. For the next century, boned corsets were an essential component of women's fashion.

Circle of Jacques-Louis David, *Portrait of a Young Woman in White*, Chester Dale Collection, National Gallery of Art, Washington, D.C.

L'utile. M.de de Corsets

(Paris)

N° 37

Le Dépôt chez Edmet, rue des St Pères 11.

Imp. Lith. de M.lle Formentin, rue des St Pères 14.

Published by Charles Tilt, 86. fleet street London.

2 Art and Nature
Corset Controversies of the Nineteenth Century

FEMINIST HISTORIANS HAVE ARGUED THAT the corset was deeply implicated in the nineteenth-century construction of a "submissive," "masochistic" feminine ideal.[1] Indeed, the corset has been described as a "quintessentially Victorian" garment, because of its role in creating and policing middle-class femininity.[2] Although plausible, this thesis is ultimately unconvincing. Men were not responsible for forcing women to wear corsets. On the contrary, a number of powerful male authority figures, including many doctors, opposed corsetry. So did a vocal minority of dress reformers of both sexes, who wondered why the majority of women persisted in wearing corsets. Were they the dupes of cunning dressmakers? Did they actually think that the fashionable corseted waist was beautiful? "Never has a stone image, consecrated by cunning priests, exercised a more magic influence on a superstitious heathen's mind than the invisible Fashion Fetish on the modern feminine intellect."[3]

Certainly, women's reluctance to abandon the corset was closely related to their interest in fashionable dress. But "Fashion" can not logically be reified as a magic power that causes women to behave in ways contrary to their own best interests. Historians have tended to interpret Victorian clothing, especially corsetry, in terms of bourgeois sexual repression.[4] However, recent research demonstrates that Victorian sexual attitudes and behavior were not nearly as prudish as we have assumed.[5] It is true that within the context of nineteenth-century society, the corset played an ambivalent role. In order to be "decently" dressed, women had to wear corsets. The English especially believed that a straitlaced woman was not loose. Yet Victorian women (and by this I mean not only women in Great Britain, but also those in France and the United States) were well aware that the corset also functioned as an adjunct to female sexual beauty. By simultaneously constructing an image of irreproachable propriety and one of blatant sexual allure, the corset allowed women to articulate sexual subjectivity in a socially acceptable way. The corset was also supposed to make women look more "beautiful" by concealing physical features that were less than "ideal."

The triumph of corsetry occurred not because Victorian women were more oppressed or masochistic than their predecessors, but because the

Charles Philipon, *Marchande de Corsets*, 1830.

Industrial Revolution and the democratization of fashion gave more women access to corsets. Beauty was now supposed to be every woman's "duty" (or her "right"), by means of artifice if not naturally. The history of the corset from the end of the French Revolution to the First World War is not only about "fashioning the bourgeoisie," since corsetry, like fashion in general, was rapidly becoming a mass phenomenon.[6] Moreover, as the socioeconomic and political structure of society changed, the very concept of sartorial display hitherto associated with the "aristocratic body" became transformed into a "feminine" ideal of beauty that potentially applied to women of all classes.[7] Many elements of aristocratic fashion, such as color and decoration, were increasingly reserved for women's clothing. A new sartorial code for men developed only gradually, however, and certain categories of male clothing, such as military uniforms, retained many aristocratic elements.

Some men also wore corsets, although this was controversial. Fragmentary evidence indicates that a few military men may have worn stays in the eighteenth century, but the practice seems to have become more common in the early nineteenth century with the phenomenon of dandyism. Appearing first in Regency England and then migrating to France during the Romantic era, dandyism drew on both bourgeois and aristocratic proto-types.[8] Although dandies were deeply interested in fashion, they were not fops, since their style of dress was characterized by a refined sobriety. It was also rather body-revealing.

The number of dandy caricatures produced between about 1815 and 1820 indicates that at least a conspicuous minority of fashionable men wore stays or corsets, the terms by this point being essentially interchangeable. Nevertheless, the idea of a man wearing stays struck many people as truly ludicrous, especially as it could easily evoke the complementary idea of women in breeches. A caricature entitled *The Hen-Pecked Dandy* portrays an overweight woman wearing lace-trimmed breeches, while her husband "Sir Fopling" has, "in revenge," taken to wearing stays. The idea that "effeminate" men endangered national strength had been a theme in British popular culture at least from the middle of the eighteenth century, when attacks on fops and macaronies were common in the iconography of political carica-ture. Regency dandy caricatures continued this theme, along with its corol-lary, the spread of effeminacy throughout society.

Lacing in Style – or, a Dandy midshipman preparing for attraction!! depicts the protagonist exclaiming "Very well, my hearties very *indeed*. Pon honor, this lacing is not very agreeable, but it will be fully compensated by the grand dash I shall make at the East London Theatre tonight – Oh! I shall be the most *enchanting*! Oh, *charming*! Oh, *delightful*!" An old sailor nearby comments, "I say, Master Midshipman, I always thought you a little crack-brained, now I'm convinced . . ." Still another sailor exclaims, "My eyes!! Oh Murder! Ha!

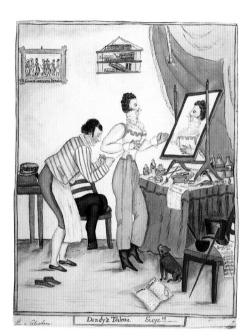

The Dandy's Toilette, c. 1818. Courtesy of Cora Ginsberg.

George Cruikshank, *Laceing a Dandy*, c. 1819. Courtesy of the University Club Library, New York.

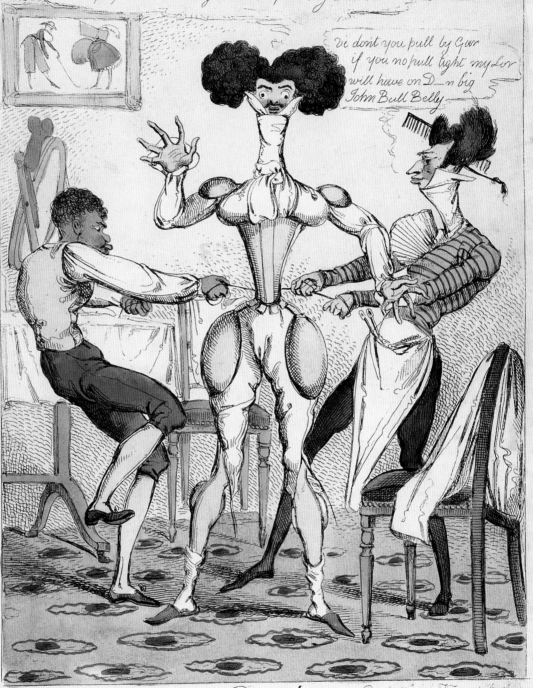

Laceing a Dandy

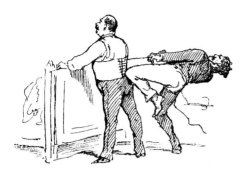

Illustration of a stout man being laced up, from Bertall, *La Comédie de notre temps*, 1874.

Le Lion, c. 1830.

Ha! Ha! Jack Greathead the cheesemonger's son got *stays*!!! Well, I've a good mind to get *petticoats*! These dandies are a disgrace to Great Britain!"[9]

Yet because corsets support the back (at least in the short run), they were favored by military men, especially cavalry officers, well into the nineteenth century. Dostoevsky's underground man sarcastically toasted Lieutenant Zverkov with a speech beginning, "I hate phrases, phrasemongers, and men in corsets . . ."[10] Some civilian men also wore corsets for sports such as horseback riding, just as today weightlifters often wear wide leather belts. These corsets were made of sturdy cloth or leather, and only sometimes incorporated whalebone or metal wire. *The Workwoman's Guide*, published in London in 1838, notes that "men's stays or belts . . . are worn by gentlemen in the army, hunters, or by those using violent exercise."[11]

Stout gentlemen also sometimes wore corsets, both as an aide to dieting and to improve their appearance. The fat and vain Joseph Sedley, a character in Thackeray's *Vanity Fair*, had tried "every girth, stay, and waistband then invented."[12] The famous Regency dandy Beau Brummell may not have needed corsets but his "fat friend," the Prince Regent, might have used them to fit into his fashionable clothes.[13] The caricaturist George Cruikshank did a number of images of men in corsets. *Laceing* [sic] *a Dandy* (c. 1819), for example, shows the protagonist complaining to his servants, "Fore God, ye Wretches, you'll never get my stays tight enough." One servant then says to the other, "If you don't pull tight, my Lord will have a damn big John Bull belly." Notice, however, that a big belly was, at least potentially, associated with English cultural nationalism, at least when it was a man who was fat. A fat woman had no such justification. Nor did a fat Frenchman.

In Balzac's *Cousin Bette*, the Baron Hulot adopted a corset when he wanted to seduce Madame Valérie Marneffe. A former soldier of the Imperial army, Hulot was perhaps especially predisposed to wear stays. As Balzac writes:

Foreseeing the collapse of the Empire beau, Valérie thought it necessary to hasten it.

"Why do you bother, my own old soldier?" she said to him, six months after their clandestine and doubly adulterous union. . . . "Do you want to be unfaithful to me? I should like you so much better if you stopped using . . . your rubber belt, your tight-waistcoat, the dye on your hair . . ."

And so, believing that Madame Marneffe loved him . . . the Baron . . . left off wearing his leather waistcoat and his stays; he got rid of all his harness. His stomach sagged; obesity was obvious.[14]

Fashionable menswear continued to emphasize a cinched waist throughout the 1830s. One French dandy of the Romantic era insisted that "The secret . . . of dress lies in the thinness and narrowness of the waist. Catechize your tailor about this . . . Insist, order, menace . . . Shoulders large, the skirts of the coat ample and flowing, the waistline strangled – that's my rule."[15]

Although belts and corsets for men continued to be advertised throughout the nineteenth century, they were increasingly frowned upon as effeminate vanity. A disagreeable character in Anne Brontë's novel *Agnes Grey* (1847) is described in the following terms:

> He was a thick-set, strongly-built man, but he had found some means of compressing his waist into a remarkably small compass, and that, together with the unnatural stiffness of his form, showed that the lofty-minded, manly Mr Robson, the scorner of the female sex, was not above the foppery of stays.[16]

Advertisement for American Gentleman Corsets, 1903.

After about 1850, men who wore corsets usually claimed to need them for medical reasons, often back support. Not only had fashionable menswear become looser, obviating the potential need for figure-controlling garments, but the prevailing bourgeois worldview increasingly held that men should not think about trivialities such as fashion. There did exist a minority of male corset enthusiasts and crossdressers, as we shall see, but their proclivities remained largely hidden from view. Accounts of men in corsets tended to situate them in other countries. English fetishists claimed that Austrian men regularly wore corsets, while French corsetiers reported in 1904 that men in America and England had taken to wearing stays: "One estimate has it that more than 100,000 men in America wear corsets."[17]

The great majority of people wearing corsets were, of course, women. However, the shape and construction of corsets had changed as a result of both technical innovations and changing fashions. When the fashionable Empire waistline began to drop, corsets lengthened and the tabs at the bottom were replaced by gussets. Additional shaping was also provided on top by gussets for the breasts. Most corsets now had a solid busk in front and were laced up the back. The manner in which corsets were worn also changed. In the nineteenth century, corsets definitively stayed underneath the dress, and were almost always made of plain white cotton or linen, or at most white satin. White was associated with chastity, and corsets formed part of an array of modest underwear. It is true that women occasionally wore colorful corselettes on top of their dresses, in addition to white corsets underneath, but between 1800 and about 1870, corsets were almost always white. Apparently, there did exist exceptions to the rule, since David Wilkie's painting *The Scottish Bedroom* (1824) depicts two young women getting dressed; one wears a pale blue corset, the other a red corset.

Many women made their own corsets. "It is not amusing to make a corset, as it can be to make a ballgown [or] a hat . . . but that doesn't matter; a young woman must be able to make everything she needs," declared Madame Burtel, author of *L'Art de faire les corsets* (1828).[18] English books, such as *The Workwoman's Guide* (1838) and *The Young Woman's Guide Containing Correct Rules for the Pursuit of Millinery, Dress and Corset Making* (1847), also included

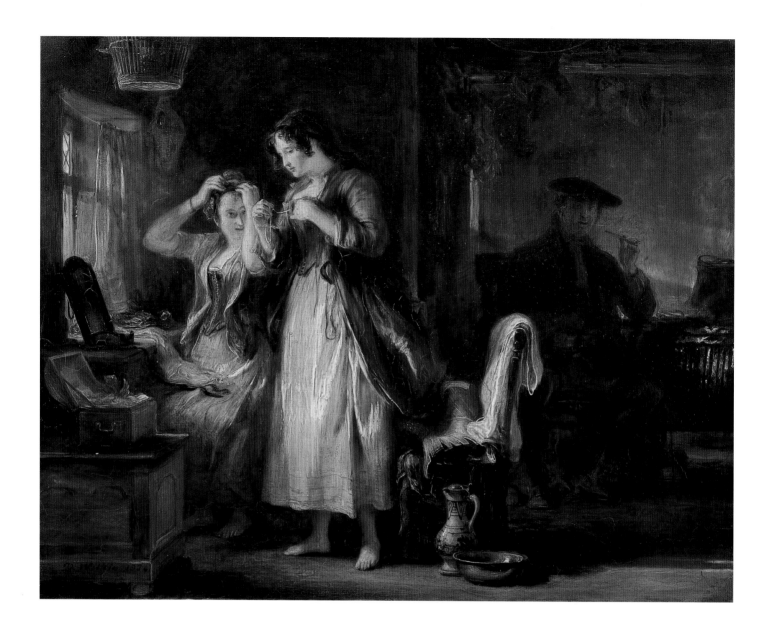

David Wilkie, *The Scottish Bedroom*, 1824.
Reproduced by permission of the Trustees
of the Wallace Collection, London.

information on constructing homemade corsets, while fashion magazines
such as *Godey's* regularly published patterns for stays. Measurements needed
to be taken for the waist (sometimes subtracting two inches to allow for the
clothing) and also for the bust (no allowance here for clothes), the back,
hips, and length of busk. Then there were directions for choosing and cutting
out the material, preparing the bones, making eyelets, and putting the pieces
of the corset together. Although many women had no option but to make
their own and their children's clothes, early patterns were not easy to use,
and women with even a small amount of money often preferred to purchase
corsets.

Women had begun to establish themselves as professional staymakers in
the eighteenth century. By the early nineteenth century, the majority of small

Fashion illustration showing a visible corselette, 1820.

and medium-sized corset manufacturers and retailers were women. So were most dressmakers. A few names have come down to us, including Madame Saint-Evron, who had a workshop on the rue de Richelieu in the 1820s where she made and sold a variety of corsets, including corsets without busks, corsets for pregnant women, French corsets, English corsets, and night corsets. At the 1823 exposition in Paris, Madame Mayer presented corsets made without a busk or whalebone, which utilized cording. The English corsetière, Madame Roxey A. Caplin, exhibited her "hygienic corsets" in Paris in 1848, and proudly quoted the testimony of French medical men as to her product's superiority.

Caplin's book, *Health and Beauty; or corsets and clothing constructed in accordance with the physiological laws of the human body* (London, 1854) deserves to be quoted at length, since it expresses not only the self-interest of an individual corset-maker but also beliefs that seem to have been widespread among female consumers. She begins by citing the condemnation of corsets by medical men:

> The evils are all portrayed by a master hand, but there is not one hint that can be of the least service to the world by remedying it . . . It never seems to have occurred to the Doctors that ladies must and will wear stays, in spite of all the medical men of Europe. The strong and perfect feel the benefit of using them; and to the weak and delicate or imperfect, they are absolutely indispensable.[19]

And why do women wear corsets? It is "natural," Caplin argues, that ladies "desire to retain as long as possible the charm of beauty and the appearance of youth." Unfortunately, "corset making has fallen into the hands of quacks" and "working people, generally females of little or no education," who study fashion, instead of Nature. Their corsets are "painful" and often "injure the

Installation photograph from the exhibition "The Corset," depicting early nineteenth-century corsets and bust-bodices. Left to right: early 1800s (The Museum of The City of New York, Bequest of Ellen Bates); American, 1820s (MFIT); American, c. 1840 (MFIT). Gift of Mrs. Bernice Margulies); French, c. 1810 (MFIT); American, c. 1800 (lent by Verna Metz). Photograph by Irving Solero. Courtesy of the Museum at the Fashion Institute of Technology, New York.

Fashion illustration depicting a woman in a corset, 1830s.

Illustration after Déveria, 1829.

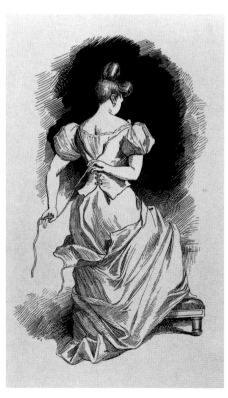

body." At best, such corsets are "useful only to conceal defects" – although "that is something . . . considering how many defective people there are in the world."[20] However, "properly constructed" corsets give support "where it is needed," and actually help Nature "correct" defects. Specifically, they "maintain the uprightness of the superior regions of the body," support "the fullness of the breasts," and work to counteract "the spreading of the frame at a certain period of life." At the same time, they provide "perfect freedom" of movement. Or as an admiring French doctor told her: "Madame, your corset is more like a new layer of muscles than an artificial extraneous article of dress!"[21]

Although many of Madame Caplin's claims are ludicrous, and she had certainly not "succeeded in inventing a muscular envelope,"[22] two of her propositions seem to have been accurate: first, her belief that the majority of women regarded some kind of corset as a necessary adjunct to female beauty;

Illustration of a corset shop by Pierre Vidal, from Octave Uzanne, *La Femme à Paris*, 1894.

and second, her perception that women wanted healthier, more comfortable corsets. Throughout the nineteenth century, numerous patents testify to the myriad inventions intended to make corsets more functional and comfortable. Many inventions, such as the "electro-magnetic busks" promoted by Madame Caplin, were useless. Others were significant.

The first steel front-busk fastening, which allowed a woman to put on or take off her corset without assistance, was invented in 1829 by the French corsetier Jean-Julien Josselin, although it did not become common until after 1850. There were various other devices available, however, so it was no longer necessary for someone else to lace and unlace a woman's stays. Mrs. Mills, a corsetière with a shop on Regent Street, London, imported corsets in 1835 with a "Patent back, which is instantly unlaced in cases of sudden indisposition." Mrs. Bell sold a version of Josselin's split-busk corset, which could be instantly separated by pulling a catch, which was convenient, she pointed out, in the event of "swooning, vapours, oppressions and spasms."[23] In 1848 Joseph Cooper patented the slot-and-stud fastening for the two-part busk. This worked so well that after 1850 virtually all corsets utilized it.

"Elastic" corsets were advertised in the 1820s, although this term seems to have meant corsets utilizing coiled metal wires and springs. Vulcanized India rubber became commercially available in 1830, and within a year Mrs. Bell announced that she was "substituting India rubber for elastic wires. The rubber is manufactured in strong but delicate fibres, which possess all the

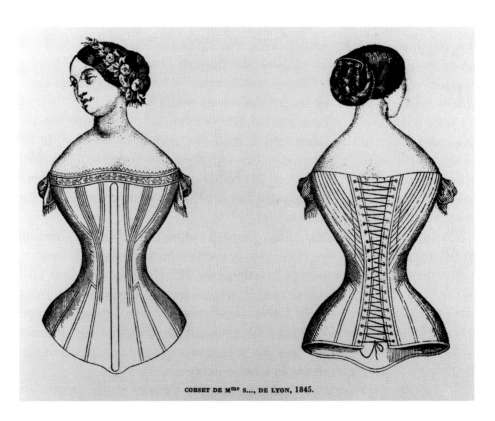

CORSET DE M^{me} S..., DE LYON, 1845.

"Corset de Madame S . . . de Lyons," 1845.

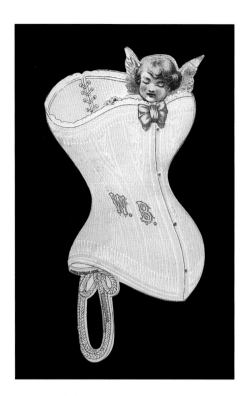

Trade card for the W. B. Corset.

elasticity of wire without being like it subject to snap or corrode." Mrs. Follet also advertised "India rubber corsets [which] substitute perfect ease and freedom in place of awkward restraint . . . they allow the form its fullest opportunity for expansion."[24]

The very idea that corsets should accommodate the body rather than the other way round was relatively new. (The word "comfort" only entered the French language in 1815, although "comfortable" had been borrowed from English by 1786.)[25] During the nineteenth century, people increasingly valued comfort, and objects such as furniture were designed to be more comfortable.[26] Corset-makers also touted their new, improved models.

"Formerly one suffered wearing a corset; it was necessary in order to be beautiful," declared *Modes Parisiennes* in 1843. "Today Mr. Pousse can make you beautiful without suffering. He has found the secret."[27] Unfortunately, promises exceeded results. Nor was comfort the only, or even the most important, consideration. Other new inventions made it possible to lace corsets more tightly. Metal eyelets, for example, were invented in 1828, replacing thread-sewn eyelets, which tore when undue pressure was applied. Other inventions also potentially facilitated tight-lacing by making corsets stronger and more closely fitting, or simply less expensive to produce. The process of steam moulding corsets on metal forms, for example, made it possible to achieve a close fit without taking the individual woman's measurements, which aided the mass production of corsets.

Corsets were produced in ever greater numbers and in all price ranges. In 1855, some 10,000 workers in Paris specialized in the production of corsets. In 1861 it was estimated that the number of corsets sold annually in Paris was 1,200,000. The cheapest corsets for workers and peasants cost from 3 to 20 francs each; by comparison, silk corsets cost from 25 to 60 francs, and some corsets decorated with handmade lace sold for 200 francs.[28] The French were famous for custom-made corsets in luxury materials. The English and American markets were dominated by mass-produced corsets made in a variety of styles and standardized sizes – usually 18 to 30 inches at the waist, although larger sizes were also readily available. Corsets were provided for different ages, body types, and activities, including sports.

During the first two-thirds of the nineteenth century, fashion magazines seldom featured images of women dressed only in corsets and petticoats. A French fashion plate from the 1830s showing a corseted woman with her clothed companion is a rare exception. For the most part publishers appear to have been reluctant to print "indecent" illustrations of women in their underwear. Until the 1870s, most corset advertisements consisted of pictures of disembodied corsets, and even later this convention remained popular. The half-length female figure in a corset formed the link between illustrations of an isolated corset and later images that showed the full-length corseted figure. At first rather sketchy and small in scale, these illustrations rapidly became

Trade card for Down's Self-Adjusting Corset.

more elaborate; women were depicted playing with a baby or a pet, looking in a mirror, or being laced up by putti.

The corset was also, however, the subject of many humorous and erotic prints. Throughout most of the nineteenth century, censorship laws generally forbade the representation of naked women, except in high art. However, the corset assumed the role of surrogate for the body; it also functioned as a sign of undressing and making love. The act of lacing and unlacing the corset was treated as a symbol of sexual intercourse in prints such as *Le Matin*, also known as *The Lover as Lady's Maid* (c. 1830). In a humorous print of the following decade, Gavarni depicts a husband puzzled because he tied his wife's corset laces with one kind of knot, but found it tied another way that evening. The woman stares stonily into the distance, presumably hoping that he will be too stupid to realize that her lover must have unlaced and retied her corset over the course of the day.

Literary references reinforce the association between the corset and the sexual act. In Balzac's *Cousin Bette* (1847) Madame Marneffe jokes with her lover Wenceslas, "Just fancy not knowing how to lace up a woman after two years! You're far too much of a Pole, my boy." As Balzac writes: "It is at such moments that a woman who is neither too plump nor too slender . . . seems more than ordinarily beautiful. . . . The lines of the body, then so lightly veiled, are so clearly suggested by the shining folds of the petticoat and the lower part of the stays that a woman becomes quite irresistible, like every joy when we must say good-bye to it."[29] Moments later, they are interrupted by the appearance of her Brazilian lover. More ominously, Flaubert's *Madame Bovary* includes a description of how an "aroused" Emma "undressed herself

FACING PAGE BOTTOM Trade card for the Bortree Corset, c. 1880.

RIGHT Numa, *Le Matin*, or *The Lover as Lady's Maid*, 1830s.

FAR RIGHT Gavarni, "Ah! Par exemple! Voila qui est bizarre! . . . ce matin j'ai fait un noeud à ce lacet-la et ce soir il y a une rosette!" 1840s.

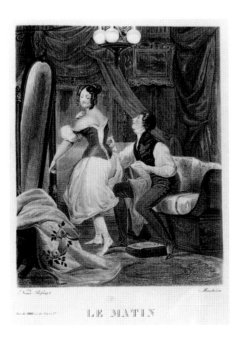

LE MATIN

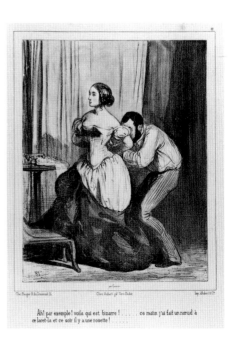

Ah! par exemple! voila qui est bizarre ! ce matin j'ai fait un noeud à ce lacet-la et ce soir il y a une rosette !

"La vitrine de la Maison Léoty à l'Exposition," from *La Vie Parisienne Almanach*, 1867.

brutally, ripping out the fine cord of her corset, which hissed around her thighs like a slithering adder."[30]

Despite their intimate character, corsets were displayed openly in shop windows and international exhibitions, which sometimes aroused the ire of moralists. In one of Daumier's images, a man notices in a window several corsets of different shapes and sizes; he comments that they resemble various women he has known, from his first lover Fifine to his wife "up there in the corner." The corset functions here as a stand-in for the body – with all its flaws and idiosyncracies. In other images, however, especially advertisements, the corset functions as an ideal version of the female body.

Meanwhile, corset design continued to develop in response to technological inventions and changes in fashion. Edwin Izod invented the steam moulding process in 1868: this involved first the creation of "ideal" torso forms, which were cast, usually in metal. Then corsets were placed over the metal forms, which were heated until the corsets took on the correct shape. When the crinoline was in style during the 1860s, full skirts made almost anyone's waist look relatively small, and most corsets were relatively short. As skirts became tighter in the 1870s, corsets became longer, encasing not only the waist but also the abdomen. This was the so-called cuirass-style of corsetry. In the 1880s, the spoon-shaped busk was fashionable, curving in at the waist and out again over the abdomen. Mass-produced corsets became increasingly inexpensive and well made. Some corset manufacturers proudly displayed images of smoke-belching factories on their trade cards and stationery, linking their products to notions of technical innovation and progress.

Honoré Daumier, "C'est unique! J'ai pris quatre tailles juste comme celles là dans ma vie . . . ," 1840s.

Bill from Ball's Corset Factory.

Evolution of corset design between 1867 and 1878, from Libron, *Le Corset*.

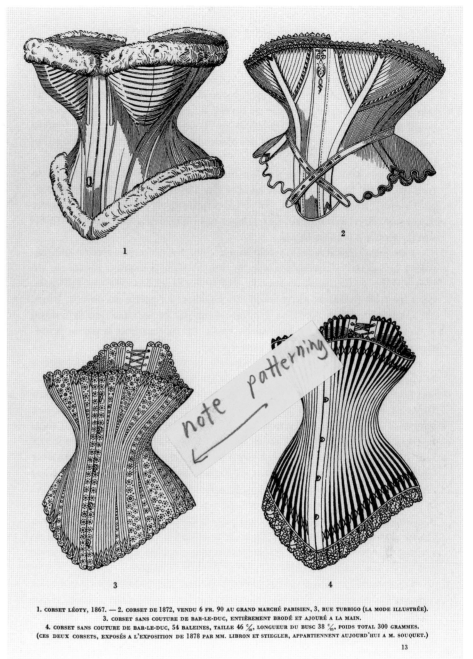

1. CORSET LÉOTY, 1867. — 2. CORSET DE 1872, VENDU 6 FR. 90 AU GRAND MARCHÉ PARISIEN, 3, RUE TURBIGO (LA MODE ILLUSTRÉE).
3. CORSET SANS COUTURE DE BAR-LE-DUC, ENTIÈREMENT BRODÉ ET AJOURÉ A LA MAIN.
4. CORSET SANS COUTURE DE BAR-LE-DUC, 54 BALEINES, TAILLE 46 %, LONGUEUR DU BUSC 38 %, POIDS TOTAL 300 GRAMMES.
(CES DEUX CORSETS, EXPOSÉS A L'EXPOSITION DE 1878 PAR MM. LIBRON ET STIEGLER, APPARTIENNENT AUJOURD'HUI A M. SOUQUET.)

13

Advertisement for Y&N Diagonal Seam Corset, showing the spoon-shaped busk, 1880s.

The elite may have tried to differentiate themselves through fashion, but they were constantly imitated by those from more humble backgrounds. Not only did industrialization result in the mass production of consumer items such as clothing, it also contributed to an urban population explosion. In the modern urban environment, increasing anonymity also seems to have led to a greater emphasis on appearances. Certainly, modernity opened up new possibilities for the creation of identity. The bourgeoisie frequently complained that it was becoming impossible to distinguish the mistresses from the maids.

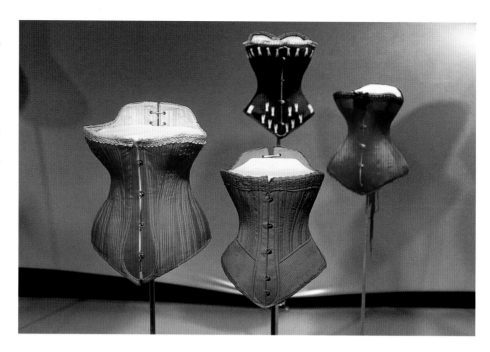

Installation photograph from the exhibition "The Corset," depicting the mass-produced, khaki-colored Pretty Housemaid Corset, c. 1885 (Leicestershire Museums Arts and Records Services, Symington Collection), along with a more expensive red corset, c. 1880 (MFIT). Behind are two other custom-made corsets from the same period: French black corset, c. 1880 (MFIT); French colored satin corset, c. 1880 (lent by Mark Walsh). Photograph by Irving Solero. Courtesy of The Museum at the Fashion Institute of Technology, New York.

A. Grévin, *Les Domestiques*, 1870s.

This was always something of an exaggeration, since working-class clothing was of poorer quality. However, shopgirls and other working women did often follow the general outline of fashion.

The bourgeoisie liked to think of themselves as distinctively different from the laboring classes. A slender waist, for example, like dainty hands, was often perceived as a natural sign of superior "race" or hereditary class status. Caricatures not infrequently contrasted the ample torsos of working-class women with the diminutive corsets worn by bourgeois ladies. Class distinctions sometimes overlapped with distinctions of gender, as working-class women were envisioned as being large and strong like men. "Within the symbolic lexicon of Victorian sexuality, the lady is a picture of exaggerated femininity."[31]

There is evidence, however, that working-class women did not see themselves as the bourgeoisie did. The famous Symington collection of corsetry in Leicester, England contains an example of the Pretty Housemaid corset from the 1880s. Advertised as being "The strongest and cheapest corset ever made," the Pretty Housemaid featured a patented busk protector and extra cording over the abdomen, since the wearer would put extra pressure on her corset by bending and performing hard physical labor. Like many mass-produced corsets, it contained metal stays, rather than whalebone, which was becoming increasingly expensive as supplies dwindled in comparison with demand. It was also made of hardwearing material, unlike more expensive models which were made of silks and satins in a growing array of colors. Yet despite such differences, the Pretty Housemaid corset created exactly the same fashionable hourglass silhouette.

Thorstein Veblen, author of *The Theory of the Leisure Class* (1899), famously described the corset as "a mutilation, undergone for the purpose of lowering the subject's vitality and rendering her permanently and obviously unfit for work."[32] He was wrong. Corsets did not prevent women from working, and ladies of the "leisure class" were not the only ones to wear them. By the nineteenth century, many urban working-class women wore corsets, either on Sunday or every day. By 1824, apparently even the poorest streetwalkers in London wore corsets.[33] Commonly worn in England, corsets seem to have been worn by fewer working-class French women. According to one study, 33% of working-class French wives owned corsets in the period between 1850 and 1874. This figure rose to 44% of working-class wives between 1875 and 1909, including both Paris and the provinces.[34] In nineteenth-century America, not only did free black women wear corsets, but so also did some enslaved women, especially if they were young and worked in the household, not the fields.[35] Indeed, Veblen himself backtracked a few pages later and admitted that women's dress seemed designed "to impress upon the beholder the fact (often indeed a fiction) that the wearer does not and can not habitually engage in useful work."[36]

Although Veblen regarded the corset – and the high heel – as signs of expensive infirmity, conspicuous leisure, and female dependency, in reality such fashions did not prevent women from working. The corset did function as a sign of gentility and respectability but, as such, it was a sign that laboring women appropriated for themselves. Not only did fashionable dress fail to police class boundaries, it actually served to weaken them. The corset did serve as a means of gender differentiation, since by the middle of the nineteenth century very few men wore corsets, and even little boys were seldom corseted.

Little girls continued to be put into corsets, although they now wore special models designed for immature bodies, rather than the miniature adult stays typical of the eighteenth century. There were many supposedly "healthy" brands of children's corsets, since popular belief still held that the use of properly fitted corsets was necessary to "correct ungraceful posture" and prevent growing bodies from becoming crooked.[37] Girls usually started wearing quasi-adult corsets only at adolescence. Although no longer so physically restrictive, corsets still functioned to prepare girls for certain social roles, including the necessity of conforming to contemporary standards of feminine beauty and propriety.

Many popular accounts of corsetry described rational men trying to convince foolish young women not to wear tight corsets. For example, in a "true story of tight-lacing" of 1892, Gordon Stables ("Medicus" of *The Girl's Own Paper*) described how 19-year-old Susie laces more tightly after she becomes engaged – a practice that her mother regards as normal, but that distresses her doctor father. "The girl is being squeezed to death . . . Bother those

Advertisement for Ferris's Good Sense Corset Waists for women and children, c. 1880.

corsets anyhow!" Worried that she is "growing more refined-like," he invites her to go to the seaside for a vacation, and to wear her "easiest corset" for the trip. Then he gets rid of her other corsets, and she becomes "better, stronger, rosier, happier." Her fiancé, clearly another sensible man, is delighted.[38]

The novelist Charles Reade devoted much of the plot of *A Simpleton* (c. 1873) to a condemnation of corsets. His hero, Dr. Staines, argues that the heroine, Rosa, should "throw that diabolical machine [i.e. a corset] into the fire." Rosa defends corsetry on a number of grounds: corsets are necessary for warmth; "it is so unfeminine not to wear them;" "a tiny waist is beautiful;" and gentlemen (including fathers and husbands) have no business "interfering in such things." At one point, she angrily advises Staines to "go and marry a Circassian slave. They don't wear stays, and they do wear trousers; so she will be unfeminine enough, even for you."[39] Interestingly, when the novel was serialized in *London Society* (August 1872–September 1873), the author apparently requested that it not be illustrated, presumably because illustrations tended to exaggerate the slenderness of women's waists, thus working against the moral of the story.

By the late nineteenth century, however, at least some young women wanted to liberate themselves from the corset. In her memoirs, Gwen Raverat, a granddaughter of Charles Darwin, writes feelingly about her personal experiences of corsetry:

> We knew it was almost hopeless – we were outnumbered and outflanked on every side – but we *did* rebel against stays. Margaret says that the first time she was put into them – when she was about thirteen – she ran round and round the nursery screaming with rage. I did not do that. I simply went away and took them off; endured sullenly the row which ensued, when my soft-shelled condition was discovered; was forcibly recorseted; and, as soon as possible went away and took them off again. One of my governesses used to weep over my wickedness in this respect. I had a bad figure, and to me they were real instruments of torture; they prevented me from breathing, and dug deep holes in my softer parts on every side. I am sure that no hair-shirt could have been worse to me.[40]

This firsthand account is extremely compelling, and it is easy to empathize with Gwen and Margaret's rebellion. It is important to recognize, however, that the girls' parents and governesses were not deliberately cruel.

"The thought of the discomfort, restraint and pain, which we had to endure from our clothes, makes me even angrier now than it did then," declared Raverat:

> *for in those days nearly everyone accepted their inconvenience as inevitable.* Except for the most small-waisted, naturally dumb-bell-shaped females, the ladies

Anti-corset image from Luke Limner, *Madre Natura Versus the Moloch of Fashion*, 1874.

50

never seemed at ease . . . For their dresses were always made too tight, and the bodices wrinkled laterally from the strain; and their stays showed in a sharp ledge across the middles of their backs. And in spite of the whalebone, they were apt to bulge below the waist in front; for, poor dears, they were but human after all, and they had to expand somewhere. How my heart went out to a fat French lady we met once in a train, who said she was going into the country for a holiday "pour prendre mes aises sans corset."[41]

Older women, not men, were primarily responsible for enforcing sartorial norms. Within the family, the patriarch usually deferred to his wife's or even his mother's authority in deciding how the females of the family should be dressed. The cultural weight placed on propriety and respectability made it difficult for women to abandon the corset, even if they wanted to. Edith Rode, for example, was born into an upper-middle-class family in Copenhagen in 1879. In her memoir of life during the 1890s, she recalled trying to avoid wearing a boned corset under her ball gown:

Trade card for Dr. and Madame Strong's Corsets.

"My child," said grandmother firmly, "you must at least wear your corset to the ball!"

"I can't breathe," I said defiantly.

"I can breathe," said grandmother, "your mother can breathe, and your sisters can breathe — and you can breathe, too! . . . It is unfitting and disreputable not to wear a corset . . . And where would you have the young man place his arm, if I may ask?"

"Well, she's wearing a bodice," my mother said, hurt.

But grandmother was unperturbed. "A bodice!" she scoffed. "He can't place his arm on a bodice!"[42]

An unboned or lightly boned foundation, a bodice, was just not the same as a boned corset. Edith's grandmother would have agreed with the fashion writer who argued in the late 1870s that "People who refuse to wear any corset at all look very slovenly."[43]

The fact that corsets had been a component of elite fashionable dress for centuries gave corsetry the authority of tradition. As Karl Marx wrote (in quite a different context): "Men make their own history, but they do not make it just as they please; they do not make it under circumstances of their own choosing, but under circumstances directly encountered, given, and transmitted from the past. The tradition of all the dead generations weighs like a nightmare on the brain of the living."[44] During the nineteenth century, many aspects of life were rapidly changing but some traditions, especially those surrounding women, were all the more anxiously retained. Moreover, since most women's socioeconomic lives depended on marriage, it was understandable that their mothers and grandmothers should want to maximize both their physical "beauty" and their reputation for propriety.

Trade card for Ball's Health-Preserving Corsets.

Illustration from *Fashion in Deformity*, 1881.

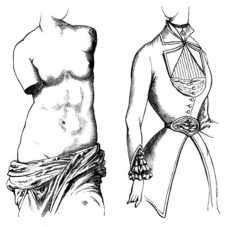

FIG. 20.
Torso of the Statue of Venus of Milo.

FIG. 21.
Paris Fashion, May 1880.

The corset controversies that raged throughout the century were not primarily between absolute opponents and defenders of the corset. As one American writer observed in 1890, "Probably no article of feminine attire has ever been the subject of so much argument as the corset." But although there were "extremists" on both sides, most people came down somewhere in the middle: opposed to "tight-lacing" or the "abuse" of corsetry, but in favor of "moderate" corsetry, however these terms were defined.[45] Advice on corseting adolescent girls was especially divided, with many doctors stressing how unhealthy this was, while others argued that moderate corseting was harmless or beneficial. Doctors tended to blame mothers for encouraging their daughters to tight-lace in order to win a rich husband, while mothers often argued that their daughters persisted in the practice despite pleas to stop. Both doctors and members of the general public tended to believe that women's bodies were, by nature, weaker than men's. Attention was overwhelmingly focused on the reform and modification of corsetry, not its abolition. Only a few people argued that "Our sons hold themselves erect, without busk or corset, or framework of whale-bone. Why should not our daughters also?"[46]

All evidence, including the testimony of dress reformers, indicates that the majority of women regarded some kind of corsetry as a necessity. However, only a tiny minority of people advocated tight-lacing; their letters in the pages of certain periodicals, such as *The Englishwoman's Domestic Magazine*, aroused anger and incredulity among the general public. The self-proclaimed "votaries of tight-lacing," who boasted of achieving waists of less than sixteen inches, will be discussed in a later chapter. But even women who were not tight-lacing enthusiasts did reduce their waists. According to the English beauty writer Arnold Cooley in 1866, "The . . . waist of healthy . . . women . . . is found to measure twenty-eight to twenty-nine inches in circumference. . . . Yet most women do not permit themselves to exceed twenty-four inches round the waist, whilst tens of thousands lace themselves down to twenty-two inches, and many deluded victims of fashion and vanity to twenty-one and even to twenty inches."[47]

The discourse on corsetry tended to rely on certain concepts, such as Nature, Beauty, Fashion, and Deformity. Thus, for example, Cooley argued that "The fashionable . . . waist of Western Europe is not the waist of nature, nor the waist of beauty. It is an absolute deformity."[48] Many other people also characterized the "fashionable" waist as a "deformity" on a par with Chinese bound feet, and compared it invidiously with both "natural" uncorseted waists and the waists of classical statues, such as the Venus de Milo, which symbolized an ideal of "beauty":

We laugh at the folly of the Chinese belles, who compress their feet until they are no longer fit for walking . . . and yet our own females are equally

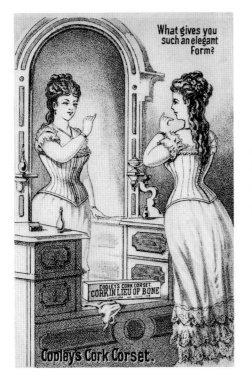

Trade card for Cooley's Cork Corset.

Trade card for Cooley's Globe Corset.

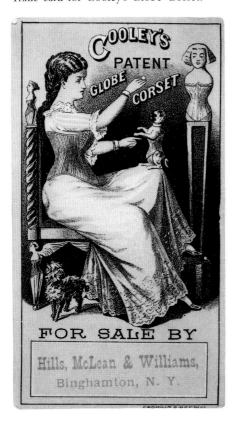

ridiculous, and even more criminal, when they imagine that they improve the beauty of their chests and waists by distorting them from that form which nature has wisely imparted to them; and thus, by a perverted taste, entail disease and pain upon their daughters, or hurry them to an early grave.[49]

According to Cooley, "in the nude figure [the fashionable waist] would be actually intolerable. It is only the extraneous assistance of dress that disguises it, and enables it to pass muster in the tout-ensemble."[50] On the contrary, replied Mrs. Fanny Douglas, another English fashion and beauty writer around 1894:

The opponents of the corset and the waist are a little too fond of point-ing to the Venus de Milo as proof of how beautiful a waistless woman can be. They forget or ignore the fact that the Venus de Milo is a charming nudity, and that it is the custom in most countries to cover oneself with clothes. Had Venus been compelled by a cold climate to drape herself, we have little doubt she would have worn stays to give her clothes the shape they lacked.[51]

Mrs. Douglas employs several strategies to break down the opposition between Beauty and Fashion. To begin with, she implies that there are two kinds of female beauty: first, the nude, which would have been associated both with classical art and with nature; and second, the clothed, which is how most women would have seen themselves. Then, by using the term "waistless," she cleverly shifts the terms of the argument, since only a few dress reformers argued that "There is positively no waist-line in the natural body."[52] Most people believed that the corset exaggerated a "natural" differ-ence between men and women, that is, women's more pronounced waist-line. Douglas counts on her readers to believe that the waistless female figure would be much more of a deformity than than a fashionable beauty in a corset.

The nineteenth-century literature on female beauty praises "natural proportions" while simultaneously expressing admiration for the "naturally slender" waist. The French beauty writer Ernest Feydeau, for example, in 1874 professed to be amazed that "the generality of women envy the elegant monstrosities" portrayed in fashion illustrations: "a slim little waist in strange contrast with exaggerated hips and broad shoulders." Yet, for all his emphasis on harmony, grace, and proportion, he nonetheless concluded that "thick, large" waists are "simply hideous . . . to a man of taste."[53]

Reformers insisted that "The Unnatural Can Never Be Beautiful."[54] But they also reluctantly admitted that "Deformity has through long custom become to us beauty."[55] Even an artist, who was "thoroughly in harmony with the best classic standards," confessed to his friend, a dress reformer, that

Advertisement: "Thin Busts Perfected."

THIN BUSTS—Perfected.

Beauty is a joy e'er real,
Nature doth too often fail,
Art steps in with her "Ideal,"
Nature need ne'er more bewail.

IDEAL CORSET.—Patented. Words cannot describe its effect in perfecting thin figures. Softly padded Regulators (Patent) inside each breast, laced more or less closely; regulate at wearer's pleasure any desired fulness, with the graceful curves of a beautifully proportioned bust. Court dressmakers say—"It delightfully supersedes padded dresses, and for Jersey bodices is matchless." Unprecedented testimonials, with nearest agents' addresses, from Patentees—

EVANS AND BALE,
52, ALDERMANBURY, LONDON.
White, 10s. 9d., 14s. 9d., 16s. 9d. Black Stitched Amber, 14s. 9d.
As guarantee, on receipt of money a "Genuine Ideal" sent on approval, carriage paid, plain parcel, to provincial address not near Agent. Money returned if desired. Send waist measure; ordinary corset unstretched. Avoid deceptive recommendations. No other corset in the world can impart similar effect.

Trade card for Thomson's Glove-Fitting Corset, c. 1890.

when he saw a fashionably dressed woman, "the lines of her distorted figure, nevertheless, pleased me. Now what is the matter with *me*?"[56] However, most people would probably have agreed with the American doctor who argued that "Nature 'demands' that women should have small waists, and the misery and harm . . . inflicted by the over use of corsets is only a blind, ignorant obedience to an instinct, which properly directed is graceful and natural." After all, he added, "The woman who affects loose garments is lazy and violates all rules of good dressing."[57]

Women's stubborn adherence to corsetry implies that they believed corsets served some useful function. Most people today tend to think of the corset as a waist-cincher. Certainly, women could and did use corsets to "improve" a relatively undefined waist–hip ratio or to suppress a heavy abdomen. However, the corset also functioned as a brassiere, indeed as a kind of Wonderbra, lifting the breasts, "augmenting their volume," and allowing them to "blossom in all their splendor and amplitude."[58] Girls and women who were insufficiently buxom could approximate the desired curves with a discreetly padded corset. The Ideal and the Configurateur Corsets, for example, were specifically designed to "transform" a "thin bust" by lacing padded "regulators" inside the breast gores. The Kyoto Costume Institute owns a beautiful example of Thomson's La Fiancée corset in brilliant fuschia-colored satin, which would have created a highly unrealistic impression of the wearer's actual figure. The corset also supported heavy or sagging breasts, or a prominent abdomen, or simply a "corpulent" figure. Indeed, it was often said that the real purpose of the corset was to correct, or at least conceal, a variety of physical flaws.

Art assisted Nature, declared defenders of the corset. This idea is clearly expressed in an American trade card from the 1890s, which depicts a woman sculptor carving a statue of a half-length female figure in a fashionable "Glove-Fitting" corset. Although this particular image implicitly credited

54

Corset Léoty, from Libron, *Le Corset*.

women with their own transformation, the subtext clearly emphasized the importance of choosing the right brand of corset. Interested parties such as the corset manufacturer Ernest Léoty argued that "The corsetière makes the woman – a living statue carved by Nature – into a statuette of gracious fragility, of conventional form, but so seductive."[59] The corset was also essential for a fashionable appearance. As the fashion writer Octave Uzanne put it in 1902: "A narrow waist between tasty hips and a proud bosom" is always admired, but even a "splendid form" may be "transformed according to the fantasies of fashion."[60] Such comments implicitly present the corset in association with a whole complex of attitudes, especially as a symbol of "femininity."

Corset advertising sometimes featured naive scenarios, which implied that if a woman looked unattractive it was the fault of a bad corset. As soon as she switched to the right brand of corset, her true beauty could shine forth and she would find a husband. This was a gratifying fantasy, not only for corset manufacturers but also for women who were dissatisfied with their appearance or their lives. Cooley's Corsets, for example, printed several folding trade cards, which conveyed the before ("How uncomfortable I feel and how horrid I look!") and the transformative after of good corsetry ("I hardly knew myself! How comfortable."). One of the cards describes a "romance," with begins with Miss Smith dressing for a ball: "I look so

Trade card (closed and open) for Cooley's Cork Corset.

Trade card for Ball's Riding Corset.

Trade card for the W. B. Cyclist's Corset.

frightful I don't care if I do not go at all – and Charlie won't be pleased I fear." Fortunately, her friend Miss Jones gives her some fashion advice and she finds that "In Cooley's Globe Corset at the ball she was the most admired of all, and Charlie told his love – so she lived happily ever after." Of course, not all advertising was so didactic. Cooley's also produced an odd trade card showing a corseted woman playing with her corseted dog. Like many Victorian trade cards, those advertising corsets were sometimes positively surreal.

The text of corset advertisements usually focused on issues of conscious concern to women. Almost always touted were the "comfort" and the "elegant" appearance produced by the corset, as well as patented improvements, such as "unbreakable" steels or "adjustable sides." As sports became more popular, corset advertising increasingly focused on specialized models for horseback riding or bicycling, which tended to be more flexible with cutaway hips and elastic gores. Advertising is obviously characterized by a considerable degree of exaggeration and outright duplicity, as well as attempts to create consumer desires. Nevertheless, in order to succeed, advertisers must respond to what they think consumers want.

Beyond rational arguments, however, there was also scope for interjecting subliminal appeals to women's more or less unconcious desires. Many corset advertisements and trade cards, for example, depict putti – figures that allude both to babies and to cupids. Winged putti peek out from inside corsets, lace up corsets, paint or photograph corsets. Since nineteenth-century doctors frequently warned that tight corsets could complicate pregnancy and injure the fetus, these putti may represent not only cupids or angels but also healthy babies. At a time when many women experienced repeated pregnancies, they may also have hoped that a good corset would counteract the ravages of both pregnancies and time. Of course, some of these putti might also have served

Advertisement for Warner's
Rust-Proof Corset, 1901.

Trade card for Warner's Corset.

as acceptable surrogates for an adult male lover, whose presence was not
acceptable in corset advertising.

Nevertheless, in those innocent pre-Freudian days, quite explicit images
often went unremarked, at least in America. One advertisement, from 1901,
promoted Warner's Rustproof Corset – with an image of a little boy holding
a hose between his legs and spraying water on the corset, which floats in the
air. Since the corset has essentially the same shape as the female torso, we
could even say that the stream of water is being directed to the area analo-

Trade card for Royal Worcester Corsets.

gous to the female genitals. Censorious members of the public did complain about this advertisement: they insisted that the naked little boy had to put on some clothes, and some copies of the advertisement were duly altered. No one appears to have commented on the rest of the sexual symbolism. Nor are there any recorded protests about racist images of a Chinese laundry, which were also used to advertise rustfree corsets.

The next three chapters will explore in detail the medical consequences of corsetry, the controversy about tight-lacing, and the erotic iconography of the corset. But first we need to look more closely at the dress reformers' critique of the corset. As we shall see, the hardcore anticorset contingent included many (but by no means all) doctors and many (but by no means all) feminists. Medical ambivalence about corsetry may well have been "related, at least in part, to the profession's general opposition to feminist claims."[61] But feminists and female doctors were themselves ambivalent about corsetry. Lydia Becker, editor of the *Woman's Suffrage Journal*, publicly urged women to "stick to your stays."[62]

Some men and women opposed any and all use of the corset on the grounds that it interfered with women's reproductive role: "O, young women! O, young mothers! Undo your girdles! Do not be afraid to admit that from birth heaven created you to become mothers."[63] However, many American feminists supported dress reform and opposed corsetry on the grounds that women's fashions not only caused specific diseases but also, more generally, impaired vitality and prevented women from achieving equality with men.

"It has ceased to be a metaphor that [woman] is *'dressed to kill'*," declared Elizabeth Stuart Phelps in 1873. "We are of tougher stuff than our brothers, or we should have sunk in our shackles long ago. . . . Could your father or your husband live in your clothes? . . . Could he conduct his business and support his family in your corsets?" Apparently, even certain hairstyles were

Illustration from Woolson, *Dress-Reform*, 1874.

"The Man and the Woman of Tomorrow," from *Les Dessous Elégants*, 1904.

VIII. — L'HOMME ET LA FEMME DE DEMAIN
Le corset masculin
Les gouvernements décrétant le corset *masculin*, aucun budget ne permettra d'indemniser les cor-setières, victimes de ce désarmement imprévu !!

unhealthy, since she went on to demand: "Could he prosecute 'a course of study' in your chignon?"[64] But corsets were the worst, and she urged women:

> Off with the corsets! . . . No, don't give them to Biddy. Never fasten about another woman, in the sacred name of charity, the chains from which you have yourself escaped. Never give away your earrings, when you have acquired a distaste for the wearing of them. Never make presents of the gew-gaws and frippery which your maturing taste discards. What is intrinsically unbecoming or unrighteous is as unbecoming and unrighteous for your cook as for yourself . . . So burn up the corsets! No, nor do you save the whalebones. You will never need whalebones again. Make a bonfire of the cruel steel that has lorded it over the contents of the abdomen and thorax so many thoughtless years, and heave a sigh of relief; for your "emancipation," I assure you, has from this moment begun.[65]

Yet she admitted that the majority of ordinary women had declined to throw away their corsets. According to Phelps, "the average woman" was tolerably content with her style of dress. Another reason for the failure of dress reform was its association with controversial ideas, such as "atheism and . . . free love," female suffrage, "an opium-fed baby, and a dinnerless and button-less husband."[66] Some dress reformers, of course, *were* associated with radical political movements for women's rights, temperance, and abolitionism. Utopian communities such as Robert Owen's New Harmony advocated unconventional views of both dress and marriage. But reformers' attempts to devise less restrictive forms of female clothing, like the Bloomer costume, which proposed trousers for women, conjured up in many people's minds lurid images of unrestrained female sexuality and social liberty, including a veritable world turned upside down, where trousered women smoked cigarettes and hen-pecked men washed the laundry and took care of the children. Even in the early twentieth century, a French corsetiers' journal continued to raise the specter of masculinized women and effeminate men.

Popularly associated with free love, many feminist dress reformers were nevertheless sexually puritanical. They characterized Fashion as a monster designed to "incite lust," and argued that if women would only discard sartorial devices that identified gender and emphasized sexual characteristics, men and women could relate to each other mentally and spiritually, rather than through "sensuous" attraction. Reformers argued that fashion gave them the appearance of "solely sexual creatures," thereby "foster[ing] depravity in men."[67]

Clothing should be utilitarian, not decorative, dress reformers declared. Women should stop wasting their time and money on fashion. This argument, still popular a century later among British and American feminists of the 1970s, ignored the fact that many women experienced at least some

Illustration from Ecob, *The Well-Dressed Woman*, 1893.

aspects of fashion as pleasurable. Few women were receptive to the argument that

> All ornaments worn upon the person should at least pretend to serve some useful purpose. There is no pretense of use in bracelets, earrings, necklaces, and such meaningless appendages, which are an inheritance from the barbarous tribes. . . . Men have rid their dress of such unworthy gew-gaws; and . . . we shall in time discard heathenish baubles for something less suited to childish tastes.[68]

Behind the dress reformers' belief that menswear was intrinsically superior to women's clothing was the assumption that men themselves were more rational than women.

"Niggardly waists and niggardly brains go together," argued Frances Willard. "A ligature around the vital organs at the smallest diameter of the womanly figure means an impoverished blood supply in the brain, and may explain why women scream when they see a mouse."[69] Mrs. E. M. King of the Rational Dress Society in 1882 explicitly compared women's dress to that of "savages." By contrast, she argued, the "civilised man" wore decent, comfortable clothing, and expressed his "love of beauty" by collecting pictures, "rather than attempting to make a picture of himself, to be stared at and admired."[70]

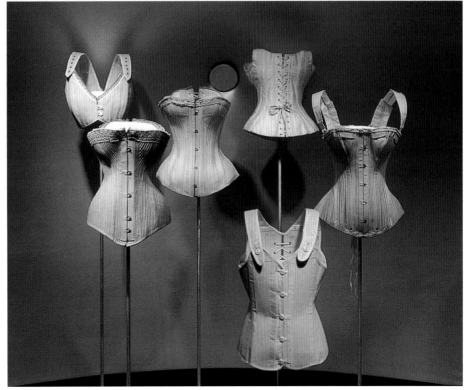

Installation photograph from the exhibition "The Corset," depicting various health and children's corsets and a bust-bodice. Left to right: French, 1890s (MFIT); English, 1880s (Leicestershire Museums Arts and Records Services, Symington Collection); Dr. Strong's Tricora Corset, U.S.A., 1893 (MFIT); pink corset, measuring 35-32-36 inches, U.S.A., 1880s (MFIT); McCabe's Sanative Corset, U.S.A., 1882 (The Brooklyn Museum of Art). Photograph by Irving Solero. Courtesy of The Museum at the Fashion Institute of Technology, New York.

FACING PAGE Trade card for Ball's Corset: "A Revolution in Corsets."

Morality and medicine were frequently conflated. It was not "morally right" for Christian women to decorate themselves in "an unnatural and degrading" manner.[71] Women's dress "dangerously" overheated parts of the body, while leaving other parts exposed. Instead of providing a uniform temperature over the surface of the entire body, fashionable dress created a "frigid zone" on the shoulders and chest and a "torrid zone" below the belt, where an excess of cloth resulted in "a chronic inflammation of the internal organs, – mother of a hundred ills that afflict women."[72] Women's underpants (closed drawers) were "extremely unhealthy." High heels were "a fruitful cause of disease," and long skirts were unhygienic, because they picked up dirt and germs.[73]

It was one thing to argue that the Christian women of a republican nation should shun extravagant fashions devised by "the demi-monde fashion mongers of Paris."[74] But what then should they wear? Throughout the nineteenth century, dress reformers tried and failed to invent an acceptable alternative to fashionable ideals of dress and beauty. Attempts to design "hygienic" dress usually entailed only the modification of ordinary clothing, such as shorter skirts, lower heels, and "health waists" featuring shoulder straps and cording instead of steels. Some women adopted "artistic" or "aesthetic" dress. Whereas "rational" dress carried too much ideological baggage for most women, aesthetic dress primarily served to proclaim the taste of the wearer. It gained popularity, especially in the form of teagowns and other indoor dresses from companies like Liberty of London.[75] The Belgian architect and designer Henry van de Velde created artistic dresses, as did the Austrian artist Gustav Klimt, who collaborated with his girlfriend the couturière Emilie Flöge. By the early twentieth century, this "anti-fashion movement . . . was

Advertisement for R & G Corsets.

Trade card for the Warner Brothers' Coraline Corset.

Advertisement for Hancock and James
Corsets.

glamorized and transformed" into a stylish alternative fashion, at least among bohemian women.[76]

Ordinary women might have been concerned about the medical conse-quences of fashion, but they usually declined to adopt reform dress, except for the occasional teagown. One reason for this arises in the literature again and again. "I am very stout," said one woman; "I should look like a tub without a corset." The dress reformer Helen Ecob had anticipated just such an objection, and in 1893 she reassured her hypothetical reader, "It is no worse to look like a tub than an hourglass . . . your size will be less appar-ent, if your clothing is loose. Of two evils choose the less. Obesity can never be made becoming; if it can not be overcome, it must be accepted as one accepts other physical deformities."[77] However, many women continued to believe that corsets gave them the appearance of a better figure.

"There is one horror which no lady can bear to contemplate, viz. Fat," wrote the beauty expert Henry Finck in 1887. "Many women consider the corset necessary as a figure-improver, especially if they suffer from excessive fatness." This belief was mistaken, he argued. Fat needs to be "burned away" through respiration, and since corsetry impeded respiration, "the corset is one of the principle causes of [women's] corpulence."[78] His explanation is somewhat confused, since restricted respiration does not per se prevent the expenditure of calories; but he was ahead of his time in stressing the importance of diet and exercise in controlling weight. It was also the case that while concealing "flaws" the corset also contributed to them. Over time, for example, the downward pressure of the corset tends to distend the abdomen, a situation made worse by the atrophy of the back and abdominal muscles.

It would be simplistic to interpret corsetry as the pre-modern equivalent of dieting, since dieting was already a recognized phenomenon, albeit not a very common one. Nor should tight-lacing be reductively associated with anorexia, although there are sometimes certain parallels. For example, the pioneering psychiatrist Charcot observed one patient who was so afraid of becoming fat that she wore a ribbon around her waist as a measure that the waist was not to exceed.[79] The Empress Elizabeth of Austria (1837–98), known as Sisi to her intimates, was another extreme case; measuring 5 ft 9 inches, she weighed only about 100 pounds, insisted on a rigid low-calorie diet, exercised obsessively, and always wore a tight corset with a nineteen-inch waist. She also kept a photograph collection with pictures of the most beautiful women of the time, and obviously associated slenderness with beauty. Whereas medieval saints had fasted and mortified their bodies in order to exalt the spirit, with Sisi we see the beginning of the modern ideal of slenderness as beauty.[80] But Sisi was much thinner than the contemporary ideal. The late nineteenth century was, after all, the era of the fifteen-course

meal, when a big eater like Lillian Russell took off her corset before sitting down to dinner.[81]

Nevertheless, the subject of corsets and corpulence occurs often enough to be significant. As the anonymous author of *Beauty* (1890) put it: "In spite of the warfare made upon them by the comparatively few, the majority will continue to wear [corsets] for centuries to come." And why? "There are women whose figures require support and who, without aid of this kind, are rendered extremely uncomfortable to themselves, and beyond question, unsightly to others." In particular, some women have a "tendency to stoutness [that] often merges into actual obesity, and, without the corset, the possessors of bulky figures would suffer both physically and mentally." Furthermore, even if corsets were unavailable, "in some way [women] would manage to reduce their figures to their ideal of beauty."[82] Or as an American dress reformer put it: "One of the strongest reasons for the adoption of the corset, though it is not commonly avowed, is the belief that it conduces beauty and symmetry of figure. Slender forms are usually praised, and chiefly because they are associated with the litheness and undeveloped graces of youth."[83]

"Slender" is putting it too strongly, perhaps, since the ideal female figure of the nineteenth century was more well-padded than it is today. Many beauty writers actually encouraged *embonpoint*, or "a pleasing roundness."[84] Certainly most men liked voluptuous women: as the anonymous author of the pornographic "autobiography" *My Secret Life* put it, "Few men . . . will keep long to a bony lady whose skinny buttocks can be held in one hand."[85] However, actual obesity was not admired, and "fat" had to be in the right places – on the hips, thighs, bosom, and buttocks, not the abdomen or the waist. The slender waist – if not yet the thin body – was popularly associated with youth and beauty. Moving into the twentieth century, the ideal figure gradually became less rounded and more slender, with subcutaneous fat increasingly regarded as "an unsavory opulence."[86]

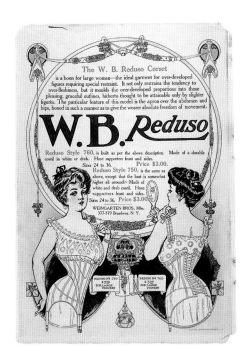

Advertisement for the W. B. Reduso Corset, c. 1900.

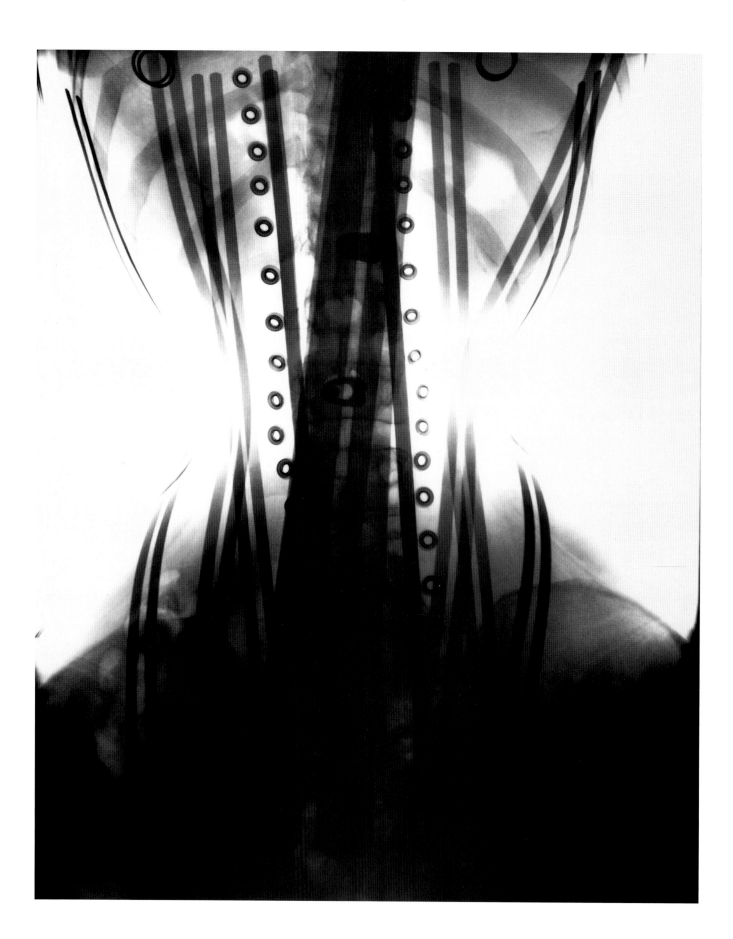

3 Dressed to Kill
The Medical Consequences of Corsetry

THE CORSET HAS BEEN BLAMED for causing dozens of diseases, from cancer to curvature of the spine, deformities of the ribs and displacements of the internal organs, respiratory and circulatory diseases, birth defects, miscarriages, and "female complaints," as well as medical traumas such as broken ribs and puncture wounds. *The Lancet*, Britain's most important medical journal, published more than an article a year from the late 1860s to the early 1890s on the medical dangers of tight-lacing. Deaths from tight-lacing were also mentioned. In one case, for example, the "heart was found to be so impeded in its action as to render life impracticable." An editorial against tight-lacing said that the practice "surpasses belief" and commented sarcastically that "there can be no need to adopt artificial measures for the repression of feminine brains."[1]

Luke Limner's famous attack on the corset, *Madre Natura versus the Moloch of Fashion* (1874), lists ninety-seven "Diseases produced by Stays and Corsets according to the testimony of eminent medical men." These range from "Pains in the head . . . according to Bonnaud" to "Sickly and short life . . . [according to] Camper," and include apoplexy, asthma, chlorosis, consumption, cough, diseases of the kidney, displacement of the bones of the chest, disturbance of the circulation, disturbance of the functions of the diaphragm, dropsy of the belly, epilepsy, fainting, hemorrhoids, hernia of the bladder, hunchback, hysteria, impediment to the action of the lungs, impediments in the action of the heart, inability to suckle in consequence of pressure on the breasts, inclination of the mouth of the uterus toward the sacrum, inflammation of the liver, leucorrhea, loss of appetite, lung abscesses, melancholy, miscarriages, pains in the stomach, premature labor, schirrhus in the mammary glands, and ultimately cancer, sores on the chest, sterility, swollen feet, ugly children, unhealthy children, want of energy, and weakening of the thorax.[2] *Punch* satirized tight-lacing in caricatures such as "Fashionable Suicide," while the American periodical *Puck* suggested that women were "martyrs" to fashion, or geese, running to their graves.

How dangerous were corsets? The modern feminist critique of corsetry rests in large part on an uncritical acceptance of doctors' and dress

X-ray of Cathy Jung's ribs, while wearing a tight corset. Courtesy of Catherine and Robert Jung.

THE MODE AND THE MARTYRS.

reformers' claims about the medical dangers of corsetry. The historian Leigh
Summers, for example, confidently argues that "the corset was largely respon-
sible for a dazzling constellation of female complaints."[3] The historian's
attempts to assess medical diagnoses from the past are fraught with difficul-
ties, but from the perspective of modern medicine, corsets were extremely
unlikely to have caused most of the diseases for which they were blamed.
Yet they almost certainly did cause or aggravate some health problems. In
investigating the medical aspects of corsetry, I was fortunate to be able to
collaborate with the cardiologist Dr. Lynn Kutsche, who spent a year at the
Fashion Institute of Technology. As we planned our research strategy to inves-
tigate accounts of corset-induced disease, Kutsche argued that we needed to
ask a series of questions. Could the corset possibly have caused a particular
disease? Is there any evidence that it caused that disease? Is that evidence
convincing?[4]

Both the normal anatomy of the body and its physiology need to be con-
sidered. The position of the corset indicates that it might affect the lungs,
heart, and upper abdominal organs, such as the liver and stomach. Could
anatomic deformities in these areas have occurred as a result of corsetry? For
example, did the ribs contract under pressure from a tight corset? Did the
position of the internal organs change? Whenever possible, we compared
historical allegations and studies with present-day evidence. For example,
some people today wear corsets, either for personal reasons or to replicate a
historical style. x-rays of the tight-lacer Catherine Jung indicate clearly that

Illustration of a woman's skeleton, uncorseted and corseted, from Witkowsky, *Tetoniana*, 1898, after von Soemmering, 1793.

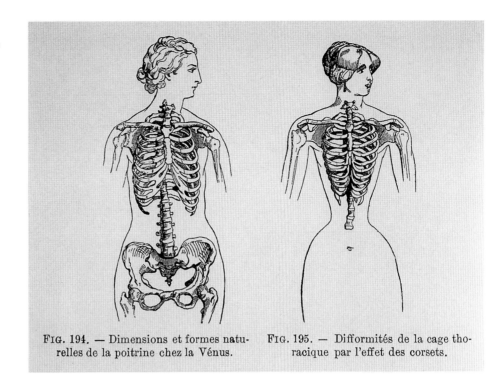

FIG. 194. — Dimensions et formes natu-
relles de la poitrine chez la Vénus.

FIG. 195. — Difformités de la cage tho-
racique par l'effet des corsets.

a tight corset does indeed push the ribs significantly in and up, altering the position of internal organs. Her x-rays are also virtually identical with those illustrated by Dr. Dickenson in his 1910 paper "Toleration of the Corset."[5]

If anatomical deformities are present, it is still necessary to determine both the degree of deviation from normal anatomy and the extent of physiological aberration. For example, once we determine that the lungs are compressed, we still need to know how much pulmonary function is impaired. What is the symptomatology, and how does it compare with that proposed by doctors and dress reformers of the past? According to *The Lancet* of 1868, "Tight-lacing seriously limits, indeed almost annihilates, the respiratory movements of the diaphragm."[6] This might seem to overstate the case, but hard evidence proves that this aspect of the medical critique of corsetry was not completely mistaken.

For her doctoral dissertation, "Historical Medical Perspectives of Corseting and Two Physiological Studies With Reenactors," Colleen Ruby Gau, a former registered nurse, conducted physiologic experiments in 1998 with volunteers who wore reproductions of nineteenth-century corsets. Gau's subjects wore 1870s-style corsets laced three inches less than their natural waist measurements. Modern technology revealed that they did have diminished lung capacity, losing "an average of 9% of their tidal volume as measured by spirometer, with the range from 2% to 29%." Torso pressure was evident, and all of the subjects felt some degree of shortness of breath, although this

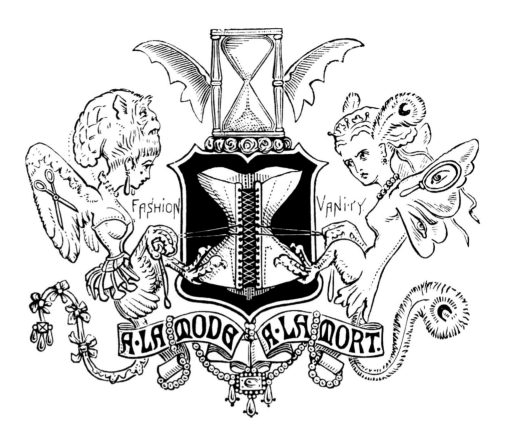

was relieved easily with rest and they were able to fulfill their activities as reenactors.[7]

Gau and others have demonstrated that total lung capacity is reduced by wearing even a moderately laced corset or chest binding. Victorian physicians were correct about that. The movement of the diaphragm (the most important muscle for respiration) is definitely impeded by tight clothing, thus reducing its effectiveness, resulting in reduced inspiration of breath and dyspnea (shortness of breath).[8] Corseted women must rely on the accessory respiratory muscles, resulting in shallow upper-diaphragmatic (or costal) breathing. This is not, per se, a life-threatening condition, since pregnant women and obese people also breathe from the upper diaphragm. However, it was so conspicuous among Victorian women that some nineteenth-century physicians felt it necessary to prove that costal breathing was not an intrinsic aspect of female physiology.[9]

People who wear corsets do get out of breath easily – a fact confirmed by contemporary tight-lacers and modern studies.[10] Reports of corseted women fainting are likely to have been accurate. Fainting would have been especially likely to occur during physical activity, such as dancing at a ball. The cultural significance of fainting is interesting: from a contemporary feminist perspective, corset-induced fainting seems to have reinforced the image of female weakness and disability. To the extent that "swooning" is perceived

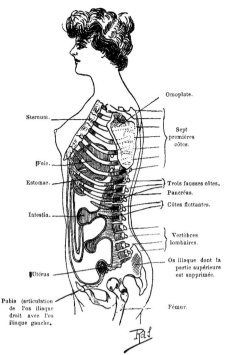

Fig. 134. — Coupe antéro-postérieure d'un tronc féminin normal.

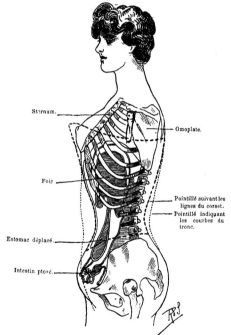

Fig. 135. — Comment le corset cambré déforme le corps.

Illustrations from Dr. O'Followell, *Le Corset*, 1908.

as related both to orgasm and to death, fainting also seems to support a romantic and morbid ideal of femininity. According to modern corset enthusiasts, the famous tight-lacer Mrs. Ethel Granger was filmed dramatically fainting, a scenario which supports a sadomasochistic interpretation of the phenomenon.[11]

There is undoubtedly a sexual subtext both to fainting as a phenomenon and to accounts of gentlemen ready to cut a woman's stay-laces. Nevertheless, I am reluctant to interpret the fainting of a corseted Victorian woman primarily as the eroticized enactment of feminine "death." It is true, however, that the heaving bosom that was regarded as sexually alluring was, in fact, a visible sign of laborious breathing and probably of insufficient oxygen. More significantly, because corsets interfere with respiration, doctors warned that women were "forced to give up everything that [was] worthy of the name of exercise."[12] Of course, some Victorian women did exercise, but it is undeniable that corsetry was a disincentive to do so.

Reduced lung capacity and abnormal breathing patterns could have aggravated other respiratory conditions, such as "consumption," which were common in the past. However, it is important to realize that many diseases were routinely ascribed to the ill effects of women's clothing. The evidence to disprove hypotheses about the corset's alleged role in causing specific diseases came in only gradually. The tubercule bacillus, for example, was discovered only in 1882. Before that, some doctors argued that the corset caused turberculosis in women by creating friction between the lung and ribs. Why men also got tuberculosis was left unclear. It is true that the friction of the corset against the skin can cause abrasions, although there is no evidence to suggest that this could possibly lead to breast cancer, as some nineteenth-century physicians speculated. Modern tight-lacers do complain of bruising and skin irritation.

Corsets did not cause scoliosis (the lateral curvature of the spine). Indeed, if anything, corsets probably helped the condition. It is not surprising, however, that some doctors thought corsets were to blame, because scoliosis was (and still is) six to eight times commoner in women than men, and usually has its onset in early adolescence. Today, persons suffering from curvature of the spine are still put into medical corsets as part of the treatment for the disease, as they were in the past.

In the short run, corsets help support the back and can ease back pain. However, when worn for extended periods, they do weaken the back and abdominal muscles, resulting in muscle atrophy, lower-back pain, and an increased reliance on the corset. Women who wear corsets for years cannot stop wearing them without suffering discomfort. As the *Lancet* noted in the 1880s, "A tight-laced pair of stays acts precisely as a splint to the trunk, and prevents or greatly impedes the action of the chief back muscles, which therefore become weakened. The unfortunate wearer feels her spine weaken, thinks

Fig. 185. — Corset orthopédique de Chemin

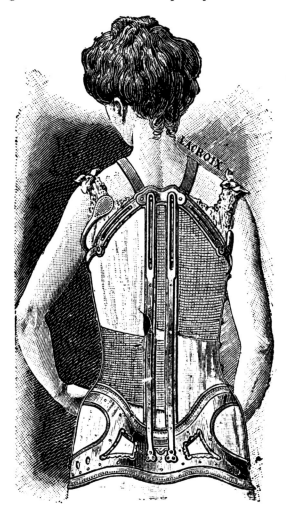

she wants more support, so laces herself still tighter; she no doubt gets some support this way, but at what a terrible cost!"[13] Although the muscles can to some extent be rehabilitated, this requires expert knowledge and sustained effort. Like some Victorian physicians, Gau recommends that regular corset wearers should maintain a routine of trunk strengthening exercises, performed without a corset, in order to prevent muscle atrophy.[14]

Corsets could and probably did cause permanent rib deformations, at least if the individual began wearing corsets in childhood, when the ribs are still extremely malleable. According to Dr. Kutsche, "Compression could cause permanent alterations in the bony contour of the ribs, especially if corsetry began at or before adolescence. The extent would depend on the extent of tight-lacing."[15] It was, of course, standard practice throughout the eighteenth and nineteenth centuries for girls to begin corseting at or before adolescence – a practice which Summers dramatically describes as "corporeal bonsai."[16] However, permanent rib compression may _____ ion during the eighteenth century, _____ en were put into miniature versions _____ the nineteenth century, children's stays were usually designed to follow the shape of juvenile bodies.

Contemporary empirical evidence indicates that if an *adult* begins wearing corsets, the ribs move in only temporarily. When the individual takes the corset off, the ribs expand again, just as the fat does. Whether or not corsets were worn continuously would, probably, be another factor in determining whether the ribs were permanently or only temporarily moved. While fashionable women of the eighteenth century did sometimes wear lightly boned corsets at night, this practice became much less common in the nineteenth century, when only fanatical tight-lacers wore corsets to bed.

If the compressed ribs fractured and punctured the lungs or liver, this would, obviously, be extremely serious, especially in an era before antibiotics. Although I have not seen any medical reports recounting this scenario without external trauma (that is, caused by the tightness of the corset alone), it is not inconceivable that the pressure of a corset tightened to a very extreme degree could fracture one or more ribs. It is also possible that stories of fractured ribs have been confused or conflated with injuries caused by broken corset

bones – the whalebone, steel, or other rigid inserts that provided stiffening for the corset itself. Stay bones were certainly prone to breakage, and the sharp end of a broken stay bone could have caused damage ranging from a cut to a puncture of the internal organs. Indeed, corset bones or steels must have snapped fairly frequently, since corset advertisements often claimed that their particular brand was guaranteed not to break or rust. Just in case, extra bones or steels were often included in the corset box. Corset shields, which were sewn into the corset at stress points, such as the hips or abdomen, were also widely advertised.

Rib deformities have a variety of causes, and cannot simply be attributed to corsetry. In 1984 I heard that there were a number of skeletons with rib deformities in the collection of the Smithsonian Institution. Claudia Kidwell, Curator of Costume at the National Museum of American History, and I immediately went to see the skeletons. We were told by a forensic anthropologist at the Smithsonian that these deformities (slightly bent ribs and calcium deposits on the bone) had been caused by 1880s-style corsets. However, when I asked the estimated birthdates of the women whose skeletons these were, it turned out that they had been born around 1900, and would thus have been very unlikely to have worn boned corsets (they probably did wear elasticized girdles). The theory that the deformities were caused by boned corsets thus seems rather fanciful. Not only had no one checked the dates, no one had done any research into male skeletons to see if they, too, had rib deformities. Moreover, other possible causes of rib deformities had been ignored, including rickets, which was endemic during the nineteenth century and remained thereafter a serious medical problem of the poor and malnourished, and which often caused a narrow chest with deformed ribs.

A widely believed myth holds that at least a few ultra-fashionable Victorians had their lower ribs removed in order to facilitate lacing their waists to a smaller size. There is no evidence at all that this practice ever existed in reality. After years of research, neither Lynn Kutsche nor I found any nineteenth-century medical article about this procedure. Neither did Colleen Gau, although she notes that rib removal was "mentioned in lay press articles."[17] Historians sometimes claim that rib removal occurred, but without providing evidence, or they hedge their bets by mentioning the "rumor" that certain women had this operation.[18] Yet there is a great deal of circumstantial evidence that such an operation could not have been performed in the nineteenth century without the patient being at serious risk of dying. Chest surgery was an extremely high-risk procedure. Anesthesia was unavailable until the the middle of the century, and for some time thereafter it was medically unsophisticated and risky. Antisepsis was not widely accepted until the 1880s, and there were no antibiotics until the discovery of penicillin in 1928. It would have been very difficult for a woman to find a trained surgeon

FACING PAGE Orthopedic corsets, from Dr. O'Followell, *Le Corset*, 1908.

willing to undertake such a hazardous operation for cosmetic purposes. Histories of plastic surgery do not mention rib removal.[19]

Rumors of movie stars having their lower ribs removed still circulate. It would now theoretically be possible to perform such an operation, and someone somewhere may have done it. "But there's never been anything published about it; no one has owned up to performing such a procedure, much less to having had one," says Dr. John E. Sherman of Cornell University's medical school. "To risk your life – your ribs are right there up against your lung tissue – for what would be a relatively minor change in aesthetics would be crazy."[20]

Why does this myth continue to flourish? It may be based in part on the fact that the lower "floating" ribs are often rudimentary. The existence of skeletons with rudimentary lower ribs (known, for example, through autopsies, medical anatomy classes, or mounted specimens) might have seemed to lend some credibility to stories of surgically removed ribs. There also exist other rib variations that occur commonly, but are not caused by corsets. Most significantly, tight-laced women often look as though something surgical must have been done to them to create such an extreme figure. People often ask Catherine Jung if she has had her ribs removed, and her husband always replies that "It isn't necessary."[21] By wearing a tight corset day and night for ten years, she has reduced her waist to about seventeen inches. When she takes her corset off, however, her ribs expand again, as does her flesh. The persistent rumour that the singer Cher has had ribs removed may have originated because she is widely thought to have had much other plastic surgery, and because she maintains a very small waist, apparently through vigorous exercise.

Surgical fat removal, on the other hand, has a long history. Abdominal aprononectomy – the removal of an "apron" of fat – was developed by the American doctor Howard A. Kelly. "On May 15, 1899 he removed the 'pendulous abdomen' weighing 14.9 pounds from a 285-pound woman." Three years earlier, another doctor had removed 25 pounds of fat from the same woman's breasts.[22]

"The corset liver is well-known in the dissecting room," declared Mrs. Mary Wood-Allen, M.D., in 1899. Sometimes it is almost "cut in two."[23] Gwen Raverat also recalled that as a girl in the 1890s her aunt "used to tell us a dreadful moral tale about a lady who laced herself so hard that she cut her liver *right in half*, and died in consequence."[24] But the many stories of "tight-lacing liver" seem to be based on a misunderstanding of anatomy. Autopsies frequently reveal enlarged or distorted livers. There also exists a normal anatomical variant of the liver which is characterized by an accessory lobe. Doctors who were predisposed to find evidence of corset-induced disease may well have blamed such abnormalities on tight-lacing, although the cause

might have been hepatitis or cirrhosis, or even a normal anatomical variation that looked peculiar.[25]

The liver occupied an important place in popular discourse about the corset. For example, when the sculptor Hiram Powers was observed watching a fashionably dressed woman, his friend said to him, "What an elegant figure she has, hasn't she?" "Well," said Powers, "I was wondering where she put her liver."[26] Tight corsets certainly did push the liver in and down, elongating it and pressing the ribs against it. According to Kutsche, "This was well demonstrated by the dissertations of Fricke (1892), Hansen (1893), and Hackman (1894) from the Kiel University Medical School, and was also described by Karl Rokitansky, one of Vienna's leading physicians."[27] It is possible that under certain conditions, this might impair the functioning of the liver — and yet a person can lose much of his or her liver function without causing health problems. As Dr. Kutsche says, "There can be marked anatomic deformity without any alteration in physiologic function."[28] It has been speculated that pressure on the liver and upper gastrointestinal tract might have contributed to "chlorosis, an unexplained (hypochromatic iron deficiency) anemia that afflicted many young women in the late 1800s." On the other hand, it may be that better nutrition today is responsible for the disappearance of the disease, or that the condition still exists but is now known under a different name.[29]

Victorian physicians sometimes suggested that corsetry interfered with the gallbladder, causing gallstones, especially in middle-aged females. But as Dr. Kutsche points out, even today, the classic sufferer of gallbladder disease is "fat, forty, and female." Nineteenth-century medical accounts not only mention dyspepsia but also speculate that constriction of the stomach might lead to ulcers and cancer. There is no evidence for this. It is true that by constricting the stomach and the intestines, the corset could and probably often did cause digestive problems, such as constipation. Contemporary corset enthusiasts tend to report that it is uncomfortable to eat too much at a time. Corsets can also produce increased pressure on the bladder, and may cause problems controlling urination.

Nineteenth-century doctors often claimed that the corset caused "congestion" of the blood, with resulting diseases in the afflicted organs.[30] For example, according to Kutsche, congestion in blood flow to and from the brain was said to cause hysteria and mental defects; congestion of blood to the heart and lungs was said to cause cardiac dysfunction and lung disease; congestion below the diaphragm was said to cause diseases of the liver and female organs, and so on. Respected gynecologists believed that "errors in dress causing obstruction in the venous circulation of the pelvis will be found to be frequent causes of congestive hypertrophy of the uterus."[31] These hypotheses were largely conjectural, however; modern medicine does not recognize any such condition as "congestion of the blood."

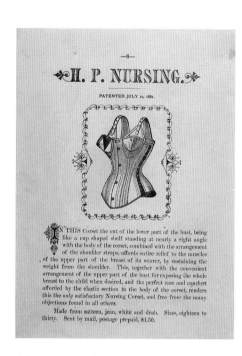

Advertisement for HP Nursing Corset,
c. 1880.

Damage to the reproductive system was a real danger, however. Many women in the nineteenth century suffered from a prolapsed uterus, in part due to multiple pregnancies. By exerting downward pressure on the abdomen, corsets could and probably did contribute to aggravating this serious medical condition. Treatment for prolapsed uterus was the utilization of a pessary attachment, a mechanical device resembling a rubber plug, which was inserted into the vagina to hold the uterus inside the body. Ironically, patents for pessaries often depict them attached to the corset, with phyicians often recommending a health corset or abdominal support. Physicians and dress reformers also argued that corsets deformed women's breasts, especially their nipples, making it difficult or impossible to nurse.

Women who wore tight corsets during and after pregnancy, as most did, were engaging in potentially dangerous behavior. There did exist special pregnancy corsets that expanded as the fetus grew. However, many pregnancy corsets closely resembled ordinary fashionable models, being heavily boned and with rigid metal busks. Worn even moderately tightly, these corsets would have inhibited the expansion of the uterus. In so doing, they could have contributed to miscarriages or difficulties in labor. It is certainly possible that some women might have felt ambivalent or embarrassed about pregnancy, which could have led them to try to conceal the condition under tight corsets. It is also possible that some women deliberately used tight-lacing in an attempt to abort the fetus.

Tight corsets were accused of causing birth defects and weak, unhealthy children. It is difficult to interpret these historical accounts, however, since physical and moral injuries are often conflated. The mother becomes a scapegoat for anything bad that happens to her child. According to a writer for *The Rational Dress Society's Gazette* in 1889: "In many cases, the cripple, the idiot, the inebriate, the profligate, would find that they owed their sufferings and their sorrows to the folly of their mothers. Tight-laced women bequeath to their children an imperfect vitality, which often leads to vicious ways."[32] A French writer in 1862 also recalled knowing "a very vain woman who delivered only crippled infants because she crippled them in her womb to keep a slim waist."[33]

Attacks on the corset were often linked to ideological campaigns in favor of motherhood, reflecting fears that if women broke away from their domestic sphere, the entire social order would be threatened. The German literature on dress reform is especially notable for its antifeminist bias.[34] But the relatively progressive French Ligue des Mères de Famille in 1909 also attacked the corset as "the assassin of the human race."[35] In France, an extremely low birthrate led to widespread fears about depopulation, but motherhood was also extolled in Britain and America.

The prejudice of doctors against corsets does not necessarily mean that they were wrong to worry about corset-induced reproductive problems. Historical accounts of corset-induced gynecological and reproductive diseases

should be treated with caution, however, because they may reflect the doctors' anxiety about female sexuality, together with a lack of knowledge about the "mysterious" uterus. A "disease" such as hysteria that involved aspects of both the reproductive and nervous systems should arouse special suspicions. Indeed, anything having to do with the uterus, the breasts, maternity, or sexuality must be examined critically and not simply taken at face value.

The anticorset literature was similar in tone and line of argument to diatribes on the terrible effects of masturbation and drinking. Corsets "are a slow and fashionable poison," warned an American physician in 1827. "But strange, unaccountable infatuation! Corsets are established in fashion, and the mother and the daughter alike, are strenuous advocates of their use. *Because they are fashionable*, you wear them." Yet wearing corsets is "a crime," like "self-murder." Corsets "lay their victims in the grave . . . loaded with guilt."[36]

An analysis of Orson S. Fowler's book *Intemperance and Tight-Lacing* (c. 1846) shows how "medicine" and "science" were marshaled against the use of the corset. According to Fowler, by squeezing the liver, the corset renders the blood "impure." The "corrupt" and "boiling" blood then "diseases the brain," which causes "insanity." The nervous system is disordered and the brain inflamed, "which necessarily excites the organs of Amativeness, situated in the lowest point of the brain." At the same time, compression produces retention of the blood "in the bowels . . . and thereby inflames all the organs of the abdomen, which thereby excites amative desires." In short, "tight-lacing . . . necessarily kindles impure feelings . . . at the same time that it renders their possessors more weak-minded, so as the more easily to be led into temptation. . . . Are women so weak or crazy? Tight-lacing has already been shown to produce partial insanity, and also to excite impure desires." Fowler appealed to women to reject both the sexualizing corset and the "fashionable libertine." "Unloose your corset . . . and remember that you are born, not to court and please, not to be courted and pleased by, fashionable rowdies, but to become wives and mothers."[37] (Presumably, the children could be produced without unduly arousing anyone's organs of Amativeness.)

An American who was famous as a phrenologist, Fowler attacked tight-lacers as "suicides and infanticides." Their real crime, however, was their indulgence in "impure desires," their more or less deliberate excitement of "the organs of Amativeness." Phrenological theories, based on the controversial ideas of Franz Joseph Gall, sought to explain temperamental, behavioral, and even moral characteristics with reference to areas of the brain externally visible as "bumps" on the skull. This theory had a wide public following during the nineteenth century, and Fowler's work was frequently reprinted. But it is discouraging that modern historians should still cite Fowler as a reputable medical authority, when by today's standards he was clearly far out on the lunatic fringe of pseudoscience.

Even the orthodox medical literature of the past is often unreliable. Indeed, it is rather surprising that historians have been so reluctant to question accounts of corset-induced disease without considering the state of medical knowledge, clinical medicine, and the manifold biases of many physicians of the time. Historians who would never accept medical accounts of the dangers of masturbation (causes blindness and insanity) or female education (sucks the blood from the uterus to the brain with appalling results) become perversely credulous whenever fashion is the subject of medical anathema. Yet nineteenth-century doctors (and dress reformers) marshaled the forces of science and medicine against a variety of sins. The American physician Dr. Coleman, for example, warned in 1899:

> Women beware. You are on the brink of destruction: You have hitherto been engaged in crushing your waists; now you are attempting to cultivate your mind: You have been merely dancing all night in the foul air of the ball-room; now you are beginning to spend all your mornings in study. You have been incessantly stimulating your emotions with concerts . . . and French novels; now you are exerting your understanding to learn Greek. . . . Beware!! science pronounces that the woman who studies is lost.[38]

Not all doctors were so obviously biased. According to Kutsche, "A review of medical textbooks of the later nineteenth century shows a more rational, scientific approach."[39] In addition, a tentative alliance among dress reformers, feminists, and physicians resulted in texts such as *Dress Reform: A Series of Lectures delivered in Boston on Dress as it affects the Health of Women* (1874). Much useful information about physiology was conveyed to the public in these lectures, mixed, however, with some rather dubious evidence. In the first lecture, for example, Mary J. Safford-Blake, M.D. recounted a visit to Vienna, where she had observed laboring women, whose "broad peasant waist[s] [had] never been crowded into corsets." When a building collapsed, killing several of these workers, she expected that she would "have an opportunity of seeing the internal organs of women normally adjusted." To her "utter astonishment," however, she discovered that one woman's liver "had been completely cut in two, and was only held together by a calloused bit of tissue." She also found overlapped ribs, and one instance of a rib piercing the liver; most of the women's livers were displaced, the spleen either enlarged or atrophied, and the uterus, "in every instance more or less removed from a normal position." Although she admitted that they wore no corsets, she argued that their heavy skirts and petticoats weighed on "their hips, with each band snugly drawn about the waist and tied with strings."[40] The effect, she implied, was equivalent to a corset. Today we would be inclined to ascribe the pathologies observed in these women to prolonged heavy labor, exposure to industrial accidents, dietary deficiencies, and other effects of privation.

Reports of death from tight-lacing occurred periodically in the medical literature. *The Lancet*, for example, in 1869 noted the following:

> We record for the benefit of the ladies of England the melancholy death of a young lady in New York from tight lacing. Miss Jones, the lady in question, died suddenly, and, it is alleged, from apoplexy of the lungs in consequence of unusual tight corset lacing. There was an actual post-mortem examination and inquest, ending in a verdict in accordance with the above statements. Ladies will, of course, be in the fashion. We only show them that this occasionally involves going out of the world.[41]

This is not an objective account, and no actual autopsy data is provided. The diagnosis of "apoplexy of the lungs" is also unclear. According to Kutsche, "Apoplexy or stroke was described in the seventeenth century as a hemorrhage of the cerebral vessels," but the word is no longer used in modern medicine except to describe "an acute hemorrhagic infarction of a pituitary adenoma." Presumably a diagnosis of "apoplexy of the lungs" was intended to refer to a pulmonary hemorrhage, which, however, as Kutsche notes, "could be caused by many diseases, especially 'consumption.' The young woman's death was almost certainly not related to her corset."[42]

Another article, from 1887, cited "an inquest on the body of an elderly female [which] revealed the fact that death was due to the direct consequences of having the stays too tightly laced." Although it is noted that "tight-lacing forces together the two elastic ribs and narrows the space within the thorax," and there is a great deal of criticism of women as "worshipper[s] of a false ideal," no explicit autopsy information is given, not even the age of the deceased.[43] Again, we do not know why this woman died. As Dr. Kutsche points out, however, "There are changes in the lungs and ribs with age. In infants and young children, the ribs are nearly horizontal. After the second year these become more oblique, and this elongation in the appearance of the chest progresses with age, with the ribs becoming more oblique and the chest appearing narrower. The rib cage also becomes more rigid and loses its elasticity. Degeneration of the intervertebral disks, which is exaggerated by osteoporosis, common in elderly women, decreases chest capacity and narrows the space within the thorax."[44] But, as is so often the case, the doctor seems to have decided in advance on a diagnosis of death by tight-lacing.

With all the evidence that corsets could in fact be uncomfortable and unhealthy, it seems excessive for physicians to have argued that they also killed people. However, with few coherent and valid scientific theories to explain what caused most diseases, it was natural for nineteenth-century doctors to look for what seemed like plausible causes of the diseases they encountered. One can sympathize to some extent with a doctor who reasoned, "This young woman was wearing a tight corset, and she died from a blood clot

in her lungs; therefore the clot was caused by the corset," or "many women get breast cancer or uterine cancer, and almost all women wear corsets, therefore corsets cause these cancers." Today, of course, many women still get cancer, but we no longer blame their corsets (though a recent book proposed that wearing bras was a contributory cause of breast cancer).[45]

Thanks to feminism, we are much more aware of the ways women have been blamed for their own victimization. However, some feminist historians have suggested on the contrary that doctors were to blame for the continuation of corsetry because they benefited financially from women's ill health and, therefore, did not energetically oppose corsetry.[46] There is not much evidence to support this position. In fact, the majority of doctors were more or less opposed to corsetry, although some expressed doubt that the corset caused every evil from cancer downward, while others believed that some kind of support was necessary, at least for the stout or buxom, and still others had given up hope that women would ever abandon corsetry and aimed only to mitigate its effects.

Dr. Frederick Treves, writing in 1882, was strongly anticorset: "Even a moderate or slight amount of tight-lacing will deform the body."[47] Dr. William Flower, author of *Fashion in Deformity* (1881), a Darwinian analysis of fashion, argued that corsetry was more detrimental to health than either skull deformation or footbinding. "It was reserved for medieval civilized Europe to have invented the system of squeezing together, rendering immobile, and actually deforming, the most important part of the human frame."[48] William Wilberforce Smith, M.D. not only published in British medical journals but also wrote about the medical consequences of corsetry for *Aglaia*, the journal of the Healthy and Artistic Dress Society.[49] Dr. John Harvey Kellogg of Michigan was also an advocate of healthful clothing. Charles Roux, author of *Contre le corset* (1855), argued flatly that "the use of the corset is dangerous. I say the use. . . . Here the abuse can not be separated from the use; hygiene proscribes the one and the other."[50]

Other doctors believed that the real health issue was tight-lacing, not corsetry per se. Dr. Sauveur Henri-Victor Bouvier, for example, argued in 1853 that the support of the bust and spine and the control of obesity, together with "woman's social destination," necessitated the use of a corset.[51] Dr. Ludovic O'Followell wrote a heavily illustrated two-volume history of the corset (1905, 1908), which described health problems and deformations caused by corsets, but insisted that the garment should be improved, not abolished.[52] Indeed, Dr. O'Followell wrote a regular column for the deluxe corsetiers' magazine, *Les Dessous Elégants*.

Some doctors responded to the controversy by inventing "improved," "hygienic" versions of the corset. However, many so-called health corsets were based on bogus "medical" theories. Dr. Gustav Jaeger made a fortune selling woolen garments, including wool corsets, which had, he claimed, "all

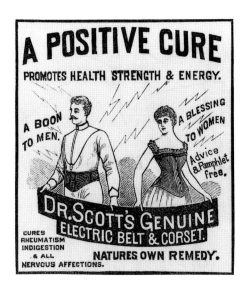

Advertisement for Dr. Scott's Electric Belt and Corset.

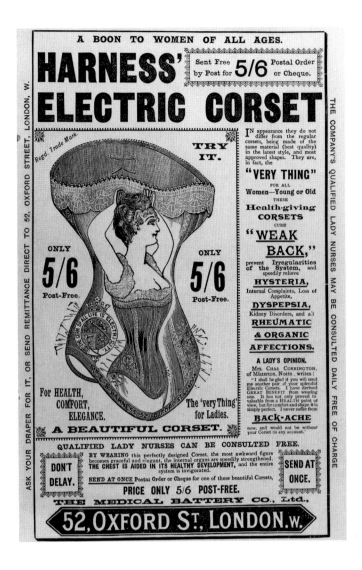

Advertisement for the Harness Electric Corset.

the advantages of girded loins without the disadvantages." (Jaeger thought that cotton clothing emitted noxious vegetable vapors and he dismissed silk as the "excreta of worms.")[53] Another supposedly "healthy" garment was Dr. Scott's "Electric Corset," which was endorsed by Dr. William A. Hammond, the Surgeon General of the United States. Fortunately, this corset was not actually electrified, although electricity had been sent through the metal stays during the production process. There were other electric items as well, such as men's "belts" and hairbrushes. There still exist so-called "magnetic" belts, which claim to cure various complaints – evidence that pseudoscience is alive and well today.

Some health corsets were at least more comfortable than ordinary corsets, if only because they used flexible cording instead of whalebone or metal stays. An example of the Perfect Corded corset of around 1880, from the collection of the Museum at the Fashion Institute of Technology measures a comfortable 35–32–36 inches. Except for the metal busk front and

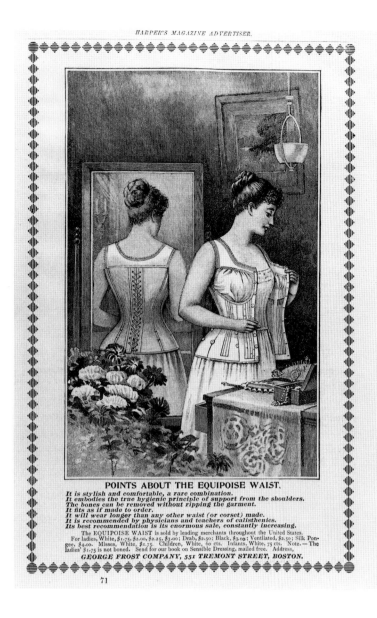

POINTS ABOUT THE EQUIPOISE WAIST.

It is stylish and comfortable, a rare combination.
It embodies the true hygienic principle of support from the shoulders.
The bones can be removed without ripping the garment.
It fits as if made to order.
It will wear longer than any other waist (or corset) made.
It is recommended by physicians and teachers of calisthenics.
Its best recommendation is its enormous sale, constantly increasing.

The EQUIPOISE WAIST is sold by leading merchants throughout the United States.
For ladies, White, $1.75, $2.00, $2.25, $3.00; Drab, $2.50; Black, $3.00; Ventilated, $2.50; Silk Pongee, $4.00. Misses, White, $1.75. Children, White, 60 cts. Infants, White, 75 cts. Note.— The ladies' $1.75 is not boned. Send for our book on Sensible Dressing, mailed free. Address,

GEORGE FROST COMPANY, 551 TREMONT STREET, BOSTON.

71

Advertisement for the Equipoise Waist.

center back, and whalebone to support the breasts, the rest of the corset utilized corded cotton sateen. Cording was also inexpensive, which was probably attractive to manufacturers looking for cheap substitutes for whalebone. Many brands, including Dr. Strong's Tricora corset, were stiffened with coralene, manufactured from ixtle, a Mexican plant resembling aloe. The leaves contain strong fibers which can be wound with thread as a substitute for whalebone. A trade card for Doctor and Madame Strong's health corsets claimed that they "reliev[ed] the delicate and vital organs of all injurious pressure."

"Why were so many physicians concerned with the corset and 'tight-lacing'?"asks Kutsche. "And why does so much of what they wrote seem so biased and unscientific?"[54] She continues:

During the nineteenth century, when the corset controversy was at its height, physicians were a diverse, heterogeneous, and unregulated group. They lacked effective governing bodies and standards of education and clinical training, and many medical schools were seriously deficient. (The American Medical Association fought to impose uniform standards of training, but was unsuccessful in doing so until the end of the nineteenth century.) Outside the mainstream of allopathic medicine, alternative therapeutic regimes proliferated; these included homeopathy, phrenology, hydropathy, the Tomasonians, the Grahamites, chiropathics, and adventists. Each of these groups had its own theories of the causes of disease, and their own treatments. Many alternative practitioners attracted substantial numbers of patients, in part because of mainstream medicine's inability to offer effective treatments and cures. Scientific medical knowledge advanced markedly during the nineteenth century, as did diagnostic technology, but therapeutics lagged far behind; physicians knew more than before, but could cure no more effectively. With the causes of most diseases and deformities largely unknown, and with traditional medicine having little to offer in terms of treatment, it is not surprising that people turned to other types of medicine.

But why would physicians want to get involved in the corset controversy? In the nineteenth century, the medical profession (dominated by

men, and highly patriarchal in its attitudes) came to be viewed as respon-
sible for the maintenence of health, not just the treatment of disease.
Personal and public hygiene came within the physician's purview. For
women, personal hygiene included issues of dress and practices undertaken
to enhance beauty, as well as sexuality, motherhood, and "female com-
plaints." The concept of "health" broadened to include moral, spiritual,
psychological, and sexual health, as well as public health and the welfare
of future generations. As communications media of all kinds, including
professional and popular journals, proliferated during the course of the
century, doctors began to publish their views on these matters. Many
offered, or were asked to provide, advice on controversial topics such as
corsets and "tight-lacing." Practitioners from alternative groups added to
this medical literature, including the literature on the corset, resulting in
a voluminous, diverse, and contradictory body of published medical
opinion.[55]

But physicians tended to share certain assumptions about sex differences
which influenced their attitudes toward women's bodies and clothes. Over
the course of the late eighteenth and nineteenth centuries, physicians and
scientists had turned away from the Galenic tradition that women were
simply lesser versions of men, replacing it with a "biomedical model of male
and female" as "opposite" and "complementary." According to this paradigm,
the uterus was the single most important part of a woman's body, affecting
all aspects of her anatomical, physiological, and social destiny. Illustrations of
female skeletons, for example, emphasized "how much smaller of cranium
and wider of pelvis" they were in comparison with male skeletons, thus
"proving" that each sex was "naturally" suited to fulfill certain social roles.
In their role as public hygienists, members of the medical profession stressed
their "responsibility for the human sources of national fertility." By charac-
terizing "women as vessels of reproduction," physicians contributed to a dis-
course that interpreted the individual body as a sign of the health (or illness)
of the social body.[56]

Concerns about depopulation were especially intense in France which, as
we have seen, had an unusually low birthrate and low marital fertility,
which triggered widespread anxiety about national decline. Depopulation was
also popularly associated with degeneration, as physicians worried about the
strength and vitality of those children who were born.[57] In the search for a
scapegoat, the image of the tight-laced mother was an easy target. Like the
masturbator, the woman who wore a tight corset injured not only herself
but her children (if she had any) and her nation. As Charles Dubois wrote
in 1857:

If in twenty years we are engaged in a serious struggle that we must sustain
for a while, army recruitment in France will become more and more dif-

ficult, asuming that the corset continues its ravages. . . . To fight and win, to attain glory, it is not enough for a soldier to have courage, he also needs a body and strong limbs; is it not the same for a nation?[58]

It is certainly not true, as many people believe, that corsets fell out of favor after 1900 because women were finally convinced by the medical arguments against corsetry. However, the design of corsets did undergo a change at the beginning of the twentieth century. A French corsetière with a degree in medicine, Madame Inez Gâches-Sarraute, has usually received credit for designing the new "hygienic" straight-front corset, although there were probably several other people working on the same type of modification. Like many doctors, she believed that busks which curved inward at the waist were unhealthy, because inward pressure "forced the organs downward." By contrast, her straight-busk corset would support the abdomen and "add to the effects of nature." Furthermore, her corset, being lower on top, would not "suppress the bust."[59]

The straight-front corset seems to have been adopted quite rapidly. According to *The Lady's Magazine* in 1901, "There is in Paris a new corset, which is the rage. . . . The new straightfronted corset . . . is likely to create a new style of waist and figure entirely, and it is in every way, a more hygienic and healthy garment than any of the old-fashioned stays . . . The waist is not nearly so small as formerly, a much more important point in the figure now being the long, straight-sloping line in the front. The new cut of corset, of course, drops the bust, and to attain that curved look so essential to a good figure it is necessary for thin women to have a ruching or even two ruchings of ribbon put inside the new, lowbusted corset."[60]

While this new style of corset might have involved some attempt to create a better and more healthy design, it did not succeed in doing so in practice. When laced even moderately tightly, which it often was, the new style of corset produced a figure known as the S-bend, with the abdomen pushed back, the breasts thrown forward, and the back arched. The fashionable waist was still small, and the modern woman was no longer supposed to have a stomach. Indeed, another name for the straight-front corset was the *sans ventre* corset. Being cut lower on top, the new corset no longer functioned as well to support the breasts, and some women began to wear bust-bodices along with their corsets – a trend which eventually lead to the development of the modern brassiere.

As Kutsche emphasizes, the new corset was no more "hygienic" than it had ever been:

As Dickinson demonstrated as early as 1911,[61] the straight-front corset threw the shoulders forward, the hips and buttocks back, and caused downward and backward pressure on the pelvis. The S-bend was achieved through increased lordosis (anterior curvature of the spine); pressure on

Untitled illustration of a straight-front corset, probably for an advertisement, c. 1903. From a scrapbook of corset illustrations and advertisements collected by Sir Basil Liddell Hart, in the Liddell Hart Collection on Costume, Liverpool John Moores University Learning and Information Services, Special Collections.

the pelvic bones distorted the connection between the pelvis and the spine, which would have caused lower-back pain in many cases. The S-bend also caused hyperextension of the knees, resulting in knee and gait abnormalities. The straight-front corset probably caused more uterine and bladder pressure and symptoms than earlier Victorian models had done.[62]

When Colleen Gau compared the "hourglass" corset style of 1865 with the "straight-front" corset of 1900 with respect to their effects on the exercise capacity of ten female reenactors using treadmill testing, she found "the straight-front corset to be more deleterious to the physiologic performance and capacity for exercise than the hourglass style when laced to the same degree." Wearing the supposedly healthier corsets of 1900, Gau's subjects also complained of balance difficulties and increased back pain.[63] After decades, indeed centuries, of medical advice and appeals by dress reformers, women in 1900 had finally obtained . . . a more uncomfortable corset.

4 Fashion and Fetishism
The Votaries of Tight-Lacing

THROUGHOUT THE NINETEENTH CENTURY, popular wisdom held that tight-lacing was foolish, pernicious, and all too common. "There is not one woman in a hundred" who does not suffer from "the wasp-waist mania," argued an American writer. Although physicians had denounced tight-lacing for centuries, they had failed to cure the "disease." Women's addiction to "the corset habit" was a "mystery" that "no man can understand," except by reference to "the proverbial feminine craze for emulating one another and arousing envy by excelling in some extravagance of dress, no matter at what cost."[1] Critics of tight-lacing attacked the practice on both "hygienic" and "aesthetic" grounds: it was dangerously unhealthy, and it was ugly and unnatural.[2] But by characterizing tight-lacing as a mania, a disease, and an addiction, it seems clear that critics perceived the real issue as the supposed immorality and depravity of the practice.

Girls and women who tight-laced were not merely vain and irrational. They were thought to be engaged in an evil habit, akin to masturbation. Their "perverted taste" and "criminal" behavior would necessarily result in "disease and pain."[3] "No young lady acknowledges herself to be laced too tight," warned Mrs. Sigourney. Mothers had to be aware of the symptoms of "hurtful practices" and "habits that shun the light." "Though the sufferer from tight-lacing may not own herself to be uncomfortable," though she may "throw an illusion over those who try to save her . . . and like the Spartan culprit, conceal the destroyer that feeds upon her vitals," the wise mother would know that "the laborious respiration, the constrained movement, perhaps the curved spine, bring different testimony."[4]

How tightly were corsets really laced? Significantly, there was no agreement about the precise definition of "tight-lacing." Women usually denied that they personally tight-laced. It was always someone else, such as an actress or a servant or a foolish young girl, who was accused of being a tight-lacer. This is hardly surprising, since, as we have seen, tight-lacers were frequently compared to suicides and infanticides, torturers and murderers. They were bad women, who solicited the lecherous gaze of "vulgar" men. Specifically, they were bad mothers – at a time in the late nineteenth century when

"A fashionable young lady being 'drawn-in' by a buxom maid, superintended by her mistress," *London Life*, 1929. By permission of The British Library, London.

motherhood was seen as women's sacred duty. As the English fashion writer Mrs. Haweis warned, "The sins of the mothers are . . . visited on the children. . . . a deformed parent may create an idiot child . . . and many obscure horrors may spring from such a seed as a pinched waist."[5] Like "savages," tight-lacers deliberately deformed their God-given bodies until they resembled insects.

There were, however, some people who openly boasted about tight-lacing. From 1867 to 1874, *The Englishwoman's Domestic Magazine* (*EDM*) printed more than 150 letters on corsetry, many of which described tight-lacing to extreme tenuity (wasp waists of 16 inches or less). The letters included firsthand testimony of enforced tight-lacing at fashionable boarding schools, as well as fervent defenses of tight-lacing. The "corset correspondence" published in the magazine was revived occasionally thereafter in other periodicals, and it radically altered the discourse about tight-lacing in two ways. First, in its extreme claims and notoriety, it tended to overwhelm other contemporary discussions of tight-lacing. Secondly, it became retrospectively the primary source of "documentary" material on Victorian tight-lacing, skewing almost all later analyses of the subject.

Size is the first issue. How tightly did women lace? "Women ought to measure from 27 to 29 inches round the waist; but most females do not allow themselves to grow beyond 24; thousands are laced to 21, some to less than 20," declared *The Family Herald* (1848).[6] Although it is impossible to be certain, the evidence indicates that these figures seem plausible, at least for younger women. Yet the *EDM* correspondence focuses on much smaller waist sizes. The circumstances in which tight-lacing occurred also differ significantly. A great many young women probably did lace rather tightly on occasion, such as to attend a party that required clothing that was both formal and fashionable.

But the self-proclaimed "votaries of tight-lacing" emphasized dramatic reductions in waist size through rigorous "disciplinary" practices. "A Lady from Edinburgh," for example, wrote to

Photograph of a tight-lacer, c. 1895. Courtesy of Peter Farrer.

the *EDM* in March 1867 to say that her daughter had been subjected at boarding school to a "merciless system of tight lacing." She and her fellow pupils had been "imprisoned in vices of whalebone drawn tight by the muscular arms of sturdy waiting maids, till the fashionable standard of tenuity was attained." It was "torture," but "all entreaties were in vain," and "the lady principal . . . punished [her] severely for rebelling against the discipline of the school."[7] This was followed by many other letters, such as one from "Nora," who wrote to the *EDM* in May 1867, claiming to have attended

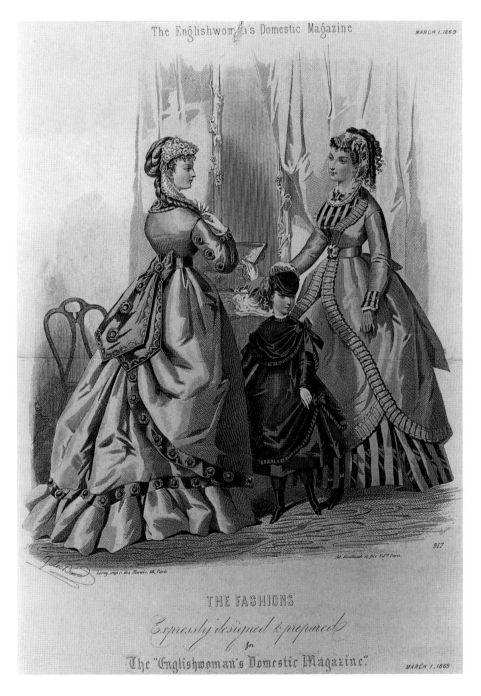

Fashion plate from The *"Englishwoman's Domestic Magazine,"* 1869.

The Englishwoman's Domestic Magazine

MARCH 1.1869

917

Ad. Goubaud et fils EdRs Paris.

Leroy, imp.r. des Marais. 66, Paris

THE FASHIONS

Expressly designed & prepared

for

The "Englishwoman's Domestic Magazine."

MARCH 1.1869

"a fashionable school in London" where "it was the custom for the waists of the pupils to be reduced one inch per month . . . When I left school . . . my waist measured only thirteen inches."[8]

The *EDM* correspondence is fascinating to read, and it has frequently been cited as evidence of horrific tight-lacing during the Victorian era.[9] Correspondents such as "Alfred" expounded on the desirability of girls being "subjected to the strictest discipline of the corset." "Moralist" declared, "If you want a girl to grow up gentle and womanly in her ways and her feelings, lace her tight."[10] This does indeed sound like patriarchal abuse run mad, but there are serious problems with such a naive reading of this material.

To begin with, are these stories true? And are they typical of the behavior and attitudes of the period? Mainstream periodicals as diverse as *The Saturday Review*, *Punch*, and *The Lancet* heaped scorn on the *EDM* letters. The veracity of the letters was denied, while the opinions expressed were derided. Clearly, a nerve had been struck. In an article of 1869 on "The Elasticity of Young Ladies," *Punch* even compared the *EDM* correspondents with the notorious murderess Maria Manning (who killed her

husband).[11] Some dress scholars, such as Doris Langley Moore in 1949, also characterized the *EDM* letters as "spurious" and simply the fantasies of a few "perverts," among whom she included the magazine's editor, Samuel Beeton.[12] This judgment seems to suggest that the letters should be dismissed altogether as evidence about nineteenth-century corsetry. Yet, at the very least, they provide valuable evidence of sexual fantasies about corsetry.

Other scholars, notably the art historian David Kunzle, have gone to the other extreme, arguing that the letters are largely authentic reports of personal experiences, accurately described. But whereas feminists have interpreted the letters as evidence that Victorian women were forced to submit to tight-lacing, either because fashion dictated a small waist or because male fetishists made women wear tight corsets, Kunzle argues that most tight-lacers who wrote to the *EDM* were sexually assertive female "fetishists," who were themselves erotically stimulated by tight corsets.[13] There are many problems with this idea, even apart from the reliability of the source material. For example, although he denies that women who wore tight corsets were masochists, the scenarios described tend to focus on bondage and discipline. It is doubtful, however, whether the reality of tight-lacing (whether fetishist or not) corresponded to the picture presented by the corset correspondents, let alone to Kunzle's edited and sanitized version, which omits or plays down references to "punishment corsets" and "fair flagellants."

Over the course of this chapter, it will become apparent that these letters need to be analyzed primarily as sexual fantasies, although they also reveal the existence of sexual subcultures involving fetishism, sadomasochism, and transvestism.[14] More importantly, it will become evident that fetishistic tight-lacing should not be confused with ordinary fashionable corsetry. Many women today wear high-heeled shoes, for example, but we recognize that there is a difference between ordinary fashionable shoes and the kind of fetish shoes with seven-inch heels worn by the professional dominatrix. Yet it is entirely possible that ordinarily fashionable women also sometimes tight-laced. Indeed, as we shall see, this is quite likely, although the definitions of "tight-lacing," the circumstances under which tight-lacing occurred, and the significance it had may be quite different in the real world than in the literature of Victorian fetishists.

What is fetishism? The term is often used loosely to refer to the objectification of the female body. More precisely, fetishism is a type of variant sexuality involving the use of specific stimuli (such as corsets or high heels) for sexual arousal. There are degrees of fetishism, ranging from a preference for certain stimuli to the necessity for specific stimuli if sexual arousal and performance is to occur. In extreme cases, the fetish actually takes the place of a sex partner. For example, the fetishist might masturbate with a pair of shoes. Some psychiatrists believe that a degree of fetishizing is "the norm for males." Clinical studies also show that a higher level of fetishism frequently overlaps

Thomson's Glove-Fitting Corset, from *The Corset and the Crinoline*, 1868.

with sadomasochism and transvestism. As with all of the sexual "perversions," clinical cases of fetishism overwhelmingly involve males. The only (partial) exception is masochism, which is mainly a male characteristic but which is also found in a small but statistically significant number of women. Even so, by some estimates male masochists outnumber female masochists by a ratio of twenty to one; 99% of sexual fetishists are believed to be men.[15]

The question of female fetishism is important, nevertheless. In their book *Female Fetishism* (1994), Lorraine Gamman and Merja Makinen write: "Representations of women in corsets or high-heeled shoes may look fetishistic to some feminists, but whose is the fetishism under scrutiny, and what degree of fetishism are we talking about?"[16] The authors are attracted to the idea that fetishism is potentially sexually liberating for women, although they also suggest that eating disorders may constitute a type of fetishism. Moreover, despite Gamman and Makinen's characterization of some modern women as "active practitioners of fetishism,"[17] it seems improbable that there were more than a tiny number of Victorian female corset fetishists. On the contrary, the evidence indicates that the vast majority of corset fetishists were (and are) men. Among contemporary tight-lacers, men seem to outnumber women. Women who wear fetish clothing on a regular basis usually do so either because they are sex workers or because their male partners like these clothes. Cathy Jung, for example, says that she wears a tight corset because her husband finds it attractive.[18] With regard to the corset correspondences in Victorian magazines, it seems likely that men were the source of most stories about eroticized tight-lacing, and that most of these stories represented fantasies rather than actual experience. To distinguish among fashion, fetish, and fantasy, it is necessary to explore the specialized literature on tight-lacing.

"What is the smallest size waist known?" asked "Seraphine."[19] The year was 1862 and Samuel Beeton, editor of the *EDM*, only briefly quoted from the letter in which she claimed to have a waist measuring 15¾ inches. Later he actively solicited correspondence on the subject. Meanwhile, in 1863, "Constance" wrote to another fashion magazine, *The Queen*, also founded by Beeton, asking if tight-lacing was becoming fashionable and claiming to have a waist measurement of 16½ inches.[20] The next week, "Fanny" wrote to *The Queen* to say that yes, tight-lacing was fashionable; many women had waists of 16 inches or even less; and that she had personally attended a tight-lacing school outside Paris. Specifics of corset "discipline" and "bondage" were combined with a dream-like vagueness of narrative:

> Up to the age of fifteen, I was . . . suffered to run . . . wild . . . and grew
> stout, indifferent and careless as to personal appearance . . . Family cir-
> cumstances and change of fortune . . . led my relatives to the conclusion
> that my education required a continental finish. . . . I was . . . packed off

to a highly genteel and fashionable establishment for young ladies, situated in the suburbs of Paris . . . [where] I was subjected to the strict and rigid system of lacing in force through the whole establishment, no relaxation of its discipline being allowed. . . . and on taking my departure [three years later] I had grown from a clumsy girl to a very smart young lady, and my waist was exactly seven inches less than on the day of my arrival.[21]

Over the next few years, dozens of letters for and against tight-lacing were published in *The Queen*. "Eliza," for example, wrote several times in 1863 in favor of tight-lacing and claimed to have a 16-inch waist.[22]

A specialized literature in favor of tight-lacing was proliferating. In 1865, an unidentified person, using the nom de plume Madame de la Santé, wrote a pamphlet entitled *The Corset Defended*, which was approvingly reviewed in *The Queen*.[23] No sooner had the correspondence lapsed in *The Queen* than it flared up in the *EDM*. A number of the pro-tight-lacing letters were then reprinted in a book entitled *The Corset and the Crinoline* (1868), which also quoted La Santé's *The Corset Defended*: "Madame La Santé says − 'A waist may vary in circumference from seventeen to twenty-three inches.' . . . We have abundant evidence before us, however, that seventeen inches is by no means the lowest standard of waist-measure to be met with in the fashionable circles of either London, New York, Paris, or Vienna. Numbers of corsets [measure] sixteen inches at the waist, and even less . . ."[24] Another book was published in 1871, entitled *Figure Training* by "E.D.M." Later it was reissued under the more pejorative title, *Freaks of Fashion*.

Figure Training by E. D. M., 1871.

The corset correspondence in the *EDM* caused a sensation in Victorian England, because of what we now recognize as its sexually fetishistic and sadomasochistic nature. Correspondents argued that "half the charm in a small waist comes, not in spite of, but on account of, its being tight-laced"; "− the tighter the better"; "well-applied restraint is in itself attractive." Such opinions were, of course, diametrically opposed to the generally expressed belief that only "naturally small" waists were really attractive. Many of the tight-lacing letters have a pronounced sadomasochistic tone. References to "discipline," "confinement," "compulsion," "suffering," "torture," "agony," "submission," "martyrs," and "victims" abound − as do references to the "delightful," "delicious," "exquisite," "exciting," "pleasurable," and "superb" sensations experienced by tight-lacers. By contrast, the ordinary pro-corset literature, including corset advertisements, emphasized that well-made corsets provided "ease," "freedom," and "comfort." The anti-corset literature often described tight-lacing as "torture," but the only "victims" mentioned were unborn children. The *EDM* also published dozens of letters on flagellation, high heels, cross-dressing, and spurs for lady riders − all, needless to say, highly atypical of the ordinary discourse on fashion and corsetry.

The letters advocating enforced and painful tight-lacing of girls should

really be read in conjunction with those on corporal punishment and cross-dressing. There were so many letters on whipping submitted to the *EDM* that the magazine published a special supplement devoted to them. There also developed an entire subgenre of letters advocating that boys and young men should be tight-laced at the hands of powerful women. The first and most famous of these was "Walter's" letter to the *EDM* of November 1867, which was still being quoted decades later in other fetishist correspondences:

> I was early sent to school in Austria, where lacing is not considered ridiculous in a gentleman as it is in England, and I objected in a thoroughly English way when the doctor's wife required me to be laced. . . . A sturdy *mädchen* was stoically deaf to my remonstrances, and speedily laced me up tightly. . . . the daily lacing tighter and tighter produced inconvenience and absolute pain. In a few months, however, I was . . . anxious . . . to have my corsets laced as tightly as a pair of strong arms could draw them.[25]

Over the years, many letters argued that disciplinary corsetry had "advantages, not only for girls, but also for boys."[26] Indeed, youths were said to need discipline more than their sisters, because they were rowdier and being corseted would make them "more tractable to the ladies having their management."[27]

In the 1880s, *The Family Doctor and People's Medical Advisor* picked up where the *EDM* had left off, publishing many articles and letters on tight-lacing, as well as letters on corporal punishment, high heels, underwear, and piercing. Not a professional medical journal, *The Family Doctor* was put out by the publishers of *The Illustrated Police News* and was sensationalistic. The "slaves of the stay lace" (as they called themselves) found bondage and waist confinement erotic in its own right. This was highly atypical of popular opinion, which praised "naturally" small waists, and complained that obvious compression was ugly as well as unhealthy. The correspondents for *The Family Doctor* also talked a lot about tight-lacing boarding schools.

An illustration from *The Family Doctor* of 1888 purports to show three young "martyrs" to tight-lacing: Mabel M who is described as having a waist of 12 inches; Bertha G, age 15, waist 11 inches; and Constance, waist 14½ inches."[28] Similar measurements were given in an article "Does Tight-Lacing Really Exist?" by Hygeia, which included the following chart:[29]

Name	Age	Size of waist	Reduce to	To wear corset
Nelly G.	15	20 inches	16 inches	Night and Day
Helen Vogler	12	21 inches	15 inches	Day
G. Van de M.	14	19 inches	13 inches	Night and Day
V.G.	13	22 inches	12 inches, if possible	Night and Day
Alice M.	17	16 inches	14 inches	Night and Day
Cora S.	16	18 inches	13 inches	Night and Day

Throughout the 1890s and into the twentieth century, other periodicals such as *Modern Society*, *Society*, and *London Life* published letters from advocates of tight-lacing, cross-dressing, and the rod.[30] Pornographic books, such as *Experiences of Flagellation* (1885) by "an amateur flagellant," also continued to cite the *EDM* while gloating about "FLOGGING SCHOOL."[31] Corporal punishment was, of course, a real feature of Victorian life, especially in boys' boarding schools, but other aspects of the tight-lacing scenarios seem more fantastic.

"Martyrs to Tight Lacing," *The Family Doctor*, 1888. Courtesy of Peter Farrer.

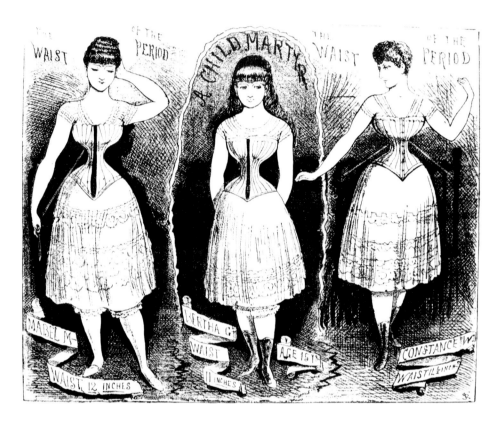

Certain foreign locales, especially Vienna, were said to be hotbeds of tight-lacing and crossdressing. In 1893, for example, V.S. wrote to say that he had been sent to Vienna, where "both sexes lace up tight." The school was run by a retired officer: "All his pupils were required to wear stays." Discipline was enforced by the principal's two tight-lacing daughters, one of whom was seventeen years old and had a 14-inch waist.[32] "An Upright Figure" was also sent to school in Vienna and quickly "found myself thoroughly under stay-lace *régime*," held "more and more erect" in an 18-inch corset.[33] Undisciplined and uncorseted for years, the boys are ultimately forced to submit – often at foreign boarding schools and almost always at the hands of a cruel but beautiful governess, principal, stepmother, French mistress, aided by various maids and daughters.

"National Waists," *The Family Doctor*, 1888.
Courtesy of Peter Farrer.

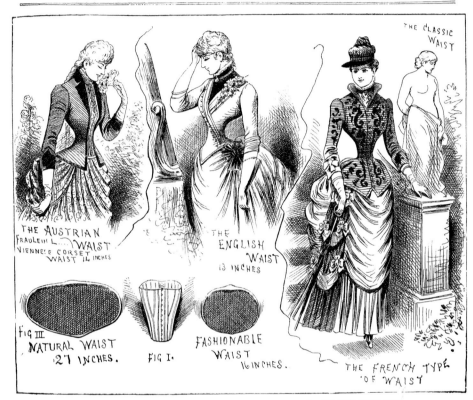

THE
FAMILY DOCTOR
AND PEOPLE'S MEDICAL ADVISER.

No. 162.　　　　SATURDAY, APRIL 7, 1888.　　　　Price One Penny

THE AUSTRIAN WAIST
Fraulein L. Waist
Viennese Corset
Waist 14 inches

THE ENGLISH WAIST
13 INCHES

THE CLASSIC WAIST

Fig III
NATURAL WAIST
27 INCHES.

FIG I.

FASHIONABLE WAIST
16 INCHES.

THE FRENCH TYPE OF WAIST

NATIONAL WAISTS.

THE CORSET IN AUSTRIA AND FRANCE.

This subject is discussed and commented upon with undiminished interest, and we, therefore, before leaving it for a time, give the above illustrations, from photos of some "national waists." The "English waist" is that of a young lady a friend of Miss Ethel M——'s, and the corset worn is a "Sylph," made especially with a waist of 13 inches, but as the young lady says in a letter accompanying the sketch, "my corset is not laced close by an inch, as it is very heavily boned (to my order), and the edges irri-

tate if it is laced close. I always have a light and semi-flexible steel busk, as I am naturally slight, and to be a little embonpoint is not unbecoming. Ethel M—— has shown me your knickerbocker costume, I mean the one you wear on dress occasions, and, pretty as it is, I could never adopt it if it means giving up stays."

The "French waist" is described in a letter to us :—Dear Maggie—You are a perfect bother. There now, I didn't mean to say that. Only I had nearly made up my mind not to help you

again. You will find my own photo and that of —— enclosed. She is only just from Vienna, although she speaks English wonderfully well. I find the new stays which mother bought me in Paris awfully nice to wear—such a lovely and comfortable shape, although an inch less than I used to wear before. They are beautifully cut, and fit me like a glove. You will notice quickly the very broad busk. This is made of steel, and is nearly rigid, but curves outward from just where the waist is narrowest to the top of the

Vol. VII.

In a letter that recalls "Fanny's" 1863 missive to *The Queen*, "Stays" recounted how, "up to the age of sixteen I was allowed by my guardian unrestrained license to eat . . . and to slouch about." Then he was sent off to a school where all the boys were put into corsets, "which were laced each morning as firmly as possible by two maids when we came down to be inspected . . . by our principal's wife, who had herself the great advantage of going through the *régime* of an extremely fashionable finishing school in

Paris."[34] "Admirer of Pretty Feet" (who clearly had several fetishes) also advocated "the compulsory wearing of . . . good, strongly-boned, stiff-busked, firm corsets," and claimed to have gone to a strict school, where he was tight-laced, slapped, and whipped by the "young lady" in charge:

> To be thoroughly well corseted . . . is an excellent reminder to any lad . . . that he can not have all his own way. The degree of tightness must vary, of course . . . but as a general rule it may be considered that in a moderate time any pupil, whether youth or girl, may be required to lace to two-thirds of the natural waist measurement. . . . As to the best persons to administer discipline, I have not a moment's hesitation in giving my voice in favour of the fair sex. . . . it is one of the privileges of a pretty woman to be tyrannical.[35]

Contemporary pornography also frequently features dominant females, or what the Victorians liked to call "cruel ladies." Such representations of women should not, however, be taken at face value.

Another correspondent reported that when flogging failed to tame him, he was sent to a special tight-lacing boarding school:

> On my arrival I was immediately laced into an extremely tight, heavily-boned corset, fastened with a small padlock, and was securely locked in with a tiny key, which dangled among the jeweled charms fastened to the slender waist of the lady principal, a handsome widow, who was then about twenty-four. . . . The fair disciplinarian was . . . extremely strict. If she was displeased with us she would frequently tighten our corset with her own small, delicate white hands, and then, having made us prisoners with the dreaded key, would laughingly dismiss us with a smart slap on our cheek. . . . I went there a conceited, rough lad, and I left a perfectly obedient, polite youth.[36]

The theme of boarding schools, so popular in the corset correspondences, may well be related to the existence of specialized brothels, where male clients could engage in what today is known as role playing. There is no evidence that special tight-lacing boarding schools existed, either in England or in exotic foreign cities, such as Paris and Vienna. However, it is known that nineteenth-century brothels frequently did contain wardrobes of dress-up clothes, including nuns' habits, which recall pornographic fantasies of sexual misbehavior in convents.

It is also true that one occasionally finds advertisements for men's corsets, which seem to be aimed at a specialized client base. Madame Dowding, for example, in the late 1890s not only advertised a woman's corset called The Princess Wasp Waist, but also sold a variety of men's belts and stays — often with military names, such as the Carlton and the Marlboro.

The boarding school is also a class marker: many of the corset correspond-

MADAME DOWDING,
8 & 10, CHARING CROSS ROAD (Opposite the National Gallery, Trafalgar Square),
Ladies' Tailor, Corsetiere, and Court Dressmaker.

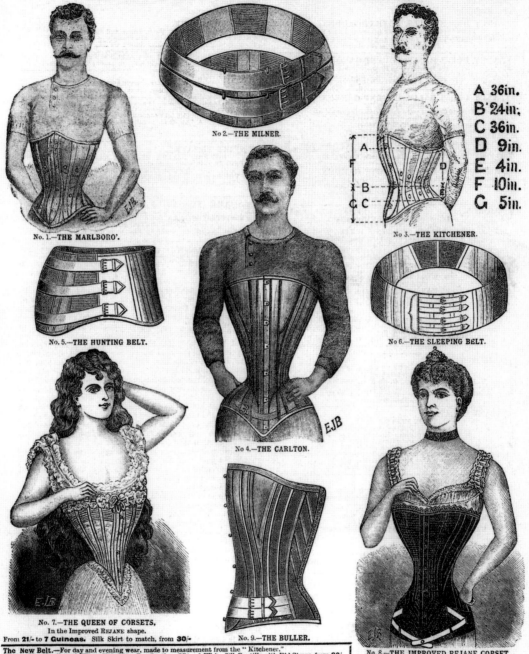

No. 1.—THE MARLBORO'.

No. 2.—THE MILNER.

A 36in.
B 24in.
C 36in.
D 9in.
E 4in.
F 10in.
G 5in.

No. 3.—THE KITCHENER.

No. 5.—THE HUNTING BELT.

No. 4.—THE CARLTON.

No. 6.—THE SLEEPING BELT.

No. 7.—THE QUEEN OF CORSETS,
In the Improved REJANE shape.
From 21/- to 7 Guineas. Silk Skirt to match, from 30/-

No. 9.—THE BULLER.

No. 8.—THE IMPROVED REJANE CORSET
For Obesity.
Price from 38s. to 7½ guineas.
Made to order in Silk Coutille, from 2 guineas.
The improved Rejane Corset, designed by
Madame Dowding, is declared by several of the West
End doctors to be the most perfect of any "anatomi-
cal" Corset yet invented, and supplies a long-felt
requirement to those habitually inclined to "embon-
point." This new Corset has been tried with marvel-
lous results by ladies inclined to obesity.

The New Belt.—For day and evening wear, made to measurement from the "Kitchener."
No. 1.—The Marlboro'. White Kid, 30/- ; Tan Leather, 35/- ; & White Silk Coutille with Kid Straps, from 38/-
No. 2.—The Milner. White Leather and Elastic, 25/- ; White Flannel, Elastic, with White Kid Straps, from 21/-
No. 3.—The Kitchener. Most suitable for Hunting and Cultivating the Figure, with Elastic Gores and
ventilated Eyelets, from 30/-
No. 4.—The Carlton. A great favourite with military gentlemen. Silk Coutille, from 30/- ; Black and
Coloured Sateens, lined, from 50/-
No. 5.—The Hunting Belt. Tan Leather, 30/- ; Coutille, with Leather Bands, from 30/-
No. 6.—The Sleeping Belt. White Flannel with Elastic Gores and perforated Eyelets. The first Belt for
Cultivating the Figure.
No. 9.—The Buller. A most comfortable shape for day or evening wear, made in all materials, from 35/- to
6 guineas. Most popular Belt for gentlemen inclined to obesity.

All these Belts are absolutely Hygienic, and can only be procured from Madame DOWDING, the Sole Inventor and Designer.
No orders can be executed under seven days' notice. The demand for these Corsets is daily increasing, and is, indeed, a great satisfaction to the Inventor.
MADAME DOWDING begs to thank the numerous West End Tailors for their kind recommendations. All Communications STRICTLY PRIVATE in Belt Dept.

ents boast about their genteel families and aristocratic classmates. Anti-tight-lacing writers argue, in contrast, that the practice is seldom seen in good society, but only among servants and other lower-class women. The actual class background of correspondents is, of course, impossible to determine, although style, content, and production values of the *EDM* and *The Family Doctor* seem to indicate that both magazines had a predominantly middle-and/or lower-middle-class readership. Circulation figures are unknown, although these would not necessarily indicate the size of the "fetishist" readership, which was probably only a small percentage of total readers.

Sexual and gender ambiguity is characteristic of fetishist pornography. "A Male Wasp Waist," for example, not only admired corseted women but also wore corsets himself and dressed "like a lady." He enjoyed being mistaken for a woman, or fantasizing about this: "I have been struck by the number of men who admired me, and would, no doubt, have liked to put their arms round my small waist." Notice how the place he imagines other men touching is his (corseted) waist. "If they had only known I was also one of their sex!" The corset makes him look like a woman, but he remains a man, or as modern transvestites would say, the corset transforms him from he-male to she-male, but he remains a "chick with a dick." Indeed, the uncorseted female waist, symbolic perhaps of the female genitalia, is repulsive: "To my mind a non-stayed waist is horrid. What man enjoys a dance holding a flabby waist, where his fingers sink into fat? . . . We men love a stiff, hard, well-boned waist to hold."[37]

The phallic symbolism of the corset may have been a major source of its erotic fascination, at least for some male enthusiasts. Phallic fantasies almost certainly lie behind the fantasmagoric image of the stiff, hard corset that measures about 13 inches. It may be significant in this regard that the tight-lacing correspondents almost never mention bust or hip size. *The Gentlewoman*, which published a series of articles on "The Sin and Scandal of Tight-Lacing," was unusual in giving complete measurements, such as 40-14-38 and 37-13-38.[38] Yet a number of other nineteenth-century sources indicate that the primary purpose of the corset (as actually and ordinarily worn) was to support and accentuate the bust, while twentieth-century studies stress that it is the waist-hip differential that is usually significant for erotic allure.

Sometimes the correspondent speaks as the disciplinarian herself. One Amy Canning, for example, wrote to *Society* in 1900, claiming to be a young female tight-lacer who collaborated with her French maid to "tame" her 16-year-old step-son by forcing him to wear tight corsets: "I intend reducing his waist measurement 1 inch per month, and tomorrow he will be fitted for high boots with 4-inch French heels. I shall make good use of him as an attendant page to lace my corset, which measures only 17 inches . . ."[39] However, correspondents may have lied about their gender as well as other aspects of their stories.

In a letter to *Society* (1899), "Wasp-Waist" recounted what happened when she rebelled against being laced smaller than eighteen inches:

> The French mistress, on hearing this, became very angry, for it was her special business to see that all the girls should have wasp waists. I then received a punishment which thoroughly subdued me, and it most certainly did me a lot of good. The weight of my body was suspended from my wrists, which were fastened above my head, while my feet, which were encased in tight, high-heeled boots, were fastened to a ring in the floor. In this position, only protected by my stays, I received a severe whipping across the back, which gave me intense pain, but left no mark, owing to my being tightly laced. After this castigation I was very humble. But before the French mistress would untie my hands, she reduced the size of my waist to fifteen inches.[40]

Many of the corset and tight-lacing letters recount scenarios, like this one, that could easily have been part of a pornographic novel. An illustration from the notoriously fetishistic *London Life* (1929) portrays some of the key elements in the prototypical tight-lacing scenario: the victim is suspended by her arms, while a maid laces her under the eye of a female authority figure, who is also tight-laced.

The history of sexual behavior is notoriously difficult to research, since empirical data are incomplete and so much of the evidence is problematic. Bearing this limitation in mind, we do know that sexual subcultures involving transvestism and sadomasochism existed as early as the eighteenth century in London and Paris. Nineteenth-century European sexologists also uncovered much material relating to sexual fetishism and prostitution, as have more recent sex researchers.[41] We know, for example, that in Britain magazines were the primary medium for fetishistic erotica, whereas in France and Germany the preferred media were novels and photographs. By the early twentieth century, *London Life* had an enormous circulation throughout the British Empire, having incorporated a number of earlier publications, including *Modern Society*.[42] (Although in many ways similar to some of the antecedent publications, the *EDM* was not in *London Life*'s direct line of development.)

An unknown number of individual fetishists probably did do many of the things they described: tight-laced, crossdressed, had themselves whipped, pierced their nipples. However, they almost certainly did not do so under the circumstances that they describe: at the tight-lacing boarding school, at the hands of a sexy sadistic schoolmistress, and to the degree of tenuity they claimed. Nor do their sexual fantasies and acting out of these fantasies have much to do with sensations and experiences of the average corseted woman, any more than the average woman wearing high heels today is actually imprisoned in padlocked shoes with seven-inch heels. The idea that the average Victorian woman was a sexual fetishist or masochist dedicated to

extreme body modification finds no substantiation in the non-fetishist literature.

Visual evidence for the existence of wasp waists also needs to be analyzed carefully. A famous caricature, William Heath's *A New Machine for Winding Up the Ladies* (c. 1828), portrayed a system of tight-lacing based on the winching mechanism. It should be obvious that the machine portrayed was a fantasy: no one ever laced her corset this way. Yet fashion illustrations can also be misleading, and even photographs may be altered. As one Victorian

William Heath, *A Correct View of the New Machine for Winding Up the Ladies*, c. 1828. Photograph by Irving Solero. Courtesy of The Museum at the Fashion Institute of Technology, New York.

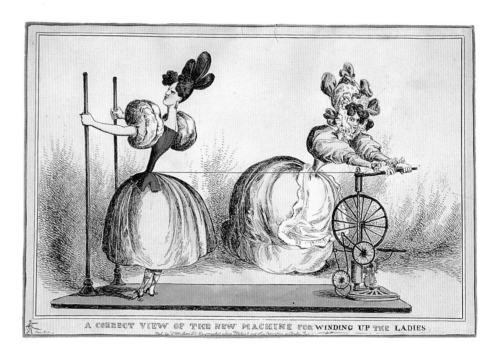

A CORRECT VIEW OF THE NEW MACHINE FOR WINDING UP THE LADIES

photographer observed, "The retoucher may slice off, or curve the lady's waist after his own idea of shape and form and size."[43]

Measurements of the many corsets in museum collections certainly do not support the idea of Victorian girls with 16-inch waists. I once took the famous tight-lacer and corsetier Mr. Pearl through the Costume Institute of the Metropolitan Museum of Art in New York, and he was very disappointed to find that none of the corsets was as small as his own 18-inch waist – although one suede corset was twice as large. Statistics from the Symington Collection of the Leicestershire Museums Service indicate that out of 197 corsets, only one measured 18 inches. Another 11 (five per cent of the collection) were 19 inches. Most were 20 to 26 inches.[44] We have no way of knowing, of course, whether extant corsets are typical of their period, or whether a disproportionate number of them happened to be saved because they were unusually small or pretty.

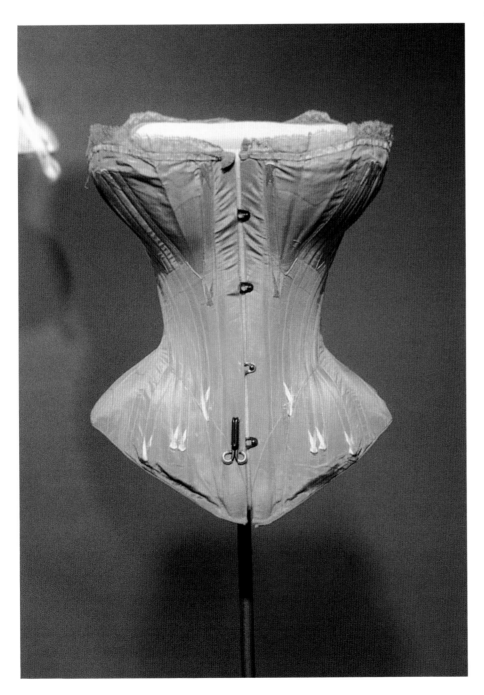

Corset, c. 1866, measuring 32-18-25 inches, from the collection of The Museum of the City of New York. Photograph by Irving Solero. Courtesy of The Museum at the Fashion Institute of Technology, New York.

Although often heavily boned, eighteenth-century stays are seldom as small at the waist as nineteenth-century corsets, since technological developments had made it possible to fit the body more closely and lace it more tightly. It will be remembered that the smallest pair of stays at Colonial Williamsburg measured 24 inches (61 centimeters). Eighteenth-century corsets from France and America in the collection of the Museum at the Fashion Institute of Technology measured 25 to 26 inches around the outside, although some of these corsets are thick and the smallest internal measurements are 21 to 22 inches.[45] By contrast, the smallest nineteenth-century European corset in the collection of the Kyoto Costume Institute in Japan, from the 1870s, measures 45 centimeters (or 17.7 inches) at the waist and 66 at the bust. No hip measurements are given. Two others measure 49 centimeters at the waist: one from around 1828–40 has a waist of 49 centimeters and a bust of 80, while another from 1880 is 49 at the waist and 76 centimeters at the bust. The other nineteenth-century corsets featured in Kyoto's exhibition catalogue have waist measurements ranging from 51 to 81 centimeters, while a corset from 1907 measures 48 centimeters at the waist.[46] In a private collection, I once saw a corset that measured 15 inches at the waist when laced completely closed.

When my colleague Fred Dennis and I organized an exhibition on corsetry at the Fashion Institute of Technology in New York, drawing on a number of museum and private collections, the smallest nineteenth-century corset we displayed had an 18-inch waist when laced completely closed. This particular corset dated from about 1866 and measured 32-18-25 inches, indicating a slender woman with a waist-hip ratio of .72. Other corsets we displayed from the 1870s and 1880s had measurements such as

30-20-30, 33-21-32, 32-22-33, and 30-23-31. A century later, the ideal proportions were similar.

For comparison, consider the following figures given in *The Photography of Women*, published in 1965:

> Give or take one or two inches, hips and bust that measure 36 inches at their largest parts should have a waistline 10 inches less or 26 inches in all. These dimensions may be scaled up or down. However, proportions should be about the same . . . As an example, hips and bust that measure 34 inches should have a waist measuring 24 inches.[47]

Although the twentieth-century woman is not supposed to rely on a corset, in fact, in 1965 she might have worn a girdle that took one or two inches off her waist.

Nineteenth-century corsets were usually advertised with waist sizes of 18 to 30 inches, although larger sizes were often available only at a slightly higher cost. In 1882, for example, Lord & Taylor sold the Madeleine Corset in sizes 18 to 30 inches for $1.25, while sizes 31 to 36 inches cost $1.35. The W. B. Reduso Corset, "a boon for large women," went up to 36 inches. Advertisements for the Williamson Corset & Brace company listed "ordinary sizes," 18 to 30 inches, as costing $3.00 per pair in 1890. "Extra sizes, 31 to 36, 25 cents extra. 37 and up, 50 cents extra." In 1901, the Royal Worcester Corset catalogue advertised some styles in sizes 18 to 24 inches; most styles were 18 to 30 inches, but many were also sold in sizes 18 to 36 inches, or 18 to 43 inches. The prices went up in increments of 25 cents for larger sizes. Worcester's children's corsets were advertised in sizes 20 to 26, while misses' (age 12 to 16 years) wore sizes 18 to 26. Only a very few advertisements mention smaller sizes: Giraud's Small Waist Corset, for example, came in sizes 15 to 23, for "exceptional figures."[48]

The size of the corset alone does not indicate how tightly it might have been laced, however. A corset with an 18-inch waist might have been laced completely closed, i.e. down to 18 inches. But it might also have been left open one, two, or more inches in back. According to a booklet entitled *The Dress Reform Problem*:

> A distinction should be made between actual and corset measurements, because stays, as ordinarily worn, do not meet at the back. . . . Young girls, especially, derive intense satisfaction from proclaiming the diminutive size of their corset. Many purchase eighteen and nineteen inch stays, who must leave them open two, three, and four inches. . . . Fifteen, sixteen, and seventeen inch waists are glibly chattered about, as though they were common enough . . . [yet] we question whether it is a physical possibility for women to reduce their natural waist measure below seventeen or eighteen inches.[49]

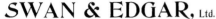

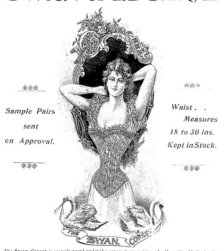

Advertisement for Swan & Edgar Corsets, c. 1890.

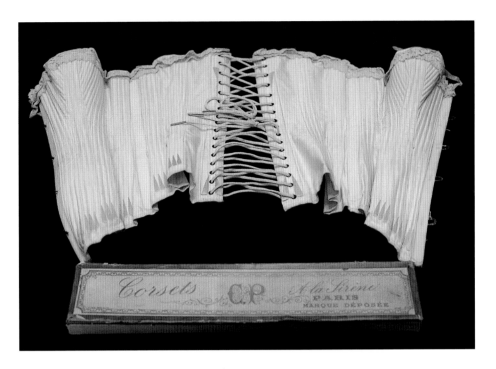

Actually, it is physically possible to lace below seventeen inches, as the famous twentieth-century tight-lacer Mrs. Ethel Granger proved – and for which she was duly entered into *The Guiness Book of Records*.

Nevertheless, historical corsets are usually quite a bit larger. The size of the corset also provides only an approximate indication of the size of the waist, because making a waist "small" involves a complex manipulation of flesh. The circumference of the waist is only the most obvious factor. The volume of the torso is redistributed. Fat is pushed in different directions, and the shape of the waist changes from an oval to more of a circle. Depending on the style of the corset (which changed according to the fashionable silhouette), the corset causes more or less compression in different places. It may be worth pointing out that corset advertisements not only mention the waist size, they also frequently mention the front length of the corset, which usually ranged from 13 to 17 inches. Although this had nothing to do with the circumference of the waist, it may have put some people's minds toward this range of numbers.

What size were women's waists, before and after the corset? As we have seen, nineteenth-century doctors tended to consider the natural size of the female waist as being 27 to 29 inches. If we compare this with the size of corsets in museum collections (usually 20 to 26 inches), then it seems that many women laced two or three inches smaller than their natural waists, while some may have laced four, five, or six inches smaller. To reduce from a natural waist of, say, 27 inches down to 21 inches seems quite tight – although it still needs to be distinguished from the notorious fetishistic

accounts of tight-lacers who claimed to have attained waists of 16 inches or less.

When calculating waist and corset measurements, however, it is important not to become obsessed with absolute numbers, but rather to think in terms of proportions and degrees. Some women, especially young women who have never had children, have waists as small or smaller than 22 inches. A 22-inch waist can easily be laced down to 19. A woman with a 27-inch waist can, with more difficulty, be laced down to 20 inches. The latter is obviously more extreme tight-lacing, although the first woman's 19-inch waist ends up being smaller in absolute terms. A thin woman is less likely to be able to tight-lace dramatically, because she simply does not have the fat to push around. As a result, corsets designed for thin women tend to be padded in the bosom and hips. (When the actress Nicole Kidman played Isabel Archer in the film *Portrait of a Lady*, press reports said that she wore a 19-inch corset, but this fact in isolation does not tell us whether or how much she was tight-lacing.)

The dress reformer Helen Ecob quoted unnamed corset makers in London as saying that "Fashionable ladies and thousands who imitate them purchase corsets which are from three to ten inches smaller than their waists, and then lace them so as to reduce their waist by two to eight inches." Notice how this implies that corsets are usually left open in back from one to two inches, a fact which other observers also pointed out. According to Ecob's sources, the average waist size had become two inches less over the previous 25 years, that is between about 1865 and 1890. Since people were not getting smaller, this implied that tight-lacing was on the increase. Ecob also quoted the reformer Dio Lewis to the effect that corsets "reduce the waist from [by] three to fifteen inches" – a much more dramatic span.[50]

It must be remembered, however, that corsets were designed not only to compress the waist but also to make it look smaller. Visual perceptions can be misleading. I have often heard visitors to museums exclaiming that corsets on display must measure sixteen inches, when I know them to be at least four inches larger. Writing in 1906, Elizabeth Anstruther recalled having recently seen a young woman at a famous café:

> This girl had brought a waist naturally about twenty inches into a compass that looked to be not more than twelve, but was probably sixteen. The effect was so grotesque that people giggled audibly as she passed out.[51]

According to Anstruther, young women sometimes laced very tightly in a mistaken effort to make themselves look "pretty," but "we invariably laugh at the martyr to discomfort for the sake of vanity." Yet she also insisted that she saw no harm in corsets, "judiciously worn," and, furthermore, even if corsets were harmful, "I'd rather know some harm done than have to look at the majority of women going corsetless." Her ambivalence runs through her text, for as she says,

A sensibly large corset that fits the figure and is loosely laced, so as to leave a space of three inches open across the spine, is a great comfort, an immense aid to the satisfactory wearing of such clothing as our fates decree, and so little likely to do any considerable harm that no one need bother herself about ill-effects from it. On the other hand, lacing in any degree is so immeasurably harmful that no one can overstate its dangers. My own private test for a corset is the ability to put both hands inside it after it is fastened and run them down to the waist line and below it. No one need ever try to tell me that a corset so worn is injurious, for I shall not believe it.[52]

Why did women tight-lace? The commonest answer given in the nineteenth century was "vanity," or excessive pride in one's appearance. *La Vie Parisienne*, for example, argued that female vanity and a sense of competition with other women motivated tight-lacers. This magazine, which might be characterized as the *Playboy* of nineteenth-century France, printed a number of centerfolds on the erotic aspects of fashion. *Considérations sur le Corset* (published April 19, 1879) shows a young and pretty woman holding onto a mantelpiece, looking casually over her shoulder as her husband, her maid, the cook, monsieur's valet, and the groom all tug away at her laces. In front of her are a crowd of cupids who pull in the opposite direction. According to the caption, "She is happy! She won't be able to sit down . . . or laugh, but she will have the smallest waist in society. Can one buy such happiness too dearly?"[53] A smaller picture shows a comic version of vanity: a plump woman is being laced up by her maids. They make "a vigorous effort. And the miracle occurs."[54] The implication here is that fat women virtually require tight-lacing if they are to fit into their clothing. This is sexist, of course – the illustrator, Henri de Montaut, is nothing if not sexist – but it is not fetishistic like the *EDM*.

Fashionable women could certainly have tight-laced, without being either themselves sexual fetishists or the partners of fetishists. The novel *Vanity!* includes a description of two tight-lacers, one of whom, Mrs. Wiltshire, who sleeps in a "steel belt" and "boasts" about her waist size, comes intriguingly close to that of the stereotyped tight-lacer of contemporary journalism. The other, Lady Farrington, although also "tightly corseted," responds to her dressmaker's suggestion to abandon an "exaggerated waist" in favor of beautiful proportions:

"Your figure seems perfect," I said. "Perhaps the waist is a trifle too . . . too –"

"My dear creature! not too *large?*"

"Oh, no . . . Just the reverse. I was about to suggest you should not lace quite so tightly."

"Tightly! I assure you my corsets are absolutely loose . . . Oh! don't say

"Considérations sur le Corset," *La Vie Parisienne*, April 19, 1879.

I look tight-laced like Mrs. Wiltshire. She boasts, you know, that she has the smallest waist of any woman in London. Of course, you know her by sight?"

"Who does not? She makes me feel *sick*. I always think she's going to break in half."

"I'm so glad you don't admire her. It's really too wonderful to be – nice. They say she sleeps with a steel belt round her."

"What does she gain by such penance?"

"Admiration and envy."

"Not from any sensible person – of that I'm sure."

[The fitter comes in to take measurements.]

"Waist – twenty inches," she began. . . . "That will never do, you know," I said. "Take my advice – let out to twenty-two, or three. You won't look any larger, and the fit will benefit ever so much – no strain."

"But are you *sure* I won't look clumsy?"

"On the contrary, you will have elegance and grace. The way I cut my

gowns makes your actual waist look quite one inch smaller than it is, but I insist on proportion. With your bust and hips your waist could not look large.[55]

Lady Farrington's tight-laced waist (of 22 or 23 inches) is presented here as beautiful, especially in conjunction with full bust and hips, but the very tightly laced waist is not beautiful or "nice," but sickening.

A caricature by Gil Baër, undated but probably from the 1890s, takes a decidedly grimmer view of tight-lacing, which also places the blame on female vanity." *Fine taille, horribles détails* shows a woman urging her husband and maid to "pull, pull!" Then, "crack!" her waist is laced so tightly that it breaks in two, pitching her headfirst into a mirror, while her husband and maid fall flat on the ground.[56] It is unclear whether the sadism and misogyny of this image would have been apparent to contemporary viewers.

Even after boned corsets had ceased to be fashionable, images of tight-lacing continued to be produced. An illustration from the 1920s, for example, shows a young woman being laced by cupids. Tight-lacing in this instance cannot logically refer to a dramatic cinching of the waist, since the fashionable figure no longer emphasized a cinched waist. Yet the act of being laced up still seemed erotic. Apparently, the idea of a woman's body being shaped through the power of a man's hand (or via surrogates like the cupids) retained an allure outlasting the fashion of corsetry as such.

The military strategist Basil Liddell Hart was a corset enthusiast, who had a fixation on the wasp waist. Born in 1895, Liddell Hart found that corsetry

Gil Baër, *Fine taille, horribles détails*, from Dr. G. J. Witkowski, *Tetoniana*, 1898.

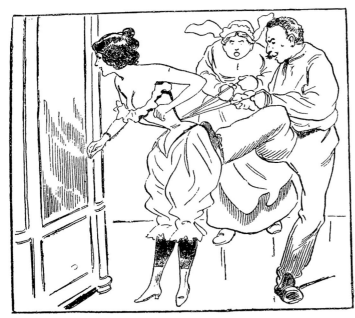

FIG. 209. — Serrez ! Serrez !

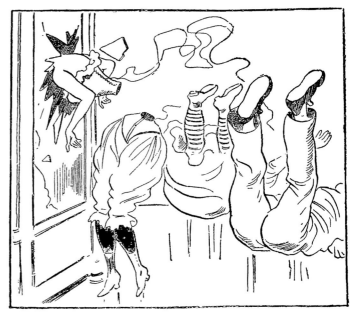

FIG. 210. — Ser... Crac ! ! !

was no longer in fashion by the time he was an adult. Yet not only did he himself wear corsets, he also insisted that his first wife, Jessie, tight-lace. Some Victorian women may also have tight-laced to please their partners. A recent biography of Liddell Hart quotes from his meticulous diaries in which he recorded the measurements of his wife's clothes:

> waist 19″ to allow for stretching
> 2½″ higher in bust all round
> 1½″ longer in skirt
> bones ½″ shorter
> hook below bust
> single broad busk
> 4 detachable suspenders
> special V shape contoured
> strongly boned as possible[57]

Photograph of Polaire, from *The Lady's Realm*, 1909.

Photo by Boiak.

The tyranny of fashion.
Who has not seen a girl laced until she resemble an hour-glass ?

The diaries also contain a line in Jessie's handwriting: "Hubby dear – I don't like these [?illegible] corsets because I am uncomfortable and they make me feel sick." However, Liddell Hart's biographer notes that this is the only evidence of protest or complaint. For the most part she seemed biddable, and Liddell Hart noted complacently, "She was bright as a butterfly at the chance to dress up and pull in." Certainly, she liked to dress; as she once told him, "There'd be no point in living with you if I couldn't dress as well as I do."[58]

According to their son, there were two views of his parents' relationship. Either "she had become involved with other men," or he was a "neurotic," who "had been introduced to his innocent young wife by a sex pervert in her home town . . . He continued the transvestite practices with which he was already engaging and required a submission involving a degree of physical sadism . . . with this she long continued to put up . . . Other men had been introduced by my father himself into this set-up and then my father, bored by his wife's companionship, had been enticed away, leaving her to live unhappily ever afterwards."[59] Liddell Hart amassed a library of material on corsets and tight-lacing, and was greatly intrigued by accounts of Victorian girls with 14 and 15-inch waists. But he wondered if there was any proof that these stories were true.

For the average woman, tight-lacing was the extreme of a continuum of corset wearing. The evidence indicates that women's use of corsets varied according to the age, class, location, situation, personality, and figure of the individual woman. Younger women tended to have smaller waists, both naturally and because they tended to be more interested in fashion. (Employed single women also had more disposable income than married women of a comparable class.) Middle-class women had more access to corsets than working-class women did. Paris was obviously more fashionable than the French provinces. Certain areas, such as the United States and, espe-

cially, Boston, were centers of dress reform, and boned corsets may have been less commonly worn there than in Great Britain and France.[60] During both the eighteenth and nineteenth centuries, women in England were believed to lace more often and more tightly than women in other countries. However, most accounts of extreme tight-lacing seem to be exaggerated.

Certainly, the famous 16-inch waist should not be regarded as the Victorian norm. As we have seen, most corsets were produced in sizes of 18 to 30 inches, with larger sizes readily available. Also relevant was the context within which the corset was worn. Contemporary accounts indicate that middle-class women tended to lace comfortably at home, especially in the morning when performing household tasks. They may have worn unboned or lightly boned corsets at such times, just as they often did for sports or when traveling. They tended to lace more tightly in the afternoon for going out shopping or visiting, less tightly again during tea time, and most tightly for special occasions such as balls. Some women loosened their corsets before a big meal. Most women took off their corsets at night. The fashions in dress influenced the type of corset worn, the degree and manner of lacing, and the visual appearance of the waist. Ironically, the period of the *EDM* corset correspondence (1867–74) was one in which fashion emphasized a short, slightly raised waistline and a full skirt, which made even an ordinary waist look relatively slim. It was much harder to "cheat" during the late 1870s and early 1880s, when a long waistline and a tight skirt drew attention to the entire torso.

In the controversies about tight-lacing, especially those that raged after the publication of the corset correspondence in the *EDM*, we can detect rival representations of tight-laced women. The old image of woman's "vanity" is implicitly contrasted with a new and much more disturbing image of the sexually "perverse" woman, addicted to secret practices, ranging from autoeroticism to sadomasochism. The usual conventions of sexual decorum generally prevented any awareness, let alone discussion, of variant sexual practices. But the publication of pro-tight-lacing letters brought certain covert anxieties about women and sexuality to the surface of consciousness. Although the actual number of tight-lacing "female fetishists" was probably minuscule, sexologists were beginning to publish case histories of sexual fetishists, transvestites, and sadomasochists – accounts of which filtered through to the public at large and became conflated with contemporary fantasies of feminine evil. Indeed, a wave of misogyny swept through fin-de-siècle European culture.[61]

The notoriety of the corset correspondence in the *EDM* has obscured the fact that the entire Victorian discourse on "tight-lacing" needs to be analyzed as a projection of widespread anxiety about women, and especially about their sexuality. The tightly corseted female torso was the site on which a variety of fears and desires were mapped. The tight-lacing controversy even

Cathy Jung wearing a sterling silver corset cover. Photograph by Aaron Cobbett, 2000.

appeared in boys' adventure stories such as H. Rider Haggard's *She* (1886), in which the fabulous Ayesha presents herself to the hero, saying:

> Now my waist! Perchance thou thinkest it too large, but of a truth it is not so; it is this golden snake that is too large, and doth not bind it as it should. It is a wise snake, and knoweth that it is ill to tie in the waist. But see, give me thy hands – so – now press them round me: There, with but a little force, thy fingers almost touch, O Holly.[62]

At this point, Holly falls to his knees and announces that he worships her. Exactly what She is wearing remains unclear, apart from her gold snake-corset. In real life, corsetry and tight-lacing were frequently assimilated to "Fashion," and that, too, was controversial.

Medical journals like *The Lancet* not only attacked specific fashions, such as corsets or tight-lacing, but also criticized "the sex which worships the idol of fashion."[63] Indeed, virtually any criticism of "Fashion" rapidly moved into a diatribe on women's vanity and stupidity. "Tight-lacing" was so ill-defined and the practice apparently so ubiquitous that it seemed to prove all women's mental – and moral – inferiority. Tight-lacing came to stand for everything that was wrong about women.

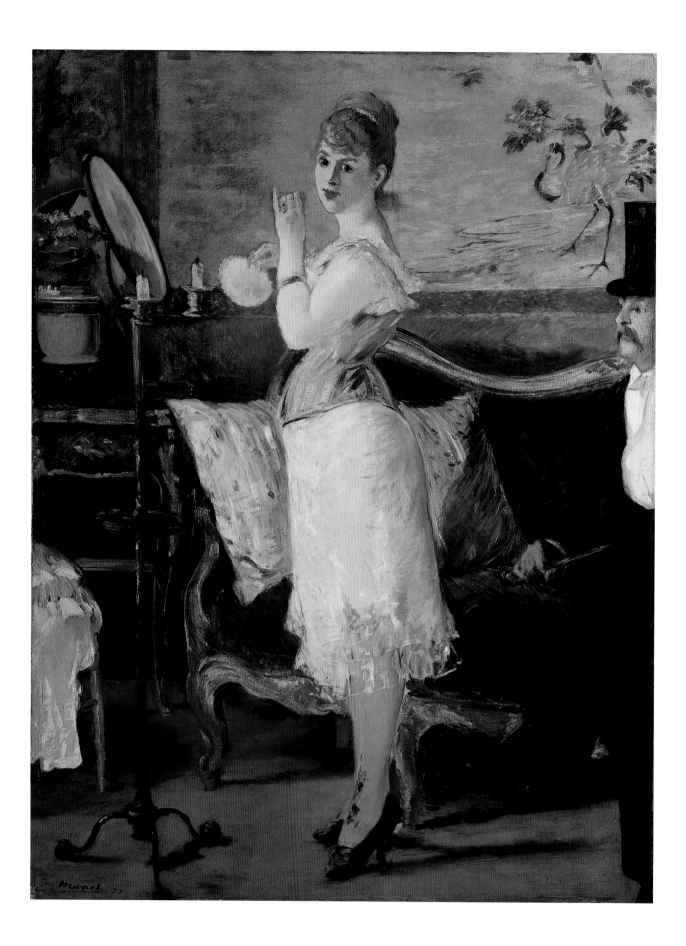

5 The Satin Corset
An Erotic Iconography

THE SATIN CORSET MAY BE THE NUDE OF OUR ERA," suggested Edouard Manet, whose famous painting *Nana* depicts the actress Henrietta Hauser wearing a pale blue satin corset.[1] When *Nana* was first displayed in 1877, reviewers seized on her attire – what one critic called her "*très grand négligé*" – as the key to the picture.[2] A poem on Manet's "Nana" was even published, which included the following stanza:

> More than nude, in her chemise, the *fille* shows off
> Her charms and the flesh that tempts. There she is.
> She has put on her satin corset and is getting dressed
> Calmly, near a man, who has come to see her.[3]

But how can Nana be described as "more than nude" when she reveals hardly more flesh than a woman in an evening gown? Why is her corset so erotic? What does it mean to compare the satin corset with the nude – specifically, the modern nude?

As the art historian Marcia Pointon observes, the nude is "a form of visual rhetoric."[4] Defined as a naked or unclothed person or body, or a representation of the naked body, the nude carries a range of cultural meanings. In metaphorical and philosophical terms, nakedness has often been regarded favorably. We speak of "the naked truth," because, like Plato, we believe on some level that nakedness signifies both ideal form and eternal verities, and that the truth can be seen once the veils of illusion and deceit are stripped away. Conversely, the Judeo-Christian tradition asserts that the naked, fleshly body is sinful, while the soul is clothed in glory. Within most cultures, it has generally been regarded as indecent and immoral for actual living people to appear naked in public.

Anatomical nakedness, however, may be transposed into artistic nudity, while fashionable dress may be criticized on moral grounds. In Titian's *Sacred and Profane Love* (c. 1515), sacred love is a nude figure and profane love is clothed in contemporary dress. Nudes have long been a recognized artistic genre; and during the nineteenth century they were widely, although not

Edouard Manet, *Nana*, 1877. Hamburger Kunsthalle, Hamburg. Photograph © Elke Walford, Hamburg.

universally, accepted as an element of high culture. The Salon was full of paintings and sculptures of naked men and women.

Not all nudes were created equal, however. Some nudes, such as Cabanel's *Birth of Venus* (1863) were successfully sanitized. Stripped of (most) disturbing references to carnality and individual particularities, and clothed in the aura of mythology, wholeness, and contained form, the high-art nude could be admired as an example of "ideal beauty." Other nudes, such as Manet's *Olympia* (1863), were controversial – not so much because they depicted naked women but because they clearly alluded to modern fashion, suggesting that nakedness was an impermanent condition. We cannot, therefore, simply assume that *Olympia* is to *Nana* as the Naked is to the Clothed. In her book *Seeing Through Clothes* (1975), Anne Hollander demonstrated that the clothed body is not the opposite of the naked body, but a variation on it: "The rendering of the nude in art usually derives from the current form in which the clothed figure is conceived."[5] This can be seen quite clearly by comparing Goya's *Naked* and *Clothed Mayas*, where the breasts of the naked Maya are positioned as if held in place by an invisible corset.

According to Kenneth Clark's influential discourse of 1956 on the naked and the nude, the nude is the naked body "clothed" in art. Yet, as feminist art historians such as Lynda Nead have demonstrated, this assumes that the naked or natural body can exist "as a biologically determined and pre-cultural given."[6] This is highly problematic, however, since even as a biological organism, the body is invariably conceived of as representing certain concepts and ideas. Moreover, when we compare the theorized construct of the female nude with that of the male nude, we find that the female body has often been associated with nature, sexuality, and abjection, while the male body has been associated with strength and wholeness.

Since clothing is perceived both as "an extension of the body" and also as something apart from it, something that can be removed, it exists as a "scandalous intermediary state" (to use Linda Nochlin's phrase) that both "links and separates" the concepts of body and culture.[7] Mario Perniola argues further that "In the figurative arts, eroticism appears as a relationship between clothing and nudity. Therefore, it is conditional on the possibility of movement – transit – from one state to the other."[8] Certain kinds of clothing play an especially important role in "the symbolically powerful economy of the body."[9] Part of the appeal of the corset clearly derived from its status as underwear, a category of clothing that complicates the traditional paradigm of the naked and the clothed, since a person in underwear is simultaneously dressed and undressed.

Underwear increasingly became a focus of sexual interest in the nineteenth century. Traditionally, historians have assumed that this enthusiasm for underwear was the result of sexual prudery about the naked body.[10] This is a serious

Caricature of Manet's *Nana*, from *La Vie Parisienne*, 1877.

MANET : *Nana.* — Petite planche de toilette pour l'intimité. Corset de Mme X... Lingerie de Mme Y... Honneur au courage malheureux !

oversimplification. Concealed from sight, like the body that it touches, underwear implicitly alludes to the act of undressing, a transition often perceived as a prelude to sexual intimacy. By delaying the sight of the naked body, layers of clothing and underclothing function as a kind of striptease, arousing sexual curiosity by holding in promise the thrill of exposure. Moreover, the sexual charm of the naked body seems to "rub off" on underwear, which then adds an additional excitement all its own. In *Au Bonheur des Dames* (1883), for example, Emile Zola describes the lingerie on display at a Paris department store looking "as if a group of pretty girls had undressed, piece by piece, down to the satin nudity of their skin."[11]

Courtesans and actresses were the first to wear conspicuously erotic underwear. "The aristocracy of vice is recognizable today by its lingerie," wrote J. K. Huysmans in his review of Manet's *Nana*. "Silk is the trademark of courtesans who rent out at a high price." Who else but a prostitute would permit the "luxury of glimpsed undergarments"? Indeed, far from being merely glimpsed, Nana's underwear is brazenly flaunted. Nor is it ordinary, respectable, modest underwear, such as most women still wore. She is unembarrassed to be seen wearing a luxurious, frilly chemise and a colorful satin corset, because "intelligent and corrupted as she is, she has understood that [such] elegance . . . is . . . one of the most precious adjuncts that *filles de joie* have invented for overthrowing men."[12]

The periodical *La Vie Parisienne* (May 12, 1877) caricatured *Nana*, along with several other paintings at that year's Salon, in an illustration which purported to analyze them in terms of the coming fashions. The society painter Carolus Duran, for example, was described as an "eminent couturier," and the dress in his painting was said to utilize 75 meters of silk, an abundance which would benefit the weavers of Lyon. Manet's painting received much less space and was described simply as "A little illustration of the outfit for intimacy. Corset by Mme X . . . Lingerie by Mme Y . . . Honor to unhappy courage."[13] Since fashions were often specific to the occasion, with teagowns for five o'clock tea and dinner dresses for dinner, then an "outfit for intimacy" alludes to the time allotted for an illicit sexual act, often, in fact, between five and seven o'clock in the evening. The references to Madame

Blue satin corset, c.1890, measuring 32–20–31 inches. From the collection of Joy Meier. Photograph by Irving Solero. Courtesy of The Museum at the Fashion Institute of Technology, New York.

X and Madame Y place the image within the context of commercial fashion illustration – and perhaps also commercial sex.

Focusing closely on the figure of Nana, the illustration, or more accurately the caricature, alters Manet's image in small but significant respects. To begin with, it emphasizes the darkness of her corset and the frill on her petticoat. These, as we shall see, are important erotic signifiers within the fashion code

of the time. Her clothed male companion – whom Manet places at the extreme righthand side side of the painting, bisected by the edge of the picture frame – is here shown full-face and pushed up close to Nana's derrière. His presence is clearly regarded as significant, and so is her use of cosmetics, for, instead of simply holding a powder puff in one hand and a lipstick in the other, Nana is shown actively powdering her face. Most striking, however, is the alteration in her corseted torso. Manet's Nana is voluptuously plump. But the caricature emphasizes the swollen curve of her abdomen, so that she looks almost pregnant. Perhaps this merely exaggerates the curves of the corseted figure, but it may also be a joke about the consequences of sexual intimacy.

In her blue satin corset, Manet's Nana is every inch the fashionable *demimondaine*, since in the 1870s most respectable women still wore plain white corsets. According to *La Vie Parisienne*, "The proper and virtuous woman [*la femme comme il faut et honnête*] wears a white satin corset; never a colored corset." White satin is praised as "The king of corsets! Flexible, shimmering, soft against the body that it delineates without squeezing." Like its wearer, it was elegant

Henri de Montaut, *Les Etudes sur les Femmes*. Plate II: *Les Corsets*, 1882. The Metropolitan Museum of Art, The Elisha Whittelsey Collection, The Elisha Whittelsey Fund, 1951. (51.624.3). Photograph © 2000 The Metropolitan Museum of Art, New York.

Figure of the cocotte, detail from Henri de Montaut, *Les Dessous*, from *La Vie Parisienne*, May 2, 1885.

and seductive, soft and white, but not too overtly sexual.[14] *Etudes sur la Toilette: Les Corsets* (January 15, 1881) by Henri de Montaut was one of a series of centerfold illustrations in *La Vie Parisienne* that provides information about the sexual and social meanings associated with fashionable undress. It focused on different categories of women and corsets.

Some corsets are "poems," while others are "stupid and ugly." By implication, some women are sexually attractive, while others are not. The corset functions here as a synecdoche for the woman herself. Thus, there was a subtle but important difference between the ideal white satin corset and "the decent corset," although this, too, was generally "white satin or silk, sometimes pearl grey." However, the decent corset encased a figure of which "there is always too much or not enough." Consequently, it has "numerous bones that hide the absences or disperse the assemblages" of flesh. Although cleverly made, this corset "does not succeed in deceiving anyone" – or not for long. The reference to decent corsets was probably an allusion to the sexual deceptions practiced by supposedly decent women, but it also serves to remind us that the corset did not only function as a sexualizing device. It was also perceived as a necessity if a woman were to be decently dressed.

Black lingerie is today perceived as highly erotic, but according to Henri de Montaut the plain black satin corset was "forbidding" and "decent." However, the black satin corset was also "the ideal of the little laundress who is considering going bad" – especially when accompanied by brilliant blue garters. Even after colorful satin corsets and petticoats had become fashionable in the 1880s, some observers perceived the style as a manifestation of decadence and neurasthenia. As one French writer of the 1890s put it: "Color,

Cover illustration for a miniature advertising calendar and brochure for Thomson's Glove-Fitting Corsets, 1904.

Trade card for Kabo corsets, c. 1890.

in the secret clothing of women, is an entirely modern taste, deriving no doubt from the nervousness that torments our imagination, from the dulling of our sensations, from that unceasingly unsatisfied desire that causes us to suffer . . . and that we apply to all manifestations of our feverish life."[15]

The visual and tactile appeal of fashionable corsets was certainly part of their mystique. Despite criticism, the modern taste for luxurious, erotic lingerie grew steadily. Another centerfold from *La Vie Parisienne*, "*Les Dessous*" (May 2, 1885), elaborated on the correspondences between women and corsets. The *cocotte*, a woman whose role was primarily sexual, was addicted to "*jeu de corsets.*" One of these fanciful corsets has a design of peacock feathers. Another corset of "tea-rose" colored satin was also apparently designed for the woman of easy virtue: "Very elegant and extremely becoming. Evidently destined to be seen and . . . looked at!" The "true corset of combat," it was scented with a perfume that "smells stronger as it grows warmer."[16]

Clearly, certain kinds of corsets were regarded as being especially erotic. However, sexual display was always interpreted in conjunction with other criteria, such as the woman's class, age, and body type. The *parvenue*, for example, wore ornate "brocade corsets" with embroidery, lace, and bows. This did not necessarily indicate that she was personally immoral, but it did demonstrate a lack of breeding: "a display of unprecedented luxury, but no real elegance." She was quite mistaken in believing that she dressed in an aristocratic manner. The simplest corset was sometimes best, de Montaut continued, particularly for "the young girl," who was advised to wear a "corset of white coutil – the one that almost always contains the prettiest things." It was judged to be "more provocative, despite all, than many others that attempt to be more" – a conclusion that might apply to its wearer as well.[17]

Montaut and Manet were certainly not the only artists to portray a woman in her corset, and their work would have been interpreted in its own time in the light of earlier images, from the eighteenth-century *essai du corset* to the erotic prints of the 1830s. Literature also was full of references to the erotic appeal of corsets. Rousseau's *La Nouvelle Héloïse* describes how Julie's breasts leave "delicious imprints" on the inside of her stays. Moreover, the term Rousseau uses for corset is *le corps*, and as Peter Brooks points out in *Body Work*, "The corset is a body, one that 'embraces' and gives form to the body, and in turn takes its shape from the body."[18] As we have seen, the very act of pushing the stay laces through the holes of the corset functioned as a metaphor for sexual intercourse. Indeed, *La Vie Parisienne* printed a story, "La Corbeille de Mariage" (1884), in which the nuptial night is described in terms that directly link the unlacing of the corset with the act of making love:

Trembling, happy, your husband unlaces you with an uncertain and clumsy hand, and you laugh, mischievously, joyously ascertaining that his confu-

sion is caused by the sight of your beauty. You are happy to feel your omnipotence: you take care not to help him untie the knots or find his way among the lace-holes; on the contrary, you take pleasure in prolonging his tentative gropings, which tickle you deliciously.[19]

Feminist historians have argued that the "erotic connotations" of the corset were "closely related to . . . constriction and pain," and were probably "more appreciated by men than by women."[20] Yet this conclusion is based on a confusion between ordinary fashionable corsetry and the minority practice of fetishistic tight-lacing, which did, indeed, overlap with sadomasochism and transvestism. One of Montaut's pictures for *La Vie Parisienne* depicts a corseted "old beau," but he seems to function as a comic stereotype, like the unstylish provincial. Neither extreme body modification nor sadomasochism was the central issue for most nineteenth-century men and women who found corsets in some way an adjunct to feminine erotic beauty. The controversy surrounding tight-lacing, while fascinating in its own right, has obscured the corset's other erotic associations, which were many. *La Vie Parisienne*, for example, loved corsets, but warned that if a woman laced too tightly, her corset would "vein the skin . . . [and] create red lines and creases that are very slow to fade."[21]

Manet's characterization of the satin corset as the modern nude strongly recalls the art criticism of his contemporaries Charles Baudelaire and Théophile Gaultier. In his review of the Salon of 1846, Baudelaire had argued that the contemporary nude would be depicted in bed (like *Olympia*) or in the anatomy theatre. By 1863, when he published *The Painter of Modern Life*, he put the nude under the sign of the "natural," and privileged the artificiality of fashion. For Gaultier, too, the nude seemed outdated, and he advised modern artists to focus on portraying the contemporary clothed figure. Fashion was not only the key to modernity, it was increasingly central to the artist's conception of female erotic beauty. As Baudelaire put it: "What poet would dare, in the depiction of the pleasure caused by the sight of a beautiful woman, separate the woman and her dress?"

Manet's pastel *The Garter* (originally known as *The Toilette*), for example, depicts a woman in a corset and petticoat. As she leans forward to fasten her garter, her corset pushes up her breasts and presses them together in a display of opulent flesh that shocked most critics. But as Huysmans enthusiastically observed: "To envelope his people with the scent of fashion to which they belong, such has been one of M. Manet's most constant preoccupations."[22] By contrast, the nudity of antique statues apparently left most nineteenth-century viewers cold, if we may trust their smug references to "the chaste beauty of the Grecian model."[23] However, when nudity recalled the presence of clothing, it aroused controversy. "Take an antique Venus, pure as the day, and pare her down to the fashionable dimensions of a modern corset, and

Edouard Manet, *Woman Fastening Her Garter*, 1878–9. Ordrupgaard, Copenhagen. Photograph by Ole Woldbye.

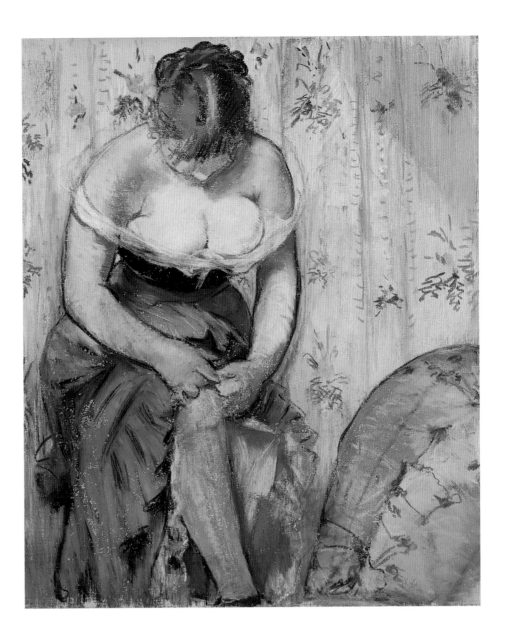

see how the chastity of divine truth would depart, and feelings of disgust and immodesty usurp their place,"[24] declared one anti-corset writer for whom the sexual attraction of modern bodies was all too apparent.

Like Manet's *Nana*, Henri Gervex's painting *Rolla* (1878) caused a scandal, because of the way it linked dress, undress, and sex. Based on Alfred de Musset's poem "Rolla," the painting told the story of a young man's ill-fated love affair with a courtesan. Gervex chose to paint the moment just before Rolla commits suicide, having spent the last of his money on Marion, who lies sleeping, naked, on the bed. There was nothing objectionable about Gervex's depiction of the nude Marion. What caused the picture to be banned from the Salon was the pile of clothing next to the bed. In a jumble, half on the floor and half on an armchair, lie Marion's pink

121

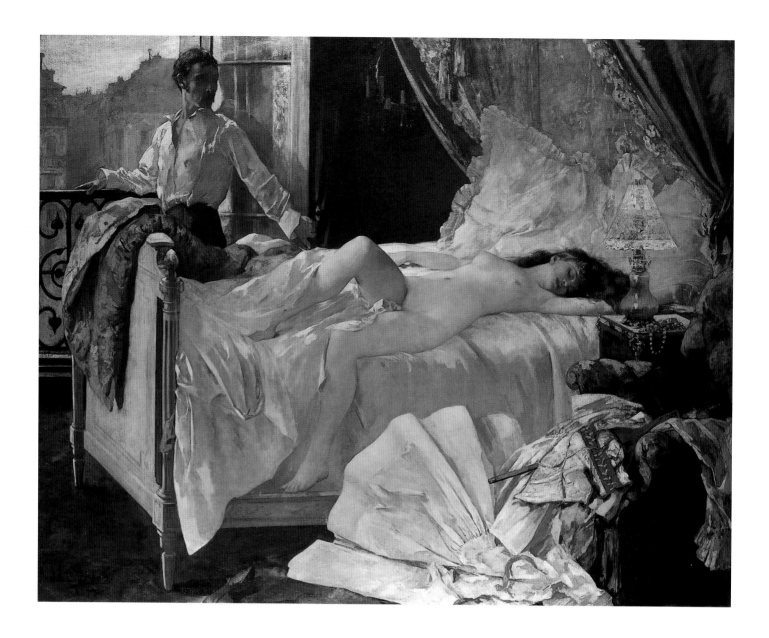

Henri Gervex, *Rolla*, 1878. Musée des
Beaux-Arts, Bordeaux.

dress and stiff white petticoat, punctuated by a rose-colored garter and a red
corset, which is splayed open to reveal its white lining. Protruding from
underneath her corset is the man's cane. In the corner of the armchair lies
his top hat.

In her book *Painted Love*, Hollis Clayson points out that this sartorial "still-
life . . . enacts a surrogate intercourse in the foreground of the postcoital
human scene." The layering of the clothing also indicates that "she was appar-
ently out of her corset before he put down his hat." Contemporary critics
who defended Gervex's work argued that "our censors" were threatened by
the modernity of the figures, as identified by their clothes: "a man in his shirt
sleeves, and, upon an armchair a top hat of the latest style, an umbrella (*bone
Deus!*), a corset (horrors!) . . ." Many years later, Gervex recalled that Degas

had suggested painting the clothes: "You have to make them understand that 'your' woman is not a model. Where's the dress she's taken off? Then put a corset on the floor!" When the Salon ordered the painting's removal, Degas triumphantly declared, "You see . . . they understood that she's a woman who takes her clothes off."[25]

In a notebook entry of about May 1879, Degas reminded himself: "Do all sorts of objects in use, placed and accompanied so as to have life . . . corsets, for instance, that have just been taken off and that seem to retain the shape of the body, etc., etc."[26] He had, in fact, already included a still life of a corset lying on the floor in his *The Interior* (1868–9). This painting, also known as *The Rape*, depicts a disturbing scene involving some kind of dispute between a man, standing with his back against the bedroom door, and a woman, cowering on the floor, wearing only a chemise, which has slipped off her shoulder. It is easy to imagine that it depicts the aftermath of an unhappy sexual encounter.

Edgar Degas, *Woman Combing Her Hair before a Mirror*, c. 1877. Norton Simon Art Foundation, Pasadena, CA.

Degas also did another, little-known painting of a woman in a white corset, *Woman Combing her Hair before a Mirror* (c. 1877). Unlike many of Degas's works devoted to women at their toilette, it does not seem to show a prostitute. Indeed, the woman looks as demure as a bride in her spotless chemise and white satin corset. There is no question, however, that such an intimate scene carried erotic connotations, although the motif of hair may be more significant for Degas than the corset, since a model once remarked of Degas: "He is an odd monsieur – he spent the four hours of my posing session combing my hair."[27] Degas did several other works devoted to women combing their hair or having it combed, but *Woman Combing her Hair* seems to be his only picture of a woman in a corset, not including those of his ballet dancers who wear corselets instead of sashes. There is certainly something very Parisian, very elegant about this painting of modern life. Not as overtly erotic as *Nana*, the work resembles, instead, another of Manet's paintings.

Manet's *Before the Mirror* was probably painted at about the same time as *Nana,* although it was not exhibited until 1880. Popular opinion associated the two works. Indeed, Paul Alexis called it *Nana Before the Mirror*, probably because the model wore the same blue corset and the same haircomb.

Edouard Manet, *Before the Mirror*, 1876. The Solomon R. Guggenheim Museum, New York. Thannhauser Collection, Gift of Justin K. Thannhauser, 1978. Photograph by David Heald © The Solomon R. Guggenheim Foundation, New York.

A. Grévin, "What a Bore!" from *Les Parisiennes*, c. 1880.

Although she is seen from behind and her face is not visible in the full-length mirror, the model was apparently again Henrietta Hauser. According to Manet's biographer, *Before the Mirror* "seems to be a preparatory oil sketch for *Nana* and may have been the subject Manet had in mind: a woman at her toilette, the invasion of a woman's private space . . . and a tantalizing crossover from tart to bourgeoise."[28] Without her male friend sitting on the sofa watching her, and without her gaze locking into ours, the model becomes her own love object.

A number of artists and illustrators in France appear to have been influenced by Manet's *Nana*. The cartoonist A. Grévin, for example, specialized in

images of prostitutes and actresses, collectively characterized as *Les Parisiennes*. Under the title *What a Bore!* he depicted a shapely young woman in a corset standing in front of her seated lover, complaining, "Your family, your family . . . Do I bore you like that about my family?" Another Grévin illustration, *Between Intimates*, showed a young woman holding open the top of her corset, saying, "Too squeezed! Oh, my friend . . . Doctor, put your hand here." More oblique is Théodore de Banville's *Faute de s'entendre* (which might be translated as "If We're Not Getting Along"), which shows a maid lacing her mistress in front of a man, who is presumably the woman's lover. Seurat combined elements from both *Nana* and *In Front of the Mirror* in *Woman Powdering Herself* (1889–90), which depicted his common-law wife Madeleine Knobloch sitting in front of her dressing table, her ample figure crammed into a corset, her bosom almost spilling out. Only her "downcast eyes and introverted demeanor" keep her from looking like a vulgar tart.[29]

Toulouse Lautrec portrayed another full-bodied woman in a corset in his *Femme à la toilette*, also known as *Conquête de passage* (1896), an expression that can be translated as "Street Seduction." This oil sketch was the basis for

BELOW LEFT A. Grévin, *Between Intimates*, from *Les Parisiennes*, c. 1880.

BELOW RIGHT Théodore de Banville, *Faute de s'entendre*, c. 1880.

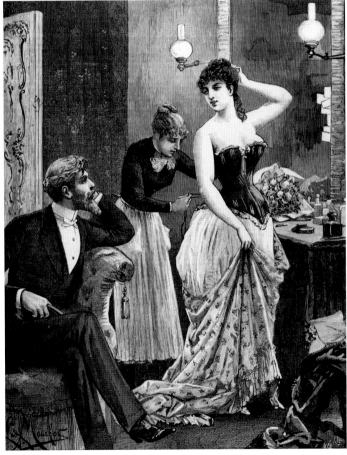

FACING PAGE Georges Seurat,
Woman Powdering Herself,
1889–90. The Courtauld
Institute Gallery, London.

RIGHT Henri de Toulouse
Lautrec, *Conquête de passage*,
1896. Musée des Augustins,
Mairie de Toulouse.

Eugène Vidal, *Jeune fille au corset rose*.
Monochrome illustration from Libron,
Le Corset. Present whereabouts of original
pastel drawing unknown.

a lithograph with the more complete title *Femme en corset, conquête de passage*,
which was part of an album of eleven color lithographs on the intimate life
of prostitutes. Occupying the center of the picture is a seated woman reach-
ing back to tighten her corset laces. She is intently watched by a man, posi-
tioned at the side of the picture. The only masculine figure in the series of
lithographs, he alludes directly to the top-hatted man who sits watching

Nana. Not only does the corset evoke the modern nude, the real body of a living woman, but that woman is often implicitly a courtesan or prostitute.

A student of Gerôme and friend of Degas, Eugène Vidal, also did a pastel drawing, *Jeune Fille au corset rose* (1896), which depicts a young woman reaching back to lace or unlace her pink corset. The "lazy lacing" system (which made it possible for a woman to deal with her corset laces unaided) was well established by the 1890s, and at the same time colored satin corsets had become extremely fashionable, so we can no longer assume that the wearer is a prostitute; but the drawing conveys an air of sexual allure. Although the majority of corsets produced in the late nineteenth century were still white, black, or drab, pink was regarded as an appropriate and flattering color. A woman with such a slender figure would probably have worn a corset that was discreetly padded in the bosom.

The New Temptation of Saint Anthony, 1895.

The 1890s was the great epoch of lingerie, however, and it seems that for many men then, women in intimate undress were more sexually stimulating than the naked, unadorned body. A French caricature, *The New Temptation of Saint Anthony* (1895), for example, showed the saint unmoved by a naked female figure but aroused to delight after she dons her chemise, drawers, and corset.

Very different, yet equally revealing of cultural attitudes, is an American trade card from roughly 1880, which also depicts a contemporary woman in fashionable underwear. This trade card advertised the Adjustable Duplex Corset, made in Jackson, Michigan and available at the company's New York salesroom at 17 Mercer Street. When folded closed, the card shows two young women, one with her eye to the keyhole of a door. The captain reads: "The Secret Out at last – Why Mrs. Brown has such a *perfect* figure." When unfolded, the scene behind the door is revealed, as Mrs. Brown stands

American trade card (open and closed) for the Adjustable Duplex Corset: "The Secret Out at Last – Why Mrs. Brown has such a *perfect* figure," c. 1882.

FACING PAGE Berthe Morisot, *The Psyché*, 1876. © Museo Thyssen-Bornemisza, Madrid.

in her (white) corset and petticoat, admiring herself in the mirror. No men are present in her boudoir, not even Mr. Brown. Or, perhaps we should say, especially not Mr. Brown, since his wife clearly has eyes only for herself. Nor is there necessarily a male gaze directed at her from outside the picture, as is implicit with Manet's *Nana*. There is, however, not only a palpable sense of autoeroticism, but also an overt display of voyeurism on the part of the two other women. Probably neither the corset manufacturer nor those who viewed the card (predominantly male shopkeepers and salesmen, as well as female consumers) were fully aware of the sexual undertones of such an image.

The mirror, that traditional symbol of female vanity, is common in nineteenth-century art and popular illustration. But what kind of image of themselves did women see? In her book *Berthe Morisot's Images of Women*, Anne Higonnet suggests that the female painter often seems to invite "a public and masculine gaze into private feminine space." Morisot's painting *The Psyché* (1876), for example, depicts a young woman gathering her loose chemise around her waist, as though she were considering how her figure would look after putting on a corset. According to Higonnet, "She is

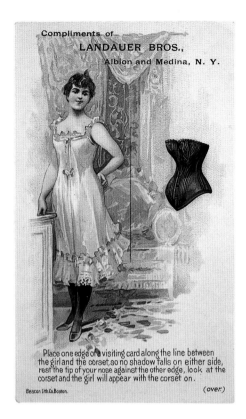

Trade card for Ball's Corsets, 1880s.

absorbed by the mirror image of alterations intended for the public eye, more specifically by the artifices of contemporary eroticism."[30] This may be so – and yet the "public eye" is not solely a masculine one, nor is eroticism simply an artificial construct.

Some corset images were almost certainly directed at a masculine gaze. For example, the Landauer Brothers of New York advertised Ball's Corsets with a trade card that played with visual perception: on the left side of the card was a picture of a young woman in a frilly chemise; on the right was a black 1880s corset. The viewer was instructed to "Place one edge of a visiting card along the line between the girl and the corset, so no shadow falls on either side, rest the tip of your nose against the other edge, look at the corset and the girl will appear with the corset on." Other advertising images, however, seem to presume a female viewer, albeit one who may have internalized the vision of herself as a spectacle for others' eyes. Whether the spectators were presumed to be masculine is another open question.

"The only satisfaction a woman can get from having a wasp-waist is the envy of other silly women," complained the beauty writer Henry T. Finck in 1887.[31] But, perhaps, women were not solely concerned with their appearance in the eyes of others. In the mirror, they may also see their own erotic ideal of beauty, at least insofar as their conception resembled their culture's image of female erotic beauty. Clearly, the idea of looking at a woman in her corset was regarded as erotic, whether the gaze was male or female, autoerotic, or voyeuristic. A wealth of information strongly suggests that by the end of the nineteenth century many "respectable" women were also embracing the concept of erotic lingerie.

RIGHT Trade card for Ball's Corsets, 1880s.

FACING PAGE Corset box label for the Jewel-Case Corset. The Leicestershire Museum and Art Gallery.

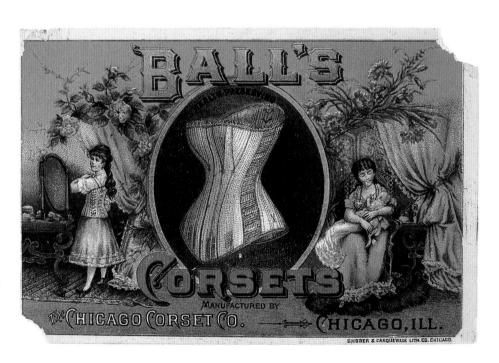

Fashion journalism and advertising increasingly emphasized the importance of luxurious and seductive lingerie, including colorful, decorative corsets. The information contained in corset advertisements – including corset names, images, and text – tells us a great deal about what manufacturers thought would appeal to women. Corset names evoking mythical or even divine beauty include the Venus Corset, the Diana, *Le Corset Déesse* (Goddess), and the Cleopatra. *La Samothrace* was named after the classical Greek statue, the Nike (or Victory) of Samothrace in the Louvre. The IC Persephone Corset was named after the Greek goddess of fertility. The Leda, billed as the "Queen of Corsets," was named after Jupiter's lover, whom he took after assuming the form of a swan. The Swanbill Corset, whose logo was a swan gliding past waterplants, was probably intended to conjure up the image of a gently curving figure.

Other corset names alluding to beauty and charm include the Perfection, the Statuesque, *L'Irrésistible*, *La Délice*, *Le Svelte*, the Serpentine, the Radiant, the Enchantress, and *La Sylphide*. The Rival Corset ("perfect shape") and Thomson's *La Fiancée* promised physical beauty and success in marital competition. Many corset names were romantic, such as *L'Aimée* (the Loved One), *Le Rêve* (the Dream) and L'Apparition. Some were named for jewels, such as the Sapphire, or compared to jewels, as when the Specialité Corset was likened to "that Gem of Gems, the Diamond."

The names could also allude to exalted status: the Princess, the Duchess, the Viscountess, the Empress, Her Majesty's Corset, La Chatelaine, and the May Queen. Since it was widely believed that "The possession of a slender waist is a question of race," corsets with "aristocratic" names implicitly promised a "refined" figure. Both French and English corsets were given the name "jewel box," which in Freudian dream symbolism refers to the female genitals. Most people, of course, would probably not have consciously been aware of such symbolism. The Grand Calyx Corset of Madame Guillot, "creator of mystery," refers to the outer ring of parts in a flower. Such a term may be obscure today, but in the nineteenth century legions of amateur botanists would have known that flowers are not only a symbol of feminine beauty but also the sex organs of plants.

In addition to the text, the images used in corset advertisements provide clues about women's desires, at least as these were perceived by advertisers. In the fantasy lives of many women, the corset seems to have symbolized a dream of beauty, love, and happiness. Corset advertisements implicitly promised that by changing her corset (body), a woman could change her life. A trade card promoting "A True Story of The Madame Warren Corset" shows a sequence of four vignettes or "chapters" surrounding a central image of a woman in a corset admiring herself in a hand mirror. At the upper left is the first vignette, depicting a stiff, boyish-looking figure dressed in a plain red bodice and bustle skirt. Staring in a mirror, she exclaims: "Oh, how

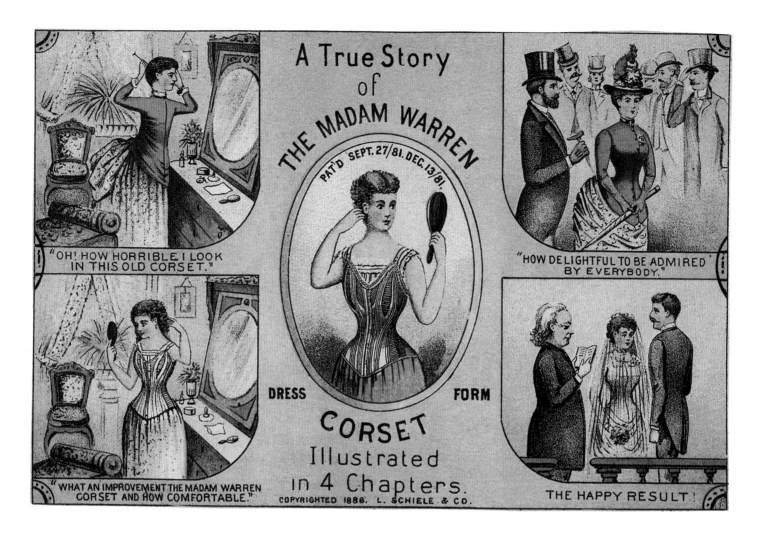

Trade card, "A True Story of The Madam Warren Corset," 1880s.

horrible I look in this old corset!" The second vignette shows her in a petticoat and corset, which reveal the curves of her torso. "What an improvement the Madame Warren Corset and how comfortable." In the third picture she is shown fully dressed, in her same red bodice and bustle skirt, but now showing off a curvacious figure. Surrounded by gentlemen in top hats, she thinks to herself, "How delightful to be admired by everybody." The final scene shows her in a bridal gown, together with the groom and a minister. The caption reads: "The happy result."

One especially erotic corset advertisement appeared at the turn of the century in several English fashion magazines. It shows a beautiful sleeping woman on a sofa. Her lacy peignoir is open, revealing her corseted torso above a smooth petticoat ending in a mass of frills. The caption reads: "The Specialité Corset is a Dream of Comfort." An American trade card from two decades earlier also showed a woman sleeping in the clouds, a bare arm and leg luxuriously outstretched, and surrounded by putti, with the caption, "Blissful dreams assured by using Warner Bros Coraline Corsets." Since few

"The Specialité Corset is a Dream of Comfort," from *The Gentlewoman*, 1901. The Gallery of English Costume and Platt Hall, Manchester. © Manchester City Art Galleries.

women still slept in their corsets, these images can not be taken literally. Dreaming, not sleeping, was the issue here.

Men also had dreams, both pleasant and threatening. Within the pages of *La Vie Parisienne*, studies of the toilette functioned primarily as studies of Woman herself. The centerfolds devoted to corsets and underwear formed part of a more general investigation into women's erotic lives as revealed through fetishized items of clothing. The series also included illustrations of shoes and stockings, underpants, and chemises, as well as related centerfolds with titles such as "*Comment Elles S'Habillent de Nuit*" (November 9, 1878) and "*Intimités – Toilettes d'Intérieur Offensives et Defensives*" (June 2, 1883). *La Vie Parisienne* was not an ordinary fashion magazine, since it presented a highly sexualized and often satirical view of fashion, and was directed more toward men than women. Yet it articulated more clearly than most publications what men desired and feared about the female body.

Images of female physical beauty arouse conflicting feelings, observes Francette Pacteau in her book *The Symptom of Beauty*. "Some feminist writers . . . attempt to 'demystify'; or . . . altogether *repress* [such images] in favor of 'positive' representations of women." Yet, she argues, "To speak of the subordination of woman's desire to men's fantasies is to apply a sociological model to the workings of the unconscious, one which overlooks its structural autonomy and negates the way in which fantasies circulate between subjects – the fantasy production of one inflecting that of the other."[32]

Evidence that some men found the female body (almost always) seriously flawed can be seen in the illustration "*Avant et Après le Corset,*" published in *La Vie Parisienne* (September 9, 1882). For the illustrator Henri de Montaut, neither the "before" nor the "after" was satisfactory. The woman at the upper

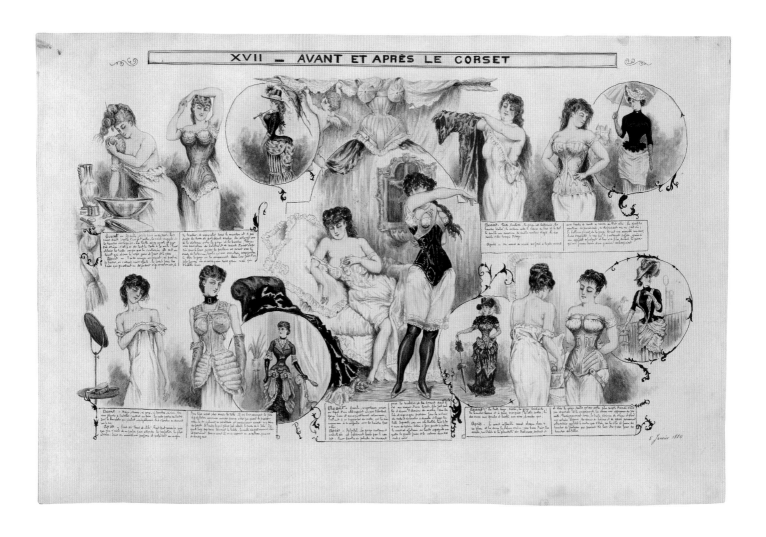

Henri de Montaut, *Les Etudes sur les Femmes*. Plate XVII: *Avant et après le corset*, 1882. The Metropolitan Museum of Art, The Elisha Whittelsey Collection, The Elisha Whittelsey Fund, 1951. (51.624.3). Photograph © 2000 The Metropolitan Museum of Art, New York.

left, for example, is described as "large" and "*svelte*," but with a waist that is "rather short and not very slim . . . not at all the fashionable waist." "She puts on a corset that pinches and spoils the young, fresh body," making her "stiff as a post." Now she will look well-dressed. Although Montaut initially seems to be critical of corsetry, his descriptions of women's bodies become increasingly derogatory.

The woman at the lower left of the picture is described as "Thin, bony; no bosom, no hips, no nothing." So she equips herself with "rubber breasts that palpitate" automatically when touched, rubber hips and derrière, even long padded gloves. The final product is so obviously artificial as to be repulsive: "With this corset, one often has adventures, but never *a rendezvous*." Another woman is fat. Her "waist seems like a succession of double chins." Squeezed into a reinforced corset, "the double chins disappear, dispersing themselves one knows not where." Still another woman has a "large" waist, a "falling" bosom, and hips that are "scarcely indicated." The corset "flattens the stomach which spreads out on the sides and forms fantasy hips, that can be taken for real ones." A "steel bar raises the bosom."

The central and largest figure is that of a "grand, still majestic" woman, but her "plumpness . . . is a little too overflowing." Specifically, her "low and remarkably voluminous bosom tends to approach the stomach which, itself, is beginning to be lost in the bulging hips." In her corset, though, she is "Splendid!" But this estimation is immediately qualified: her flesh only "gives the illusion of marble." The fat on her stomach and hips has not disappeared, but only been pushed down, and her breasts require a harness to hold them up. If she appeared in a dress cut low in back, her fat would swell out. In short, whatever her clothed appearance, the woman's real body was almost always flawed and ugly. Particularly striking is the way Montaut tends to envision the female body as soft, formless, almost fluid – only held together by the rigid armature of the corset.[33]

This image of the flawed female body reveals an underlying anxiety, which the corset only partially assuaged. Eugène Chapus, author of the 1862 *Manuel de l'homme et de la femme comme il faut*, put it bluntly: "A woman in a corset is a lie, a falsehood, a fiction, but for us this fiction is better than the reality."[34] "Nature . . . has had her day," mused the hero of Huysmans' decadent novel, *A Rebours* (1884). Even her most beautiful work – woman – has been exceeded by "an animate yet artificial creature" – the railway locomotive, which is described as a sensuous body "imprisoned in a shiny brass corset," or "encased in armour-plating of cast iron." Her energy, grace, and "fantastic power" are terrifying "when she stiffens her muscles of steel [and] sends the sweat pouring down her steaming flanks."[35] Conversely, in his poem "Vowels," Arthur Rimbaud evoked the image of a putrefying female body when he characterized the letter A as a "furry black corset of spectacular flies that thrum around the savage smells."[36]

Unidentified corset advertisement, c. 1905. Bibliothèque des Arts Décoratifs, Paris.

Klaus Theweleit's analysis of male fantasies among members of the German Freikorps indicates that many men have envisioned the female body as soft and fluid, in comparison with the hard male body.[37] Yet, as Lynda Nead observes,

> Although there is an absolute contrast between the psychic conceptions of the male and female body (a contrast between the hardness of male form and the deliquescence of female matter), there is a striking identity between the idealized forms of the male and female body, in both of which the threat of the flesh must be remorselessly disciplined. . . . The characteristically female body is paradoxically subject to a masculinization, in order to make it conform to the ideal of the male body that precisely depends upon a dread that the male body might itself revert to what it is feared may secretly be its own "female" formlessness.[38]

The classical male nude with its armature of muscles is significantly known as the *cuirasse ésthetique*. Thus, the ideal male body is implicitly envisioned as corseted, albeit in a corset of muscles. The nude female body "become[s] art

by controlling and containing the limits of the form."[39] By armoring the surface of the body, the corset also serves to conceal the inside of the body and to control the form of the body.

It may seem perverse to imagine corsetry in terms of the "masculinization" of the female body, since the corset was primarily a woman's garment, but it undeniably served to make the torso hard and erect. We find a similar psychic function in the military uniform, as described in Herman Broch's 1931 novel *The Sleepwalkers*:

> A uniform provides its wearer with a definitive line of demarcation between his person and the world. . . . It is the uniform's true function to manifest and ordain order in the world, to arrest the confusion and flux of life, just as it conceals whatever in the human body is soft and flowing, covering up the soldier's underclothes and skin. . . . Closed up in his hard casing, braced in with straps and belts, he begins to forget his own undergarments, and the uncertainty of life.[40]

The military uniform, like the corset, has long been recognized as a common sexual fetish, which exhibits what Walter Benjamin called "the sex appeal of the inorganic."

Notwithstanding masculine obsessions with the phallus, castration anxiety, and female virginity, women's own experience of bodily integrity and its dissolution may have more to do with parturition than anything else. For women also had fears about sexuality, and it may be significant that the cultural theorist Julia Kristeva likens abjection to the bodily state of pregnancy, which positions the maternal body at the borderline of categories, between life and death, self and other.[41] Certainly, women articulated the fear, which was well founded, that repeated pregnancies permanently altered the figure. It may be relevant, then, that the gradual disappearance of the corset in the twentieth century coincided with a decline in the birthrate, as well as an increasing assimilation of female roles and body imagery to the male model of a muscular corset.

Hostility to tight-lacing probably derived more directly from cultural anxieties about female sexuality than it did from a feminist critique of the restrictions placed on women. At the same time, however, for many men and women, the corset represented female sexual beauty, and some of men's hostility to the perceived threat of dress reform may have derived from fears that emancipated women would reject a sexual role. The following text represents an unofficial advertisement, a "puff," for Léoty corsets, published in *La Vie Parisienne* in 1886:

> The corset will live as long as the innate desire to please lives in woman's heart . . . They have tried to combat it. . . . Vain efforts! Useless furies! . . . One can destroy a religion, overthrow a government; against the corset

Figure of the *gratineuse*, detail from Henri de Montaut, *Les Dessous*, from *La Vie Parisienne*, 1885.

one can do nothing! Hail, then, intimate and mysterious garment that increases the charm of women. . . . Hail, O corset! You are blessed by all women, and even those whom nature has overwhelmed with gifts cannot pass your competitive exam. Your reign has come without having been predicted by the prophets, and the clamors of hell do not prevail against you! May your power grow still greater, if this is possible, and may your name be glorified all over the earth. . . . Amen.[42]

The reference to competitive examinations was probably a passing blow at the idea of education for women. There is also an obvious allusion to the Hail Mary in the line, "Hail, O corset! You are blessed by all women." The blasphemy strikes a strange note, but the perception that the corset was being attacked, but would (must?) emerge victorious, may not have been uncommon.

Two of the illustrations in *La Vie Parisienne* provide oblique clues to the emerging demise of the corset. As we have seen, the idea of dress reform frightened many men, in part because it seemed to threaten an end to female sexual beauty. The most negative figure in *Les Dessous* is the *gratineuse*, who sought "to reform the feminine toilette" and so abandoned the corset for a

Detail of the central figure from Henri de Montaut, *Les Corsets*, from *La Vie Parisienne*, 1881.

Mlle Lavalière, *Figaro-Modes*, 1903.

Mme Réjane, *Figaro-Modes*, 1903.

"very solid and tight" silk jersey. Such a woman, complained Montaut in 1885, had a "total absence of the desire to please or agitate the gentlemen" – and that, after all, was the primary function of the corset as far as *La Vie Parisienne* was concerned. The central figure in *Les Corsets* is also uncorseted and wears only a "silk maillot." Yet this woman is presented as being extremely beautiful and seductive. According to *La Vie Parisienne* of 1881: "The best is, without any doubt, not to wear a corset, but it is necessary to be able to do without it, and this is extremely rare. One has more or less need of it (generally more than less)."[43]

By the early twentieth century, however, attitudes toward the corseted body were changing, as we can see from a series of interviews with actresses published in *Figaro-Modes* in 1903. Each actress was asked about her fashion preferences, such as her favorite couturier and milliner – and her favorite type of corset. Most complied, naming a variety of corsetières. But when the interviewer asked Madame Réjane about her favorite corset, she replied: "No need." Mademoiselle Eve Lavallière also maintained: "I don't wear corsets."[44] In their photographs, both women appear to be corseted, but neither was willing to admit to needing artificial assistance. The corset was beginning to be viewed as an orthopedic device for the aging and overweight. It was the beginning of the end for traditional corsetry.

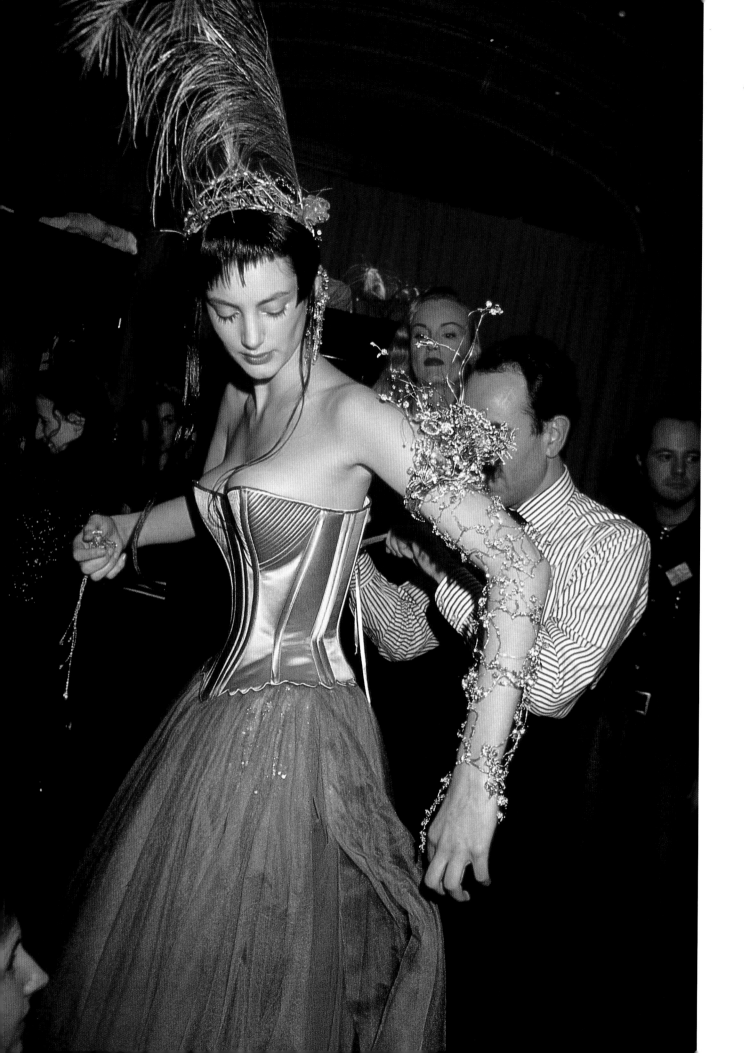

6 The Hard Body
A Muscular Corset

WHY DID WOMEN FINALLY ABANDON THE CORSET? Historians have usually credited the dress reform and women's rights movements for the disappearance of corsetry. The movement for women's rights was, indeed, associated with the movement for rational dress, although by the late nineteenth century most feminists did not make dress reform a high priority. What is incorrect is the conclusion that female emancipation went hand in hand with the progressive reform of women's dress. In fact, by the close of the nineteenth century, "no major dress reform had occurred."[1] Changes were occurring below the surface, however, as there was increasingly said to be a "modern type" of beauty, whose "graceful figure [was] developed by all manner of outdoor sports."[2] Ultimately, this change in the physical ideal – from an opulent Venus to a slender, athletic Diana – would render the corset obsolete. Or would it?

The transition from the whalebone corset to the muscular corset took the greater part of the twentieth century. Despite a growing emphasis on diet and physical exercise, and notwithstanding the development of more flexible girdles, some type of foundation garment continued to be an integral component of the female wardrobe until well into the 1960s. Even after that, the corset did not so much disappear as become internalized through diet, exercise, and plastic surgery – known euphemistically as "body sculpting." As the twentieth century drew to a close, it seemed that the hard body had definitively replaced the boned corset. Yet in recent years, the corset has reappeared in fashion, transformed from underwear to outerwear. As *Vogue* announced in 2000: "It's a cinch. If all else fails, whittle your waist with one of Mr. Pearl's famous couture corsets."[3] This chapter will explore changing attitudes toward the corseted body, as well as the changing symbolism of the corset itself.

The year 1900 saw the appearance of a new luxury periodical, *Les Dessous Elégants*. Directed towards corset and lingerie manufacturers and retailers, the magazine featured elaborate color plates depicting the latest fashionable styles. Typography and line drawings in the Art Nouveau style announced regular features, such as "Le Luxe de Corset" and Dr. O'Followell's "Le Corset: Étude

Christian Lacroix couture evening dress with corset. The model is being laced up by the famous corsetier Mr. Pearl. Photograph 1998 © Roxanne Lowit.

LE CORSET

THE LONDON CORSET CO.
42 NEW BOND ST., LONDON, W.

Corsets from 16|6 to 4 Guineas

Every Corset made in Paris

"LA SAMOTHRACE"

which aptly takes its name from an ancient statue of Greece, is a conspicuous success, thin of texture, admirable of outline, and obtainable in Brocades, or plain or striped Silk Batistes. There are to be found at **42 NEW BOND STREET, W.**, short stays and long stays, stays of broad hips and stays of narrow hips, stays of straight fronts and stays of curves, stays, indeed, adaptable to the needs of all women, and, even as the Frenchman remarked when writing of woman's mind, it may be observed of her body, that 'Souvent femme varie.' She will be wise, therefore, if in search after the corset comfortable and elegant, she devotes her attention exclusively to

The London Corset Company

Médicale et Physiologique," which focused on how to "improve" corsets, rather than abolish them. Nor was this the only publication to promote luxurious corsets and lingerie. Ordinary fashion magazines were scarcely less enthusiastic. Month after month in *The Lady's Realm*, the English fashion writer Mrs. Pritchard elaborated on the theme "Lingerie is an enthralling subject."[4] She insisted that "lovely lingerie" did not belong "only to the 'fast'" and "dainty undergarments . . . are not necessarily a sign of depravity." "The most virtuous of us are now allowed to possess pretty undergarments, without being looked upon as suspicious characters."[5]

Every woman should "go to a first-class *corsetière*," and "learn how best to hide her bad points and bring out the good," declared Mrs. Pritchard.[6] She also explicitly linked "exquisite lingerie" and sexual satisfaction within marriage, blaming failed marriages on the wife's unwillingness to adopt "dainty undergarments." Too often, the "respectable British matron" wore drab underwear and a "well-boned and substantial coutille corset – a veritable armour – generally in that peculiar shade of grey so popular with the well-meaning 'Mother of Many'." Warming to her theme, Mrs. Pritchard asked, "Can one wonder that marriage is so often a failure, and that the English husband of such a class of women goes where he can admire the petticoat of aspirations?"[7] Facing the title page of her book, *The Cult of Chiffon* (1902), was a full-page advertisement for the London Corset Company, featuring an illustration of a woman in a suitably glamourous petticoat and corset.

The straight-front corset was the dominant style from about 1900 to 1908. It flattened the stomach making the waist itself less conspicuous. Some fashion journalists argued that this created less incentive to tightlace. However, the new corset forced the lower back to arch uncomfortably.

It also provided less bust support than previous styles, with the result that some women chose to wear a proto-brassiere in addition to a corset.

Advocates of the corset were increasingly on the defensive. When the American doctor Arabella Keneally claimed that corsets caused ill-health, she was roundly denounced in *Les Dessous Elégants* as "an enemy of the corset."[8] In 1904, the editor of *Les Dessous Elégants* published an article on "Corset et Féminisme" in which he insisted that the corset imposed "elegance of deportment" and had a "salutary" effect on women's behavior. "A slackening in the bearing of the individual produces a looseness in manners and speech . . . Certain young women, extremely twentieth-century . . . by deliberately abandoning the corset, have abandoned the majority of good manners." These "emancipated" women use vulgar slang, cross their legs like men, even smoke in public. The author concluded: "For the woman who wants to remain womanly, moderate corsetry is indispensable. . . . This is good feminism,

Advertisement for the Corset C/B.

II. — LES JOIES DU COSTUME-RÉFORME.
— Je ne peux pas mettre les mains ni sur mes bretelles, ni sur ma cravate.
— Les miennes étaient cassées! j'ai pris les tiennes.

RIGHT "Dress Reform," from *Les Dessous Elégants*, 1906. Courtesy of Dean Sonnenberg.

Poster for the Corset N.D., c. 1904.

infinitely more profitable to women than the '*bon garçonnisme*' with which certain women try to dress themselves."[9] Caricatures implied that if women adopted reform dress or underwear, they would become ugly and masculine.

Despite the anxieties of corset manufacturers, few women had abandoned corsets altogether. There were changes in fashion, however, which led people to believe that the corset was about to disappear. Not only had exercise and sport become increasingly popular, but certain design features hitherto associated with aesthetic or reform dress had begun to penetrate the most advanced Parisian couture houses. In 1908, *Vogue*'s Paris correspondent reported that "The fashionable figure is growing straighter and straighter, less bust, less hips, more waist, and a wonderfully long, slender suppleness about the limbs. . . . How slim, how graceful, how elegant women look!"[10] Corsets had not disappeared, but their shape and construction were changing.

The couturier Paul Poiret was among the first to promote the new fashion. As a journalist for *The Queen* wrote in 1911, "The New Figure . . . may, I think, be called the Poiret figure, for it is certainly in his salons that the boneless corset is most in vogue."[11] In his autobiography, Poiret boasted,

Paul Iribe, illustration from *Les Robes de Paul Poiret*, 1908.

"Using the Broom in Exercise," from *The Complete Beauty Book*, 1906.

It was still the age of the corset. I waged war upon it. . . . It was . . . in the name of Liberty that I proclaimed the fall of the corset and the adoption of the brassiere which, since then, has won the day. Yes, I freed the bust.[12]

Other designers also took credit for abolishing the corset, in statements as self-serving as Poiret's. "It was I who got rid of corsets," said Madeleine Vionnet. "At Doucet's, in 1907, I presented mannequins for the first time with bare feet and sandals, and in their own skins."[13] The English couturier Lucile also claimed that she had "brought in the brassiere in opposition to the hideous corset."[14] The socialite Caresse Crosby even claimed to have invented the brassiere.[15] Of course, no one person invented the brassiere. Various types of bust-bodice, *soutien-gorge*, and brassiere had been patented

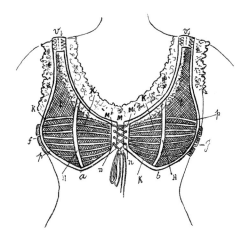

The corselet-gorge of Madame Cadolle, from Dr. O'Followell, *Le Corset*, 1905.

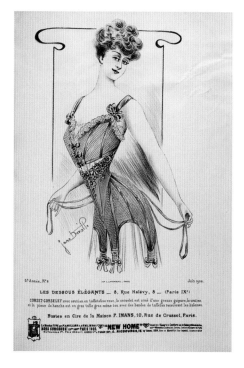

Corset with bust support, from *Les Dessous Elégants*, June 1906. Courtesy of Dean Sonnenberg.

and advertised in the nineteenth and early twentieth centuries. As a professional journal, *Les Dessous Elégants* proudly publicized innovations in underwear, including early versions of the brassiere.

Nor was Poiret the only designer to be moving toward a "corsetless" figure, although he was widely credited with the abolishment of corsets. Representatives of the corset industry "pleaded plaintively with him not to ruin their trade; but he pointed out that short hair on women had not ruined the hairdressers' trade."[16] Poiret was right. The rise of avant-garde fashion did not automatically result in the disappearance of traditional corsetry. Instead, "the desire for the natural uncorseted effect"[17] led to the development of new types of corsets. Changing in shape and construction, the corset began to evolve into modern foundation garments incorporating new stretch fabrics and manufacturing techniques that provided support with greater flexibility and comfort.

Yet the history of the corset in the twentieth century is not a simple story of progress and liberation. Corset advertisements stressed that their products gave "the corsetless figure so much admired."[18] Needless to say, this was not literally a corsetless figure. Indeed, many women complained that the new fashions were "very trying to the average figure."[19] Between about 1907 and 1910, the fashionable silhouette gradually became straighter and less constricted at the waist, but slim at the hips. A "slender" young woman might need no more than a brassiere and a "boneless" elasticized girdle, sometimes known as a "tango corset," that provided extreme flexibility.[20] But the woman with an "average figure" had to wear a long sheath-like "Hip-Confiner" corset or a "Thigh-Diminishing" model made of reinforced cloth and steel.[21] Until about 1919, the majority of corsets continued to have at least some boning, increasingly rubber-coated steel rather than whalebone, an innovation which dealt the whalebone industry a blow from which it "never recovered."[22] Most corsets still had a split busk in front and were laced in back.

At the same time, there was a growing emphasis on "the slimming craze." In 1912, the *Journal des Dames et des Modes* argued that "thinness [*la maigreur*] triumphs." For centuries, the ideal had been the "fat" woman, who "symbolised the family." But the "new beauty" had a "tanagraesque silhouette," which conveyed "a different conception of love."

> Your glances no longer go to anyone but the willowy, slender woman. . . . It is no longer a question of breasts or hips, or so little! . . . I challenge you to notice a fat woman today, so much has the tyranny of fashion imperiously formed and strangled our preferences. . . . At present the thin woman seduces us with her disquieting and alert glamour. She comes and goes. . . . Nothing rejuvenates like thinness, and . . . youth is *a priori* thin.[23]

Since the quest for thinness now seems tyrannical to many women, it is important to stress this association of thinness and youth. Even before the

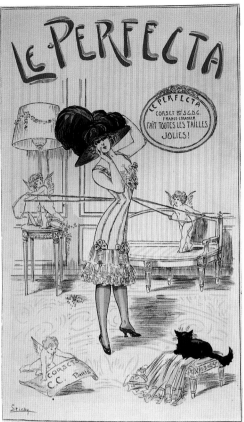

Illustrations from Warner's corset catalogue, 1914.

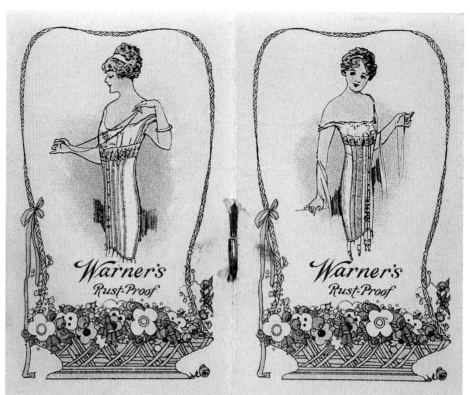

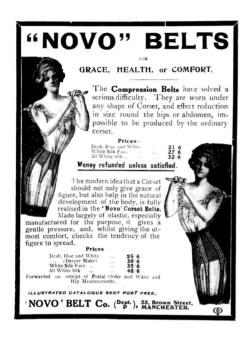

ABOVE Advertisement of 1910 for Novo elastic "compression belts," designed to be "worn under any shape of corset" to reduce the size of the hips and abdomen.

Corsets and brassieres from the Au Louvre catalogue, 1914.

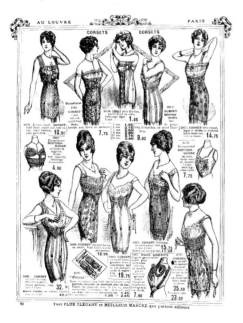

"flappers" of the 1920s came of age, fashion was increasingly associated with youth, and this was because young unmarried women were becoming more independent. We see a similar phenomenon in the 1960s, when youth culture led to fashions such as the mini-skirt.

Conservatives increasingly denounced young women's growing independence, as well as the spread of commercialized sexuality, as expressed in fashion and advertising. The culture clash was especially noticeable in Berlin, which had been transformed by rapid industrialization and state formation from a small provincial town to a cosmopolitan metropolis. In 1913, corset displays in the shop windows of Berlin were suddenly denounced as blatantly immoral. One culture critic even devoted an entire article to the "corset pleasures" visible in windows along the Tauentzienstrasse. It was bad enough that male passersby might be titillated, but women who looked at these window displays would forget the corset's unhealthy effects, succumbing to the "indiscreet craving to have dealings with the secrets and intimacies of the dressing room behind each windowpane."[24] Police President von Jagow ordered the arrest of a corset shop owner and the confiscation of the offending display mannequins. Humor magazines ridiculed the actions, as in a cartoon titled *The Rape of the Sabines Is Not by Schönthan, but by von Jagow*, which depicted leering policemen carrying off wax mannequins wearing corsets.

"Rape of the Sabines," caricature from *Lustige Blätter*, 1914. The McCormick Library of Special Collections, Northwestern University Library.

Detail of a receipt from the Maison Paul Homo, 1917.

Since the First World War was in many respects the dividing line between the nineteenth century and the modern era, it seems plausible to suppose that the war must somehow have caused a revolutionary change in clothing and attitudes toward the body. However, although the war did significantly affect the appearance and behavior of both men and women, "changes [in fashion] had already begun before 1914 and . . . the war merely hastened and developed them."[25] For example, although hemlines were still at the ankle in 1912, narrow skirts were often slit almost up to the knee, revealing colored stockings or boots.

Contrary to popular belief, the First World War did not bring an end to corsetry, although the metal used in corsets does seem to have been requisitioned for the war. According to a member of the U.S. War Industries Board, "American women's sacrifice of their stays during the war released 28,000 tons of steel – 'enough to build two battleships.'" Sales of boned corsets also began to decline in 1917 from "a fairly even level around $70,000,000."[26] However, there already existed alternatives to metal stays, such as the nineteenth-century favorite, Coralene. A temporary shortage of steel fails to explain what was soon a dramatic shift toward rubberized girdles. Nor did hemlines rise during the war because of a shortage of fabric. The so-called war crinoline of 1915–16 had a short but very full skirt, and the fashion should not be interpreted as a "practical" response to the needs of working women. During the war years, Allied propaganda characterized German women as fat and frumpy, while French fashion was interpreted as being symbolic of western civilization, much like the bombed French cathedrals. Meanwhile, the war crinoline gave way to the barrel line, and the fashionable waistline gradually dropped from just below the bosom almost to the hips.

The war did indirectly have a profound impact on fashion: the carnage of the war years further loosened the grip of Victorian propriety, and as men went off to the front, many never to return, women assumed more responsibilities. Certainly, contemporaries believed that the war had an "enormous influence" on young women. As Jacques Boulanger, editor of *L'Opinion* wrote in 1924: "The *femme moderne* . . . is freer in her behavior than women before the war. . . . She dances without a corset; she swims in a maillot. . . . She is absolutely determined to be independent."[27] The modern woman horrified some observers such as this young Parisian law student, who wrote in 1925:

> Can one define *la jeune fille moderne*? No, no more than the waist on the dresses she wears. Young girls of today are difficult to locate precisely. If you want to be true to French tradition, it would be barbaric, in my opionion, to call our pretty *parisiennes* young girls.
>
> These beings – without breasts, without hips, without "underwear," who smoke, work, argue, and fight exactly like boys, and who, during the

RIGHT Decorative stamp showing the
Model Brassiere, c. 1920.

FAR RIGHT Advertisement for the S&S
Sports Corset, c. 1925.

FACING PAGE TOP AND CENTER
Advertisements for College Girl Corsets,
c. 1921.

FACING PAGE BOTTOM Advertisements for
P. N. Practical Front Corsets, 1921.

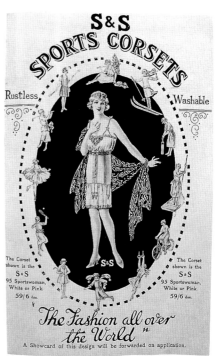

Evening dress by Madeleine Vionnet,
illustration from *Gazette du Bon Ton*, 1923.

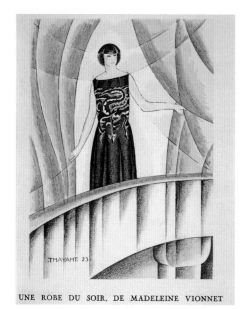

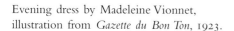

UNE ROBE DU SOIR, DE MADELEINE VIONNET

night at the Bois de Boulogne, with their heads swimming under several cocktails, seek out savory and acrobatic pleasures on the plush seats of 5 horsepower Citröens — these aren't young girls! There aren't any more young girls! No more women either![28]

"Fashion bore the symbolic weight of a whole set of social anxieties concerning the war's perceived effects on gender relations," writes Mary Louise Roberts in her *Civilization Without Sexes: Reconstructing Gender in Postwar France, 1917–1927*. For many men, the modern woman was a "being" without a waist, symbol of a civilization without cathedrals or sexes. At the same time, however, postwar fashion was also positively interpreted as an aspect of women's struggle for social and political power. "Feminists, designers (both male and female), and the women who put on the new fashions interpreted them as affording physical mobility and freedom. Because the new fashions were seen in this way — as a visual language of liberation — they also became invested with political meaning."[29]

Women eagerly seized on the idea of "freedom."[30] "I have never been able to tolerate corsets myself," recalled the couturière Madeleine Vionnet. "Why should I have inflicted them on other women? *Le corset, c'est une chose orthopédique.*"[31] Coco Chanel also later claimed to have "liberated" women from constraints like the corset. Such a picture, however, is greatly exaggerated. Although the traditional boned corset gradually disappeared during the 1920s, most women still wore some kind of corset, corselette, or girdle. Fashion magazines and advice books promoted diet, exercise — and proper

152

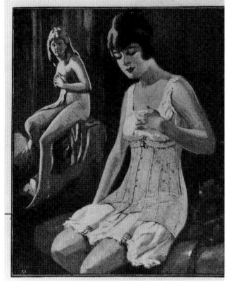

foundations. You should exercise "every day," advised one writer in 1918. "In days gone by, women of leisure did not exercise," she claimed, and so they usually "became fat at forty" and died by the time they were forty-five. "Why? Because they wore ugly, tight corsets that gave no freedom and they were so frail, so delicate, that when illness assailed them they were as susceptible to it as a drunkard is to pneumonia." On the very next page, she began explaining how to choose "the proper corset," and went on to argue that "the size of the corset should be two to four inches smaller than the original waist measurement."[32]

An advertisement for College Girl Corsets argued that "wearing these scientific corsets is like making a daily habit of healthy exercise." Consumers were promised that "within a month," they would see better "health and figure improvement."[33] "To be comfortably, healthfully, fashionably corseted without the corsetified look – what could be closer to woman's heart desire!" declared another advertisement for the P.N. Practical Front Corset in 1921, an elaborate construction with "a vest of pliable elastic" which clasped closed, over which came an outer flap that laced closed. The result was "the joy of the correct, comfortable and beautiful in corset anatomy."[34] Or as *Vogue* put it in 1922:

> With the aid of the corsetiere, the physical culturist and the non-starchy diet, shall we soon develop a race of slender, willowy women? After all, how much more enjoyment can one get out of life if one is slim and active, and excess of avoir dupois leads to inactivity and boredom. Long live the mode of slimness.[35]

Meanwhile, until the happy day when a new slim race of women appeared, fashion pundits continued to insist that "Stout women must wear corsets to

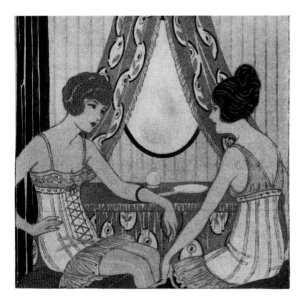

MODEL A.
If you are very slender.

Illustration from *The Joy of Looking Slim*, 1926.

hold their flesh." Of course, they should not lace themselves too tightly, an "ugly method of restriction" that had supposedly disappeared after the war. "The stout woman now evenly *distributes* her flesh into the corset." "She who must struggle with heavy flesh is not wise to permit herself the comfortable pleasure of rubber corsets," since they "permit the body to spread" and "do not hold the figure unless they are of strongly knit surgical elastic." On the other hand, "a stout woman may exercise in rubber corsets [because] they have the merit of reducing thick flesh over the waist by friction."[36]

A corset pamphlet of 1926 was titled *The Joy of Looking Slim*. After ten pages devoted to "corrective exercises," the subject turned to the correct corset with captions such as "YOUTH AND SLIMNESS NOT A MATTER OF YEARS."[37] A 1928 book for art students also described "the ideal type of the present" as "slim and muscularly perfect," with a "slim waist" and "rounded hips," adding "It is no fault if the breasts are only small."[38] Indeed, breasts were flattened with tight brassieres. Nevertheless, the ideal figure of the 1920s was not so much "boyish" as youthful. Like Twiggy, the waif-like fashion model of the 1960s (whose figure measured 31–24–33), the beauties of the 1920s did have curves. Although fashion created a straight silhouette, the body underneath was supposed to have "a rounded slenderness." The heroine of a popular Twenties novel was said to be "flexible and tubular, like a boa constrictor . . . dressed in clothes that emphasized this serpentine slenderness."[39] Slimness is relative, however, and the Miss America winners of the 1920s weighed more than their counterparts do today. Although their breasts were smaller than today's beauty contest winners, their waist–hip ratios were much the same.[40]

During the 1920s, corset manufacturers worried that their days were numbered. Yet just as hairdressers adjusted to the fashion for bobbed hair, so also did corset manufacturers stay in business. By 1930, the American trade journal *The Corset and Underwear Review* confidently proclaimed "Corsets – The Foundation of the Mode for Centuries."[41] In 1931, the corset department was said to be "the biggest profit-maker in virtually every department store in the country."[42] The word "corset," however, was increasingly stigmatized. According to an article in *The New Republic*, sarcastically titled "Stay, Gentle Stays!"

We had been told so often that women would never, never again lace themselves up that we had begun to believe it. . . . The word corset, reviv-

ing all the terrible things physicians once said it did to the female liver, is something to recoil from; it gives an immediate sense of constriction and suffocation. And who does not want to be free? But a foundation garment – that is another matter. . . .

Foundation garments do not have to be laced by a French maid . . . The more architectonic of these new foundations are fairly elaborate affairs, with rather complicated adjustments of flaps, overlappings and lacings, occasionally simplified by zippers. But the indispensible sense of freedom is preserved because any woman can strap herself in unaided.[43]

Poster for Le Furet corsets, c. 1933.

The various new types of foundations included panty-girdles, which were invented in 1935 for use under trousers. Girdles were often worn in conjunction with brassieres, although there also existed one-piece foundation garments, which were still often referred to as corsets. Meanwhile, the iconography of the corset expanded to include various more or less surreal images that combined mannequins, women, and corsets.

The metaphor of foundations was increasingly prominent. "Houses and figures stand or fall by their foundations," declared American *Vogue* in 1935. "There is no more important purchase in a woman's wardrobe than her corset." An article entitled "Boning Up on Corsets" touted technical improvements in corsetry, such as the development of Lastex "two-way stretch" fabric, which replaced rubber elastic and was said to give both "restraint and freedom."[44] Invented in 1931, Lastex was the tradename for strips of rubber covered with silk, cotton, wool or rayon to form a yarn; it should not be confused with latex, which is the sticky sap from the rubber tree. Lastex further revolutionized the corset industry. The rhetorical use of phrases such as "restraint and freedom" on the part of advertisers and journalists alike reveals the perceived necessity of disciplining the unruly female body. At the same time, however, there is an implied acknowledgment that women do not want to wear uncomfortable foundations, which they associate with the despised boned corsets of the past.

The word "control" occurs often in the discourse on foundations, sometimes linked to "comfort," as in a 1938 advertisement for Formfit foundations, which claimed that "Comfortable wide 'Lastex' sections connect a front and rear material panel for the right amount of control."[45] On the most literal level, it refers to control over flabby, unsightly, excessive flesh. However, it also seems to imply a more comprehensive control of the body, sexuality, and desire. Foucault's concept of the "disciplined body" seems entirely applicable. The potential dangers of the "free" body also appear regularly in the literature on underwear. A 1939 department store advertisement warned that "It can appear quite *tempting* on a hot summer's day to take off one's brassiere, but it is *dangerous*, very dangerous; only very few busts can do without the gentle support a brassiere can give and summer dresses mercilessly reveal

flabbiness or defects underneath. The same is true of the girdle or corselette. Only very few women can allow their figures to be quite *free*."[46]

As embarrassing as excessive freedom was a badly fitted corset. An article mockingly titled "Are You a Corset Contortionist" described women whose corsets fit poorly: "The Yanker" was "perpetually tugging at the lower edge of her girdle," because it was not long enough. "The Bulger" was a "lady who, beneath sleek hips, suddenly bursts out with too, too thriving thighs. She has erred in choosing a corset that is too tight, forcing the unfortunate flesh to find an outlet below." "The Roller" had a bulging "spare tire" above her girdle; she needs a corset with a high waistline or a one-piece foundation garment, and so on. The goal for all was "a sleek midriff and controlled curves above and below."[47] If the word "curves" implies sexual excitement, as well as abundant flesh, then the phrase "controlled curves" seems revealing of a certain sexual ambivalence.

A fashion show called "Under Control" was staged in the Grand Ballroom of the Hotel Astor in New York on January 18, 1938. Organized by Warner Brothers, the show featured 48 fashion models parading down a runway in the latest foundations. The underfashion show was attended by almost 800 corset manufacturers, retail buyers, and members of the press who were in New York to celebrate Corset Week. As one journalist reported, "The corset isn't dead and never has been. Upset three times and terribly frightened once, the $65,000,000 corset industry feels fine today." Although changing fashions – especially the 1920s "corsetless" look – had temporarily caused problems for manufacturers, the industry was secure because "at least three women out of five in the U.S. . . . are all too fat or grievously out of proportion in the region of the bosom, waist, or hips," which means that "they *must* – assuming they are vain enough and rich enough to care – wear some sort of corset regardless of what the prevailing mode may be."[48]

Certain modes, however, emphasized feminine curves more dramatically than others, and by winter 1938/9, the fashion press announced a revival of the "wasp waist." "Small waists and new corsets are coming back. . . . They are very beautiful but uncomfortable, but women will wear them. Women will wear anything if it's fashion," declared Mrs. Adam Gimbel, wife of the president of Saks Fifth Avenue, on her return from Paris. "We have had comfort for years, now we are going to be dignified. You have to hold your head up with a corset. Everybody has to be dignified wearing corsets."[49]

It was in 1939 that Horst P. Horst created his famous photograph of a Mainbocher corset for *Vogue*. This image, which has often been reproduced, called attention to the erotic possibilities of corsetry – from the curves of the female body to the sexual symbolism of the laces. Although the corset had long been reduced to a "necessity" for "defective figures," it was here

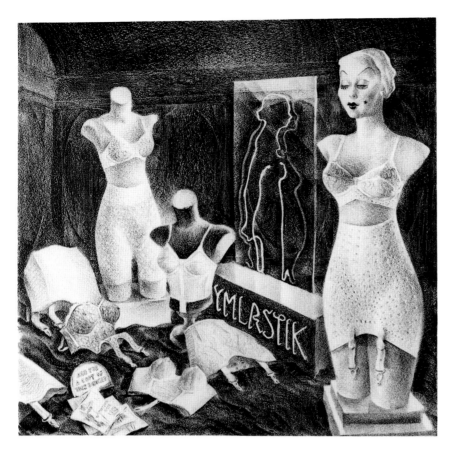

triumphantly represented as an icon of erotic femininity. The movie *Gone With the Wind* was also released in 1939, when millions watched Vivien Leigh as Scarlett O'Hara being laced into her corset.

With the outbreak of the Second World War, however, many materials used in making corsets, such as steel and rubber, were rationed or requisitioned for the war effort. (The Malayan rubber plantations were captured by the Japanese in 1941, and synthetic rubber was reserved for gas masks and other military equipment.) In Great Britain, the production of "inessential" goods was banned, and corset factories were ordered to produce supplies for the armed services, such as parachute harnesses and chinstraps for helmets.[50] After Pearl Harbor, the United States entered the war, and the U.S. government also declared rubber and some metals to be strategic materials. Armaments manufacturing superseded the production of hooks and eyes and stocking supporters.

Yet the production of foundations did not cease entirely. In the United States, wartime regulation L-90 specified the production of bras and girdles after 1942. It was said that female war workers protested that they needed the back support given by foundations. Supplies were much scarcer in Great Britain, where some English women made their own corsets at home.[51] Others recycled fittings and bones, making do with the 1930s-style corsets or girdles they already owned. As one corsetière recalled, working-class Englishwomen were accustomed to wearing sturdy corsets that lasted for several years, "and ten years was not unknown for the life of a corset."[52] Materials were also scarce in occupied

France, although some custom corsets, bustiers, and *guêpières* ("waspies") were still produced for wealthy clients and film stars.

After the war ended, corsetry rapidly became central to international fashion. Especially influential was the appearance of Christian Dior's New Look in 1947. Almost overnight, fashion became extravagantly romantic, nostalgic, and ultra-feminine. Hemlines dropped and waists were pinched. "Without foundations there can be no fashion," declared Dior.[53] As with Poiret's fashion revolution, Dior's New Look was only the most conspicuous part of a more general movement in fashion. Many designers, both male and female, couturiers, and anonymous designers for the mass market, created clothing that emphasized feminine curves. Jacques Fath was especially well-known for his sexy, feminine evening clothes. One such dress from 1947 was made of pink satin, not unlike lingerie material, and was laced up the back like an old-fashioned corset. Many of Dior's dresses were boned inside, like nineteenth-century dresses, and required no additional corsetry. But most New Look dresses, including the myriad copies that appeared almost instantly, were clearly designed to be worn over what *Life* in 1947 called "waist pinchers," "new tiny corsets [that] squeeze waists, [and] emphasize full hips and high bosoms." The magazine argued that this development was "bad news to the American male" who would have to pay for foundations that "will present a Maginot Line of elastic and steel" every time he "sneaks an arm around an attractive waist."[54]

Advertisement for Formfit corset, 1949.

Women, however, seem to have responded as corset and girdle manufacturers developed new styles that cinched waists, flattened the abdomen, and lifted and separated the breasts. Many of the old arguments about youth and beauty reappeared. A 1949 advertisement for the Formfit all-in-one Foundation, for example, boasted that it created "a sweetheart of a figure":

> It's an outmoded idea that women must submit to the verdict of the years. Young, fresh figure charm can be safeguarded year after year by wearing the right Formfit all-in-one Foundation. Millions of women insist upon this smooth, supple control from bustline to thigh line. No other foundation combines the magic of Life Bra and Life Girdle all in one piece. No matter what your figure faults, it gives you the look of figure-perfection . . .[55]

In his influential book *Look Younger, Live Longer* (1951), Gayelord Hauser advised readers that

> There is no such things as a "stylish stout." Stoutness is forever unhealthy, unstylish, and unnecessary. If you have allowed yourself to become overweight, get your waistline down again. Flatten it. Strengthen it. Make it your aim in life to keep your muscles so strong and elastic that you can

Pink silk satin evening gown by Jacques
Fath, 1947. The Metropolitan Museum of
Art, Gift of Richard Martin, 1993.
(1993.55). Photograph © 1993 The
Metropolitan Museum of Art, New York.

free yourself permanently from that one-piece harness called the corset. Your own muscular corset is the best of all undergarments.[56]

But throughout the 1950s and well into the 1960s, most women wore some sort of body-shaping foundation garment. Corsetry was not limited to women trying to deal with heavy figures. It was widely believed that the right foundations could "preserve" a youthful figure. "An uncorseted body is prone to fatigue and even if slim, with taut stomach muscles, it is wise to guard early against future 'spread'," declared one fashion writer. "This isn't something you can afford to be slack about."[57]

In 1956 Nancy Mitford wrote that it was "U" (upperclass) to say "stays" and non-U to say "corsets."[58] But the postwar terminology was actually far more complex and confusing, since one person's girdle was another's roll-on or corselette. Looking back on the fifties, one woman recalled, "If you did not need a long-leg panty girdle, you wore one anyway."[59] Young women who worked in offices tended to wear girdles all day, every day. Another woman who was in college then remembered, "As I got heavier, I welcomed those tortuous girdles with the hose clips on them, as they seemed to enable one to fit more smoothly into sheath skirts."[60] Even quite young girls were supposed to wear panty girdles (or "panti-girdles") and "training bras."

According to advertisements, the "Vanishette . . . Figure Slimming Miracle of Paris!" featured a "Magic Lastex Waist Band" that will "INSTANTLY Vanish

BELOW LEFT Illustration from Spencer Foundation catalogue, 1957.

BELOW RIGHT "Contemporary Venus," advertisement for Excelsior corsets and bras, c. 1955.

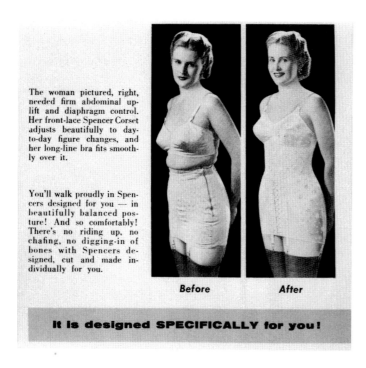

The woman pictured, right, needed firm abdominal uplift and diaphragm control. Her front-lace Spencer Corset adjusts beautifully to day-to-day figure changes, and her long-line bra fits smoothly over it.

You'll walk proudly in Spencers designed for you — in beautifully balanced posture! And so comfortably! There's no riding up, no chafing, no digging-in of bones with Spencers designed, cut and made individually for you.

Before **After**

It is designed SPECIFICALLY for you!

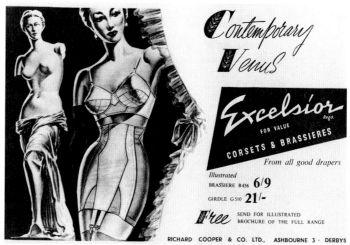

Contemporary Venus

Excelsior Regd.
FOR VALUE
CORSETS & BRASSIERES
From all good drapers

Illustrated
BRASSIERE B456 6/9
GIRDLE G510 21/-

Free SEND FOR ILLUSTRATED BROCHURE OF THE FULL RANGE

RICHARD COOPER & CO. LTD., ASHBOURNE 3 · DERBYS

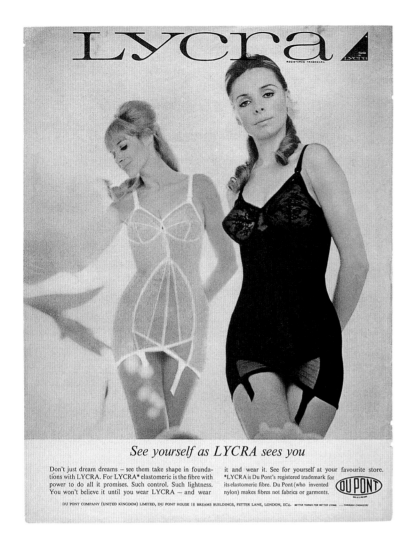

See yourself as LYCRA sees you

Don't just dream dreams – see them take shape in founda-
tions with LYCRA. For LYCRA* elastomeric is the fibre with
power to do all it promises. Such control. Such lightness.
You won't believe it until you wear LYCRA — and wear

it and wear it. See for yourself at your favourite store.
*LYCRA is Du Pont's registered trademark for
its elastomeric fibre. Du Pont (who invented
nylon) makes fibres not fabrics or garments.

DU PONT COMPANY (UNITED KINGDOM) LIMITED, DU PONT HOUSE 18 BREAMS BUILDINGS, FETTER LANE, LONDON, EC4. BETTER THINGS FOR BETTER LIVING ... THROUGH CHEMISTRY

"See yourself as LYCRA sees you."
Advertisement for Du Pont's LYCRA, 1960s.
The Advertising Archives, London.

4 INCHES OFF YOUR WAIST!"[61] And American *Vogue* declared in 1956, "Women like waistlines. Proof: the famous waistmaking 'Merry Widow', a brassiere-and-waist-cincher-combination – sells over $6,000,000 every year."[62] Paris *Vogue* agreed that there was a corset for every age and figure problem: "to dissimulate cellulite," "to appear thin when one is not," and so on.[63] In her 1959 book *Wife-Dressing*, the fashion designer Anne Fogarty advocated wearing a girdle "with everything," even when scrubbing the floor – a practice that she happily compared with Chinese foot binding. Fogarty boasted about her "eighteen-inch waist" and favored cocktail dresses so tight that she could not sit down. She felt "very strongly" that clothes should fit snugly, especially after five o'clock. "You're not meant to suffer," she reassured her readers, but the feeling "should be one of *constraint* rather than comfort."[64]

The year 1959 was also when Du Pont USA developed Lycra, a synthetic elastomeric fabric with good recovery properties. It was put into production in 1960, and immediately revolutionized foundationwear. Warner's "Birthday Suit" of 1961, for example, used Lycra to create a seamless, closefitting garment that resembled a bathing suit. Another important innovation was pantihose, which rapidly replaced girdles and stockings – especially important with the rise of the mini-skirt. Yet issues of control and respectability continued to preoccupy women. Flesh was not supposed to "jiggle." One woman recalled, "I remember panty girdles in the ninth grade, in 1962. We wore straight skirts and without a girdle your fanny would move. Considered very crude." Another woman also remembered, "We had to wear girdles because God forbid someone should see something move."[65]

Meanwhile, the development of an international youth culture placed an even greater premium on the young, slender figure, which was increasingly exposed in light, abbreviated clothing. Fashion magazines struggled to explain new modes and manners to older readers. For example, *Harper's Bazaar* in April 1965 featured a cover article entitled "Frug That Fat Away," as well as a glossary of the latest "lingo." Readers were solemnly informed that "bread" means money, a "groove" is a fun thing, and a "hang up" is a bother. There were also photographs of the latest pop fashions by designers like André Courrèges. But the very same issue contained more girdle advertisements

than had been the case thirty years previously. One advertisement for Warner's asked:

> Which is worse? Not wearing a girdle and looking floppy? Or wearing one and showing girdle through your clinging dress. Warner's® thinks they're both awful, so we've invented The Riddle.™ No panels, no seams. But see that paiseley? It's set, not sewn, into the fabric by a secret Warner process. So it holds with all the power of a panel, but with no seams or telltale bumps to show through. Just smooth you.[66]

The issue of "smoothness" was related to technology and the development of new fabrics and construction techniques that allowed girdles to have smoother surfaces, so that no part of the foundation would show through the outer clothing. Although adjectives such as "sleek" and "smooth" had appeared in girdle advertisements as early as the 1930s, smoothness became increasingly important in the 1960s, when girdles became more and more of a second skin that invisibly shaped and smoothed the body. The same issue of *Harper's Bazaar* also featured an advertisement for Rudi Gernreich's "NO BRA" bra ("Looks and feels as if you're wearing absolutely *nothing*"). For those who wanted more coverage, there was also the "ALL-IN-NONE" ("Rudi's one-piece masterpiece"). Still other advertisements touted the Poirette girdle with "hidden Bodybands and chiffon powernet"; "The Next-To-Nothingness of Nude Tral"; "The Curve Encouragers," a bra and panti-girdle, the latter "power embroidered to pamper but not to inhibit"; another girdle "with an embroidered hold on you"; and last but not least, the "Venus cling," described as "four ounces of nylon and . . . spandex . . . designed to slip curvy girls into skinny pants."[67]

It is only in the late 1960s and early 1970s that we see a noticeable trend away from "control garments" and toward other forms of body-shaping such as diet and exercise. Although these had long played a role in female beauty regimes, they now became central to the body project. What caused this development? Among the most significant sociocultural phenomena of the era were the hippy subculture and the feminist movement, and it is likely that both contributed to this shift in attitudes toward the body. Not that the average woman was a hippy or a feminist, but certain attitudes associated with both groups spread fairly rapidly through society. Fashion was widely denounced as conformist and artificial, and young people responded to calls for honesty, authenticity, and self-expression in dress. Girdles, especially, but also brassieres, were increasingly perceived as restrictive, uncomfortable, and mendacious. In addition, foundations were criticized on the grounds that they were productive of negative sexual attitudes, although the hippies stressed sexual liberation, while feminists decried sexual commodification.[68]

Dieting was the main form of body sculpting up through the 1970s, although by the end of the decade both men and women were increasingly

being urged to exercise. Aerobic exercises, especially running and jogging, were emphasized first. An article on "Joy through Exercise" informed English women that "exercise is more than something one does to keep fit and to trim down a spreading waistline. It can be the key to extraordinary high energy levels and . . . a sense of tremendous physical and psychic freedom."[69]

By the 1980s, men and women also began to "work out" and build visible muscle tone. British *Vogue* informed readers that "The ideal fitness workout combines aerobic exercise with light weight training," adding, reassuringly, that "working out with light weights will not overdevelop muscles – they become leaner and more contoured."[70] The same 1988 issue also included a major article on women and sport, which quoted the British javelin champion Fatima Whitbread as saying, "I have to be this shape to win. I don't dislike my muscles. I enjoy looking healthy, feeling good."[71] Accustomed to exercise gurus like Jane Fonda, Americans were noticeably more enthusiastic about visible muscles than Europeans were. Health clubs rapidly supplemented their supply of free weights with an array of weight machines.

Weight-lifting, hitherto a fringe enthusiasm among male subcultures, began to become popular, especially in America. Soon both men and women were encouraged to invest in their own weight machines. Some advertisements targeted men by associating visible musculature with virility, using slogans like "A hard man is good to find." Other advertisements showed men who had "bulked up" and women who had "slimmed down" through regular weight training. One advertisement from 1999 explicitly compared two photographs – one of a corseted female torso, the other of a muscular young woman whose bare midriff was toned to perfection by rowing.

While fashion was still criticized as artificial, body building was usually assumed to be natural and empowering. Yet as Lynda Nead points out:

> Body building is a mixed blessing for feminism. On the one hand, it seems to offer a certain kind of liberation, a way for women to develop their muscularity and physical strength. It produces a different kind of body-image which could be seen to blur the conventional definitions of gendered identity. But on the other hand, this revised femininity seems simply to exchange one stereotype . . . one body beautiful for another.[72]

Furthermore, within this aesthetic, "fat" is envisioned as excess matter. Nead quotes Jane Fonda as saying, "I like to be close to the bone." Or, as Naomi Wolf puts it, "women's sense of liberation from the older constraints of fashion was countered by a new and sinister relationship to their bodies."[73]

By the 1990s, popular journalism increasingly featured articles and advertisements on plastic surgery or "body-sculpting." Cosmetic surgery had long been available and readers were still urged to eat less and exercise more. But now journalists suggested that, if all else failed, there was always liposuction.

Front jacket of *Jane Fonda's Workout Book*, London, 1982.

As an article in *Vogue* put it: "The best way to shape the waist is to twist it – dancing, gymnastics, snowboarding, skateboarding, aerial ski jumping, swinging a bat or a golf club." The same article described liposuction as "the waist-defining plastic surgery of choice." Readers were told that they could get liposuction on Friday and be back to work as early as Monday.[74] Operations such as liposuction (invented in 1977) and the innocuous sounding "tummy tuck" are not without pain and risks, however. Cosmetic surgeons like to present themselves as sculptors, but the image of masked surgeons wielding giant needles was cleverly used in an advertisement for a diet snack with the caption "There has got to be an easier way to lose weight."

Let us return, however, to the journalist from *Vogue*. Not content with quoting doctors and designers, she emphasized that fashion's focus on the waist was not a passing trend. According to *Vogue*, science proved that "Women whose waists are 70 percent the size of their hips are invariably rated as more attractive by men," since beauties as disparate as "Twiggy, Marilyn Monroe, Kate Moss, Sophie Lauren, and the Venus de Milo all had [waist-to-hip] ratios around .7"[75] There has, in fact, been considerable research on ideals of beauty and their relation to sexual dimorphism (the fact that men and women have different shapes) – although whether this amounts to scientific proof is still an open question.

Most scholars in the humanities are extremely wary of theories that smack of biological determinism. The following material is, therefore, not introduced as immutable fact but rather as grounds for fruitful speculation. Cross-cultural studies suggest that human ideals of beauty are surprisingly similar and may be, in part, the product of evolutionary biology. Young women who are not pregnant or obese tend to have a waist–hip ratio (WHR) ranging from .67 to .80, whereas healthy young men have a WHR in the range of .85 to .95.[76] (After menopause, hormonal changes cause women's bodies to approach the male ratio.) Preferred bust size and overall body weight vary, but the role of "body fat distribution as measured by waist-to-hip ratio" is consistently significant in the assessment of female physical attractiveness. There is also "ethnic and gender consensus for the effect of waist-to-hip ratio on judgement of women's attractiveness." Poor peasants from India, young Indonesians, Hispanics, and African-American men and women concurred in finding most attractive a woman with a slender curvacious figure and a WHR of about .7 – that is, waist seven tenths as large as hips. In evolutionary terms, this preference is functional, since a ratio in this range signals high fertility and good health.[77]

Researchers found that even "a small increase in waist size . . . significantly decreases [women's] attractiveness and makes them appear to be overweight." Moreover, "the impact of being overweight on judgements of attractiveness was strongly negative," even among groups popularly believed to prefer

heavier women, such as "uneducated landless laborers from India."[78] Nor is it that contemporary Indians have simply been influenced by western attitudes, since in traditional Indian mythology a typical description of a beautiful woman's body says that "her hips and breasts were full, her waist slender."[79] The voluptuous Marilyn Monroe had measurements of 36–24–34 (WHR of .71), while Twiggy, as we have seen, was 31–24–33 (WHR of .73), and Elle MacPherson, one of today's most popular models, measures 36–24–35 (WHR of .68). If our ideals of beauty are to some extent the product of evolutionary sexual selection, as many researchers in evolutionary psychology believe, then the corset may function as an artificial sexualizing device for women who lack such spectacular sexually dimorphic curves.[80]

Corsetry was a form of body modification with profound implications for women's lives. As Susan Brownmiller observes, no discussion of the female body "can make real sense without getting a grip on the corset," because it has played "a starring role in the body's history."[81] Yet the very concept of "the body" is more complicated than it appears. It is popularly believed that the fashions of the past constrained and "deformed" the body, while the twentieth century gave birth to a "free," "natural" body. The corset is a perfect example of the kind of rigid, physically oppressive garment that we habitually contrast with the relaxed, "liberating" clothing of the present day. Yet although the body is a biological entity and a product of evolution, it is also and always culturally mediated.

Throughout human history, people in all cultures have demonstrated an urge to "dress" or "fashion" their bodies in ways that respond to particular sociocultural ideals of beauty, eroticism, status, conformity, and other powerful forces. They have also developed various "techniques of the body" whereby individuals learn "how to use their bodies," and also how to understand their bodies as symbolic entities. Exploring the history of the corset enables us to delve deeply into one of the most important examples of this very human practice. Admittedly, a garment such as the corset seems like an assault on the body, whereas a sports bra is a more functional and comfortable garment. Yet the brassiere cannot really be said to be any more "natural," unless women grew their own bras at adolescence. Most people today would agree that it is a good thing that women no longer feel that they have to wear corsets. However, in a sense, the corset has simply become internalized in a transformation of disciplinary regimes akin to Foucault's description of a shift from the "fleshy" to the "mindful" body.[82]

As the hard body replaced the boned corset, the corset itself has taken on new roles in fashion. Long exiled from mainstream fashion, the corset (and also the elasticized girdle) continued to exist in the subculture of fetishistic pornography, where corsetry was associated with the image of the powerful Phallic Woman, and with the sexual "perversions" of sadomasochism and transvestism. According to a participant in the fetish subculture, although

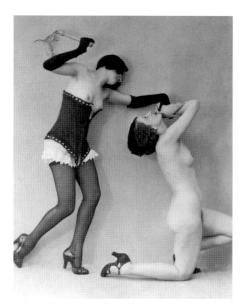

Fetish photograph, 1930s.

outsiders "might imagine that in the world of SM roleplay, the corset wearer is always the submissive" person, in fact the meaning of the corset is contextual. "The dominatrix wears her corset as armour, its extreme and rigid curvature the ultimate sexual taunt at the slave who may look but not touch. . . . The slave, on the other hand, is corsetted as punishment."[83] The erotic appeal of the corset may be related to "the mystery of woman," suggests one dominatrix. "All I know is if I wear a corset in a scene, it gets better results with a slave than if I'm not wearing it."[84]

As fetishists started to come out of the closet in the wake of the sexual liberation movement, young women associated with London's punk and goth subcultures in the early 1970s began to reappropriate the corset as a symbol of rebellion and "sexual perversity." Corsets were also increasingly adopted by young men who wore the fetish garment to clubs that welcomed expressions of "radical" or "transgressive" sexuality. Adopted by avant-garde fashion designers, such as Vivienne Westwood, herself a punk in the 1970s, the corset began a second life in fashion. Indeed, Westwood's revival of the corset may be one of her most important contributions to late twentieth-century fashion. Once women no longer felt that they had to wear corsets – when the corset, in fact, was stigmatized – some women consciously chose to wear them. Now, however, the corset was worn openly – as fashionable outerwear, rather than underwear.[85]

Long disparaged as a symbol of female oppression, the corset began to be reconceived as a symbol of female sexual empowerment. Although the punks pioneered this transformation in the meaning of the corset, the pop singer Madonna was instrumental in popularizing it, aided and abbetted by the

Corset by Vivienne Westwood from the Harris Tweed collection, 1987. Photography courtesy of Vivienne Westwood.

French designer Jean-Paul Gaultier. An aesthetic provocateur, Gaultier is known for subverting the clichés of masculinity and femininity through parodic exaggeration. He is notorious for emphasizing sexuality through the use of fetishized garments, and has made the corset an integral part of his

work. "The first fetish I did was a corset," recalled Gaultier. "That was because of my grandmother." When he was a child, he found a salmon-colored, lace-up corset in her closet. "I thought, 'My God, what is that?' . . . Later I saw her wearing it and she asked me to tighten it." She told him about tight-lacing at the turn of the century, and he was "fascinated" by what he regarded as "one of the secrets."[86] Over the years, his designs have featured a number of corsets for both men and women, as well as jackets and dresses with corset lacing. Recently he has also juxtaposed corsetry with "ethnic" styles, such as the Japanese *obi*. Even Gaultier's perfume for women is packaged in a bottle shaped like a woman's torso encased in a metal corset. Gaultier's perfume bottle also refers back to Elsa Schiaparelli's "Shocking" perfume bottle, designed for her by the artist Leonore Fini, and modeled after Mae West's voluptuous, corseted torso.

For her Blonde Ambition tour of 1990–91, Madonna wore two of Gaultier's corsets, one in shell-pink satin, the other gold. World-famous for being a powerful yet sexual woman, the singer's outrageous attitudes and sense of irony meshed perfectly with Gaultier's style. Over the years, the self-styled "material girl" has had a profound influence on fashion, and especially with her use of underwear-as-outerwear. "It's hard to keep up with the mercurial Madonna, and, if you buy Gaultier, it's also expensive," observed the New York *Daily News* in 1990, but you can easily find the "basic ingredients with which to approximate her new look." A green lace bustier, for example, only costs $22 at Screaming Mimi's, and a matching vintage panty girdle is $28.[87] Gaultier, of course, is far from being the only designer to exploit the subversive charisma of the corset.

Thierry Mugler has created many extraordinary corset fashions, ranging from the fierce to the feminine. Especially famous are his powerfully sexual images of Amazonian women in virtual body armor. In his work, Mugler likes to tell stories about women, whom he envisions as Hollywood divas, goddesses, devils, and sexy robots. The Mugler woman is frequently encased in rigid materials, such as plexiglas and metal. For his "Carapace" ensemble, made of sculpted and embossed black leather, Mugler worked with the custom leather specialist Abel Villareal. The result evokes the armored fragility of an "Insect Woman." To make his "Lingerie Couture" body corset, Mugler collaborated with Mr. Pearl. The female runway model was laced to approximately 36–18–36 inches. Many observers believe that Mugler's couture work represents the creative pinnacle of fetish-inspired corset fashion. At a less exalted level, there are also a number of companies that make "kinky" corsets for enthusiasts and "club kids" alike. Murray and Vern is a London company that creates rubber and metal corsets; Dark Gardens of San Francisco makes Victorian-style custom corsets, fetish fashions, and corsets for men.

Waistcincher. Courtesy of Dark Garden Unique Corsetry.

FACING PAGE Corset by Jean-Paul Gaultier, couture collection, Spring/Summer 1999. The Fashion Group International.

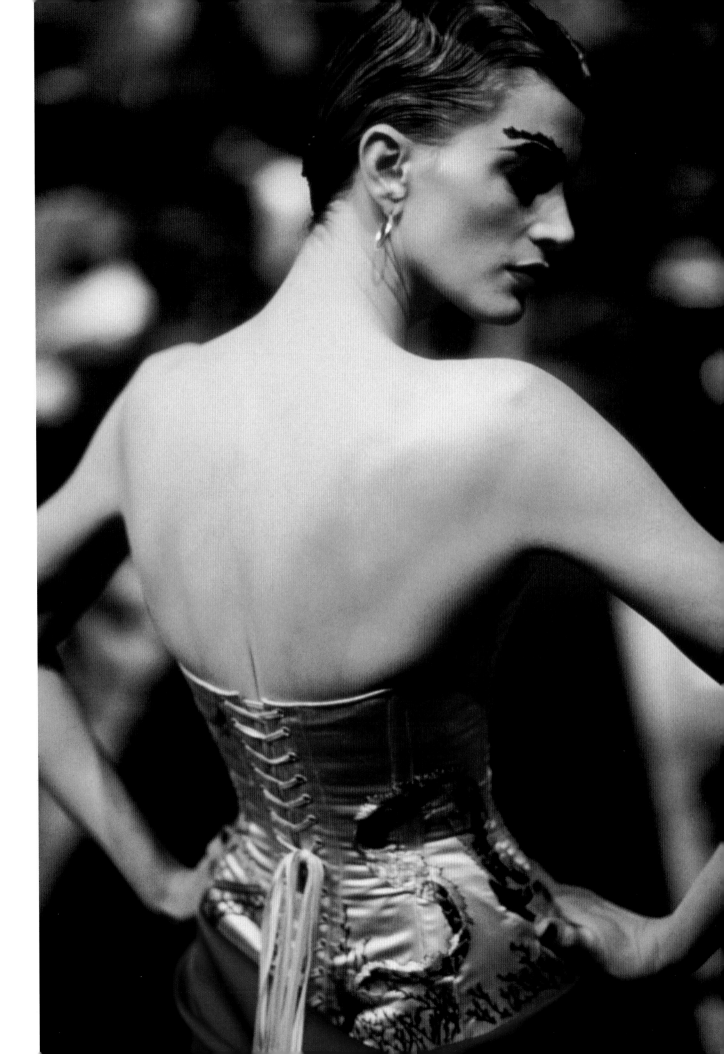

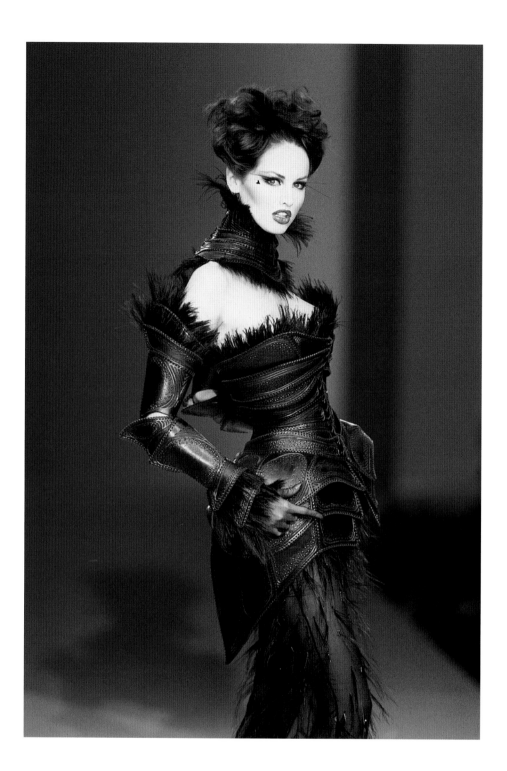

There are also ultra-feminine couture corsets by designers such as Christian Lacroix. Inspired by ballgowns of the Belle Epoch, Lacroix creates nostalgic evening dresses with historicizing details such as bustles and 1880s-style corsets. Of course, in the 1880s, the lady would have worn her corset under her dress, but as sexual attitudes and behavior have become dramatically freer, the visible corset has become a socially acceptable form of erotic display.

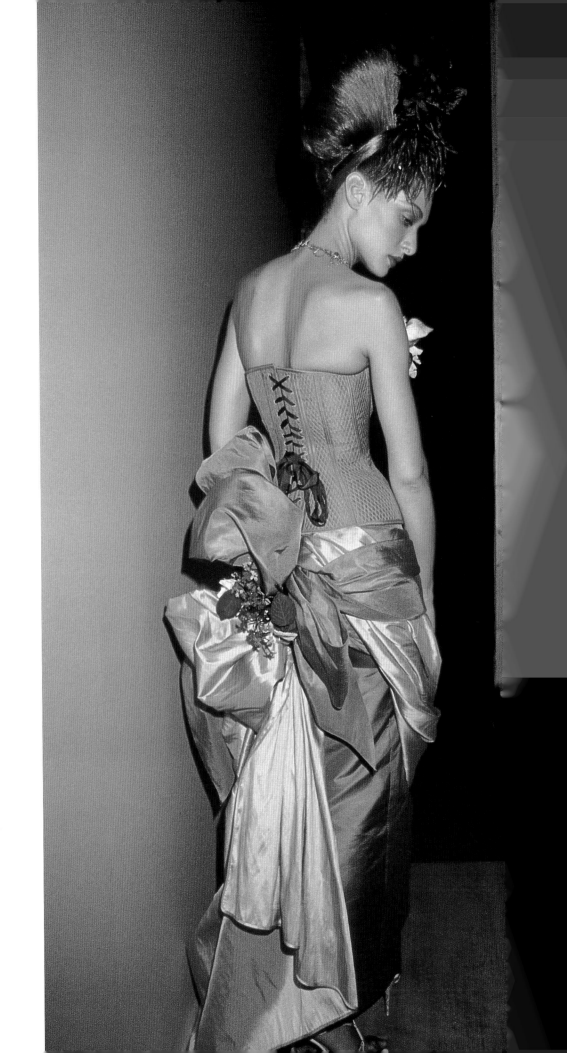

Evening dress with corset by Christian
Lacroix, 1997. Photograph © Roxanne
Lowit.

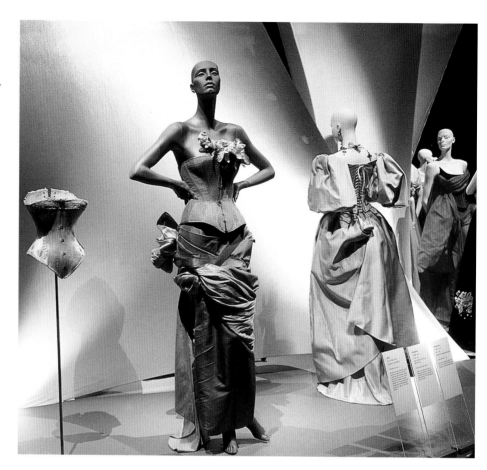

Installation photograph from the exhibition "The Corset," depicting Christian Lacroix dresses next to an 1880s corset. Photograph by Irving Solero. Courtesy of The Museum at the Fashion Institute of Technology, New York.

BELOW Couture corset by Christian Lacroix, 1996. Photograph © Roxanne Lowit.

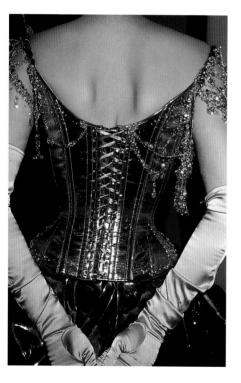

Some of the most beautiful couture corsets are handmade by Mr. Pearl. Although only a few such couture corset dresses are produced every year, less expensive versions of the style have become extremely popular for wedding dresses. Many other designers have also been inspired by the corset, including Karl Lagerfeld of Chanel, John Galliano of Christian Dior, Tom Ford of Gucci, Dolce & Gabbana, Versace, and Valentino.

The corset seems to come back into fashion now every two or three years – in 1992, 1994, 1997, 2000, and 2001. Journalistic discourse on the subject varies depending on the publication and audience. Although newspaper reporters addressing a general audience tend to interpret corsets as problematical and potentially antifeminist, fashion journalists almost always interpret the style in positive terms, while also contextualizing it within the framework of other trends. "Take a deep breath," advised *Vogue* in September 1994 before explaining why a style "made popular by Christian Dior . . . in 1947" had returned.[88] In fashion, timing is crucial, explained Sarah Mower for *Harper's Bazaar*, and in 1994 "the Wonderbra phenomenon" alerted designers to "the demand for a sexy, artificially enhanced feminine shape." Corseting was also visually congruent with "the fall of the hemline and the rise of the

Dinka man wearing a beaded "corset."
Photograph by Angela Fisher, Courtesy of
Robert Estell Photo Agency, Sudbury.

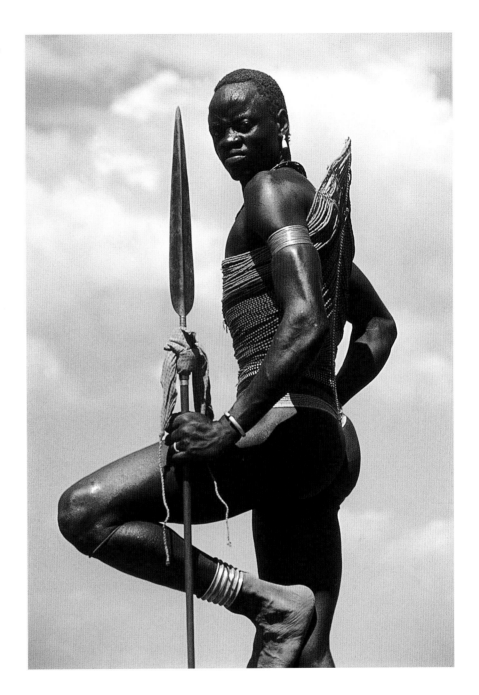

heel." Lastly, it functioned as a way of announcing "LOOK AT THE WAIST!" –
"the new erogenous zone."[89]

Most designers tend to focus on very feminine and beautiful corsets, but
there are also a variety of "exotic" corsets. Perhaps the most spectacular was
that designed by John Galliano for Christian Dior couture in 1997, which
was inspired by a picture of an African warrior in a beaded "corset." Among
the Dinka people of East Africa, young men traditionally wear beaded
"corsets," and the color of the beads symbolizes the age cohort to which the
wearer belongs.

"Surgical" corset by Hussein Chalayan, 1998. Photograph by Irving Solero. Courtesy of The Museum at the Fashion Institute of Technology, New York.

Corset by A. F. Vandevorst, 2000. Photograph © Michel Vanden Eeckhoudt/vu. Courtesy of A. F. Vandevorst.

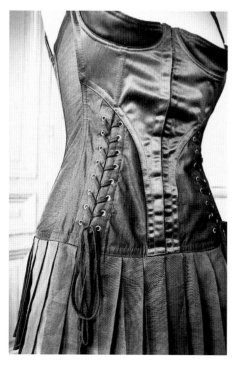

Meanwhile, Vivienne Westwood has continued to make corsets central to her design aesthetic. In place of the hourglass shape that Lacroix favors, Westwood's popular corsets are usually inspired by eighteenth-century stays. For her 1995 Vive la Coquette collection, Westwood created a "Queen of Sheba" dress, designed to look as though the wearer were exposing herself. However, the nude torso is actually an artfully constructed corset embroi-

"Prosthetic" corset by Alexander McQueen, 1999. Photograph by Irving Solero. Courtesy of The Museum at the Fashion Institute of Technology, New York.

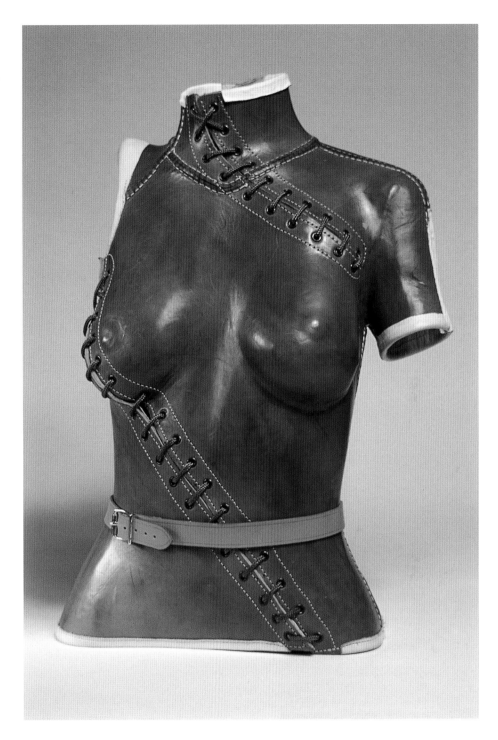

dered with rhinestones and sequins, made by Mr. Pearl. Indeed, as early as 1980, the influential Japanese designer Issey Miyake had created a molded plastic bustier that replicated the shape of the naked torso.

Finally, another type of contemporary corset treats the body not as an idealized female form, or a surrogate for the hard body, but rather as something deeply vulnerable, even wounded. The London-based avant-garde designer

Hussein Chalayan, for example, created a "surgical" corset that evokes disturbing images of physical injuries or congenital deformities. The young Belgian design team A. F. Vandevorst is also inspired by both medical imagery and corsets. Perhaps most influential is Alexander McQueen, the reigning star of London fashion, whose work combines exquisite craftwork with a powerfully dark erotic sensibility. McQueen has designed many corsets in materials as varied as purple satin, clear fiberglass, and metal. For his "prosthetic" corset, he used molded leather pieced together with crude "Frankenstein" stitching to create a monstrous parody of a pretty laced corset. Within the fashion context, such corsets are highly unusual, because they refer to pain, not pleasure, and problematize beauty.

As we enter the twenty-first century, the corset shows no sign of disappearing. During the 1990s, some observers worried that the reappearance of fashionable corsets indicated a "backlash" against feminism. This type of interpretation fails to do justice to the multiplicity of meanings conveyed. Especially within the world of fashion, cultural signs, like the corset, have no fixed meaning. Many fashionable corsets can be interpreted in terms of the assimilation of fetishistic imagery into popular culture. Although some women remain ambivalent or hostile to fetish fashion, for others the look is strong and sexy. Once the punks adopted fetish corsets as a defiantly perverse statement, it became increasingly possible to interpret at least some corsets as an ironic, postmodern manipulation of sexual stereotypes.

But the corset's traditional symbolism is also still in evidence. In April 2001, British *Vogue* suggested that "fashion's erogenous zone has shifted . . . [to] the waist," adding that "men are more drawn to women with a hand-span waist."[90] To achieve this look, new types of corrective corsetry have also proliferated. "This is not your grandmother's girdle," declared *In Style* (December, 2000): "The new body shapers are comfy, seamless and lightweight – and some zap off inches immediately. . . . It's a cinch. Like the corsets of old, these items slim your middle for a Scarlett O'Hara-size waistline."[91]

Notes

1 Steel and Whalebone

1 See Pierre Larousse, *Grand dictionnaire universel du XIXe siècle* (Paris, 1866–76; repr. Nimes: Lacour, 1990), p. 207.

2 See Helene H. Roberts, "The Exquisite Slave: The Role of Clothes in the Making of the Victorian Woman," *Signs: Journal of Women in Culture and Society* 2 (Spring, 1977), pp. 554–69; Béatrice Fontanel, *Corsets et soutiens-gorge: L'Epopée du sein de l'Antiquité à nos jours* (Paris: Editions de La Martinière, 1992); and Leigh Summers, "The Sexual Politics of Corsetry, 1850–1900," Ph.D. diss., University of Melbourne, 1999. For an alternative view, also seriously flawed, see David Kunzle, *Fashion and Fetishism: A Social History of the Corset, Tight-Lacing, and Other Forms of Body Sculpture in the West* (Totowa, New Jersey: Rowman and Littlefield, 1980).

3 Margaret Mitchell, *Gone With the Wind* (1939), quoted in Mariane Thesander, *The Feminine Ideal* (London: Reaktion Books, 1997), p. 7.

4 Linda Baumgarten and John Watson with Florine Carr, *Costume Close-Up: Clothing Construction and Pattern, 1750–1790* (Williamsburg, Virginia and New York: The Colonial Williamsburg Foundation in association with Quite Specific Media Group, 1999), p. 64. The catalogue says the largest pair of stays was 30 inches, the wall text says 32 inches.

5 See Valerie Steele, "Why People Hate Fashion," in Giannino Malossi, ed., *The Style Engine: How the Fashion Industry Uses Style to Create Wealth* (New York: Monacelli, 1998), pp. 66–71.

6 Constance Ray, "The Corset and the Form Divine," *Chicago Sunday Tribune* (December 18, 1932), p. 6.

7 Ernest Léoty, *Le Corset à travers les âges* (Paris: Paul Ollendorff, 1893), pp. x, 21.

8 See Fontanel, *Corsets et soutiens-gorge*, p. 10.

9 Naomi Tarrant, *The Development of Costume* (London and New York: Routledge, 1994) p. 56.

10 W. B. L. [William Barry Lord], *The Corset and the Crinoline* (London: Ward, Lock, and Tyler, n.d. [1868]), p. 72.

11 Advertisement for P. N. Practical Front Corsets, *Woman's Home Companion* (October, 1921), p. 65.

12 Ray, "The Corset and the Female Form Divine," p. 6.

13 C. Willett Cunnington and Phyllis Cunnington, *The History of Underclothes* (London: A. Joseph, 1951; rev. ed. A. D. and Valerie Mansfield, London: Faber and Faber, 1981), p. 48.

14 *The Work of That Famous Chirurgian Ambroise Parey*, trans. Thomas Johnson (London: Richard Cotes, 1649), p. 582.

15 *Ibid.*, p. 581. See also Paré, quoted in Georges Vigarello, "The Upward Training of the Body from the Age of Chivalry to Courtly Civility," in Michel Feher with Ramona Naddaff and Nadia Tazi, eds., *Fragments for a History of the Human Body*, Part Two. Zone 4. (New York: Urzone, 1989), p. 175 for a fuller quotation.

16 *Ibid.*, p. 581. See also Paré, quoted in Vigarello, p. 174.

17 W. B. L., *The Corset and the Crinoline*, p. 43.

18 See Tarrant, *Development of Costume*, p. 46.

19 Maurice Leloir, *Dictionnaire du costume* (Paris: Libraire Grund, 1951), p. 125. See also Norah Waugh, *Corsets and Crinolines* (London: Batsford, 1954).

20 Rabelais, *The History of Gargantua and Pantagruel*, trans. J. M. Cohen (Harmondsworth: Penguin, 1969), p. 157.

21 Janet Arnold, *Queen Elizabeth's Wardrobe Unlock'd* (Leeds: Maney, 1988), p. 146.

22 Janet Arnold, "Cut and Construction," in Kirsten Aschengreen Piacenti, ed., *Moda alle corte dei Medici gli abiti restaurati de Cosimo, Eleanora e don Garzia* (Florence: Centro di Firenze, 1993), pp. 66–7.

23 Henry Estienne, *Dialogue du nouveau langage français, italianisé* (Paris, 1579), quoted in Vigarello, "The Upward Training of the Body," p. 155.

24 Arnold, *Queen Elizabeth's Wardrobe*, p. 146.

25 Tarrant, *Development of Costume*, p. 59.

26 Quoted in Arnold, *Queen Elizabeth's Wardrobe*, p. 146.

27 Stephen Gosson, *Pleasant Quippes for Upstart Newfangled Gentlewomen* (1595), quoted in Aileen Ribeiro, *Dress and Morality* (New York: Holmes and Meier, 1986), p. 70.

28 These busks, displayed at an exhibition of the Costume Institute, The Metropolitan Museum of Art, New York, were gifts of Mrs. Edward S. Harkness.

29 Philip Gosson, quoted in Cunnington and Cunnington, *History of Underclothes*, p. 48.

30 Vigarello, "The Upward Training of the Body," p. 155.

31 Eucharius Roeslin, *Des divers travaux et enfantements des femmes* (Paris, 1536), quoted in *ibid.*, p. 173.

32 Quoted in Fernand Libron and Henry Clouzot, *Le Corset dans l'art et les moeurs du XIIIe au XXe siècles* (Paris: the authors, 1933), p. 50.

33 Mme de Sévigné, quoted in *ibid.*, p. 32.

34 See Domna Stanton, *The Aristocrat as Art: A Study of the Honnête Homme and the Dandy in Seventeenth- and Nineteenth-Century French Literature* (New York: Columbia University Press, 1980).

35 Daniel Roche, *The Culture of Clothing: Dress and Fashion in the Ancien Régime*, trans. Jean Birrell (Cambridge University Press, 1994), p. 123.

36 Michel de Montaigne, quoted in Dr. G. J. Witkowski, *Anecdotes historiques et religieuses sur les seins et l'allaitement comprenant l'histoire du décolletage et du corset* (Paris: A. Maloine, 1889), vol. 2, p. 268.

37 Wallace B. Hamby, ed., *The Case Reports and Autopsy Records of Ambroise Paré* (Springfield, Mass.: Charles C. Thomas,

1960), p. 78. I am indebted to Dr. Lynn Kutsche for this citation.

38 Lynn Kutsche, M.D., unpublished paper on the medical aspects of corsetry, given at the Fashion Institute of Technology, New York, March 7, 2000.

39 Michel de Montaigne, *Essays*, Book 1, ch. 14. See *The Complete Works of Montaigne* (Stanford University Press, 1948), p. 41. My translation differs slightly from that of Donald M. Frame.

40 *Ibid.*, pp. 40–41.

41 John Bulwer, *Anthropometamorphosis: Man Transformed: The Artificial Changeling, Historically Presented, in the Mad and Cruell Gallantry, Foolish Bravery, Ridiculous Beauty, Filthy Finenesse, and Loathsome Loveliness of Most Nations, fashioning and altering their Bodies from the mould intended by Nature; with Figures of those Transformations . . .* (London: William Hunt, 1653), pp. 338–9. Usually known as *The Artificial Changeling*.

42 *Ibid.*, pp. 340–42.

43 See Arnold, *Queen Elizabeth's Wardrobe*, p. 145.

44 D'Offemont, quoted in Libron and Clouzot, *Le Corset*, pp. 48–50.

45 Quoted in Judith G. Coffin, *The Politics of Women's Work: The Paris Garment Trades, 1750–1915* (Princeton University Press, 1996), p. 36.

46 See *ibid.*, p. 42.

47 T. Walker, *General Description of All Trades* (London, 1747) and R. Campbell, *The London Tradesman* (London, 1747; 3rd ed., 1757), quoted in Lynn Sorge, "Eighteenth-Century Stays: Their Origins and Creators," *Costume* 32 (1998), p. 19, and Aileen Ribeiro, *Dress in Eighteenth Century Europe 1715–1789* (London: Batsford, 1984), p. 58.

48 Rétif de la Bretonne, *Les Contemporaines*, quoted in Marie Simon, *Les Dessous: Les Carnets de la mode* (Paris: Chêne-Hachette, 1998), p. 18.

49 John Dunton, *Ladies Dictionary*, quoted in Waugh, *Corsets and Crinolines*, p. 50.

50 Peter and Ann Mactaggart, "Ease, Convenience and Stays, 1750–1850," *Costume* 13 (1979), pp. 45–6.

51 Elizabeth Ham, *Elizabeth Ham by Herself* (c. 1792–3), quoted in Waugh, *Corsets and Crinolines*, p. 71.

52 Duchess of Devonshire (1778), quoted in *ibid.*, p. 68.

53 Cited in *ibid.*, p. 60.

54 Samuel Thomas von Soemmerring, *Über die Wirkungen der Schnürbruste* (Berlin, 1793).

55 C. L. von Pollnitz, *Travels from Prussia Thro' Germany, Italy, France, Flanders, Holland, England, etc.* (London, 1745), vol. 3, p. 287, quoted in Ribeiro, *Dress in Eighteenth Century Europe*, p. 40.

56 Peter Kalm, quoted in Anne Buck, *Dress in Eighteenth-Century England* (London: Batsford; New York: Holmes and Meier, 1979), p. 121.

57 Mme du Bocage, quoted in *ibid.*, p. 36.

58 Samuel Richardson, *Clarissa Harlowe* (1748), quoted in Ribeiro, *Dress and Morality*, p. 103.

59 *Letters from Liselotte*, trans. and ed. Maria Kroll (New York: McCall, 1971), p. 117.

60 See Roche, *Culture of Clothing*, p. 173.

61 Buck, *Dress in Eighteenth-Century England*, p. 146.

62 Francis Place, quoted in Ribeiro, *Dress in Eighteenth Century Europe*, p. 64.

63 Merchant's diary quoted in Cunnington and Cunnington, *History of Underclothes*, p. 88.

64 Samuel Foote, *Taste* (1752) and "Beauty and Fashion," *The London Magazine* (1762), quoted in Mactaggart, "Ease, Convenience and Stays," pp. 41–2.

65 *The London World*, March 15, 1790, p. 3a, quoted in Jan Bondeson, *The London Monster: A Sanguinary Tale* (Philadelphia: University of Pennsylvania Press, 2000), p. 3.

66 John Byng, quoted in Buck, *Dress in Eighteenth-Century England*, p. 122.

67 See Sarah R. Cohen, *Art, Dance, and the Body in French Culture of the Ancien Régime* (Cambridge University Press, 2000), pp. 11, 14.

68 See Sara E. Melzer and Kathryn Norberg, eds., *From the Royal to the Republican Body* (Berkeley, Los Angeles, London: University of California Press, 1998).

69 Amanda Vickery, *The Gentleman's Daughter: Women's Lives in Georgian England* (New Haven and London: Yale University Press, 1998), pp. 163–4.

70 Roche, *Culture of Clothing*, p. 123.

71 Quoted in Waugh, *Corsets and Crinolines*, p. 59.

72 *Dictionnaire des origines* (1777), quoted in Libron and Clouzot, *Le Corset*, p. 58.

73 *The Ladies Magazine* (1785), quoted in Mactaggart, "Ease, Convenience and Stays," p. 46.

74 *Cérémonial de la Cour*, quoted in Libron and Clouzot, *Le Corset*, p. 44.

75 *Encyclopédie méthodique* (1784), quoted in *ibid.*, pp. 58–9.

76 Aileen Ribeiro, *Fashion in the French Revolution* (London: Batsford, 1988), p. 102.

77 See Nicole Pellegrin, *Les Vêtements de la liberté* (Paris: Alinea, 1989), pp. 54–5.

78 Libron and Clouzot, *Le Corset*, p. 70.

79 Poem and caricature reproduced in Vickery, *Gentleman's Daughter*, p. 178.

80 Quoted in G. J. Barker-Benfield, *The Culture of Sensibility: Sex and Society in Eighteenth-Century Britain* (University of Chicago Press, 1992), p. 78.

81 N. G. Dufief, *Nature Displayed, in her Mode of Teaching Language to Man*, 2nd ed., vol. 1. (Philadelphia: Press of John Watts, 1806), p. 15. The same page also includes the phrase "Who made you this bodice?" ("*Qui vous a fait ce corset?*")

82 Mercier, quoted in Ribeiro, *Fashion in the French Revolution*, pp. 124, 125.

83 *The Journals and Letters of Fanny Burney*, ed. J. Hemlow, 10 vols. (Oxford, 1972–82), vol. 5, p. 290.

84 Quoted in Ribeiro, *The Art of Dress: Fashion in England and France, 1750–1820* (New Haven and London: Yale University Press, 1995), p. 125.

2 Art and Nature

1 The classic account is Helene E. Roberts, "The Exquisite Slave: The Role of Clothes in the Making of the Victorian Woman," *Signs: Journal of Women in Culture and Society* 2 (Spring, 1977), pp. 554–69. See also Lois Banner, *American Beauty* (New York: Knopf, 1983), pp. 48–9; and Leigh Summers, "The Sexual Politics of Corsetry, 1850–1900," Ph.D. diss., University of Melbourne, 1999.

2 Summers, "Sexual Politics of Corsetry," p. i.

3 Henry T. Finck, *Romantic Love and Personal Beauty*. (New York and London: Macmillan [1887], 1912), p. 386.

4 See, for example, Stephen Kern, *Anatomy and Destiny: A Cultural History of the Human Body* (Indianapolis and New York: Bobbs-Merrill, 1975).

5 See Peter Gay, *The Bourgeois Experience: Victoria to Freud*, vol. 1: *The Education of the Senses* (New York and Oxford: Oxford University Press, 1984); Michael Mason, *The Making of Victorian Sexuality* (New York and Oxford: Oxford University Press, 1994); Roy Porter and Leslie Hall,

The Facts of Life: The Creation of Sexual Knowledge in Britain, 1650–1950 (New Haven and London: Yale University Press, 1995).

6 See Philippe Perrot, *Fashioning the Bourgeoisie: A History of Clothing in the Nineteenth Century*, trans. Richard Bienvenu (Princeton University Press, 1994); Claudia Kidwell and Margaret Christman, *Suiting Everyone: The Democratization of Clothing in America* (Washington, D.C.: Smithsonian Institution Press, 1974).

7 See Sara Melzer and Katryn Norberg, eds., *From the Royal to the Republican Body* (Berkeley, Los Angeles, London: University of California Press, 1998).

8 See Ellen Moers, *The Dandy* (New York: Viking, 1960); Anne Hollander, *Sex and Suits* (New York: Knopf, 1994).

9 In the collection of the University Club, New York City.

10 Fyodor Dostoevsky, *Notes from the Underground* (1864) in *Three Short Novels of Dostoevsky*, trans. Constance Garnett (Garden City: Anchor Books, 1960), p. 247.

11 *The Workwoman's Guide*, quoted in Peter Farrer, "Adcock's Riding Belt," *Journal of the Northern Society of Costume and Textiles* 3 (Spring, 1999), p. 3.

12 William Makepeace Thackeray, *Vanity Fair* (Oxford University Press, 1931), vol. I, p. 22.

13 See Moers, *The Dandy*, p. 28.

14 Honoré de Balzac, *Cousin Bette* [1846], trans. Marion Ayton Crawford (Harmondsworth: Penguin, 1965), p. 162.

15 Léon de B. (1831), quoted in Philippe Perrot, *La Travail des apparences, ou les transformations du corps féminin XVIIIᵉ–XIXᵉ siècles* (Paris: Seuil, 1984), p. 264.

16 Anne Brontë, *Agnes Grey* (Harmondsworth: Penguin, 1988), p. 102.

17 G. Viterbo, "Les Corsets-ceintures pour hommes," *Les Dessous Elégants* (August, 1904), p. 138.

18 Mme. Burtel, *L'Art de faire les corsets, suivre de l'art de faire les guêtres et les gants* (Paris: Audot, 1828), p. v.

19 Mme. Roxey A. Caplin, *Health and Beauty; or Corsets and Clothing Constructed in Accordance with the Physiological Laws of the Human Body* (London: Darton & Co., n.d. [1854]), pp. viii, x.

20 *Ibid.*, pp. 66, x–xi.

21 *Ibid.*, pp. 66, x–xii, 35, 42–3, 59.

22 *Ibid.*, pp. 66, xii.

23 Mrs. Mills's advertisement in *Townsend's Monthly Selection of Parisian Costumes* (July 1835), and Mrs. Bell's in *The World of Fashion* (November 1829), both quoted in Peter and Ann Mactaggart, "Ease, Convenience and Stays, 1750–1850," *Costume* 13 (1979), p. 44.

24 Mrs. Bell's advertisement in *World of Fashion* (March 1831), and the Follet's in *Townsend's Monthly* (August 1835), both quoted in *ibid.*, p. 50.

25 See Daniel Roche, *France in the Enlightenment* (Cambridge, Mass.: Harvard University Press, 1998), p. 638.

26 See John Gloag, *Victorian Comfort: A Social History of Design from 1830 to 1900* (London: A. & C. Black, 1961).

27 *Modes Parisiennes* (July 30, 1843), quoted in Fernand Libron and Henry Clouzot, *Le Corset dans l'art et les moeurs du XIIIᵉ au XXᵉ siècles* (Paris: the authors, 1933), p. 90.

28 See Perrot, *Fashioning the Bourgeoisie*, p. 159.

29 Balzac, *Cousin Bette*, p. 410.

30 Gustave Flaubert, *Madame Bovary*, quoted in Peter Brooks, *Body Work: Objects of Desire in Modern Narrative* (Cambridge, Mass. and London: Harvard University Press, 1993), pp. 93–4.

31 Anne McClintock, *Imperial Leather: Race, Gender, and Sexuality in the Colonial Context* (New York and London: Routledge, 1995), p. 105.

32 Thorstein Veblen, *The Theory of the Leisure Class* (New York: Modern Library, 1934), p. 172.

33 Simon Place, quoted in Mason, *Making of Victorian Sexuality*, p. 29.

34 Diana Crane, *Fashion and Its Social Agendas: Class, Gender, and Identity in Clothing* (Chicago and London: Chicago University Press, 2000), pp. 51–2.

35 See Joan Severa, *Dressed for the Photographer: Ordinary Americans and Fashion, 1840–1900* (Kent, Ohio: Kent State University Press, 1995), pp. 60–61, 122–5, 268–9, 332–3.

36 Veblen, *Theory of the Leisure Class*, p. 179.

37 *L'Encyclopédie du XXᵉ siècle*, quoted in Ernest Léoty, *Le Corset à travers les âges* (Paris: Paul Ollendorff, 1893), p. 92.

38 Gordon Stables, *The Girl's Own Book of Health and Beauty* (London: Jarrold's & Sons, 1892), p. 113.

39 Charles Reade, *A Simpleton* (Boston: Dana Estes & Co., n.d. [c. 1873], pp. 36–7, 43–5, 181.

40 Gwen Raverat, *Period Piece: A Cambridge Childhood* (London: Faber and Faber, 1952), p. 259.

41 *Ibid.*, pp. 258–9, my emphasis.

42 Edith Rode, "A Glimpse from the Nineties," quoted in Marianne Thesander, *The Feminine Ideal* (London: Reaktion Books, 1997), p. 96.

43 Mrs. Eliza Haweis, *The Art of Beauty* (New York: Harper and Brothers, 1878), p. 48; *The Art of Dress* (London: Chatto & Windus, 1879), p. 35; both books repr. together, New York: Garland, 1978.

44 Karl Marx, *The Eighteenth Brumaire of Louis Bonaparte* (New York: International Publishers, n.d. [c. 1930s]), p. 1.

45 Anonymous, *Beauty: Its Attainment and Preservation* (New York: Butterick Publishing Company, 1890), pp. 132–4.

46 Mrs. L. H. Sigourney, "On Health – To Mothers," *The Mother's Book* (August, 1838), p. 189.

47 Arnold J. Cooley, *The Toilet and Cosmetics in Ancient and Modern Times, with a Review of the Different Theories of Beauty* (London, 1866; New York: Burt Franklin, 1970), p. 352.

48 *Ibid.*, p. 353.

49 Anonymous, "Tight Dressing – Corsets," *The Mother's Book* (August, 1838), p. 170.

50 Cooley, *Toilet and Cosmetics*, p. 353.

51 Mrs. Fanny Douglas, *The Gentlewoman's Book of Dress* (London: Henry & Co., n.d. [c. 1894]), pp. 123–4.

52 Frances Mary Steele and Elizabeth Livingston Steele Adams, *Beauty of Form and Grace of Vesture* (London: B. F. Stevens, 1892), p. 26.

53 Ernest Aimé Feydeau, *The Art of Pleasing*, trans. Marie Courcelles (New York: G. W. Carlton & Co., 1874), pp. 18–19.

54 Anonymous, *Dress, Health, & Beauty* (London: Ward, Lock & Co., 1878), p. 79.

55 Ada S. Ballin, *The Science of Dress in Theory and Practice* (London: Sampson Low, Marston, Searle, and Rivington, 1885), p. 151.

56 See Steele and Adams, *Beauty of Form*, pp. 19–21.

57 Dr. Hunt, quoted in Marion Harland, *Eve's Daughters, or Common Sense for Maid, Wife and Mother* (New York: John R. Anderson and Henry S. Allen, 1882), pp. 353–6.

58 Marguerite d'Aincourt, *Etudes sur le costume féminin* (Paris: Rouveyre et G. Blond, n.d. [c. 1885]), pp. 24–5.

59 Léoty, *Le Corset à travers les âges*, p. 102.

60 Octave Uzanne, *L'Art et les artifices de la beauté* (Paris: F. Juven, 1902), pp. 94–5.

61 Summers, "Sexual Politics of Corsetry," p. 95.

62 Becker, cited in *Rational Dress Society's Gazette* (October, 1881), p. 1.

63 Achille Tola-Poix, quoted in Perrot, *Fashioning the Bourgeoisie*, p. 158.

64 Elizabeth Stuart Phelps, *What to Wear?* (Boston: James R. Osgood and Company, 1873), pp. 18–19.

65 *Ibid.*, pp. 78–9.

66 *Ibid.*, pp. 29–30.

67 Mary E. Tillotson, *Progress versus Fashion* (Vineland, New Jersey, 1873), pp. 1–2, 5.

68 Anonymous, *Dress, Health, and Beauty*, p. 123.

69 Frances Willard, quoted in Helen Gilbert Ecob, *The Well-Dressed Woman: A Study in the Practical Application to Dress of the Laws of Health, Art, and Morals* (New York: Fowler and Wells, 1893), pp. 28–9.

70 Mrs. E. M. King, *Rational Dress, or, the Dress of Women and Savages* (London: Kegan Paul, Trench & Co., 1882), p. 6.

71 Phelps, *What to Wear?* p. 25.

72 Abba Gould Woolson, ed. *Dress Reform: A Series of Lectures Delivered in Boston, on Dress as It Affects the Health of Women* (Boston: Roberts Brothers, 1874), pp. 195–6.

73 *Ibid.*, pp. 75, 77.

74 *Ibid.*, p. 1.

75 See Stella Mary Newton, *Health, Art and Reason: Dress Reformers of the 19th Century* (London: John Murray, 1974).

76 See Rebecca Houze, "Fashionable Reform Dress and the Invention of 'Style' in Fin-de-Siècle Vienna," *Fashion Theory* 4, no. 4 (2000), p. 1.

77 Ecob, *Well-Dressed Woman*, p. 141.

78 Finck, *Romantic Love*, p. 382.

79 See Walter Vandereycken and Ron van Deth, *From Fasting Saints to Anorexic Girls: The History of Self-Starvation* (New York University Press, 1994), p. 246.

80 See *ibid.*, pp. 214–15.

81 See Cleveland Amory, "Diamond Jim Brady," in *The American Heritage Cookbook and Illustrated History of American Eating and Drinking* (New York: American Heritage Publishing Company, n.d.), p. 340.

82 Anonymous, *Beauty: Its Attainment and Preservation*, pp. 132–4.

83 Woolson, *Dress Reform*, p. 208.

84 See Peter Stearns, *Fat History: Bodies and Beauty in the Modern West* (New York University Press, 1997), p. 153.

85 Anonymous, *My Secret Life* (New York: Ballantine, 1973), pp. 166–7.

86 Mary Lynn Stewart, *For Health and Beauty: Physical Culture for Frenchwomen, 1880s-1930s* (Baltimore and London: Johns Hopkins University Press, 2001), p. 29.

3 Dressed to Kill

1 "Tight-lacing Again," *The Lancet* (January 10, 1880), p. 75.

2 Luke Limner [John Leighton], *Madre Natura Versus the Moloch of Fashion* (London: Chatto & Windus, 1874), pp. 70–73.

3 Leigh Summers, "The Sexual Politics of Corsetry: 1850–1900," Ph.D. diss., University of Melbourne, 1999, p. 113.

4 Dr. Lynn Kutsche, unpublished paper on the medical consequences of corsetry, presented at the Fashion Institute of Technology, State University of New York, March 7, 2000.

5 Robert L. Dickenson, M.D., "Toleration of the Corset: Prescribing Where One Cannot Proscribe," *American Journal of Obstetrics and Gynecology* 63 (1911), pp. 1023–58.

6 Anonymous, "Tight-Lacing," *The Lancet* (June 6, 1868), p. 729.

7 Colleen Ruby Gau, "Historical Medical Perspectives of Corseting and Two Physiological Studies with Reenactors," Ph.D. diss., Iowa State University, 1998, pp. xi, 4–5.

8 *Ibid.*, ch. 7, "Related Modern Physiological Experiments," pp. 97–104.

9 Publications bearing on costal breathing and related subjects include: J. H. Kellogg, M.D., "Experimental Researches Respecting the Relation of Dress to Pelvic Diseases of Women," *Transactions of the Michigan Medical Society* (1888); J. H. Kellogg, M.D., "The Relation of Static Disturbances of the Abdominal Viscera to Displacements of the Pelvic Organs," *Proceedings of the International Congress of Gynecology and Obstetrics* (1892, repr. 1894), see esp. pp. 29–32; T. H. Manley, M.D., "The Corset: Its Use and Abuse with Tight-Lacing," *The Virginia Semi-Monthly* (September 9, 1898), pp. 302–6; Francis Sibson, *On the Mechanism of Respiration* (London: R. & J. E. Taylor, 1846); John M. Hobson, M.D., "On the Mechanism of Costal Respiration" *Journal of Anatomy and Physiology* 15 (1880–81), pp. 331–45; Havelock Ellis, *Man and Woman* [1894] (Boston: Houghton Mifflin, 1929), pp. 202–11; W. Wilberforce Smith, M.D., "On the Alleged Differences Between Male and Female Respiratory Movements," *British Medical Journal* (October 11, 1890); Henry Sewall, M.D., and Myra E. Pollard, M.A., "On the Relations of Diaphragmatic and Costal Respiration, with Particular Reference to Phonation," *Journal of Physiology* 3 (1897); W. H. Walshe, "On the Breathing-movements in the Two Sexes, and On the Alleged Influence of Stays in Producing Pulmonary Consumption," *Medical Times and Gazette* 6 (1853), pp. 366–8. Walshe refers to studies by Boerhaave.

10 Personal communication to the author by Dean Sonnenberg, corsetier and corset-wearer; Colin G. Caro, John Butler, and Arthur B. DuBois, "Some Effects of Restriction of Chest Cage Expansion on Pulmonary Function in Man: An Experimental Study," *Journal of Clinical Investigation* 39 (1960), pp. 573–83; H. R. Harty, D. R. Cornfield, R. M. Schwartzstein, and L. Adams, "External Thoracic Restriction, Respiratory Sensation, and Ventilation During Exercise in Men," *Journal of Applied Physiology* 4 (April, 1999), pp. 1142–50; M. T. Vanmeenen, J. Ghesquire, and M. Demedts, "Effects of Thoracic or Abdominal Strapping on Exercise Performance," *Bulletin of European Physiopathology and Respiration* 20, no. 2 (1984), pp. 127–32.

11 Personal communication to the author from Robert and Catherine Jung.

12 Anna M. Galbraith, M.D., *Hygiene and Physical Culture for Women* (New York: Dodd, Mead and Company, 1895), pp. 229–33.

13 *The Lancet*, quoted in Henry T. Finck, *Romantic Love and Personal Beauty* (New York and London: Macmillan, [1887] 1912), p. 381.

14 Gau, "Historical Medical Perspectives of Corseting," p. 188.

15 Dr. Lynn Kutsche, unpublished paper on the medical consequences of corsetry.

16 Summers, "Sexual Politics of Corsetry," p. i.

17 Gau, "Historical Medical Perspectives of Corseting," p. 28.

18 See Lois Banner, *American Beauty* (Chicago and London: University of Chicago Press, 1983), p. 187.

19 See, for example, Sander Gilman, *Making the Body Beautiful: A Cultural History of Aesthetic Surgery* (Princeton University Press, 1999).

20 Quoted in Jean Godfrey-June, "Waist Land," *Vogue* (August, 2000), p. 249.

21 Personal communication to the author from Robert and Catherine Jung.

22 See Gilman, *Making the Body Beautiful*, p. 239.

23 Mrs. Mary Wood-Allen, M.D., *What a Young Woman Ought to Know* (Philadelphia: The Vir Publishing Company, 1899, new ed. 1913), p. 63.

24 Gwen Raverat, *Period Piece* (London: Faber and Faber, 1952), p. 259.

25 See "Remarkable Case of Displacement of an Enlarged Liver from Tight Lacing," *The Lancet* (January 5, 1861), pp. 5–6. I am grateful to Dr. Lynn Kutsche for bringing this to my attention.

26 Quoted in Wood-Allen, *What a Young Woman Ought to Know*, p. 63.

27 Carl Rokitansky, *Handbuch der Pathologischen Anatomie* (1842), p. 315; Albert Fricke, "Ein interessanter Fall von "Schnürwickungen," Inaugural-Dissertation zur Erlangung der Doktorwürde der medicinischen Fakultät zu Kiel, 1892; Chr. Hansen, "Ein Fall von Schnürwirkungen an den Baucheingeweiden," Inaugural-Dissertation zur Erlangung der Doktorwürde der medicinischen Fakultät zu Kiel, 1893; Karl Hackman, "Schnürwirkungen," Inaugural-Dissertation zur Erlangung der Doktorwürde der medicinischen Fakultät zu Kiel, 1894. Dr. Kutsche and I wish to thank Dr. L. H. S. van Mierop for translating these for us.

28 Personal communication to the author from Dr. Lynn Kutsche.

29 See Edward D. Kilbourne, "Are New Diseases Really New?" *Natural History* (December, 1983), p. 32; Gerhardt S. Schwartz, M.D., "Society, Physicians, and the Corset," *Bulletin of the New York Academy of Medicine* 55, no. 6 (June, 1979), pp. 555–7, 584. My thanks to Dr. Kilbourne, Chairman of the Department of Microbiology at the Mount Sinai School of Medicine, for referring me to additional information in *The American Journal of Medicine* 88 (1980). In a private communication, Dr. Kilbourne observed that it was difficult "to relate [chlorosis] to effects of mechanical restriction."

30 Anonymous, "Tight-lacing Again," *The Lancet* (January 10, 1880), p. 75.

31 Helen L. Betts, M.D., "Dress of Women in its Relation to the Etiology and Treatment of Pelvic Disease," *Journal of the American Medical Association*, 10, no. 17 (1888), pp. 509–13; Thomas Addis Emmitt, M.D., *The Principles and Practice of Gynecology* (Philadelphia: Henry C. Lea, 1880); E. C. Dudley, A.M., M.D., *The Principles and Practice of Gynecology* (Philadelphia: Lea & Febiger, 1908); V. H. Taliaferro, "The Corset in its Relations to Uterine Disease," *Atlanta Medical and Surgical Journal* 10 (1873), pp. 683–93. My thanks to Dr. Lynn Kutsche for this information.

32 *The Rational Dress Society's Gazette* (April, 1889), p. 2.

33 Pierre Boitard, *Manuel-physiologie de la bonne compagnie* (Paris, 1862), quoted in Philippe Perrot, *Fashioning the Bourgeoisie: A History of Clothing in the Nineteenth Century*, trans. Richard Bienvenu (Princeton University Press, 1994), p. 159.

34 See Paul Schultze-Naumberg, *Die Kultur des weiblichen Körpers als Grundlage der Frauenkleidung* (Jena, 1901), and Christian Stratz, *Die Frauenkleidung und ihre natürliche Entwicklung* (Stuttgart, 1900).

35 Ligue des Mères de Famille, *Pour la beauté naturelle de la femme contre la mutilation de la taille par le corset*, preface by Edmond Harancourt (Paris: Ligue des Mères de Famille, 1909), pp. 3, 12.

36 Hugh Smith, M.D., *Letters to Married Ladies, to which is added a Letter on Corsets, by an American Physician* (New York: E. Bliss and E. White, 1827), pp. 199–204.

37 Orson S. Fowler, *Intemperance and Tight-Lacing; Founded on the Laws of Life, as Developed by Phrenology and Physiology* (New York, c. 1846; Manchester: John Heywood, n.d. [c. 1899]), pp. 33, 36–9.

38 Dr. Coleman cited in John S. Haller and Robin M. Haller, *The Physician and Sexuality in Victorian America* (Urbana: University of Illinois Press, 1974), p. 39.

39 Dr. Lynn Kutsche, personal communication to the author.

40 Abba Gould Woolson, ed., *Dress Reform: A Series of Lectures delivered in Boston, on Dress as it Affects the Health of Women* (Boston: Roberts Brothers, 1874), Lecture I, pp. 15–17.

41 Anonymous, "Death from Tight Lacing," *The Lancet* (May 23, 1869), p. 675. I am grateful to Dr. Lynn Kutsche for bringing this to my attention.

42 Dr. Lynn Kutsche, personal communication to the author.

43 Anonymous, "Corsets and Tight Lacing," *The Lancet* (June 25, 1887), pp. 1296–7. I am grateful to Dr. Lynn Kutsche for bringing this to my attention.

44 Dr. Lynn Kutsche, personal communication to the author.

45 Sydney Ross Singer and Soma Grismaijer, *Dressed to Kill: The Link Between Breast Cancer and Bras* (Garden City, N.Y.: Avery, 1995).

46 Leigh Summers echoes Dr. Charles Graham Cannaday, who condemned his fellow doctors for failing to make "a united protest" against corsetry. Summers, "Sexual Politics of Corsetry," p. 91.

47 Frederick Treves, F.R.C.S., *The Dress of the Period in its Relation to Health* (London: published for the National Health Society by Allman & Son, n.d. [1882]), pp. 15–20.

48 William Henry Flower, *Fashion in Deformity as Illustrated in the Customs of Barbarous and Civilised Races* (London: Macmillan & Co., 1881), pp. 79–80.

49 W. Wilberforce Smith, M.D., "Corset Wearing: The Medical Side of the Attack," *Aglaia* (July, 1893), p. 7, and (Spring, 1894), pp. 31–5.

50 Charles Roux, *Contre le corset* (Paris: E. Brière et Cie, 1855), pp. 1–4.

51 Dr. Sauveur Henri-Victor Bouvier, *Etudes historiques et médicales sur l'usage des corsets* (Paris: J.-B. Baillière, Librairie de l'Académie Impériale de médecine, 1853), pp. 32–4.

52 Dr. Ludovic O'Followell, *Le Corset: Etude historique. Histoire – médecine – hygiène* (Paris: A. Maloine, 1905, 1908), two vols.

53 Gustav Jaeger, M.D., *Selections from Essays on Health Culture and the Sanitary Woolen System* (London: Dr. Jaeger's Sanitary Woolen System, 1884), p. 165.

54 Lynn Kutsche, M.D., "The Physician and the Corset: The 19th-Century Controversy," *Fashion Theory* (forthcoming).

55 Dr. Lynn Kutsche, personal communication to the author.

56 See Robert Nye, *Masculinity and Male Codes of Honor in Modern France* (Berkeley, Los Angeles, London: University of California Press, 1993), p. 47, 51–3.

57 *Ibid.*, pp. 77–9.

58 Charles Dubois, *Considerations on Five Plagues: The Abuse of the Corset, the Use of Tobacco, the Passion for Gambling, the Abuse of Strong Drink, and Speculation* (Paris, 1857), quoted in Perrot, *Fashioning the Bourgeoisie*, pp. 158–9.

59 Mme. Inez Gâches-Saurraute, *Le Corset: Étude physiologique et pratique* (Paris: Masson et cie. éditeurs, Librairie de l'Académie de Médecine, 1900), pp. 12, 17, 1.

60 *The Lady's Magazine* (February, 1901), p. 217; (March, 1901), p. 304.

61 Robert L. Dickenson, M.D., "Toleration of the Corset: Prescribing Where One Cannot Proscribe." *American Journal of Obstetrics and Gynecology* 63 (1911): 1023–58. I am indebted to Dr. Lynn Kutsche for this reference.

62 Dr. Lynn Kutsche, private communication to the author.

63 Colleen R. Gau, "Physical Performance and Comfort of Females Exercising on a Treadmill While Wearing Historic Tight-Laced Corsets of 1865 and 1900," M.A., thesis, Iowa State University, 1996, cited in Gau, "Historical Medical Perspectives of Corseting," p. 1.

4 Fashion and Fetishism

1 Henry T. Finck, *Romantic Love and Personal Beauty* (New York: Macmillan [1887], 1912), p. 379.

2 *Ibid.*, pp. 380–81.

3 "Tight Dressing – Corsets," *The Mother's Book* (August, 1838), p. 170.

4 Mrs. L. H. Sigourney, "On Health – To Mothers," ibid., p. 188.

5 Mrs. H. R. Haweis, *The Art of Dress* (London: Chatto & Windus, 1879), p. 35.

6 *The Family Herald* (March 4, 1848), p. 700, quoted in Peter Farrar, *Tight Lacing: A Bibliography of Articles and Letters Concerning Stays and Corsets for Men and Women* (Liverpool: Karn Publications Garston, 1999), p. 6.

7 A Lady from Edinburgh, *The Englishwoman's Domestic Magazine* [hereafter *EDM*] (March 1867), pp. 164–5. Reproduced in W. B. L. [William Barry Lord], *The Corset and the Crinoline* (London: Ward, Lock, and Tyler, n.d. [1868]), p. 193, p. 172.

8 Nora, *EDM* (May, 1867), p. 279.

9 Susan Faludi, *Backlash: The Undeclared War Against American Women* (New York: Crown, 1991), p. 173.

10 Alfred, *EDM* (January, 1871), p. 62; Moralist, *EDM* (February, 1871), p. 127.

11 "The Elasticity of Young Ladies," *Punch* (September 18, 1869), p. 111.

12 Doris Langley Moore, *The Woman in Fashion* (London: Batsford, 1949), pp. 17–18.

13 See David Kunzle, *Fashion and Fetishism: A Social History of the Corset, Tight Lacing, and Other Forms of Body Sculpture in the West* (Totowa, New Jersey: Rowman and Littlefield, 1982).

14 See Valerie Steele, *Fashion and Eroticism: Ideals of Feminine Beauty from the Victorian Era to the Jazz Age* (New York and Oxford: Oxford University Press, 1985), pp. 161–91; and Valerie Steele, *Fetish: Fashion, Sex, and Power* (New York and Oxford: Oxford University Press, 1996), pp. 57–90.

15 See Steele, *Fetish*, pp. 11–14.

16 Lorraine Gamman and Merja Makinen, *Female Fetishism* (New York University Press, 1994), p. 62.

17 *Ibid.*, p. 89.

18 See Steele, *Fetish*, p. 83.

19 Seraphine, *EDM* (July, 1862), p. 144.

20 Constance, *The Queen* (July 18, 1863), p. 44. Reproduced in W. B. L., *The Corset and the Crinoline*, p. 155.

21 Fanny, *The Queen* (July 25, 1863), p. 55. Reproduced in *ibid.*, p. 156.

22 Eliza, *The Queen* (August 1, 1863), p. 80. Reproduced in *ibid.*, p. 159. See also *The Queen* (December 5, 1863), p. 376 and (December 19, 1863), p. 411.

23 Madame de la Santé, *The Corset Defended* (London: T. E. Carler, 1865), reviewed in *The Queen* (February 25, 1865), p. 127. See Peter Farrar, *Tight-Lacing*, p. 34, as well as Peter Farrer, *The Regime of the Stay-Lace: A Further Selection of Letters from Victorian Newspapers* (Liverpool: Karn Publications Garston, 1995).

24 W. B. L., *The Corset and the Crinoline*, p. 193.

25 Walter, *EDM* (November, 1867), p. 613.

26 Medicus Parens, *The Family Doctor* (May 18, 1889), p. 184.

27 Experimentum Crucis, *The Family Doctor* (June 29, 1889), p. 281.

28 *The Family Doctor* (March 3, 1888).

29 Hygeia, "Does Tight-Lacing Really Exist?" *The Family Doctor* (September 3, 1887).

30 See Steele, *Fashion and Eroticism*, pp. 249–52.

31 An Amateur Flagellant, *Experiences of Flagellation* (London: Printed for Private Circulation, 1885), pp. 14, 80.

32 V. S., *The Family Doctor* (January 7, 1893), p. 300.

33 An Upright Figure, *The Family Doctor* (May 13, 1893), p. 172.

34 Stays, *ibid.*

35 Admirer of Pretty Feet, *The Family Doctor* (June 8, 1889), pp. 232–3.

36 R.D.B., *The Family Doctor* (June 29, 1889), pp. 281–2.

37 A Male Wasp Waist, *The Family Doctor* (June 26, 1886), p. 263.

38 Anonymous, "The Sin and Scandal of Tight-Lacing," *The Gentlewoman* (December 10, 1882 to March 18, 1883).

39 Amy Canning, *Society* (April 28, 1900), pp. 282–3.

40 Wasp Waist, *Society* (September 23, 1899), p. 1871.

41 There is an enormous literature relating to sexual subcultures in history, including Dr. Richard von Krafft-Ebing, *Psychopathia Sexualis* [1886], trans. F. J. Rebman (Brooklyn, New York: Physicians and Surgeons Book Company, 1926, 1934); Jeffrey Weeks, *Sexuality and Its Discontents* (London: Routledge and Kegan Paul, 1985); Alain Corbin, *Women for Hire: Prostitution and Sexuality in France after 1850*, trans. Alan Sheridan (Cambridge, Mass.: Harvard University Press, 1990); Peter Mendes, *Clandestine Erotic Fiction in English, 1800–1930: A Bibliographical Study* (London: Scolar, 1993); Robert V. Bienvenue, "The Development of Sado-masochism as a Cultural Style in the Twentieth-Century United States" (Ph.D. diss., Indiana University, 1998).

42 See Bienvenue, "Development of Sadomasochism," pp. 40–44.

43 Quoted in Alison Gernsheim, *The History of Photography, 1865–1914* (New York: McGraw-Hill, 1969), p. 235.

44 Statistics courtesy of Ms. Annette Carruthers, Assistant Keeper of Decorative Arts, Leicestershire Museum and Art Gallery.

45 For example, one French corset measured 26 inches on the outside and 25 inches on the inside; another measured 25 inches on the outside and 21½ inches on the inside; a third measured 25½ inches on the outside and 23½ inches on the inside. One American corset measured 25½ inches on the outside and 22½ inches on the inside, while another was 25 inches on the outside and 23 inches on the inside. Nineteenth-century corsets are not as thick.

46 See Kyoto Costume Institute, *Visions of the Body: Fashion or Invisible Corset* (Kyoto Costume Institute, n.d. [2000]), pp. 18–19.

47 *The Photography of Women* (1965), quoted in Francette Pacteau, *The Symptom of*

Beauty (Cambridge, Mass.: Harvard University Press, 1994), p. 77.

48 Corset sizes are given in most advertisements. See R. L. Shep, *Corsets: A Visual History* (Mendocino, Calif: R. L. Shep, 1993). See also Royal Worcester Corset Co., *Dreams of Fair Women* (Worcester, Mass., 1901).

49 E. Ward & Co., *The Dress Reform Problem: A Chapter for Women* (London and Bradford: Hamilton, Adams & Co.; John Dale & Co., 1886).

50 Helen Gilbert Ecob, *The Well-Dressed Woman* (New York: Fowler and Wells, 1893), pp. 26–8.

51 Elizabeth Anstruther, *The Complete Beauty Book* (New York: D. Appleton and Company, 1906), p. 173.

52 *Ibid.*, pp. 173, 180–81.

53 "Considérations sur le corset," *La Vie Parisienne* (April 19, 1879), pp. 224–5.

54 *Ibid.*

55 "Rita," *Vanity! The Confessions of a Court Modiste* (London: T. Fischer Unwin, 1901).

56 *Fine taille, horribles détails* is reproduced in Dr. G. J. Witkowski, *Anecdotes historiques et religieuses sur les seins et l'allaitement comprenant l'histoire du décolletage et du corset* (Paris: A. Maloine, 1889), vol. 2, pp. 360–61.

57 Alex Danchev, *Alchemist of War: The Life of Basil Liddell Hart* (London: Weidenfeld & Nicolson, 1998), p. 93.

58 *Ibid.*, pp. 93, 91.

59 *Ibid.*, p. 94.

60 See Diana Crane, *Fashion and its Social Agendas: Class, Gender, and Identity in Clothing* (Chicago and London: University of Chicago Press, 2000), pp. 29, 52, 73, 113.

61 See Bram Dijkstra, *Idols of Perversity: Fantasies of Feminine Evil in Fin-de-Siècle Culture* (New York and Oxford: Oxford University Press, 1986).

62 H. Rider Haggard, *She: A History of Adventure* [1886] (London: Longmans, Green, and Co., 1916), p. 187.

63 *The Lancet*, quoted in *Sylvia's Home Journal* (April, 1878), p. 150.

5 The Satin Corset

1 See Beth Archer Brombert, *Edouard Manet: Rebel in a Frock Coat* (Boston: Little, Brown, 1996), p. 384.

2 "Le Monde Parisien," *Le Soleil* (May 3, 1877), p. 3, quoted in Hollis Clayson, *Painted Love: Prostitution in French Art of the Impressionist Era* (New Haven and London: Yale University Press, 1991), p. 75.

3 "Nana," *Le Tintamarre* (May 13, 1877), p. 2, quoted in *ibid.*, p. 75.

4 Marcia Pointon, *Naked Authority: The Body in Western Painting, 1830–1908* (Cambridge University Press, 1990), p. 120.

5 Anne Hollander, *Seeing Through Clothes* (New York: Viking 1975), p. xiii.

6 Lynda Nead, *The Female Nude: Art, Obscenity and Sexuality* (London and New York: Routledge, 1992), p. 71; see also pp. 12–16, and Kenneth Clark, *The Nude: A Study of Ideal Art* (London: John Murray, 1956).

7 Linda Nochlin, quoted in Pointon, *Naked Authority*, p. 119.

8 Mario Perniola, "Between Clothing and Nudity," in Michel Feher with Ramona Naddaff and Nadia Tazi, *Fragments for a History of the Human Body*, Part Two. Zone 4. (New York: Urzone, 1989), p. 237.

9 Kathleen Adler and Marcia Pointon, *The Body Imaged: The Human Form and Visual Culture since the Renaissance* (Cambridge University Press, 1993), p. 128.

10 Stephen Kern, *Anatomy and Destiny: A Cultural History of the Human Body* (New York: Bobbs-Merrill, 1975), p. 10; Philippe Perrot, *Fashioning the Bourgeoisie: A History of Clothing in the Nineteenth Century*, trans. Richard Bienvenu (Princeton University Press, 1994), p. 150.

11 Emile Zola, *Au Bonheur des Dames* (Paris: Livre du Poche, n.d.), p. 478.

12 J.-K. Huysmans, "La Nana de Manet," *L'Artiste de Bruxelles* (May 13, 1877), pp. 148–9, quoted in Clayson, *Painted Love*, p. 78.

13 Caricature of Nana in *La Vie Parisienne* (May 12, 1877), pp. 258–9.

14 "Les Corsets," *La Vie Parisienne* (January 15, 1881), pp. 38–9; "Les Dessous," *La Vie Parisienne* (May 2, 1885), pp. 252–3.

15 Quoted in Perrot, *Fashioning the Bourgeoisie*, p. 282.

16 "Les Dessous," *La Vie Parisienne* (May 2, 1885), pp. 252–3; "Les Corsets," *La Vie Parisienne* (January 15, 1881), pp. 38–9.

17 *Ibid.*

18 Peter Brooks, *Body Work: Objects of Desire in Modern Narrative* (Cambridge, Mass. and London: Harvard University Press, 1993), p. 45.

19 *La Vie Parisienne* (May 17, 1884), p. 270.

20 Helene E. Roberts, "Reply to David Kunzle's 'Dress Reform as Antifeminism'," *Signs: Journal of Women in Culture and Society* 3 (Winter 1978), p. 519. See also Susan Faludi, *Backlash: The Undeclared War Against American Women* (New York: Crown, 1991), p. 189; Betty Friedan, *The Feminine Mystique* (New York: Norton [1963], 1983), p. 94.

21 "Les Dessous," *La Vie Parisienne* (May 2, 1885), p. 252–3.

22 Huysmans, quoted in Clayson, *Painted Love*, p. 79.

23 A. F. Crell, M. D., and W. M. Wallace, *The Family Oracle of Health: Economy, Medicine, and Good Living* (London: J. Bulcock, 1825), p. 414.

24 Luke Limner, *Madre Natura Versus the Moloch of Fashion* (London: Chatto & Windus, 1874), p. 41.

25 Clayson, *Painted Love*, pp. 83, 87–8.

26 Quoted in Roy McMullin, *Degas: His Life, Times, and Work* (Boston: Houghton Mifflin, 1984), p. 281.

27 Quoted in *ibid.*, p. 278.

28 Brombert, *Edouard Manet*, pp. 384–5.

29 Tamar Garb, *Bodies of Modernity: Figure and Flesh in Fin-de-Siècle France* (London: Thames & Hudson, 1998), p. 120.

30 Anne Higonnet, *Berthe Morisot's Images of Women* (Cambridge, Mass. and London: Harvard University Press, 1992), pp. 165–7.

31 Henry T. Finck, *Romantic Love and Personal Beauty* (New York and London: Macmillan, [1887] 1912), p. 186.

32 Francette Pacteau, *The Symptom of Beauty* (London: Reaktion Books, 1994), pp. 182, 188.

33 "Avant et après le corset," *La Vie Parisienne* (September 9, 1882), pp. 522–3.

34 Quoted in Perrot, *Fashioning the Bourgeoisie*, p. 259.

35 J.-K. Huysmans, *Against Nature*, trans. Robert Baldick (Harmondsworth: Penguin, 1974), p. 37.

36 Quoted in Graham Robb, *Rimbaud* (New York and London: Norton, 2000), p. 135.

37 See Klaus Theweleit, *Male Fantasies*, Vol. 1: *Women, Floods, Bodies, History*, trans. Stephen Conway (Minneapolis: University of Minnesota Press, 1987).

38 Nead, *The Female Nude*, p. 18.

39 *Ibid.*, p. 19.

40 Hermann Broch, *The Sleepwalkers* (1931), trans. Willa Muir and Edwin Muir (New York: Pantheon, 1964), p. 21.

41 See Julia Kristeva, *Powers of Horror: An Essay on Abjection*, trans. Leon S. Roudiez (New York: Columbia University Press, 1982); See esp. "The Improper/Unclean," pp. 3–4; "From the Beginning:

Separation," pp. 12–13; "The Horror Within" and "Confronting the Maternal" pp. 53–5; and "Fear of Women – Fear of Procreation," pp. 77–9.

42 *La Vie Parisienne* (February 27, 1886), p. 127.

43 "Les Corsets," *La Vie Parisienne* (January 15, 1881), pp. 38–9; "Les Dessous," *La Vie Parisienne* (May 2, 1885), pp. 252–3.

44 "Les Arbiters d'élégance," *Figaro-Modes* (April 15, 1903), pp. 13–14.

6 **The Hard Body**

1 Robert Riegel, "Women's Clothes and Women's Rights," *American Quarterly* 15 (Fall, 1963), p. 397.

2 Ella Fletcher, *The Woman Beautiful* [1899] (New York: Brentano, 1900), pp. 32–4.

3 Jean Godfrey-June, "Waist Land," *Vogue* (August, 2000), p. 246.

4 Mrs. Pritchard, "Lingerie is an enthralling subject," *The Lady's Realm* (April, 1903), p. 767.

5 Mrs. Pritchard, *The Cult of Chiffon* (London: Grant Richards, 1902), p. 15; *The Lady's Realm* (April, 1901), p. 776; (November, 1901), p. 115.

6 Pritchard, *The Cult of Chiffon*, pp. 11–13.

7 *Ibid.*, pp. 10–11.

8 Georges Viterbo, "Une Ennemie du corset," *Les Dessous Elégants* (June, 1904), pp. 101–3.

9 Georges Viterbo, "Corset et féminisme," *Les Dessous Elégants* (September, 1904), pp. 155–6.

10 *Vogue* (May, 1908), quoted in Palmer White, *Poiret* (New York: Clarkson Potter, 1973), p. 41.

11 *The Queen* (March, 1911), quoted in Norah Waugh, *Corsets and Crinolines* (London: Batsford, 1954), p. 112.

12 Paul Poiret, *King of Fashion: The Autobiography of Paul Poiret* (Philadelphia and London: Lippincott, 1931), pp. 77–8.

13 Vionnet, quoted in Celia Bertin, *Paris à la mode* (London: Victor Gollancz, 1956), p. 168.

14 Lady Lucy Christiana Duff-Gordon [Lucile], *Discretions and Indiscretions* (London: Jarrolds, 1932), p. 66.

15 Caresse Crosby, quoted in Elizabeth Ewing, *Dress and Undress: A History of Women's Underwear* (London: Batsford, 1978), p. 115.

16 M. D. C. Crawford, *The Ways of Fashion* (New York: Fairchild, 1948), p. 63.

17 Advertisement for Le Papillon Corset, *Vogue* (June 1, 1913), p. 85.

18 Advertisement for La Resista Corset, *Dress and Vanity Fair* (September, 1913), p. 65.

19 Quoted in *Harrison's Complete Dressmaker* (February, 1909), p. 33.

20 *Dress and Vanity Fair* (September, 1913), p. 5.

21 Catalogue for Peter Robinson, Ltd., *The Curtain is Drawn – The Fashion Line for 1914 is revealed* (London, 1914), [n.p.].

22 C. Willet Cunnington and Phyllis Cunnington, *The History of Underclothes* (London: A. Joseph, 1951; rev. ed. A. D. and Valerie Mansfield, London: Faber and Faber, 1981), p. 219.

23 *Journal des Dames et des Modes* (August 10, 1912), p. 57, and (September 10, 1912), p. 88.

24 Quoted in Sherwin Simmons, "Ernst Kirchner's Streetwalkers: Art, Luxury, and Immorality in Berlin, 1913–16," *Art Bulletin* 82, no. 1 (March, 2000), p. 125.

25 Cunnington and Cunnington, *History of Underclothes*, p. 219.

26 Quoted in Robert Cortes Holliday, *Unmentionables: From Figleaves to Scanties* (New York: Ray Long and Richard Smith, 1933), pp. 265–6.

27 Jacques Boulanger quoted in Mary Louise Roberts, *Civilization without Sexes: Reconstructing Gender in Postwar France, 1917–1927* (Chicago and London: University of Chicago Press, 1994), p. 19.

28 Quoted in *ibid.*, p. 20.

29 *Ibid.*, p. 66.

30 Holliday, *Unmentionables*, p. 274.

31 Vionnet quoted in Bruce Chatwin, *What Am I Doing Here?* (New York: Viking, 1989), p. 89.

32 Mary Brooks Picken, *The Secrets of Distinctive Dress* (Scranton, Penn.: The Woman's Institute of Domestic Arts and Sciences, 1918), pp. 153–4, 157.

33 Advertisement for College Girl Corsets, n.d. [c. 1921].

34 Advertisement for P. N. Practical Front Corsets, *Woman's Home Companion* (October, 1921), p. 65.

35 *Vogue* (1922), quoted in Caroline Cox, *Lingerie: A Lexicon of Style* (New York: St. Martin's, 2000), p. 29.

36 Anne Rittenhouse, *The Well-Dressed Woman* (New York and London: Harper & Brothers, 1924), pp. 144–5.

37 Louise Gifford, *The Joy of Looking Slim* (New York: Newman & Sons, 1926), p. 10.

38 Adolphe Armand Braun, *Figures, Faces and Folds* (London: Batsford, 1928), pp. 1–2.

39 Aldous Huxley, *Antic Hay* [1923] (New York: Modern Library, 1933), pp. 133–4.

40 Devendra Singh, "Adaptive Significance of Female Physical Attractiveness: Role of Waist-to-Hip Ratio," *Journal of Personality and Social Psychology* 65, no. 2 (1993), pp. 293–307; see pp. 296–7.

41 "Corsets – The Foundation of the Mode for Centuries," *The Corset and Underwear Review* (May, 1930).

42 Holliday, *Unmentionables*, p. 275.

43 Lee Simonson, "Stay, Gentle Stays!" *The New Republic* (April 27, 1932), quoted in Holliday, *Unmentionables*, pp. 275–6.

44 "Boning Up On Corsets," *Vogue* (July 15, 1935), pp. 50–51, 74.

45 Advertisement for Formfit Foundations in *Harper's Bazaar* (March 15, 1938), p. 116.

46 Quoted in Thesander, *The Feminine Ideal*, p. 134, my emphasis.

47 "Are You a Corset Contortionist?" unidentified periodical, dated April, 1938, [n.p.].

48 "The Corset," *Fortune* (March, 1938), p. 95.

49 Quoted in Thesander, *Feminine Ideal*, p. 150.

50 See Alison Carter, *Underwear: The Fashion History* (New York: Drama Books, 1992), pp. 105–6.

51 Peter and R. Ann Mactaggart, "Half a Century of Corset Making: Mrs. Turner's Recollections," *Costume* 11 (1977), p. 123.

52 Quoted in *ibid.*, p. 126.

53 Dior, quoted in Richard Martin and Harold Koda, *Infra-Apparel* (New York: The Metropolitan Museum of Art, 1993), p. 21.

54 "Waist Pinchers," *Life* (September 1, 1947), p. 47.

55 Advertisement for Formfit foundations, from *Woman's Home Companion* (April, 1949), p. 81.

56 Gayelord Hauser, *Look Younger, Live Longer* (London: Faber and Faber, 1951), pp. 171–2, quoted in Cox, *Lingerie*, p. 30.

57 Poppy Richard, *Dress Sense* (London: Amalgamated Press, n.d. [c. 1952]), p. 29.

58 Nancy Mitford *et al.*, *Noblesse Oblige: An Enquiry into the Identifiable Characteristics of the English Aristocracy* (London: Hamish Hamilton; New York: Harper & Brothers, 1956), p. 78.

59 Quoted in Ellen Melinkoff, *What We Wore* (New York: Quill, 1984), p. 101.

60 Quoted in Melinkoff, *What We Wore*, p. 103.

61 Advertisement for Vanishette, *Harper's Bazaar* (February 1, 1956), p. 121.

62 "Progress Report on American Corsetry," *Vogue* (February, 1956), p. 150.

63 "Silhouette neu pour tous les âges," Paris *Vogue* (March, 1954), pp. 146–7.

64 Anne Fogarty, *Wife-Dressing: The Fine Art of Being a Well-Dressed Wife* (New York: Julian Messer, 1959), p. 154.

65 Quoted in Melinkoff, *What We Wore*, p. 152.

66 Advertisement for Warner's The Riddle, from *Harper's Bazaar* (April, 1965), p. 42.

67 Miscellaneous advertisements from *Harper's Bazaar* (April, 1965), various pages.

68 There are useful discussions of these issues in Rebecca Arnold, *Fashion, Desire, and Anxiety* (New Brunswick, N.J.: Rutgers University Press, 2001); Bruno du Roselle, *La Crise du mode: La Révolution des jeunes et la mode* (Paris: Librairie Arthème Fayard, 1973); Bruno du Roselle, *La Mode* (Paris: Imprimerie National, 1980); and Elizabeth Wilson, *Adorned in Dreams: Fashion and Modernity* (London: Virago, 1987).

69 "Joy through Exercise," *Harpers & Queen* (September, 1979), p. 108.

70 "Beauty Notices," British *Vogue* (April, 1988), p. 113.

71 Fatima Whitbread, quoted in Adrianne Blue, "Women and Sport," British *Vogue* (April, 1988), p. 255.

72 Lynda Nead, *The Female Nude: Art, Obscenity, and Sexuality* (London and New York: Routledge, 1992), p. 8.

73 *Ibid.*, p. 10; Naomi Wolf, *The Beauly Myth* (New York: Morrow, 1991), p. 67.

74 Godfrey-June, "Waist Land," pp. 248–9.

75 *Ibid.*, p. 248.

76 Singh, "Adaptive Significance," p. 294.

77 *Ibid.*, 293–307; Devendra Singh and Suwardi Luis, "Ethnic and Gender Consensus for the Effect of Waist-to-Hip Ratio on Judgement of Women's Attractiveness," *Human Nature* 6, no. 1 (1995), pp. 51–65; Devendra Singh and Robert K. Young, "Body Weight, Waist-to-Hip Ratio, Breasts, and Hips: Role in Judgements of Female Attractiveness and Desirability for Relationships," *Ethnology and Sociobiology* 16 (1995), pp. 483–507.

78 Singh and Young, "Body Weight," pp. 503–4.

79 Wendy O'Flaherty, *Hindu Myths* (1975), quoted in Devendra Singh and P. Matthew Bronstad, "Sex Differences in the Anatomical Locations of Human Body Scarification and Tattooing as a Function of Pathogen Preference," *Evolution and Human Behavior* 18 (1997), p. 412.

80 See Nancy Etcoff, *Survival of the Prettiest: The Science of Beauty* (New York: Doubleday, 1999), pp. 187–95.

81 Susan Brownmiller, *Femininity* (New York and London: Simon and Schuster, 1986), p. 19.

82 Quoted in Joanne Entwhistle, *The Fashioned Body: Fashion, Dress and Modern Social Theory* (Cambridge: Polity Press, 2000), p. 14.

83 Stephanie Jones, "Strictly Fashionable: A Straight-Laced Look at Corsetry," *Skin Two* 9 (1989), pp. 45–7.

84 Quoted in Gloria Brame *et al.*, *Different Loving: An Exploration of the World of Sexual Dominance and Submission* (New York: Villard Books, 1993), p. 319.

85 See Dick Hebdidge, *Subculture: The Meaning of Style* (London: Methuen, 1979; repr. London: Routledge, 1989, 1993); Ted Polhemus, *Street Style: From Sidewalk to Catwalk* (London: Thames & Hudson, 1994); Valerie Steele, *Fetish: Fashion, Sex, and Power* (New York and Oxford: Oxford University Press, 1996).

86 Gaultier, quoted in Michelle Olley, "Jean Paul Gaultier: Rascal of Radical Chic," in *The Best of Skin Two*, ed. Tim Woodward (London: Kasak Books, 1993), p. 70.

87 Liz Rittersporn, "Achieving Madonna-hood," *Daily News* (June 7, 1990), p. 53.

88 "Waist Case," *Vogue* (September, 1994), p. 244.

89 Sarah Mower, "Learning Curves," *Harper's Bazaar* (October, 1994), pp. 194–6.

90 Kathy Philips, "Waist Time," British *Vogue* (April 2001), p. 235.

91 Kimberley Bonnell, "Shape Shifters," *In Style* (December, 2000), pp. 217–18.

Selected Bibliography

Elise Sigel, *Portrait #6* (1992). Sculpture inspired by corsetry and plastic surgery.

Abraham, Karl. "Remarks on the Psycho-Analysis of a Case of Foot and Corset Fetishism" [1910]. In *Selected Papers of Karl Abraham*, ed. and trans. Douglas Bryan and Alix Strachey. New York: Basic Books, 1960.

Adami, J. G., and C. S. Roy. "The Physiological Bearing of Waist-Belts and Stays." *The National Review* 12, November 1888, 341–9.

Adler, Kathleen, and Marcia Pointon. *The Body Imaged: The Human Form and Visual Culture Since the Renaissance*. Cambridge University Press, 1993.

d'Aincourt, Marguerite. *Etudes sur le costume féminin*. Paris: Rouveyre et G. Blond, n.d. [c. 1885].

Ambrose, Bonnie Holt. *The Little Corset Book*. New York: Costume & Fashion Press, 1997.

Anonymous. *Beauty: Its Attainment and Preservation*. New York: Butterick, 1890.

——. "The Confessions of a Tight-Lacer." *Tit-Bits*, October 27, 1894.

——. "The Corset." *Fortune*, March 1938, 95–9, 110–14.

——. "Corsets and Corpulence." *London Society*, October 1869.

——. "Corsets and Tight Lacing." *The Lancet*, June 25, 1887.

——. "Death from Tight Lacing." *The Lancet*, May 23, 1869, 675.

——. "Distortion by Tight-Lacing." In *Chambers Miscellany of Useful and Entertaining Tracts*, vol. 10. Edinburgh: William and Robert Chambers, 1846.

——. *Dress, Health, and Beauty*. London: Ward, Lock & Co., 1878.

——. "The Effects of Tight Clothing." *The Lancet*, August 3, 1889, 231.

——. "The History of the Corset." *The Queen*, December 5, 1863.

——. "The Philosophy of Tight-Lacing." *The Saturday Review*, December 17, 1887.

——. "Remarkable Case of Displacement of an Enlarged Liver from Tight Lacing." *The Lancet*, January 5, 1861.

——. "The Sin and Scandal of Tight-Lacing." *The Gentlewoman*, December 10, 1892 to March 18, 1893.

——. "Tight Dressing – Corsets." *The Mother's Book*, August 1838, 170.

——. "Tight-Lacing." *The Lancet*, June 6, 1868, 729–30.

——. "Tight-Lacing." *The Lancet*, May 28, 1881, 877.

——. "Tight-Lacing Again." *The Lancet*, January 10, 1880, 75.

Anstruther, Elizabeth. *The Complete Beauty Book*. New York: D. Appleton and Co., 1906.

Arnold, Janet. "Cut and Construction." In *Moda alle corte dei Medici gli abiti restaurati de Cosimo, Eleanora e Don Garzia*, ed. Kirsten Aschengreen Piacenti. Florence: Centro di Firenze, 1993.

——. *Patterns of Fashion*, 1. London: Macmillan, 1972.

———. *Queen Elizabeth's Wardrobe Unlock'd*. Leeds: Manley, 1988.

Ballin, Ada S. *The Science of Dress in Theory and Practice*. London: Sampson Low, Marston, Searle, and Rivington, 1885.

———. "Tight-Lacing." *Womanhood*, April 1903.

Baudelaire, Charles. *The Painter of Modern Life and Other Essays*. Trans. Jonathan Mayne. London: Phaidon, 1964.

Betts, Helen L., M.D. "Dress of Women in Its Relation to the Etiology and Treatment of Pelvic Disease." *Journal of the American Medical Association* x, no. 17 (1888), 509–13.

Bouvier, Dr. Sauveur Henri-Victor. *Etudes historiques et médicales sur l'usage des corsets*. Paris: J.-B. Baillière, Libraire de l'Académie Impériale de Médecine, 1853.

Brombert, Beth Archer. *Edouard Manet: Rebel in a Frock Coat*. Boston: Little, Brown, 1996.

Brooks, Peter. *Body Work: Objects of Desire in Modern Narrative*. Cambridge, Mass. and London: Harvard University Press, 1993.

Brownmiller, Susan. *Femininity*. New York and London: Simon & Schuster, 1986.

Buck, Anne. *Dress in Eighteenth-Century England*. London: Batsford, 1979.

Bulwer, John. *Anthropometamorphosis: Man Transformed: The Artificial Changeling, Historically Presented, in the Mad and Cruell Gallantry, Foolish Bravery, Ridiculous Beauty, Filthy Finenesse, and Loathsome Loveliness of Most Nations, Fashioning and Altering Their Bodies from the Mould Intended by Nature; with Figures of Those Transformations . . .* London: William Hunt, 1653.

Burtel, Mme. *L'Art de faire les corsets, suivre de l'art de faire les guêtres et les gants*. Paris: Audot, 1828.

Cannaday, Charles, M.D. "The Relation of Tight Lacing to Uterine Development and Pelvic Disease." *American Gynecological and Obstetrical Journal* 5 (1895), 632–40.

Caplin, Mme Roxey A. *Health and Beauty, or Corsets and Clothing Constructed in Accordance with the Physiological Laws of the Human Body*. London: Darton & Co., n.d. [1854].

Carter, Alison. *Underwear: The Fashion History*. New York: Drama Books, 1992.

Chenoune, Farid. *Beneath It All: A Century of French Lingerie*. New York: Rizzoli, 1999.

Childs, G. B., Esq. *On the Improvement and Preservation of the Female Figure: With a New Mode of Treatment of Lateral Curvature of the Spine*. London: Harvey and Darton, 1840.

Clayson, Hollis. *Painted Love: Prostitution in French Art of the Impressionist Era*. New Haven and London: Yale University Press, 1991.

Coffin, Judith G. *The Politics of Women's Work: The Paris Garment Trades, 1750–1915*. Princeton University Press, 1996.

Cohen, Sarah R. *Art, Dance and the Body in French Culture of the Ancien Régime*. Cambridge University Press, 2000.

Cooley, Arnold J. *The Toilet and Cosmetics in Ancient and Modern Times, with a Review of Different Theories of Beauty*. [London, 1866] New York: Burt Franklin, 1970.

Cox, Caroline. *Lingerie: A Lexicon of Style*. New York: St. Martin's, 2000.

Crane, Diana. *Fashion and Its Social Agendas: Class, Gender, and Identity in Clothing*. Chicago and London: University of Chicago Press, 2000.

Cunnington, C. Willett, and Phyllis Cunnington. *The History of Underclothes*. Originally published, London: A. Joseph, 1951; rev. ed. A. D. and Valerie Mansfield, London: Faber and Faber, 1981.

Davies, Mel. "Corsets and Conception: Fashion and Demographic Trends in the Nineteenth Century." *Journal of Comparative Studies in Sociology and History* 24 (1982): 611–41.

Dickenson, Robert L., M.D. "The Corset, Questions of Pressure and Displacement." *New York Medical Journal* 46 (1887), 507–16.

———. "Toleration of the Corset: Prescribing Where One Cannot Proscribe." *American Journal of Obstetrics and Gynecology* 63 (1911), 1023–58.

Douglas, Mrs. Fanny. *The Gentlewoman's Book of Dress*. London: Henry & Co., n.d. [c. 1894].

E. Ward & Co. *The Dress Reform Problem: A Chapter for Women*. London and Bradford: Hamilton, Adams & Co.; John Dale & Co., 1886.

E.D.M. *Figure-Training, or, Art the Handmaid of Nature*. London: Ward, Lock and Tyler, 1871.

Ecob, Helen Gilbert. *The Well-Dressed Woman: A Study in the Practical Application to Dress of the Laws of Health, Art, and Morals*. New York: Fowler and Wells, 1893.

Entwhistle, Joan. *The Fashioned Body: Fashion, Dress, and Modern Social Theory*. Cambridge: Polity Press, 2000.

Etcoff, Nancy. *Survival of the Prettiest: The Science of Beauty*. New York: Doubleday, 1999.

Ewing, Elizabeth. *Dress and Undress: A History of Women's Underwear*. London: Batsford, 1978.

Farrell-Beck, Jane, Laura Poresky, Jennifer Paff, and Cassandra Moon. "Brassieres and Women's Health from 1863 to 1940." *Clothing and Textiles Research Journal* 16, no. 3 (1998), 105–15.

Farrer, Peter. "Adcock's Riding Belt." *Journal of the Northern Society of Costume and Textiles* 3 (Spring, 1999), 3–4.

———. *The Regime of the Stay-Lace: A Further Selection of Letters from Victorian Newspapers*. Liverpool: Karn Publications Garston, 1995.

———. *Tight Lacing: A Bibliography of Articles and Letters Concerning Stays and Corsets for Men and Women*. Liverpool: Karn Publications Garston, 1999.

Feydeau, Ernest Aime. *The Art of Pleasing*. Trans. Marie Courcelles. New York: G. W. Carlton & Co., 1874.

Finck, Henry T. *Romantic Love and Personal Beauty*. New York and London: Macmillan, [1887] 1912.

Fletcher, Ella. *The Woman Beautiful*. New York: Brentano, 1900.

Flower, William Henry. *Fashion in Deformity, as Illustrated in the Customs of Barbarous & Civilised Races*. London: Macmillan, 1881.

Fogarty, Ann. *Wife-Dressing: The Fine Art of Being a Well-Dressed Wife*. New York: Julian Messer, 1959.

Fontanel, Béatrice. *Corsets et soutiens-gorge: L'Epopée du sein de l'antiquité à nos jours*. Paris: Editions de La Martinière, 1992.

Foucault, Michel. *Discipline and Punish: The Birth of the Prison*. Trans. Alan Sheridan. New York: Vintage, 1979.

Fowler, Orson S. *Amativeness; or, Evils and Remedies of Excessive and Perverted Sexuality; Including Warning and Advice to the Married and Single*. New York: O. S. & L. N. Fowler & S. R. Wells, 1846. Repr. Manchester: John Heywood, n.d. [c. 1897].

———. *Intemperance and Tight-Lacing: Founded on the Laws of Life, as Developed by Phrenology and Physiology*. New York: O. S. & L. N. Fowler & S. R. Wells, 1846. Repr. Manchester: John Heywood, n.d. [c. 1899].

———. *Tight-Lacing, Founded on Physiology and Phrenology: Or, the Evils Inflicted on Mind and Body, by Compressing the Organs of Animal Life, Thereby Retarding and Enfeebling the Vital Functions*. New York: O. S. & L. N. Fowler & S. R. Wells, 1846.

Gâches-Sarraute, Mme. Inez. *Le Corset: Etude physiologique et pratique*. Paris: Librairie de l'Académie de Médicine, 1900.

Galbraith, Anna M., M.D. *Hygiene and Physical Culture for Women*. New York: Dodd, Mead, 1895.

Gamman, Lorraine, and Merja Makinen. *Female Fetishism*. New York University Press, 1994.

Garb, Tamar. *Bodies of Modernity: Figure and Flesh in Fin-De-Siècle France*. London: Thames & Hudson, 1998.

Garsault, François Alexandre de. *Art du tailleur*. Paris: Académie des Sciences, 1769.

Gau, Colleen Ruby. "Historical Medical Perspectives of Corseting and Two Physiological Studies with Reenactors." Ph.D. diss., Iowa State University, 1998.

Gay, Peter. *The Bourgeois Experience: Victoria to Freud*, vol. 1: *The Education of the Senses*. New York and Oxford: Oxford University Press, 1984.

Gifford, Louise. *The Joy of Looking Slim*. New York: Newman & Sons, 1926.

Gilman, Sander. *Making the Body Beautiful: A Cultural History of Aesthetic Surgery*. Princeton University Press, 1999.

Ginsburg, Madeleine. "The Tailoring and Dressmaking Trades, 1700–1850." *Costume* 6 (1972), 64–71.

Godfrey-June, Jean. "Waist Land." *Vogue* (August, 2000), 246–9.

H. W. Gossard Co. *Corsets from a Surgical Standpoint*. Chicago: H. W. Gossard Co., n.d. [c. 1910].

Haller, John S., and Robin M. Haller. *The Physician and Sexuality in Victorian America*. Urbana: University of Illinois Press, 1974.

Hamby, Wallace B., ed. *The Case Reports and Autopsy Records of Ambroise Paré*. Springfield, Mass: Charles C. Thomas, 1960.

Harlan, Marion. *Eve's Daughters: Common Sense for Maid, Wife and Mother*. New York: Anderson & Allen, 1882.

Harty, H. R., D. R. Cornfield, R. M. Schwartzstein, and L. Adams. "External Thoracic Restriction, Respiratory Sensation, and Ventilation During Exercise in Men." *Journal of Applied Physiology* 4 (April, 1999), 1142–50.

Haweis, Mrs. Eliza. *The Art of Beauty*. New York: Harper and Brothers, 1878. Repr. in one vol. with *The Art of Dress*, New York: Garland, 1978.

——. *The Art of Dress*. London: Chatto & Windus, 1879. Repr. in one vol. with *The Art of Beauty*, New York: Garland, 1978.

Hollander, Anne. *Seeing Through Clothes*. New York: Viking, 1975.

——. *Sex and Suits*. New York: Knopf, 1994.

Houze, Rebecca. "Fashionable Reform Dress and the Invention of 'Style' in Fin-de-Siècle Vienna." *Fashion Theory* 4, no. 4 (2000), 1–20.

Hygeia. "Does Tight-Lacing Really Exist?" *The Family Doctor*, September 3, 1887.

——. "Tight-Lacing in Brighton and Parisian Schools." *The Family Doctor*, December 24, 1887.

Jaeger, Gustav, M.D. *Selections from Essays on Health Culture and the Sanitary Woolen System*. London: Dr. Jaeger's Sanitary Woolen System, 1884.

Jones, Stephanie. "Strictly Fashionable: A Strait-Laced Look at Corsetry." *Skin Two* 9 (1989), 45–7.

Kayne, Madame. *The Corset in the Nineteenth and Eighteenth Centuries*. Brighton: Greenfields, n.d. [c. 1932].

Kenealy, Dr. Arabella. "The Curse of Corsets." *The Nineteenth Century and After*, January 1904, 131–7.

Kern, Stephen. *Anatomy and Destiny: A Cultural History of the Human Body.* Indianapolis and New York: Bobbs-Merrill, 1975.

King, Mrs. E. M. *Rational Dress, or, the Dress of Women and Savages.* London: Kegan, Paul, Trench & Co., 1882.

Krafft-Ebing, Dr. Richard von. *Psychopathia Sexualis, with Especial Reference to the Antipathic Sexual Instinct: A Medico-Forensic Study.* Trans. F. J. Rebman from the 12th Ger. (1886) ed. Brooklyn, New York: Physicians and Surgeons Book Co., 1926, 1934.

Kunzle, David. "The Corset as Erotic Alchemy: From Rococo Galanterie to Montaut's Physiologies." In *Woman as Sex Object: Erotic Art, 1730–1970*, ed. Thomas Hess and Linda Nochlin. New York: Art News Annual, 38, 1972.

——. "Dress Reform as Antifeminism: A Response to Helene E. Roberts's 'the Exquisite Slave'." *Signs: Journal of Women in Culture and Society* 2 (Spring, 1977), 570–79.

——. *Fashion and Fetishism: A Social History of the Corset, Tight-Lacing, and Other Forms of Body Sculpture in the West.* Totowa, New Jersey: Rowman and Littlefield, 1982.

Kyoto Costume Institute. *Visions of the Body: Fashion or Invisible Corset.* Kyoto Costume Institute, n.d. [2000].

Lacroix, Mme. et M. *Le Corset de toilette au point de vue esthétique et physiologique.* Paris: Librairie Médicale et Scientifique, n.d. [c. 1890].

Ladies' Sanitary Association. *Wasps Have Stings; or, Beware of Tight-Lacing.* London: Ladies' Sanitary Association and John Morgan, n.d.

Larousse, Pierre. *Grand dictionnaire universel du XIX^e siècle.* Nimes: Lacour, 1866–76; repr. 1990.

Leloir, Maurice. *Dictionnaire du costume.* Paris: Libraire Grund, 1951.

Léoty, Ernest. *Le Corset à travers les âges.* Paris: Paul Ollendorff, 1893.

Leroy, Dr. Alphonse. *Recherches sur les habillements des femmes et des enfants.* Paris, 1792.

Libron, Fernand, and Henry Clouzot. *Le Corset dans l'art et les moeurs du XIII^e au XX^e siècles.* Paris: Published by the authors, 1933.

Liddell Hart, Sir Basil. "Scrapbooks." Liverpool John Moores University Learning and Information Services, Special Collections.

Ligue des Mères de Famille. *Pour la beauté naturelle de la femme contre la mutilation de la taille par le corset.* Preface by Edmond Harancourt. Paris: Ligue des Mères de Famille, 1909.

Limner, Luke [John Leighton]. *Madre Natura Versus the Moloch of Fashion.* London: Chatto & Windus, 1874.

Lorentz, Mme. E., and Mlle. A. Lacroix. *Cours complet d'enseignement professional de la coupe.* Vol. 1, *Corset;* Vol. 2, *Lingerie.* Paris: Ecole Moderne de Coupe de Paris, 1911–12.

Machray, Robert. "Fashions in Waists." *The Lady's Realm*, December 1902.

Maciet Collection, "Scrapbooks." Paris: Bibliothèque des Arts Décoratifs. Unpublished archive.

Mactaggart, Peter, and R. Ann Mactaggart. "Ease, Convenience and Stays, 1750–1850." *Costume* 13 (1979), 41–51.

——. "Half a Century of Corset Making: Mrs. Turner's Recollections." *Costume* 11 (1977), 123–32.

——. "Some Aspects of the Use of Non-Fashionable Stays." In *Strata of Society Costume Society Conference*, 20–28. London: Costume Society, 1973.

Manley, T. H., M.D. "The Corset: Its Use and Abuse with Tight-Lacing." *The Virginia Semi-Monthly*, September 9, 1898, 302–6.

Martin, Peter. *Wasp Waists: A Study of Tight-Lacing in the 19th Century and Its Motives*. London: Published by the author, 1977.

Martin, Richard, and Harold Koda. *Infra-Apparel*. New York: The Metropolitan Museum of Art, 1993.

Mason, Michael. *The Making of Victorian Sexuality*. New York: Oxford University Press, 1994.

Maynard, Elise. "Fatal Corsets, or the Perils of Tight-Lacing." *Womanhood*, April 1903.

Melzer, Sara E., and Kathryn Norberg, eds. *From the Royal to the Republican Body*. Berkeley, Los Angeles, London: University of California Press, 1998.

Moers, Ellen. *The Dandy*. New York: Viking, 1960.

Montaigne, Michael de. *The Complete Works of Montaigne*. Trans. Donald M. Frame. Stanford University Press, 1948.

Morris, Bernadine. "A History of Discomforts, Told by Corsets." *The New York Times*, October 1, 1980.

Nead, Lynda. *The Female Nude: Art, Obscenity, and Sexuality*. London and New York: Routledge, 1992.

Nye, Robert. *Masculinity and Male Codes of Honor in Modern France*. Berkeley, Los Angeles, London: University of California Press, 1993.

O'Followell, Dr. Ludovic. *Le Corset. Etude historique: Histoire-médecine-hygiène*. Preface by Paul Ginisty. 2 vols. Paris: A. Malosne, 1905, 1908.

Pacteau, Francette. *The Symptom of Beauty*. London: Reaktion Books, 1994.

Page, Christopher. *Foundations of Fashion: The Symington Collection: Corsetry from 1856 to the Present Day*. Leicester: Leicestershire Museums, 1981.

Parey [Paré], Ambroise. *The Work of That Famous Chirurgian Ambroise Parey*. Trans. by Thomas Johnson. London: Richard Cotes, 1649.

Pellegrin, Nicole. *Les Vêtements de la liberté*. Paris: Alinea, 1989.

Perrot, Philippe. *Fashioning the Bourgeoisie: A History of Clothing in the Nineteenth Century*. Trans. Richard Bienvenu. Princeton University Press, 1994. Originally published as *Les Dessus et les dessous de la bourgeoisie: Une histoire du vêtement au XIX^e siècle*. Paris: Arthème Fayard, 1981.

———. *La Travail des apparences, ou les transformations du corps féminin XVIII^e–XIX^e siècles*. Paris: Seuil, 1984.

Phelps, Elizabeth Stuart. *What to Wear?* Boston: James R. Osgood, 1873.

Pictorial History of the Corset. Vol. 1: *The Early Period*; Vol. 2: *From 1880 to 1914*; Vol. 3: *From 1915 to 1929*. Brooklyn Museum Art Library. Unpublished archive.

Pointon, Marcia. *Naked Authority: The Body in Western Painting, 1830–1908*. Cambridge University Press, 1990.

Porter, Roy, and Lesley Hall. *The Facts of Life: The Creation of Sexual Knowledge in Britain, 1650–1950*. New Haven and London: Yale University Press, 1995.

Pritchard, Mrs. Eric. *The Cult of Chiffon*. London: Grant Richards, 1902.

Rabelais. *The History of Gargantua and Pantagruel*. Trans. J. M. Cohen. Harmondsworth: Penguin, 1969.

Rational Dress Association. *The Exhibition of the Rational Dress Association: Catalogue of Exhibits and Lists of Contributors*. London: Rational Dress Association, 1883.

Raverat, Gwen. *Period Piece: A Cambridge Childhood*. London: Faber and Faber, 1952.

Ray, Constance. "The Corset and the Form Divine." *Chicago Sunday Tribune*, December 18, 1932, 6.

Reade, Charles. *A Simpleton*. Boston: Dana Estes, n.d. [c. 1873].

Ribeiro, Aileen. *The Art of Dress: Fashion in England and France, 1750–1820*. New Haven and London: Yale University Press, 1995.

———. *Dress and Morality*. New York: Holmes and Meier, 1986.

———. *Dress in Eighteenth Century Europe, 1715–1789*. London: Batsford, 1984.

———. *Fashion in the French Revolution*. London: Batsford, 1988.

Riegel, Robert. "Women's Clothes and Women's Rights." *American Quarterly* 15 (Fall, 1963), 397.

"Rita." *Vanity! The Confessions of a Court Modiste*. London: T. Fischer Unwin, 1901.

Rittenhouse, Anne. *The Well-Dressed Woman*. New York and London: Harper & Brothers, 1924.

Roberts, Helene E. "The Exquisite Slave: The Role of Clothes in the Making of the Victorian Woman." *Signs: Journal of Women in Culture and Society* 2 (Spring, 1977), 554–69.

———. "Reply to David Kunzle's 'Dress Reform as Antifeminism'." *Signs: Journal of Women in Culture and Society* 3 (Winter, 1978), 519–20.

Roberts, Mary Louise. *Civilization Without Sexes: Reconstructing Gender in Postwar France, 1917–1927*. Chicago and London: University of Chicago Press, 1994.

Roche, Daniel. *The Culture of Clothing: Dress and Fashion in the Ancien Régime*. Trans. by Jean Birrell. Cambridge University Press, 1994.

Roux, Charles. *Contre le corset*. Paris: E. Brière, 1855.

Santé, Madame de la. *The Corset Defended*. London: T. E. Carler, 1865.

Schultze-Naumberg, Paul. *Die Kultur des weiblichen Körpers als Grundlage der Frauenkleidung*. Jena, 1901.

Schwartz, Gerhard S., M.D. "Society, Physicians, and the Corset." *Bulletin of the New York Academy of Medicine* 55, no. 6 (June, 1979), 551–90.

Seeker, Miss. *Monographie du corset*. Louvain: Imprimerie Lefèvre, frères et soeur, 1887.

Severa, Joan. *Dressed for the Photographer: Ordinary Americans and Fashion, 1840–1900*. Kent, Ohio: Kent State University Press, 1995.

Shep, R. L. *Corsets: A Visual History*. Mendocino, Calif.: R. L. Shep, 1993.

Sibson, Francis. *On the Mechanism of Respiration*. London: R. & J. E. Taylor, 1846.

Sigourney, Mrs. L. H. "On Health – to Mothers." *The Mother's Book*, August 1838, 189.

Simon, Marie. *Les Dessous: Les Carnets de la mode*. Paris: Chêne-Hachette, 1998.

Singer, Sydney Ross, and Soma Grismaijer. *Dressed to Kill: The Link Between Breast Cancer and Bras*. Garden City, N.Y.: Avery, 1995.

Singh, Devendra. "Adaptive Significance of Female Physical Attractiveness: Role of Waist-to-Hip Ratio." *Journal of Personality and Social Psychology* 65, no. 2 (1993), 293–307.

———, and Suwardi Luis. "Ethnic and Gender Consensus for the Effect of Waist-to-Hip Ratio on Judgement of Women's Attractiveness." *Human Nature* 6, no. 1 (1995), 51–65.

———, and Robert K. Young. "Body Weight, Waist-to-Hip Ratio, Breasts, and Hips: Role in Judgements of Female Attractiveness and Desireability for Relationships." *Ethnology and Sociobiology* 16 (1995), 483–507.

Smith, Hugh, M.D. *Letters to Married Ladies, to Which Is Added a Letter on Corsets, by an American Physician*. New York: E. Bliss and E. White, 1827.

Smith, W. Wilberforce, M.D. "Corset Wearing: The Medical Side of the Attack." *Aglaia*, July, 1893, 7, and Spring, 1894, 31–5.

——. "On the Alleged Differences between Male and Female Respiratory Movements." *British Medical Journal* (October 11, 1890).

Soemmerring, Samuel Thomas von. *Über die Wirkungen der Schnürbruste*. Berlin, 1793.

Sorge, Lynn. "Eighteenth-Century Stays: Their Origins and Creators." *Costume* 32 (1998), 18–32.

Stables, Gordon, M.D. *The Girl's Own Book of Health and Beauty*. London: Jarrold, 1892.

Stanton, Domna. *The Aristocrat as Art: A Study of the Honnête Homme and the Dandy in Seventeenth- and Nineteenth-Century French Literature*. New York: Columbia University Press, 1980.

Steele, Frances Mary, and Elizabeth Livingston Steele Adams. *Beauty of Form and Grace of Vesture*. London: B. F. Stevens, 1892.

Steele, Valerie. *Fashion and Eroticism: Ideals of Feminine Beauty from the Victorian Era to the Jazz Age*. Oxford and New York: Oxford University Press, 1985.

——. *Fetish: Fashion, Sex, and Power*. Oxford and New York: Oxford University Press, 1996.

——. "*Le Corset*: A Material Culture Analysis of a Deluxe French Book." *Yale Journal of Criticism* 11, no. 1 (1998), 29–38.

Stewart, Mary Lynn. *For Health and Beauty: Physical Culture for Frenchwomen, 1880s–1930s*. Baltimore and London: Johns Hopkins University Press, 2001.

Stratz, Christian. *Die Frauenkleidung und ihre naturliche Entwicklung*. Stuttgart, 1900.

Summers, Leigh. "The Sexual Politics of Corsetry, 1850–1900." Ph.d. diss., University of Melbourne, 1999.

Taliaferro, V. H. "The Corset in Its Relations to Uterine Disease." *Atlanta Medical and Surgical Journal* 10 (1873), 683–93.

Tarrant, Naomi. *The Development of Costume*. London and New York: Routledge, 1994.

Thesander, Marianne. *The Feminine Ideal*. London: Reaktion Books, 1997.

Tillotson, Mary E. *Progress Versus Fashion*. Vineland, New Jersey, 1873.

Tramar, La Comtesse de [Marie-Fanny de Lagarrigue, Baronne d'Ysarn de Capdeville, Marquise de Villefort]. *Le Bréviaire de la femme: Pratiques secrètes de la beauté*. Paris: Victor Havard, 1903.

Treves, Frederick, F.R.C.S. *The Dress of the Period in Its Relation to Health*. London: Allman & Son, for the National Health Society, n.d. [1882].

Uzanne, Octave. *L'Art et les artifices de la beauté*. Paris: F. Juven, 1902.

Valverde, Mariana. "The Love of Finery: Fashion and the Fallen Woman in the Nineteenth-Century Social Discourse." *Victorian Studies* (Winter, 1989), 169–89.

Vandereycken, Walter, and Ron van Deth. *From Fasting Saints to Anorexic Girls: The History of Self-Starvation*. New York University Press, 1994.

Veblen, Thorstein. *The Theory of the Leisure Class*. New York: Modern Library, 1934. (Originally published London: Mentor Books, 1899.)

Vickery, Amanda. *The Gentleman's Daughter: Women's Lives in Georgian England*. New Haven and London: Yale University Press, 1998.

Vigarello, Georges. "The Upward Training of the Body from the Age of Chivalry to Courtly Civility." In *Fragments for a History of the Human Body*, Part Two. Zone 4, ed. Michel Feher with Ramona Naddaff and Nadia Tazi. New York: Urzone, 1989.

Viterbo, Georges. "Corset et féminisme." *Les Dessous Elégants*, September 1904, 155–6.

———. "Les Corset-ceintures pour hommes." *Les Dessous Elégants*, August 1904, 138–9.

W. B. L. [William Barry Lord]. *The Corset and the Crinoline*. London: Ward, Lock and Tyler, n.d. [1868]. Repr. as *The Freaks of Fashion*. London: Ward, Lock and Tyler, 1871.

Walker, Mrs. A. *Female Beauty, as Preserved and Improved by Regimen, Cleanliness and Dress*. London: Thomas Hust, 1837.

Waugh, Norah. *Corsets and Crinolines*. London: Batsford, 1954.

Welch, Margaret. "Corsets Past and Present." *Harper's Bazaar*, September 1901, 450–54.

Witkowski, Dr. G. J. *Anecdotes historiques et réligieuses sur les seins et l'aillaitement comprenant l'histoire du décolletage et du corset*. Paris: A. Maloine, 1889.

Wood-Allen, Mrs. Mary, M.D. *What a Young Woman Ought to Know*. New rev. ed. *Self and Sex Series*. Philadelphia: Vir Publishing, [1899] 1913.

Woolson, Abba Gould, ed. *Dress Reform: A Series of Lectures Delivered in Boston, on Dress as It Affects the Health of Women*. Boston: Roberts Brothers, 1874.

Yalom, Marilyn. *A History of the Breast*. New York: Knopf, 1997.

Zilliacus, Benedict. *The Corset*. Trans. Fred A. Brewster. Helsinki: Frencskellska Try Okeri Ab, 1963.

Periodicals

The Corset and Underwear Review
Les Dessous Elégants
Englishwomen's Domestic Magazine
The Family Doctor
Figaro-Modes
The Gentlewoman
Harper's Bazaar
Harper's and Queen
Journal des Dames et des Modes
The Lady's Magazine
The Lady's Realm
The Lancet
Life
Punch
The Queen
Rational Dress Society's Gazette
Society
Sylvia's Home Journal
La Vie Parisienne
Vogue

Index

actresses, 115, 125
adolescence, and corsetry, 49, 52, 72
advertising, corset, 55–66, 73, 92, 133–4, 148–50, 152; for girdles, 161–3
aesthetic dress, 62
America, corsetry in, 35, 49, 109
anorexia, 64
Anstruther, Elizabeth, 104
aristocracy, 1, 13, 26–8, 36
Artificial Changeling, The, 14–15
Austria, tight-lacing in, 93–4, 96
autopsy, and corsetry, 14, 25, 74, 79

Baër, Gil, 107
Ball's Corsets, 46, 52, 56, 132
Balzac, Honoré de, 38, 45
Baudelaire, Charles, 120
beauty, and corsetry, 29, 41, 50–52, 65, 83, 104–6, 120, 133, 138, 143, 164–5; and slenderness/thinness, 64–5, 146, 153–4, 165; and youth, 65, 164–5
Becker, Lydia, 59
Beeton, Samuel, 90–91
Before the Mirror, 123–4
Benjamin, Walter, 138
Berlin, corsetry and morality in, 150–51
Bertall, 38
bicycling, and corsetry, 56
Bloomer costume, 60
boarding schools, "tight-lacing," 88–9, 91–6
Bocage, Madame du, 26
"body" (term for corset), 6–8, 15, 28; Spanish-style, 14; *see also* corset; corsetry; stays
body, aristocratic, 1, 36, 114; artful, 28; as work of art, 13; body-building, 163; changing attitudes toward, 151; control/discipline/modification/training of, 12–13, 15, 107–8, 120, 135–7, 155, 165; corsetry as assault on, 1; female, as site of signification, 7, 28; female, corset as surrogate for, 45–6, 58, 118, 123, 175; female, defects corrected by corsetry, 42, 64, 135–8, 156; female, sinful, 113; hard, 143, 165, 175; natural, 114, 165; nude, 53; sculpting, 143, 162–3; slenderness as ideal, 64–5, 148, 153–4, 165; "techniques of the

body," 165; *see also* corset; corsetry; tight-lacing; waist
body, youthfulness as ideal, 148, 150–51
boneless corsets, 28–30, 146, 148
boning, 27, 29–30, 33, 40, 43, 81, 107, 118; metal, 48; metal collected as war material, 151; steel, 56; "unbreakable," 56; *see also* coraline; cording; horn; leather; reeds; rubber; springs; steel; whalebone; wood
Bonnaud, Jacques, 29
bosom, heaving, 71; *see also* breasts
bound feet, 52, 80
bourgeoisie, 1, 35–6, 47–8
Bouvier, Dr. Sauveur Henri-Victor, 80
brassiere, 30, 54, 84, 145, 147–9, 155, 157, 160–62, 165
breasts, 20–21, 28, 30, 40, 42, 54, 71, 76–7, 80, 84, 98, 114, 120, 125, 129, 145, 151, 158, 165
breathing/respiration, and corsetry, 21, 69–71, 87; costal, 70
breeches, symbol of masculinity, 21
Broch, Herman, 138
Brontë, Anne, 39
Brooks, Peter, 119
Brownmiller, Susan, 165
Brummell, Beau, 38
Buck, Anne, 27
buckram, fabric for corsets, 7
Bulwer, John, 14–15
Burney, Fanny, 33
busk, 7, 10–12, 15, 39–41, 48, 52, 76, 81, 149; electro-magnetic, 43; front-fastening, 43; split, 43; spoon-shaped, 46–7
bust-bodice, 30; *see also* brassiere

cancer, attributed to corsetry, 75, 80
Caplin, Mme Roxey A., 41–2
caricature, and stays, 21–2, 24–6; of corsetry, 48, 115–20, 135–7, 150–51; of corsets for men, 36–8; of dress-reform, 146; of tight-lacing, 67, 100
Castiglione, Giovanni, 13
Catherine de Medici, *see* Medici, Catherine de
Cavendish, Georgiana, Duchess of Devonshire, 24

Chalayan, Hussein, 174, 176
Chanel, Coco, 152; House of, 172
Chapus, Eugène, 137
Charcot, Jean Martin, 64
Cher, 74
childbirth, 12; *see also* pregnancy; reproduction
children, and corsetry, 12, 21–3, 29, 49–50, 72, 102
chlorosis, 67, 75
Clarissa Harlowe, 26
Clark, Kenneth, 114
class, and corsetry, 1, 13, 21, 35–6, 47–8, 51, 96, 98, 108–9, 119, 160; and tight-lacing, 98; *see also* status
Clayson, Hollis, 122
codpiece, 12
Collett, John, 1, 2, 21, 26
colors, of corsets, 39, 54, 113, 116–19, 122–3, 129
comfort, and clothing, 24, 61, 65; and corsetry, 24–5, 44, 50–51, 55–6, 71, 79, 85, 92, 155–6, 162
Conquête de passage, 125, 127–8
constriction, implications of, 25–6, 120
consumer society, 28
consumption, attributed to corsetry, 14–15, 67, 71, 79
control, corsetry and, 155–6, 161–2
Cooley, Arnold, 52–3
Cooley's Corsets, 55
coraline, 45, 82, 134
cording, 41, 62, 81–2
corps à la baleine, 7; *see also* whalebone body
corselet, 12; corselette, 152, 156
corset/corsets, and contemporary fashion, 165–76; as outerwear, 143, 166–8; as surrogate for female body, 45–6, 118, 123, 175; as symbol of femininity, 50, 55; colors of, 39, 54, 122–3, 129; controversies, 52, 59, 82; correspondence, 88–90, 92–6, 98–9, 109–10; custom-made, 44; demise of, 1, 138–9, 141, 143, 145–7, 152; elastic, 43, 153–4; electric, 68, 81; evolution and technological development of, 39, 44, 46–7, 146–8; homemade, 39–40; leather, 27, 38, 168; manufacturers of, 41, 156, 158;

mass-produced, 44, 46–8; measurements of, 2, 40, 44, 52, 81, 100–04, 106–7, 109; metal, 2, 4–5; myths about, 74; names of, 133; nursing, 76; origin of, 2–7, 29; orthopedic, 5, 12, 15, 39; padded, 54, 136; pregnancy and, 76; "prosthetic," 176; S-bend, 84–5; satin, 54, 113, 115, 117, 119–20; steam-moulded, 44, 46; straight-front, 84–5, 144; "surgical," 176; "tango," 148; worn by children, 12, 21, 23, 29, 49, 72; worn by men, 36–9, 49, 93–7, 107–8, 168; see also body; corsetry; foundation garments; girdle; tight-lacing; waist

Corset à travers les âges, Le, 4, 17, 28

Corset Defended, The, 92

Corset and the Crinoline, The, 4–5, 92

corsetiers/corsetières, 41, 44, 55, 84, 141, 144, 153

corsetless look, 148, 153

corsetry, and ability to work, 49; and beauty, 26, 41–2, 50–52, 64, 133, 138; and breasts/bosom, 20–21, 28, 30, 40, 42, 54, 71, 76–7, 80, 84, 114, 120, 125, 129, 145, 158; and children, 12, 21, 23, 29, 49, 72; and class/status, 1, 4, 9, 12–13, 21, 28, 35–6, 47–8, 51, 108–9, 133, 160; and comfort, 24–5, 44, 50–51, 55–6, 71, 79, 85, 92, 155–6, 162; and decency/respectability, 51, 118; and deformity, 5, 12, 15, 33, 52–3, 69, 72–3, 75, 78, 165; and digestive problems, 75; and discipline/self-discipline, 13, 89, 92–3; and fetishism, 90–91, 98–9, 105, 109, 165–6, 176; and morality, 30, 150; and naturalness, 41–2, 52–4; and pain/suffering/discomfort, 13–14, 41, 44, 50, 71, 92, 95, 120; and posture, 10, 13, 52, 71–2, 84–5; and pregnancy, 56, 59, 67, 76, 83, 117, 138; and prostitution, 49, 96, 99, 115, 125, 148; and respiration/breathing, 21, 69–71; and sports, 44, 56, 152; as mutilation of the body, 49; as oppression of women, 1–2; as punishment, 93, 166; as sexual empowerment, 166; as torture, 14, 50, 89, 92–3; caricatures of, 21–2, 24–6, 36–8, 48, 67, 100, 115–20, 135–7, 150–51; critiques of/opposition to, 2, 29–30, 76–8 (*see also* doctors; feminism); death attributed to, 13–14, 25, 49, 67, 76–7, 79; demise of, 1, 138–9, 141, 143, 145–7, 152; erotic appeal of, 20, 28, 35, 59, 98, 113–14, 132, 156–7, 165; health claims for, 16, 43, 49, 62, 76, 80–81, 84–5; meanings of, 1, 29; medical consequences of, 10, 13–15, 25, 49–50, 56, 59, 62, 67–85; men and, 36–9, 49, 93–7, 107–8, 168; obesity and, 26, 38, 51, 64–5, 80; phallic symbolism of, 98; rebellion against by young women, 50–51; *see also* body; corset; foundation garments; tight-lacing; waist

courtesans, 121; underwear of, 115

Cousin Bette, 38, 45

couturières, 17–18

crinoline, 46

Crosby, Caresse, 147

cross-dressing, *see* transvestism

Cruikshank, George, 36–8

Cult of Chiffon, The, 144

cupids, 105, 107–8; *see also* putti

dandys/dandyism, 36–9

Daumier, Honoré, 46

David, Jacques-Louis, 32–3

death, attributed to corsetry, 13–14, 25, 49, 67, 76–7, 79

defects, correction of by corsets, 42, 64, 135–8, 156

deformity, 5, 12, 15, 33, 52–3, 69, 72–3, 75, 78, 165

Degas, Edouard, 122–3

demi-monde, 62, 117

Dennis, Fred, 101

Dessous Elégants, Les, 80, 143–5, 148

Detroy, Jean-François, 18–19

Déveria, Achille, 42

diaphragm, *see* breathing

diet, and figure control, 64, 143, 152–3, 162

Dinka people, 173

Dior, Christian, 158, 172; House of, 172–3

discipline, corsetry and, 89, 92–3, 96

diseases attributed to corsetry, 67–8, 71, 74–5, 77–9, 83

doctors, opposed to corsetry, 13–15, 35, 41, 52, 56, 59, 67, 76–8, 80, 82–3, 145

Douglas, Mrs. Fanny, 53

Down's Self-Adjusting Corset, 45

drawers, 62; *see also* underwear

dress reform, 35, 52–3, 59–61, 64–5, 67–8, 76, 78, 104, 109, 138–9, 143, 146

dressmakers, 17–18

Dubois, Charles, 83

Ecob, Helen, 64, 104

EDM, see Englishwomen's Domestic Magazine, The

education for women, supposed dangers of, 78

Eleanora de Medici, *see* Medici, Eleanora de

Elizabeth I, Queen, 8, 10

Elizabeth Charlotte, Princess Palatine, 26

Elizabeth, Empress of Austria, 64

England, corsetry in, 18, 26–7, 29, 35, 49

Englishwomen's Domestic Magazine, The [EDM], 52, 88–94, 98–9, 105, 109–10

Enlightenment attitudes toward corsetry, 29–30

erotic appeal of corsetry, 20, 28, 35, 59, 98, 113–14, 132, 156–7, 165; of underwear, 135

essai du corset, 18–20, 119

Estienne, Henry, 7

exercise, 64, 143, 146, 152–3, 163

eyelets, metal, 44, 157

fainting, 70–71

Family Doctor, The, 93–5, 98

fantasies, sexual, 90–92

farthingale, 6

"Fashion before Ease," 25

fashion illustration, 100, 102, 116; of corsets, 44

fashion, as artifice, 29; critiques of, 14, 60–62; democratization of, 36; "fiend of," 6; medical consequences of, 64; morality and, 62; victims of, 2

Fath, Jacques, 158

fatness, 148, 154, 156–7, 161

femininity, corsetry and, 50, 55; submissive ideal of, 35, 108

feminism, and corsetry, 2, 29, 35, 90, 120, 145–6, 166, 176; and critiques of fashion, 60–61, 78, 80, 135, 162; and tight-lacing, 120

fetishism, 90–91, 99, 165; clothing, 135, 176; female, 90–91; and tight-lacing, 98–9, 105, 109

Feydeau, Ernest, 53

Finck, Henry, 64

flagellation, and tight-lacing, 93–4, 96, 99

Flaubert, Gustave, 45

Flöge, Emilie, 64

Flower, Dr. William, 80

Fogarty, Anne, 161

Fonda, Jane, 163

footbinding, 52, 80, 161

Foote, Samuel, 27

Foucault, Michel, 155, 165

foundation garments, 148, 155, 158, 160–62

Fouquet, Jean, 6

Fowler, Orson S., 77

France, corsetry in, 27, 29, 35, 44, 49; corset production in, 17–18, 44

Freaks of Fashion, 92

freedom, and clothing, 152, 155–6; corsetry and, 42, 44

French Revolution, 30, 33, 36

Gâches-Sarraute, Mme Inez, 84

Galliano, John, 172–3

Gamman, Lorraine, 91

Garsault, François-Alexandre de, 16, 18

Gau, Colleen Ruby, 69–70, 72–3, 85

Gaultier, Jean-Paul, 167–8

Gaultier, Théophile, 120

Gavarni, 45

Gender, and class, 48

gentility, 96, 98
Gentlewoman, The, 98
Gervex, Henri, 121–2
Gillray, James, 25, 31
girdle, 73, 102, 143, 151, 155–7, 160–62, 165, 176
Girl's Own Paper, The, 49
Godey's Ladies Magazine, 40
Gone With the Wind, 157
Goths, 166
Goya, 114
grace, attribute of women, 28–9
Granger, Mrs. Ethel, 71, 103
guêpière, 156, 158
guild, couturières', 17–18; dressmakers', 17; staymakers', 18; tailors', 16–18

Haggard, H. Rider, 100–11
hard body, 165
Harper's Bazaar, 161–2, 172
Hauser, Henrietta, 113, 124
Haweis, Mrs. Eliza, 88
health corsets, 16, 80–82, 84–5
Healthy and Artistic Dress Society, 80
Heath, William, 100
high heels, 49, 91–2, 98–9
Higonnet, Anne, 130
hips, *see* waist-hip ratio
Hogarth, William, 21–3
Hollander, Anne, 114
horn, used in corsets, 7, 9–10
horseback riding, and corsetry, 56
Horst, Horst P., 156
hourglass figure, 48, 64, 85
"Human Passions, The," 21, 24
Huysmans, J. K., 115, 120, 127
hygiene, 83–4; hygienic dress, 62
hysteria, attributed to corsetry, 67, 76–7

In Style, 176
Industrial Revolution, 28, 36

Jaeger, Dr. Gustav, 80–81
Josselin, Jean-Julien, 43
Journal des Dames et des Modes, 148
jumps, 27
Jung, Catharine (Cathy), 5, 66–9, 74, 91

Kalm, Peter, 26
Kayne, Madame, 5
Keneally, Arabella, 145
Kidwell, Claudia, 73
Klimt, Gustav, 64
Kristeva, Julia, 138
Kunzle, David, 90
Kutsche, Dr. Lynn, 68, 72–3, 75, 78–9, 82, 84
Kyoto Costume Institute, 54, 101

lacing, 102–3, 128; lacing/unlacing as symbolic sexual intercourse, 20–21, 45, 119–20, 156; techniques of, 22–3, 43–4, 129
Lacroix, Christian, 170–72
Ladies Magazine, The, 29
Lady's Realm, The, 144
Lagerfeld, Karl, 172
Lancet, The, 67, 69, 71, 79, 89, 111
Lastex, 155, 160
Lauren, Sophia, 164
Lavallière, Mlle Eva, 140–41
leather corsets, 38, 168; leather stays, 27
Léoty, Ernest, 4, 17, 28, 55; Maison, corsets of, 46, 55, 138
liberty, and dress, 25, 30, 60, 147, 152
Liddell Hart, Sir Basil, 84, 107–8
Ligue des Mères de Famille, 76
Limner, Luke, 50, 67, 70
linen, 16, 29
lingerie, 115, 119, 129, 132–3, 144
liposuction, 163–4
liver, effects of corsetry on, 67, 72, 74–5, 78, 155
London Life, 86–7, 94, 99
loose dress, and loose morals, 26
Lucile, 147
lungs, 69–72; "apoplexy of," 79; *see also* breathing
Lycra, 161

Mactaggart, Peter and Ann, 22
Madame Bovary, 45–6
Madame Dowding's Corsets, 96
Madame Warren Corset, 133–4
Madonna, 166–7
Madre Natura Versus the Moloch of Fashion, 50, 67, 70
magnetic devices, health claims for, 81
male gaze, 130, 132
Manet, Edouard, 113, 115–16, 119–21, 123–4, 130
manufacture of corsets, 41, 44, 46–8, 156, 158
Marx, Karl, 51
masochism, 35, 90, 92; *see also* sadomasochism
mass-production of corsets, 44, 46–8
masturbation, 77–8, 83, 87
McQueen, Alexander, 175–6
Medici, Catherine de, 2, 4–5, 7
Medici, Eleanora de, 6
men, corsets worn by, 12, 36–9, 49, 93–7, 107–8, 168; as opponents of corsets, 2, 49, 59
Mercier, Louis, 30, 33
"Merry Widow," 161
metal corsets, 2, 4–5
Metropolitan Museum of Art, New York, 100
military officers, corsets worn by, 38
military uniform, as fetish, 138

Minoan civilization, 2–4
Mirror of the Graces, The, 33
miscarriages, attributed to corsetry, 10, 67, 76; *see also* motherhood; pregnancy
Mitford, Nancy, 160
Miyake, Issey, 175
Modes Parisiennes, 44
Monroe, Marilyn, 164–5
Montaigne, Michel de, 13–14
Montaut, Henri de, 105, 117–20, 135–7, 139, 141
Moore, Doris Langley, 90
Morisot, Berthe, 130
Moss, Kate, 164
motherhood, and corsetry, 76–7, 83, 87–8
Mower, Sarah, 172
Mugler, Theirry, 168, 170
Murray and Vern, 168
muscles, abdominal, 42, 64, 71; and exercise, 163; as surrogate corset, 137–8, 158, 169; atrophy of due to corsetry, 71–2; back, 71–2
"muscular corset," 143, 160
Museum at the Fashion Institute of Technology, 5, 40, 48, 81, 101
Musset, Alfred de, 121
My Secret Life, 65
myths about corsetry, 2, 4, 74

names of corsets, 133
Nana, 112–13, 115–16, 123–5, 129–30
naturalness, 28–29, 30, 41, 52–4, 114, 120, 165
Nead, Lynda, 114, 137, 163
New Look, 158
Nochlin, Linda, 114
nudity, artistic, 53, 113–14, 120–21, 137–8; and naturalness, 120; versus nakedness, 113
nursing corset, 76

O'Followell, Dr. Ludovic, 71–3, 80, 143, 148
O'Hara, Scarlett, 1, 157, 176
obesity, and corsetry, 26, 38, 51, 64–5, 80
Olympia, 114, 120
opponents of corsetry, 2, 13–15, 35, 41, 49, 52, 56, 59, 67, 76–8, 80, 82–3, 145
orthopedic corsets, 5, 12, 15, 39, 71

Pacteau, Francette, 135
pain, and corsetry, 13–14, 41, 44, 50, 71, 92, 120
Paine, Thomas, 25
panty-girdle, 155, 160–61
Paré, Ambroise, 5, 13, 15
Pearl, Mr., 100, 142–3, 168, 172, 175
Perniola, Mario, 114
petticoat, 116, 134, 144
Phelps, Elizabeth Stuart, 59–60
phrenology, 77, 82

plastic/cosmetic surgery, *see* surgery
Pointon, Marcia, 113
Poiret, Paul, 146–8, 158
population, decrease in attributed to corsetry, 76–7, 83–4
pornography, 65, 94, 96, 98, 165
posture, and corsetry, 10, 13, 52, 71–2
Powers, Hiram, 75
pregnancy, and corsetry, 56, 59, 67, 76, 83, 117, 138
Pretty Housemaid Corset, 48
Pritchard, Mrs. Eric, 144
prostitution, 49, 96, 99, 115, 125, 148; and corsetry, 49, 115
Punch, 67, 89
punishment, and tight-lacing, 93
punks, 166, 176
putti, in corset advertising, 56, 134; *see also* cupids

Queen, The, 91–2, 95, 146

Rabelais, 6
rational dress, 61–2; Rational Dress Society, 61, 76
Raverat, Gwen, 50–51, 74
Reade, Charles, 50
reeds, used in stays, 27
Réjane, Mme, 140–41
respiration, *see* breathing
Revolution, French, 30, 33, 36
Ribeiro, Aileen, 30
ribs, 1, 25, 33, 67–9, 72–4, 78–9; alleged surgical removal of, 73–4
Richardson, Samuel, 26
ricketts, and skeletal deformities, 73
Rimbaud, Arthur, 137
Roberts, Mary Louise, 152
Roche, Daniel, 13
Rode, Edith, 51
Rolla, 121–2
Rome, 4, 30
Rousseau, Jean-Jacques, 29, 119
Roux, Charles, 80
Rowlandson, Thomas, 26–6
rubber, in corsets, 43–4, 148, 151, 154, 157–8, 168
Russell, Lillian, 65

S-bend corset, 84–5
Sacred and Profane Love, 113
sadomasochism, 90–92, 99, 108–9, 120, 165–6
Safford-Blake, Dr. Mary J., 78
Santé, Mme de la, 92
satin corset, 54, 113, 115, 117, 119–20
Schiaparelli, Elsa, 168
scoliosis (curvature of the spine), 5, 67, 71, 87
Seeing Through Clothes, 114

self-presentation, 13
Seurat, Georges, 125–6
Sévigné, Madame de, 12
sexual appeal of corsetry, 118; *see also* corsetry, erotic appeal of
sexual attitudes, changing, 162
sexual fantasies, 99
sexual liberation, 166
sexuality, Victorian anxieties about, 110
She, 110–11
Sherman, Dr. John E., 74
shoes, and fetishism, 90; *see also* high heels
silk, 8–9; silk corsets, 44, 48, 115, 117; silk stays, 19, 33
Sin and Scandal of Tight-Lacing, The, 98
size of corsets, *see* corsets, measurements of
skeletons, skeletal effects of corsetry, 66–7, 69, 71–3, 83
"slaves of the stay-lace," 93
slimness, as physical ideal, 64–5, 148, 153–4, 165
Smith, Dr. William Wilberforce, 80
Smithsonian Institution, 73
Society, 98–9
Soemmerring, Samuel Thomas van, 25, 69
Spécialité Corset, 134–5
sports, 143, 146, 165; and corsetry, 44, 56, 152; sports bra, 165
springs, in corsets, 43
Stables, Gordon, 49
Starkie, Miss, 9–10
Starkie, Mr., 9
status, and beauty, 165; corsetry and, 1–2, 4, 12–13, 28, 133
staymakers, 16–18, 40; *see also* corsetiers/corsetières
stays, 2, 7–8, 10, 12–13, 15–16, 18–21, 27, 29, 33, 84, 160; and decorum, 16; and gentility, 18; and respectability, 28; erotic appeal of, 18–20; measurements of, 2; status and, 12–13, 28; symbol of femininity, 21; working-class, 21; *see also* body; corset; corsetry
steam-moulded corsets, 44, 46
steel corsets, 2; steel used in corsets, 56, 62, 73, 148, 151, 157
stiffness, 13, 29
stoutness, 153, 158
straight-front corset, 84–5, 144
suicide, corsetry as, 87
Summers, Leigh, 68, 72
surgery, plastic/cosmetic, 73–4, 143, 163–4
swaddling clothes, 12
swooning, 43, 70–71
Sylph, The, 25
Symington Collection, Leicester, 48, 100

tailors, 16–18
tango corset, 148

Tarrant, Naomi, 9
tattooing, 15
teagown, 64
Theory of the Leisure Class, The, 49
Theweleit, Klaus, 137
thinness, as physical ideal, *see* slimness
Thomson's Glove-Fitting Corset, 54, 90, 119
tight-lacing, 1, 24–5, 44, 49–50, 52, 59, 64, 76–7, 82–3, 87–111; 120, 154; and class, 98; and fetishism, 87, 90–91, 98, 105, 120; and flagellation, 93–4, 96, 99; and sexual fantasies, 99; as punishment/torture, 89, 92–3; as "suicide," 67, 76–7; death attributed to, 13–14, 67, 79; diseases attributed to, 77–8; erotic appeal of, 49–50; Fowler's view of, 77; morality of, 87; political satire and, 25–6; "votaries of," 87–9; *see also* corset/corsets; corsetry; stays; waist
"Tight Lacing, or Fashion Before Ease," 21
toilette galante, la, 18, 20
torture, corsetry as, 14, 50, 89, 92–3
Toulouse Lautrec, Henri de, 125, 127–8
trade cards, 46, 54–66, 129–32
transvestism, 90–93, 99, 108–9, 120
Treves, Dr. Frederick, 80
tuberculosis, *see* consumption
Twiggy, 154, 164–5

Über die Wirkungen der Schurbruste, 25
underwear, 20, 44, 62, 114–15, 118, 135, 143–4, 151, 156; and undressing, 115; underwear-as-outerwear, 168
undressing, 115, 119–20, 129
uterus, 76, 78, 83, 85; *see also* pregnancy
Uzanne, Octave, 55

Vandevorst, A. F., 174, 176
vanity, female, 14, 26, 87, 109, 130
vasquine, 6
Veblen, Thorstein, 28, 49
velvet, 8
Venus de Milo, 52–3, 160, 164
Vernon, Elizabeth, Countess of Southampton, 8–9
Vickery, Amanda, 28
Victorian attitudes, 35; 89; sexuality, 48, 60; women, and tight-lacing, 99–100, 110
Vidal, Eugène, 128–9
Vie Parisienne, La, 46, 105–6, 115–20, 135, 138–9
Vigarello, Georges, 12
Villareal, Abel, 168
Vionnet, Madeleine, 147, 152
Vogue, 143, 146, 153, 155, 161, 163–4, 172, 176
voluptuousness, 65
voyeurism, 130, 132

W. B. Corset, 56

waist, 30, 33, 39–40, 46, 48, 52–4, 64, 76–8, 84, 100–04, 106–7, 109–11, 144, 146, 154, 156, 158, 161, 164, 173, 176; and beauty, 50–55, 110–11; as term for corset, 30; measurements/size of, 52–4, 64, 88–9, 91–4, 100–04, 106–7, 109, 154, 161; slender, as status symbol, 48; waist-cincher, 161; waist pincher, 158; *see also* wasp waist

waist-hip ratio, 54, 98, 154, 164–5

Warner Brothers corsets, 45, 134

Warner's girdles, 161–2

wasp waist, 2, 87–8, 96, 98–100, 132, 156

waspie, 158; *see also guêpière*

Westwood, Vivienne, 166, 174

whalebone, 5–9, 14, 16, 27, 29, 38, 41, 48, 52, 60, 73, 81–2, 143, 148; "whalebone body," 6–8

Williamsburg, Colonial, 2, 101

Wolf, Naomi, 163

Woman's Suffrage Journal, 59

women, oppression of by corsetry, 1, 2

women's rights movement, 143

Wonderbra, 20, 54, 172

wood, used in stays, 27

working class, and corsetry, 21, 27–8, 47–9, 60, 109, 157

World War I, 36, 151

World War II, and corsetry, 157

X-rays, 66, 68–9

youth, and ideals of beauty, 65, 148, 150–51, 160–61

Zola, Emile, 115